Thomas MORAN

AND THE SURVEYING
OF THE AMERICAN WEST

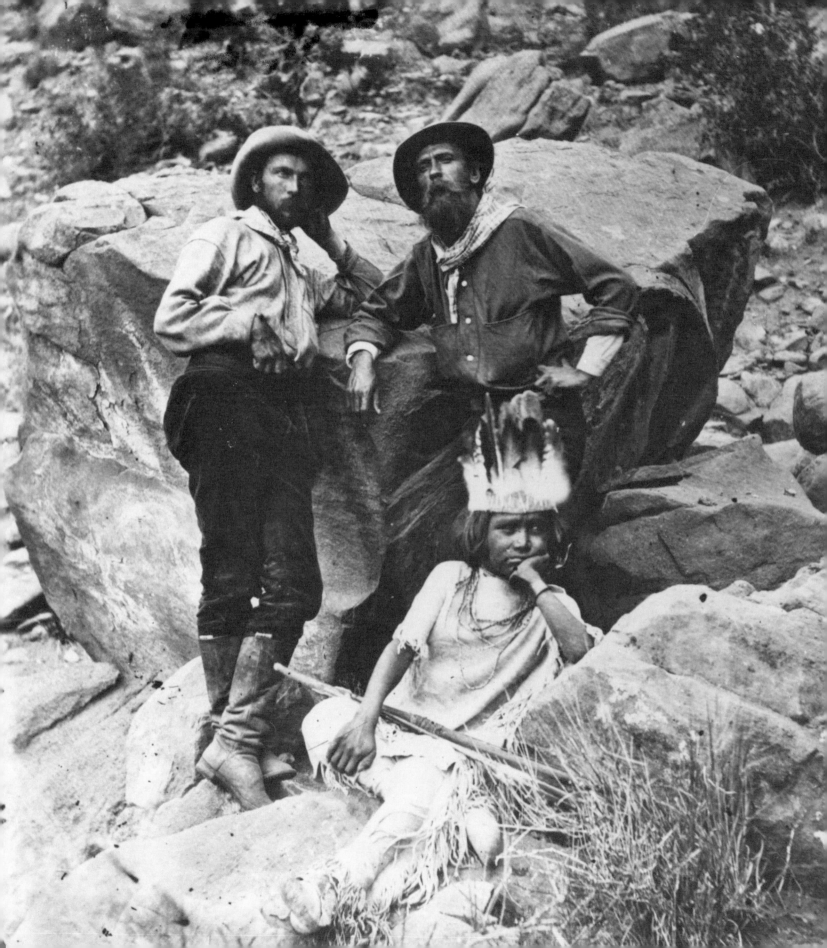

THOMAS MORAN

AND THE SURVEYING
OF THE AMERICAN WEST

JONI LOUISE KINSEY

SMITHSONIAN INSTITUTION PRESS Washington and London

Editor: Lorraine Atherton
Production Editor: Duke Johns
Designer: Janice Wheeler

Library of Congress Cataloging-in-Publication
Data
Kinsey, Joni.
 Thomas Moran and the surveying of the
American West / Joni Louise Kinsey.
 p. cm.—(New directions in American art)
 Includes bibliographical references and index.
 ISBN 1-56098-170-9 (pbk.)
 1. Moran, Thomas, 1837–1926—Criticism
and interpretation. 2. West (U.S.) in art.
 I. Title.
ND237.M715K56 1992
759.13—dc20 91-23705

British Library Cataloging-in-Publication Data
available

Manufactured in the United States of America
99 98 97 96 95 94 93 92 5 4 3 2 1

♾ The paper used in this publication meets the
minimum requirements of the American National
Standard for Permanence of Paper for Printed Li-
brary Materials Z39.48-1984

On the cover: Thomas Moran's *The Chasm of the
Colorado,* 1873–74, oil on canvas, 84⅜ × 144¾″
(214.3 × 267.6 cm). National Museum of Ameri-
can Art, Smithsonian Institution, lent by the De-
partment of the Interior, Office of the Secretary
(L. 1968.84.2).

FOR MY PARENTS,
BARRY AND CARMEN,
AND MY GRANDPARENTS,
WHO SHOWED ME
THE WAY

CONTENTS

ACKNOWLEDGMENTS

In the course of my research I have had the pleasure of working with many remarkable people and sources. I am highly indebted to the Smithsonian Institution for a fellowship at the National Museum of American Art that enabled me to work unimpeded for a year and brought me many sustaining colleagues. I would like especially to thank William Truettner, curator of nineteenth-century art, who encouraged me throughout the process and who continues to be a source of inspiration. Many others at the NMAA, including Lois Fink, Barbara Thompson, Albert Boime, Wanda Corn, and Gerald Carr, enriched my experience enormously. To my "fellow fellows" Mary Panzer, John Wetenhall, Susan Sivard, Judy Hayward, Tara Tappert, and Rebecca Zurier and Gallagher fellows Pete Daniel, Wayne Durrill, Mike O'Malley, Nina Silber, Louie Hutchins, Charlie and Mary McGovern, Karen Linn, Ron Doel, Christine Hoepfner, Julie Weiss, Lu Ann Jones, and others, I offer my warmest thanks for their friendship and support.

My work in Washington was facilitated to great degree by Cecilia Chinn, director of the NMAA/NPG Library, and her helpful staff; Barbara Wolanin, curator at the U.S. Capitol; Clifford Nelson, U.S. Geological Survey; George Gurney, NMAA; Nancy Anderson and Franklin Kelly, National Gallery of Art; Will Stapp, National Portrait Gallery; James L. Amos, *National Geographic;* Anne Hedgecock and Michael Whittington, National Park Service; Richard Crawford, National Archives. All of these individuals generously shared their expertise and resources, opening doors to many discoveries.

Others who helped in the gathering of material deserve warm thanks for their assistance. At the Gilcrease Museum in Tulsa, where as a child I first saw Thomas Moran's work, the late Fred Myers, Anne Morand, Dan McPike, and Sara Erwin have been consistently generous with their large Moran collection. Others elsewhere include Jeremy Adamson, Renwick Gallery; Stanley Baker, Minneapolis; Paul Benesek and W. D. Woodburn, Santa Fe Railroad Collection; Janet Buerger and Sara Beckner, George Eastman House; Carol Clark, Amherst College; Sara Cohen, Yale University; Elizabeth Cunningham, Anschutz Collection; Elaine Evans Dee and David Black, Cooper-Hewitt Museum; Catherine Engel, Colorado Historical Society; William Goetzmann, University of Texas; Steve Good, Rosenstock Arts; Anne

Another book on the West! Yes, and why not? There ought to be a new book on the West by some careful observer and thorough explorer, at least once a year, for so many and so various are the changes, so important the new discoveries, that a volume is but thoroughly read before the facts it narrates are old.

J. H. Beadle,
The Undeveloped West,
1873

Hyde, Louisiana State University; Dorothy King, East Hampton Free Library; Fran Krupka, National Park Service; William Lang, Montana Historical Society; Guy Logsdon, Tulsa; Augie Maestrogiusseppe, Denver Public Library; Kathleen Moenster, Jefferson National Expansion Memorial; Barbara L. Neilon and Ginny Kiefer, Colorado College; James Nottage, Gene Autry Museum; Bill Olhrich, Washington University; Thomas Pauly, University of Delaware; Robert Richardson and Charles Albi, Colorado Railroad Museum; Alfred Runte, Seattle; Ruby Shields, Minnesota Historical Society; Ellen Schwartz, California Railroad Museum; J. Gray Sweeney, Arizona State University; Sharon Uhler, Hallmark Historical Collection; Thurman Wilkins, Bandon, Oregon; and Ken Winn and Duane Snedecker, Missouri Historical Society.

I also owe a great deal to my former professors and colleagues at Washington University and to the university fellowship that allowed me valuable writing time. Angela Miller arrived at a critical point in my study and has proved a valuable ally in her support of my work and in her reading of the manuscript. I owe Wayne Fields and Pete Steefel an enormous debt for their early encouragement of my original ideas, and each has been unfailingly generous with his time and thoughts throughout the process. Mark Weil and Claudia Rousseau also deserve my deep gratitude for their friendship and support over the years.

At the Smithsonian Institution Press my acquisitions editor, Amy Pastan, and my copy editor, Lorraine Atherton, provided useful suggestions, diligent supervision throughout the production process, and, most important, enthusiastic support when it was most needed. Without their help, and that of the rest of the staff at the press, this book would not have become a reality.

Finally, I am especially grateful to my family. My father, Barry, provided a great deal of information about nineteenth-century health reforms, but more important, he and my mother, Carmen, and my grandparents have encouraged me from the beginning, always confident that I could do whatever I put my mind to. Without their support and love none of this would have been possible.

To all those, named and unnamed, that have helped bring this to fruition, I give my deepest thanks.

INTRODUCTION: VISUAL DOCUMENTATION OF THE GREAT SURVEYS

In the course of nineteenth-century American westward expansion, the act of surveying became an indispensable component of United States official policy. Initiated with Lewis and Clark's travels through the Louisiana Purchase in 1804–1806, exploratory expeditions became one of the primary means by which the government gathered information about its vast resources. Before the Civil War, these ventures to the West were primarily military and concerned with such issues as international land disputes and routes for wagon trains and railroads, all of which required accurate maps and detailed geographical description. The war interrupted much of that work, but afterward new interest developed for further investigation into the characteristics of western land, this time to promote settlement, tourism, and other forms of commerce and to exploit natural resources. From

1867 to 1879 the United States supported four expeditions in the West that have come to be known as the Great Surveys because of their wide geographical range, their long duration, and their comprehensive research. They were directed largely by civilians and were administered variously under the Department of War, the Department of the Interior, and the Smithsonian Institution, but support also came from private industry, which had a vested interest in the enterprise.[1] The railroads both facilitated and profited by the expeditions, contributing their own resources and utilizing the results for their own purposes.

The survey goals were ambitious. In its first season, for example, Ferdinand Hayden's party was commissioned to explore "all the beds, veins and other deposits of ores, coals and clays, marls, peats and other such mineral substances as well as the fossil remains of the various formations" and compile "ample collections in geology, mineralogy, and paleontology to illustrate the notes taken in the field." They were to sample soils for agricultural planning, ascertain the feasibility of introducing certain trees onto the plains, estimate mineral yields, and generally comment on the land's commercial potential. Topographers and cartographers were to make maps; scientists were to catalog specimens, study geological formations, and make weather observations; and finally, "graphic illustrations" of landscapes were to be made that would convey something of the appearance of the region. The teams were then to submit this information in reports to their superiors in Washington to aid future determinations of the land's use and add to the general knowledge of the United States.[2] It is clear from the

Every continent has its own great spirit of place. Every people is polarized in some particular locality, which is home, the homeland. Different places on the face of the earth have different vital effluence, different vibration, different chemical exhalation, different polarity with different stars: call it what you like, but the spirit of place is a great reality.

D. H. Lawrence, "The Spirit of Place"

instructions that the surveys were as comprehensive as possible and that their complete documentation, including graphic illustration, was essential. That is significant not only because it has provided unparalleled information about this period of American expansion but also because it suggests that there was something inherent in the surveying process that required visual expression.

Since the time of Coronado and Columbus, New World explorers had expressed frustration with the inadequacy of words to convey the extraordinary appearance of landscape. We read repeatedly of the desire to impart something more of the place to people far from the site than was possible through the written word. Elaborate verbal descriptions of intricacies of color, form, and spatial relationships had limited meaning without context, and the landscapes that the early explorers encountered were often unlike anything they had ever seen. In frustration the writer often resorted to metaphor, and by the mid nineteenth century this technique, likening cliffs to castles, prairies to oceans, or tall trees to Gothic spires, had become an established literary convention. Such comparisons do provide the reader a mental image, which was the goal of the writer, but that image is imprecise and often does little more than evoke an emotional response. At its best this sort of prose may be exhilarating and its effect on the reader comparable to that which the writer himself experienced at the scene, but even the best-written account of an intrinsically visual subject, such as a landscape, must fall far short of an accurate portrayal. Metaphorical description, a technique carried well into the twentieth century, relies on the reader's associations with a familiar object to create at least an impression

of the unfamiliar, if not its actual appearance. But the discrepancy can be significant; cliffs are not medieval cathedrals or castles, trees are not soaring spires, and the comparison does little to help the reader precisely visualize the particular cliffs or forest. Even the most evocative prose can be a misleading substitute for the immediate comprehension a graphic image can provide. This shortcoming was increasingly recognized throughout the nineteenth century, resulting in the inclusion of art and photographic reproductions in everything from government reports to tourist guidebooks.

The Lewis and Clark expedition was the most important United States survey to exclude the services of an artist, a surprising omission by Thomas Jefferson, who had overseen the preparations and instructed the men to bring back samples of practically everything they encountered. Although Jefferson had a refined appreciation for the visual arts, words came easily to him, and he may not have foreseen the frustrations faced by men less verbal than he. Also, since the Louisiana Territory was unknown, Jefferson may not have envisioned that the surveyors would come across scenes so unfamiliar as to render them indescribable. Meriwether Lewis himself did crude drawings in his journal, and on the expedition's return they proved invaluable in conveying some of the unusual sights the party encountered. But throughout the three-year journey Lewis wished for a better means to record his experiences, and he specifically referred to the visual medium when facing the Great Falls of the upper Missouri River:

After wrighting this imperfect discription I again viewed the falls and was so much disgusted with

the imperfect idea which it conveyed of the scene that I determined to draw my pen across it and begin agin, but then reflected that could not perhaps succeed better than pening the first impressions of the mind; I wished for the pencil of Salvator Rosa or the pen of Thompson, that I might be enabled to give to the enlightened world some just idea of this truly magnificent and sublimely grand object, which has from the commencement of time been concealed from the view of civilized man; but this was fruitless and vain. I most sincerely regreted that I had not brought a crimee [camera] obscura with me by the assistance of which even I could have hoped to have done better but alas this was also out of my reach; I have therefore with the assistance of my pen only indeavoured to trace some of the stronger features of this seen by the assistance of which and my recollection aided by some able pencil I hope still to give to the world some faint idea of an object which at this moment fills me with such pleasure and astonishment; and which of it's kind I will venture to ascert is second to but one in the known world.[3]

This heartfelt desire to record the wondrous scene in front of him echoes the wishes of many preceding explorers, and it is to Lewis's credit that he made an attempt to render the scene visually. Although there seems to be no recommendation in the Lewis and Clark expedition records for an artist to be included in future surveys, it is notable that after their landmark journey few major expeditions went without some form of visual documentation.

The job was often handled by a soldier with little more qualification than an enjoyment of sketching, but in a number of cases the artists were highly skilled members of the eastern or European art community who wished to travel and see the West. The names of many have become familiar: Titian Peale, Karl Bodmer, Alfred Jacob Miller, John Mix Stanley,

and Albert Bierstadt, to name only a few.[4] But whether they are well or little known, the expeditionary artists of the American West made a significant contribution to the understanding and awareness of the region in their own day and in the present. They provided a glimpse of country that most nineteenth-century Americans would never see, even though a great deal of it had been officially a part of the United States since 1803. It is difficult to imagine now, with our wealth of media, just how important and unique the landscape sketches and paintings by these artists were to an eager eastern public and to the policymakers who administered the unsettled lands. The terrain in such works—vast treeless plains, arid deserts, and massive snow-capped mountains—is often substantially different from that of the settled East, but the availability of pictures of the unfamiliar places made the West seem more real and imaginatively accessible to an eastern audience. The opportunity to see the fantastic scenery brought it home and made the exotic less otherworldly than if it had been imagined from written descriptions. The capacity to visualize the West through paintings, photographs, and printed illustrations contributed to the acceptance of the farthest reaches of the continent as part of America, constituting what may be called an act of aesthetic appropriation. Such an act, carried out by a broad spectrum of society, had enormous implications in a century of critical change in the United States.

The artists of the post–Civil War geological expeditions portrayed the western landscape as never before. Although they continued to create views of the scenery and peoples the surveys encountered, the later artists' work conveys a much deeper evocation of the char-

acter of the explorations than did that of their predecessors. The later art is much more than mere documentation of geological and geographical fieldwork; it is a visual synthesis of its time, reflecting contemporary events, scientific and technical developments, and an awareness of aesthetic ideals that had developed significantly since the 1850s. In general, the artists and photographers of the Great Surveys in the early 1870s were better equipped, both technically and intellectually, than their earlier counterparts, and their art reveals an increased sensitivity to the world they sought to portray.

Almost all of the post–Civil War geological expeditions included both artists and photographers. Technological developments, as well as the training and experience many photographers gained during the war, facilitated field photography and contributed to the unsurpassed quality of the Great Survey photographs. They had several major advantages over drawings or watercolors. With the advent of the collodion process in the late 1850s, multiple original prints were easily made and could be distributed separately or bound into volumes. Graphic art in the form of drawings or paintings first had to be etched, engraved, or copied onto lithographic stones before multiple prints could be produced. Photography, despite its labor-intensive requirements in those early years, was infinitely faster than that process and could produce an image of undeniable fidelity to its subject.[5]

Nevertheless, traditional artists continued to be a vital part of the expeditionary team. Photography, no matter how true the image, was subject to a number of technical hazards and mishaps, and it had one major disadvantage, the absence of color. Except for a few isolated experiments, nineteenth-century photography was limited to monochrome, and although most official reports were printed in black and white, some of the more important publications contained at least some color.[6] Furthermore, traditional watercolors and oils were exceptionally useful to the survey leaders in lobbying Congress, especially in verifying their claims about the West's unprecedented chromatic variation.

Graphic artists continued to be employed for several other reasons. The paintings they created from field sketches on their return were more impressive than even the best photographs, not only for their color but also because they could be larger (easily surpassing even mammoth plate photographs), and paintings were more closely allied with the historical notion of landscape as a fine art. Traditional media, in the late nineteenth century, were still considered more humanistic than photography, which carried with it the strong association of technology, almost devoid of human contact. Not only could painted landscapes portray topography, but they could also embody a range of meaning, from the theological and philosophical associations with Arcadia, the paradisiacal garden, or the apocalypse, to more general psychological affinities with time and place that had personal or nationalistic implications. Such claims could also be made for photographs, but that would be primarily a twentieth-century concept; in the 1870s photography was still considered the province of the technician, not that of a visionary artist.[7] That was an important, if subtle, distinction in depicting the West for an eastern audience. In the 1870s the West was

still seen, as it is nostalgically today, as mysterious, a wild and exotic place of unfamiliar peoples and customs, and the time-honored conventions of Romantic painting, imbued with notions of grandeur and history, were especially suited to this attitude.

With the new suitability of the photographic process for fieldwork, expeditionary photographers and artists became allies; often they worked together in selecting views, in the arduous technical processes, and in developing ideas for their respective images. Equally important was the artist's use of the photographs in studio works and illustrations for the official reports and the popular press after the expedition's completion. They provided greater accuracy and enabled the artist to incorporate many more scenes in his oeuvre than he could have sketched himself. Through such collaboration the visual documentation process expanded to include a variety of sources and influences, enriching each medium with the special capabilities of the other.

Although the primary purpose of expeditionary illustrations was to amplify the findings of the geologists, topographers, and geographers, their use and effect were much broader. In several instances the best photographs were issued in deluxe volumes, some were exhibited independently as landscape art, and a large number were sold to the public as stereographs, informing an entire generation of the appearance and unrealized potential of the West. Of the more traditional arts, report illustrations often appeared in popular magazines and travel guidebooks, and studio oils and watercolors appealed to a wide audience, both as originals and in chromolithographic reproduction. Their dissemination was im-

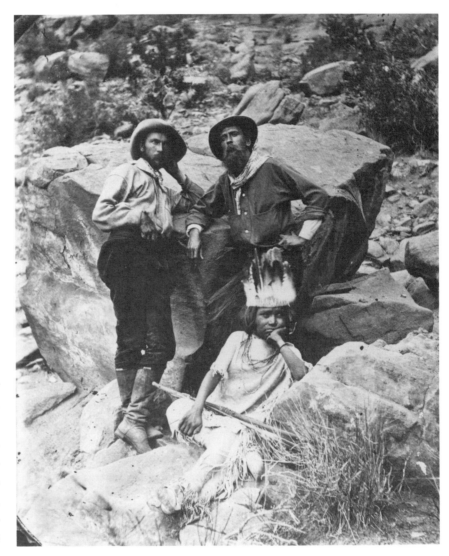

Fig. 1. Jack Hillers, *J. E. Colburn, Thomas Moran and Kaibab Paiute Boy,* 1873, photograph. National Anthropological Archives, Smithsonian Institution (1592-B).

portant not only for advertising the government's work in the West but also for promoting the artists' careers. Equally significant was the benefit to commercial enterprise; everything from railroads and publishing houses to vacation resorts and real estate developments capitalized on the expedition results to further their own interests. The cultural ramifications

of exploration imagery were far more extensive than the government's relatively small circle.

In the act of surveying—literally looking over the land to achieve a general view or a new perspective—the artists of the West supplied a visual means of incorporating the region into the national psyche. For nineteenth-century Americans this incorporation placed a new America within the context of a greatly expanded nation. For twentieth-century viewers it can provide nothing less than an opportunity for reevaluating our relationship to history and to the present.

THOMAS MORAN

Of the many artists associated with the Great Surveys, few are more closely identified with their subjects than Thomas Moran (1837–1926, fig. 1). By the end of the nineteenth century his landscape views, especially those of Yellowstone and the Grand Canyon, were recognized as the definitive treatments of those natural wonders. His work, then as now, was seen as both accurate and eloquent, with the sense of place conveyed as much by its spirit as by its appearance.[8] Moran painted from the perspective of a Romantic visionary, but in his work there is always a quality of palpable reality, a feeling of grand munificence brought within the viewer's reach.

Moran was already thirty-four years old when he first traveled west to Yellowstone with the United States Geological and Geographical Survey of the Territories, headed by Dr. Ferdinand V. Hayden. Two years later, in 1873, he ventured to the Grand Canyon with John Wesley Powell's government survey, and in 1874 he was again with Hayden, this time in Colorado to see the Mountain of the Holy Cross, the legendary natural emblem of Christianity that had been officially discovered only a year earlier.

Those trips were the foundation for much of the rest of Moran's career; the subject matter that he drew from his field sketches occupied him until his death. He identified so closely with the West that he adopted the nickname "Yellowstone" and marked his post-1872 paintings with the monogram ⩔ , for Tom "Yellowstone" Moran. His works produced from his survey experiences brought him fame and fortune, enabling him to travel West many times during his long life, and although he painted many subjects, including scenes in Europe, Mexico, and Long Island, those of the western United States compose the majority of his work and embody his most significant contribution to American art. Moran was extremely prolific, with an oeuvre of more than 1,500 oils, 800 watercolors, countless drawings, prints, and illustrations, and he managed to support himself and his family solely through the sale of his art.

Fundamental to Moran's artistic achievement are his relationship to government expeditions; his collaboration with other survey artists, geologists, and photographers; and his subsequent distillation and elaboration of his field sketches into paintings and prints. Furthermore, his role in the enormous effort by the government, railroads, and publishing industries to publicize and exploit the West in the last decades of the nineteenth century must be considered an integral component of those activities. Although Moran's association with the Great Surveys is but a part of his larger

life's work and cannot fully explain the compelling nature of his art, understanding this period's influence on his development may lead to deeper insight into his work's ability to evoke the character of the West and the region's development in the late nineteenth century.

The three major works Moran produced from his experiences with the surveys, depicting the Yellowstone, the Grand Canyon, and the Mountain of the Holy Cross, constitute the foundation of this study. These monumental canvases, all of which measure roughly seven feet in height, represent an important period of the artist's career and form a special kind of triptych, a natural series that conveys a great deal about America in the closing decades of the nineteenth century. These works and their many related images have an unusual corporate significance in every sense of the word. Seen together the three canvases compose a grand form of natural history painting with important connections to private enterprise and to America itself as a corporate body.

Much of Moran's art of the 1870s can be considered a paradigm of the Great Surveys; in many ways it is based on the same ideological foundations of exploration, analysis, dissemination of knowledge, and nationalistic vision. His images present, besides the grandeur of his era, the ambiguities and conflicts inherent in a society struggling to mature. In making remote and mysterious regions accessible to the American public through paintings, drawings, and illustrations, he influenced an entire generation's understanding of its country. Thomas Moran provided his viewers a visual sense of place, thus contributing to making the West an indelible part of the American consciousness.

PART 1

AESTHETICS: THEORY AND APPLICATION

—

1

MORAN'S AESTHETIC THEORY AND BACKGROUND

Late in his career Moran wrote several articles about his ideas on art. Of these, "American Art and American Scenery," published in 1902, contains some of his most insightful comments, especially about his dedication to being American in his art.

It has often occurred to me as a curious and anomalous fact, that American artists are prone to seek the subjects for their art in foreign lands, to the almost entire exclusion of their own. . . . That there is a nationalism in art needs no proof. It is bred from a knowledge of and sympathy with [one's own] surroundings and no foreigner can imbue himself with a spirit of a country not his own. Therefore he should paint his own land. . . .

Our countrymen seem to ignore this fact. . . . Instead of seeking their subjects and inspiration in their own land and applying their technical skill in the production of works national in character, they seem to devote themselves to imitations of foreign masters, and many even find it necessary to make occasional trips abroad to lay in a fresh stock of ideas for imitation.

Before America can pretend to a position in the world of art it will have to prove it through a characteristic nationality in its art, and our artists can only do this by painting their own country, making use of all the technical skill and knowledge they may have acquired in the schools of Europe and the study of the art of the past.[1]

Although echoing earlier sentiments such as Thomas Cole's seminal "Essay on American Scenery" (1835), or Asher B. Durand's "Letters on Landscape" (1855), with this declaration Moran also proclaimed his identity, his own commitment to the artistic life of his time and place.[2]

Early in his career Moran had done exactly what he later cautioned American artists against; he went to Europe, found his "master" in the work of J.M.W. Turner, and returned to paint in a style that often closely emulated that of the great English painter. He eventually, however, found his own subject and style, his own visual voice in the geography of his continent, and although he continued to return to Europe to paint well into his later years, Moran seemed always to understand that his truest art was that of the American landscape.

Moran sustained this vision throughout his life, and at his best, he transcended the boundaries even of his chosen genre. Indeed, in their time Moran's most evocative works were not simply pictures of their respective subjects; for many Americans the works became the places themselves in a sense. After seeing his paintings, visitors to the West often were unable to view the sites without preconceptions;

While only a select few can appreciate the discoveries of the geologists or the exact measurements of the topographers, everyone can understand a picture.

The New York Times,
April 27, 1875

the images forever changed perceptions of the land and its meaning for the culture that inhabited it.

Moran painted in the Romantic landscape mode well after that style's heyday in the 1840s and 1850s, continuing it quite successfully long after artistic trends moved into realms scarcely imagined at mid-century. The reason for this remarkable success has yet to be convincingly explained, but it surely has something to do with the ability of Moran's best paintings, like masterpieces from a variety of ages and genres, to continue to grow and deepen in their expressiveness through time. That requires an artist gifted with both talent and sensitivity to the distinctive characteristics of his subject, not merely a good eye and the facile ability to handle paint.

EARLY ARTISTIC EXPERIENCE

Thomas Moran first came to the United States from Bolton, England, in 1844 as a child of seven, the second son of a textile weaver who settled in Philadelphia. According to biographer Thurman Wilkins, the young Moran acquired an early appreciation of art and as a boy frequently visited the city's galleries and exhibitions, learning quickly to distinguish the styles of different artists.[3] In 1853, at age sixteen, he was apprenticed to the wood engraving firm of Scattergood and Telfer, and although the experience undoubtedly served him well in his later years as an illustrator, he remained in that position only three years; his talent for drawing and painting outgrew the tedious carving of the blocks. About that time he and his older brother, Edward, became the unofficial pupils of James Hamilton (1819–

78), a successful Philadelphia painter who specialized in marine subjects, and it was this artist's influence, perhaps more than any other single factor, that had the greatest effect on Moran's early development.[4]

Although he was highly respected in his day, relatively little is known about Hamilton and even less about the specifics of his teaching. It seems certain, however, that in addition to stylistic guidance, the three most important lessons he provided the young artist were an insistence on the close study of nature, an appreciation for the art of Europe, especially that of J.M.W. Turner, and an interest in the artistic possibilities offered by unfamiliar landscapes. Each of those approaches to artistic development were critical to Moran's early progress and, eventually, to his achievement in portraying the American West. And though each constitutes a separate facet in Moran's visual sensibility, they are inextricably bound to the teachings of one theorist, the English critic John Ruskin (1819–1900), who was perhaps the most influential aesthetician in the nineteenth century.

As many scholars have demonstrated, Ruskin's influence on landscape painters, especially in America, was profound, and Moran was no exception.[5] As evidence of the enthusiasm that greeted his multivolume *Modern Painters* in the United States, Ruskin himself wrote in 1855, just as Moran was beginning to work with Hamilton, that he had more readers in America than in England.[6]

With the publication of the first American edition of *Modern Painters* in 1847, artists finally had an authority who validated what were already indigenous attitudes and practices in the United States.[7] As Roger Stein has

discussed at length in his book *John Ruskin and Aesthetic Thought in America* (1967), Ruskin's theories had such sweeping influence because they "shifted the criteria of artistic judgment from the sensuous, which was suspect and unfamiliar in America, to the moral; from pictures, which were still relatively difficult to see in America, to nature, which was abundant; from the well-established European aesthetic traditions of 'taste,' to the imaginative insight of the individual observer, as he perceived the moral order of the universe."[8] Indeed, it was Ruskin's conjunction of art with morality, religion, and nature that for a time, at about mid-century, brought a number of disparate trends in American aesthetics together into something approaching a consensus, artistically and nationalistically. Although this consensus (if it ever really existed) was disintegrating by the time Moran reached maturity, that same conjunction of the visual, spiritual, and the natural worlds is one of the most provocative and distinctive characteristics of Moran's art.

Ruskin's preeminent theory asserted that "the highest art is that which seizes the specific character [of any object in nature], which develops and illustrates it, which assigns to it its proper position in the landscape, and which by means of it enhances and enforces the great impression that the picture is intended to convey." The "great impression" was, he continued, the visual and psychological recognition of "that faultless, ceaseless, inconceivable, inexhaustible loveliness, which God has stamped upon all things."[9] The moralizing message was at the heart of Ruskin's premise.

Initially his argument appears contradic-tory, insisting on absolute fidelity to appearance at the same time that it glorifies the artist's attempt to convey his "impression" of the scene, an impression that may or may not look exactly like the original subject. But Ruskin clarified, and to some extent reconciled, this conflict in volume four of *Modern Painters* essentially by creating a hierarchy of steps for approaching nature and creating an art of truth. The first task was to reproduce topography: "Not a line is to be altered, not a stick nor stone removed, not a colour deepened, not a form improved; the picture is to be, as far as possible the reflection of the place in a mirror, and the artist [is] to consider himself only as a sensitive and skilful reflector." The second stage was directed to the artist: if (and only if) he "has inventive power he is to treat his subject in a totally different way; giving not the actual facts of it but the impression it made on his mind." This depended solely on the "temper into which the mind has been brought, both by all the landscape round, and by what has been seen previously in the course of the day."[10] Such an achievement would be within reach only of an artist of more refined sensibilities, one who had thoroughly mastered the first assignment, although Ruskin was careful to assert that the initial task was neither a simple undertaking nor one without its own special attributes.

Artists in the United States took his advice literally, most notably the group of American Pre-Raphaelites who assiduously copied nature with painstaking exactitude. The journal that amplified their theory, *The New Path,* published by the Society for the Advancement of Truth in Art, continually reiterated the Ruskinian goal: "It is the artist's first duty to

be true to the real. . . . The true and noble ideal comes of that penetrating perception which, by love and long discipline, sees at once the most essential qualities of things and records these with emphasis." [11] Many artists, including Moran in his early work, wholeheartedly ascribed to this idea and produced exceptionally detailed images that mirror nature's appearance.

Although mimesis was a noble end in itself, Ruskin elevated the second aspiration of invention, which could grow out of these studies, saying:

The aim of the great inventive landscape painter must be to give the far higher and deeper truth of mental vision, rather than that of the physical facts, and to reach a representation which, though it may be totally useless to engineers or geographers, and when tried by rule and measure, totally unlike the place, shall yet be capable of producing on the far-away beholder's mind precisely the impression which the reality would have produced, and putting his heart into the same state [as that of the artist]. [12]

This was the highest achievement, closer even than a mirror of nature to divine truth. And although it seems remarkably like the older theories of the Ideal as promoted by Sir Joshua Reynolds and others (to whom Ruskin positioned himself in direct opposition), there is a significant, if subtle, difference. For Ruskin, the ultimate goal, "the far higher and deeper truth," attained by the inventive artist could only be achieved through practical knowledge of the specific nature of the visual world. For Reynolds the means of creating high art was through generalization, the manipulation of nature into a preconceived ideal according to

models found in both nature and the great art of the past. [13]

Not only did Thomas Moran aspire to be of Ruskin's higher class but he also evidently achieved it in the English critic's opinion. In an Oxford lecture Ruskin said of his American disciple, "Nor are there any descriptions of the Valley of Diamonds, or the Lake of the Black Islands, in the 'Arabian Nights,' anything like so wonderful as the scenes of California and the Rocky Mountains which you may . . . see represented with most sincere and passionate enthusiasm by the American landscape painter, Mr. Thomas Moran." The two men finally met in 1882, and although Ruskin wrote several letters containing rather pointed criticism of Moran's work at that time, it is evident from the preceding comment that the theorist held a generally high opinion of his art. [14]

Joseph Mallord William Turner (1775–1851) was for Ruskin the artist to be emulated by those artists who aspired to the highest achievement. Indeed, *Modern Painters* as a whole was an elaborate defense of Turner's art, written to offset the unjust criticism Ruskin felt it had received. One result was that although the painter's work was not well known in America when Ruskin's book was issued, his images were immediately sought out by ambitious artists. [15] James Hamilton was one of these, and he emulated the English painter's style so successfully that he was sometimes called the American Turner (a title later given to Thomas Moran himself), for his romantic penchant for stormy seascapes and rapid, tactile brushwork. [16] Hamilton became familiar with Turner's work through engravings in the United States, but in 1854, about the time of

his association with Moran, he journeyed to England to see the artist's legacy firsthand. Although few of his works from that trip have survived, Hamilton surely returned with copies of Turner's compositions and presumably shared them with the Moran brothers. Indeed, when Moran went to England in 1861–62, he went especially to study Turner and was enormously influenced by his work, especially in its color and atmospheric effects. Borrowings from the older artist found a new incarnation in Moran's work of the American West a decade later; Turner's characteristic palette of warm yellows and oranges and complementary blues and greens are indigenous to much of the region, and from his early knowledge of Turner's work Moran was, by his first trip in 1871, well prepared to convey the striking appearance of the West.

One of the most significant correspondences between the work of Moran and Turner is, of course, the tendency toward sublime subject matter. Andrew Wilton's observation of Turner could be applied equally to the younger artist: "He set great store by any personal experience of the 'Sublime'—indeed, it was only through such experience that the artist could hope to communicate grand ideas to the public."[17] Moran's greatest works are expressive of such grand ideas, and even when they are not depicting cataclysmic upheaval and elemental fury, they indicate an interest in natural change and transition. It should be recognized, however, that Moran's depiction of American sublimity was not merely a response to the great artistic tradition; his sublimity was a specific response to his own time and place. His landscapes that contain cosmic allusions, most obviously the three large can-

vases that resulted from the U.S. geological surveys, all express the direct relationship between the sublime's inherent tension of disaster and grace and the cultural events that were changing the American West in the last decades of the nineteenth century. Those events, in the context of the western landscape, were Moran's personal experience of the sublime.

Moran said of Turner:

Turner is a great artist, but he is not understood, because both painters and the public look upon his pictures as transcriptions of Nature. He certainly did not so regard them. All that he asked of a scene was simply how good a medium it was for making a picture; he cared nothing for the scene itself. Literally speaking his landscapes are false; but they contain his impressions of Nature and so many natural characteristics as were necessary adequately to convey that impression to others. . . . His aim is parallel with the greatest poets who deal not with literalism or naturalism, and whose excellence cannot be tested by such a standard. . . . In other words, he sacrificed the literal truth of the parts to the higher truth of the whole.[18]

Those remarks, of course, come straight from Ruskin and are indicative of Moran's approach to art. In the same article he continued the argument in terms of his own ambitions:

I place no value upon literal transcriptions of Nature. My general scope is not realistic; all my tendencies are toward idealization. Of course, all art must come through Nature; I do not mean to depreciate Nature or naturalism, but I believe that a place as a place, has no value itself for the artist only so far as it furnishes the material from which to construct a picture. Topography in art is valueless.[19]

Elsewhere Moran seems to have challenged that assertion:

In art, as in any profession, knowledge is power. . . . In painting . . . I have to be full of my subject. I have to have knowledge. I must know the geology. I must know the rocks and the trees and the atmosphere and the mountain torrents and the birds that fly in the blue ether above me. [20]

The apparent contradiction of his statements may be reconciled by recognizing that here is the same inherent complexity that at first appears to confuse Ruskin's central theory. Ruskin himself asserted the value of topography, saying "pure history and pure topography are most precious things," but for him mirroring the visual world and presenting a subjective impression of it were inextricably, if problematically, connected in the quest for the "great impression." [21] Aspiring to Ruskin's higher calling, Moran eschewed literal fact in favor of constructed compositions assembled from a variety of sources, and he frequently accentuated mood and proportional relationships. Nevertheless, he relied on primary experience whenever possible, traveling extensively to see his landscapes firsthand. Even at his most unrealistic, a large percentage of his views are representative of specific locations. Quoting Emile Zola and echoing Ruskin, Moran said that his landscapes are "nature seen through a temperament." [22]

One volume of Ruskin's *Modern Painters,* subtitled "Of Mountain Beauty," is devoted to an exegesis of the natural world's characteristics. [23] At times it seems more a geological treatise than an aesthetic argument, but throughout the exhaustive delineation of earthly matter, from the smallest particle of dust to the largest mountain range, the author directed his explanation to the painter of landscape, drawing his attention to the sublime and sacred subtext of the rocks. Important to this side of Ruskin's aesthetic and theological development was his mentor at Oxford, William Buckland, a geologist-minister and author of *Geology, Mineralogy Considered with Reference to Natural Theology* (1836). Merely from this title it is easy to understand the origin of Ruskin's commitment "to finding sermons in stones." [24] Buckland had counterparts in America, most notably the Reverend William Paley, whose book *Natural Theology; or, Evidences of the Existence and Attributes of the Deity, Collected from the Appearances of Nature* (1802) was enormously influential in the development of nineteenth-century philosophies of natural science.

Another reader of the "rock-leaved Bible of geology" was John Wesley Powell, one of the survey leaders who would be so important to Moran's career in the 1870s. Powell and his contemporary Clarence King were both initiates of this geo-pious tradition, and both knew Ruskin's work intimately. Indeed, through their common belief in the evocative power of nature, in the value of extensive knowledge of its parts, and in natural phenomena as the signature of the Almighty, Ruskin, King, and Powell were allies. [25]

At the foundation of their shared philosophy, and that of Moran, was the idea that to approach truth in art, in nature, or in God (and they end up being one and the same for these men), it was necessary to know the physical character of the world as fully as possible. Stein explains, in his chapter "Ruskin and the Scientists," that although such searching for sacred design in the physical world was

embraced in the early to mid nineteenth century, it came in conflict with the developing empirical, amoral, scientific method after 1860. Nevertheless, the older tradition persisted throughout the century, influencing scientists such as Powell and King to explore the physical world for both fact and revelation.

Ruskin's amplification of these ideas in *Modern Painters* further illustrates the attraction of the philosophy for aestheticians and empiricists, artists and geologists:

The more we know, and the more we feel, the more we separate; we separate to obtain a more perfect unity. Stones, in the thoughts of the peasant, lie as they do on his field, one is like another, and there is no connection between any of them. The geologist distinguishes, and in distinguishing connects them. Each becomes different from its fellow, but in differing from, assumes a relation to its fellow; they are no more each the repetition of the other,—they are parts of a system, and each implies and is connected with the existence of the rest.[26]

It was that system, of course, that the geologists whom Moran accompanied to the West were attempting to understand, and it was also the system that Moran portrayed in his great western works. The relationship of parts, rather than the parts themselves, was the focus; it was the source of the sought-after impression and the locus of the elusive truth. Each of his images was a part of the whole; each was a whole that evoked the multitude of parts.

Moran's interest in scientific investigation may have also been influenced by James Ham-

ilton, who was involved with several expedition projects as he was advising Moran. Although he seems not to have ventured West himself until much later, Hamilton worked in the East creating publishable illustrations of the region from photographs and drawings made by others.[27] Executed in the mid-1850s, these works surely were known to Moran and, in addition to the wealth of publicity about the West that characterized that decade, would have been an immediate source of visual inspiration for the younger artist's exploration art.

In her introduction to John Charles Frémont's *Memoirs of My Life* (1887), Jesse Benton Frémont explained that her husband was inspired by the German naturalist Alexander von Humboldt to use the new medium of photography in documenting his expeditions. Frémont took Solomon Carvalho on his last survey to make landscape daguerreotypes, and Hamilton used them to illustrate the official expedition report. Jesse wrote, "For some months Hamilton worked on these views, reproducing many in oil; he was a pupil of Turner and had great joy in the true cloud effects as well as in the Western mountains and castellated rock formations." Although Frémont's report was never published, Hamilton's use of expeditionary photographs in illustrating government reports and in the creation of independent paintings was no doubt an important precedent for Moran's own liberal use of survey photographs.[28]

Hamilton's other related enterprise was illustrating Elisha Kent Kane's reports of the first United States explorations in the arctic. Moran could hardly have failed to know of these publications; his close association with

Hamilton surely brought them to his attention, and the books were extremely popular with the general public. Kane's *Arctic Explorations* was said to have joined the Bible on "every parlor table in America."[29]

Kane was surgeon on the 1850 expedition sent to rescue the famed Sir John Franklin, who had disappeared in 1845 while searching for the Northwest Passage, and he led a second rescue effort in 1853. Familiar with the tradition of exploration art and obviously impressed with the fantastic appearance of the arctic landscape, Kane brought back his own sketches and commissioned Hamilton to work them up into illustrations for his publications.[30] Several became the inspiration for larger oils by Hamilton, who wrote of Kane's sketches, "Every fragment is jotted down with a perception and feeling which seize the special character of the minutest particle defined, and yet its minutiae in no way conflicting with the grandeur of the subject."[31] Such commentary could apply equally to Moran's work of a decade later. Because Hamilton moved into Kane's home in Philadelphia and "for more than a month . . . occupied the doctor's [Kane's] room, that night and day might be given to their execution," it is possible that Moran might have met the explorer and learned directly of expeditionary work.[32] Moran had a similar project a few years later, reworking for *Scribner's Monthly* the Yellowstone drawings of two explorers before he went there himself the following summer.

Hamilton's watercolors for Kane's publications (fig. 2) exhibit a remarkable similarity to Moran's later watercolor field sketches. Hamilton's loose, watery forms resonate with an evanescent transparency without completely losing their substance, a characteristic they share with Moran's wash drawings, and although they reveal an interest in scientific investigation, they are primarily romantic in both color and handling.[33]

Fig. 2. James Hamilton, *Crimson Cliffs of Beverly,* ca. 1853, watercolor on paper, 4⅞ × 8½" (12.3 × 21.7 cm). The Library Company of Philadelphia.

As important for Moran as the direct stylistic relationship of these works to his own exploration art was the questing impulse from which they originated. Prompted by Humboldt's expeditionary writings that appeared in America in 1850, a number of artists at mid-century ardently sought virgin territory for their subject matter.[34] Even at that time untrammeled country was becoming increasingly difficult to find, undoubtedly driving Frederic Church and others to venture to the far south and north and Moran to the last untouched vestiges of the American West.[35] When these unknown regions could be located and visually brought to the public in works of art, they never failed to capture public attention and wondering admiration, even after the grand landscape tradition began to lose its appeal. Perhaps, as this century's delight in the first photographs of moonscapes indicates, Humboldt's advice to the artist to find artistically unexplored land and portray its most distinctive features is perennially applicable. It certainly was for Moran and his depiction of the then unknown sights of Yellowstone, the Grand Canyon, and the Mountain of the Holy Cross in Colorado that he encountered with the U.S. geological surveys.

2

LANDSCAPE
AS METAPHOR

The early influences of Ruskin's aesthetic theory and the art of Turner and Hamilton were only part of Moran's approach to his chosen subject. In his effort to portray the character of particular places he was also working within larger traditions of landscape portrayal. One, of course, was the tradition of the sublime landscape, which dates to at least the seventeenth century in the art of Rubens, Salvator Rosa, and the Dutch school. More direct examples for Moran were the English artists Turner, Martin, and Constable, or the Americans Cole and Church, as well as philosophical treatises such as Edmund Burke's *Philosophical Enquiry into the Origins of Our Ideas of the Sublime and Beautiful* (1756). Moran's most apocalyptic and romantic scenes certainly follow the histrionic examples of his predecessors, in which the land is deluged with cataclysmic storms, riven by gorges and waterfalls, and suffused by luminous clouds

and rainbows that evoke cosmic change. A full explication of his art within the context of this legacy, however, would comprise a separate study in itself, and although it is important, even vital, to understanding his art, this venerable art historical approach is perhaps the most predictable in perceiving his artistic contribution. While it does account for many of his stylistic and thematic sources, it fails to explore Moran's more immediate context, that of his own encounters with sublimity in the American West.

Instead, an alternative tradition, that of metaphorical description, provides a different kind of insight into Moran's perception and portrayal of landscape. It is in some ways related to the artistic tradition, especially in its visual-associational aspect, but it is at once more specific to Moran's experience with the West and more general in its theoretical foundation.

Responding to the visual world through metaphor and association—where objects and scenes are noted not only for what they are but also for what they are like—had a long history in European aesthetics, and it played an exceptionally important role in America's efforts toward self-definition, both visually and verbally. Writers such as Meriwether Lewis, Columbus, and countless others, when confronted with unfamiliar landscapes for which they had no experience and limited descriptive vocabulary, had little recourse other than to remark that strange formations looked like something else, something with which they were better acquainted. In this way unusual rock formations are compared to Gothic spires, towers, and medieval castles; prairies become "inland seas" and "oceans of

grass." George Catlin wrote in the 1830s about the cliffs along the upper Missouri River: "The whole country behind us seemed to have been dug and thrown up into huge piles, as if some giant mason had been there mixing his mortar and paints, and throwing together his rude molds for some sublime structure of a colossal city—with its walls—its domes—its ramparts—its huge porticos and galleries—its castles—and in the midst of progress, he had abandoned his works to the destroying hand of time."[1] As Catlin demonstrated, artists, although able to portray visual appearances to viewers far from the site, also struggled to convey subjects for which they had no preparation, either visually or culturally. Their results were often visual analogues to the verbal comparisons: cliffs sometimes look remarkably like walls, trees resemble spires, and rocks become architecture. That visual practice was related to the traditional artistic method of improving on a subject's actual appearance in favor of a more acceptable, preconceived ideal, but it was more directly linked with unfamiliarity—that of the artist himself or of the viewer as presumed by the artist—and was an effort to compensate for the inability to recognize and comprehend something completely unknown.

In both written and visual descriptions the struggle to find analogies for experience has two primary manifestations, associational and typological. These are related, with the first referring to style, the other to form. Using the former, for example, an artist might attempt to paint a wilderness in the manner of a classical Italianate landscape in order to align his subject matter with that older, more venerated, and recognizable culture. The importa-

tion and application of associations was, of course, common practice for the first generation of American landscapists such as Thomas Cole and Washington Allston, who sought to portray their native land within the context of the grand European tradition. The second approach, the typological, relied more on indigenous sources, although it too depended on European conventions and was no less contrived. Artists looked to the subject itself to find its characteristic features, then exaggerated or otherwise altered them to make them more identifiable to an unfamiliar audience. The approach is allied with accentuating objects or relationships for dramatic or pictorial effect, but there is a subtle difference. The emphasis here is on familiarity as much as appeal; the artists who worked in this mode were searching for a means of conveying a sense of the place, but to do so, scenes far outside common experience had to be transformed to be perceived and assimilated.

Today it is difficult to conceive of that problem; our world has been so thoroughly documented that it seems familiar to us all, no matter how little traveled we may be. A recent example, however, and perhaps one of the last of such pictorial confrontations, is the famous "Earthrise" photograph taken from the surface of the moon. Had the looming disk of the earth not been included in the picture, the scene would have been not just less interesting but also practically unrecognizable; we are not used to the moon's topography as the context for our visual experience. But with the earth in the distance for us to identify with, we are able to assimilate the view immediately and consequently perceive something of the unfamiliar place.

As little as one hundred years ago, this challenge was common to landscape artists, especially in the American West. With its sparse vegetation, profusion of unusual geological formations, dramatic colors, and vast open spaces the region was, to its earliest portrayers and viewers, sometimes as unfamiliar as a moonscape, and its describers frequently resorted to metaphorical description—if not to describe what it was, then what it was like. And although Thomas Moran went West in the region's last decades of wildness and took with him a good deal of artistic experience, he, no less than his predecessors, was confronted with the problem. One result was that metaphorical and associational typology became significant components of his approach to landscape. To appreciate fully Moran's achievement in his great expedition paintings of the 1870s, it is necessary to explore the impulse that generated that tendency.

From at least the time of Thomas Jefferson, nationalistic Americans had struggled with what they perceived as a serious lack of cultural achievement in their new nation, especially in comparison with Europe. The Old World's landscape was littered with ruins from centuries of civilization, and since at least the eighteenth century they had become focal points for the musings of poets, philosophers, and artists who sought connections with the presumed glories of the past. In 1819 Washington Irving voiced his longing "to wander over the scenes of renowned achievement—to tread, as it were, in the footsteps of antiquity—to loiter about the ruined castle—to meditate on the falling tower—to escape, in short, from the commonplace reality of the present, and lose myself among the shadowy grandeurs of the past."[2] To compensate, Americans increasingly focused on the natural resources and unspoiled grandeur of their own scenery. That inclination may be found not only in nineteenth-century American literature, from Irving and Cooper to Emerson and Thoreau, but equally in the art of the Hudson River school and of the so-called Rocky Mountain school. Therefore, when travel writer Samuel Bowles, who called Colorado "the Switzerland of America," or expedition leaders Powell and Hayden used architectural terminology to describe rock formations or other natural phenomena, they may have been responding, at least in part, to a wish of nineteenth-century Americans for a noble past, physical evidence of America's significance in the world.

By the middle of the nineteenth century, the West was beginning to be recognized as the place where such distinction could be confirmed. With its unprecedented variety of unusual topography, the region especially came to be seen as a place where an individual could lose himself in grandeur and also as one that could represent the country's uniqueness, even its superiority over Europe. If American literature, art, and other cultural achievements were still not comparable to their more esteemed counterparts across the Atlantic, the natural beauty and extreme age of the rocks, trees, and waterfalls on this continent could more than compensate. In 1852 James Fenimore Cooper, although still bemoaning that Americans must "concede to Europe much [of] the noblest scenery . . . in all those effects which depend on time and association," added, "unless we resort to the Rocky Mountains, and the ranges in California and New

Mexico."[3] Journalist Horace Greeley emphasized the West's distinguished pedigree eight years later by proclaiming that the great sequoias in California were "of substantial size when David danced before the ark, when Solomon laid the foundations of the Temple, when Theseus ruled in Athens, when Aeneas fled from the burning wreck of vanquished Troy."[4] In 1872 at the founding of Yellowstone National Park, a profusion of nationalistic rhetoric emphasized that America's relative youth was finally justified by its wealth of natural attractions. *The New York Herald,* shortly after the passage of the park bill, asked:

Why should we go to Switzerland to see mountains, or to Iceland to see geysers? Thirty years ago the attraction of America to the foreign mind was Niagara Falls. Now we have attractions which diminish Niagara into an ordinary exhibition. The Yo Semite, which the nation has made a park, the Rocky mountains and their singular parks, the canyons of the Colorado, the Dalles of the Columbia, the giant trees, the lake country of Minnesota, the country of the Yellowstone with their beauty, their splendor, their extraordinary and sometimes terrible manifestations of nature, form a series of attractions possessed by no other nation.[5]

The desire to establish a natural legacy for the United States, "a green old age," especially through writers' use of architectural metaphor, may reveal more about the authors (and those who used similar techniques of comparison in other fields) than merely their cultural ethnocentrism.[6] By using landscape to extol the virtues of the new "old America," by adjusting time-honored perceptions of the land and its inhabitants to suit their purposes, they were, in a sense, recomposing the natural world in their own image, attempting a recreation of Creation. If America did not fit the preconceived notions of what was valued in the world of men, then they would simply adjust their definition to place America above it all, in the world of God, and there they would be sure to find an America of even greater value. In many cases visualizing castles, turrets, arches, and spires within rocks seems to have been as much an attempt to find nobility in an uncivilized region as it was to seek familiarity within the unprecedented. Furthermore, the landmark events that followed the initial contacts—the formation of the national park system, the establishment of federal forests and "wildernesses of the people," and the growth of commerce and tourism in such places—were continued evidence of a type of nationalistic appropriation that somehow satisfied a need to order the unordered, to civilize the uncivilized, to locate the unlocated.

The dependence on visual metaphor is seen in a number of forms in Thomas Moran's western art. His repeated depiction, for example, of specific forms of arches, towers, rocks, and trees is not simply due to their appearance in nature, although that influence can be underestimated. Natural towers, walls, and arches do exist in the "monuments" of the West (as do, of course, rocks and trees), and Moran, for the most part, based his landscape views on actual geological fact. His affinity for such features, however (as evidenced by his disparate use of similar forms and his frequent exaggeration of them coloristically and proportionally), reveals that he, like his literary counterparts, was creating American analogies to grand historical landscapes because they alluded to the mysteries of creation. His

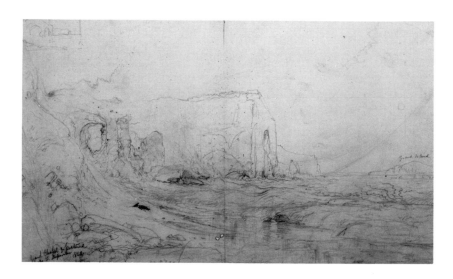

Fig. 3. Thomas Moran, *The Grand Chapel and Pictured Rocks, L. Superior,* 1860, graphite on paper, 12¾ × 21½" (15.3 × 54.6 cm). The Thomas Gilcrease Institute of American History and Art, Tulsa, Oklahoma (1326.764).

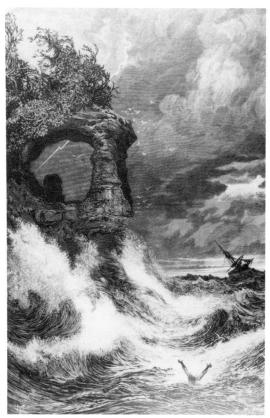

Fig. 4. Thomas Moran, *Chapel Rocks, Lake Superior,* ca. 1873, wood engraving, 13 × 9" (33 × 22.8 cm). From *The Aldine* 6(January 1873):14. Courtesy of the Library of the National Museum of American Art and the National Portrait Gallery, Smithsonian Institution; Morand and Friese no. 80.

motifs, when analyzed in this context, demonstrate that in composing his large painted views, Moran often drew from a corpus of preconceived types, which he had collected over the years, recorded in drawings, and kept as stock for his future compositions.[7] Especially when their sources can be traced to sites not in the western states or to deliberate alterations of fact, these features reveal both his working method and something of his understanding of American art and its relationship to the land.

THE ARCH

One of the earliest formations to appear in Moran's art consistently is the arch. First drawn as early as 1860 on a sketching trip to the appropriately named Pictured Rocks of Lake Superior with fellow Pennsylvania painter Isaac Williams, this bowed form appeared in Moran's landscapes throughout his career in a variety of vastly different geographic settings. The Pictured Rocks and Lake Superior had inspired Henry Wadsworth Longfellow's famed poem *Song of Hiawatha* (1855), and Moran's Michigan sketches became the foundation for a series of paintings on the poem, which occupied the artist throughout the 1870s. Moran may have been attracted to the area by its publicity in Henry Schoolcraft's *Algic Researches* (1850), which was also a source for Longfellow, and by an 1851 geological survey report that contained a pointed suggestion: "So far as we know none of our artists have visited this region and given the world representations of scenery so striking, and so different from any which can be found elsewhere. We can hardly conceive of

anything more worthy of the artist's pencil."[8]

While in the Lake Superior area, Moran produced a number of sketches and ink wash drawings. On his return, he created several works that prominently display the formation known as the Grand Chapel. *The Aldine* magazine, to which Moran later submitted illustrations to accompany a short article on the region, described the arch as "supported by two gigantic columns that appear to have been hewed and placed where they are by skillful hands. The backward reach of the roof rests upon the main cliff and within the Chapel is the base of a broken column that is strongly suggestive of a pulpit. The roof is crowned with a growth of fir trees that maintain a terrible struggle for life with the storms which are so frequent here, and to which they are always exposed."[9] Next to the Grand Chapel, an even more massive arching form dominates the scene: the Great Cave, a thickly walled edifice perforated with several smaller arches along the water's edge.

A contour field drawing in the Gilcrease Museum entitled *Grand Chapel and Pictured Rocks, L. Superior* (1860, fig. 3) depicts both forms as seen at the site, but for *The Aldine* Moran separated them to accentuate their drama. *Chapel Rocks, Lake Superior* (fig. 4), the frontispiece of the issue, depicts a close-up of the Chapel that closely corresponds to the description above. A storm suffuses the scene, wind whips through the trees atop the rocks, large waves crash at their foundation, and a lightning bolt streaks behind. In the right foreground a swimmer, nearly lost in the surf, flails the water in desperation. As if an echo, but not an answer, a ship tossing on the horizon wages its own struggle against the rolling waves. The relationship of ship to swimmer recalls Turner's *Slavers Throwing Overboard the Dead and Dying—Typhoon Coming On* (*The Slave Ship*, 1840, Museum of Fine Arts, Boston), which Moran undoubtedly knew from his study of Turner and from its much-publicized acquisition by the Museum of Fine Arts in Boston in 1872.[10]

A much calmer but no less dramatic scene is the companion wood engraving, *The Great Cave* (fig. 5). Moran placed the prominent arching form, with its vertical aperture reflected in the still water, in the center of the circular format, effectively dividing the com-

Fig. 5. Thomas Moran, *The Great Cave,* ca. 1873, wood engraving, 8⅞" diameter (22.5 cm). Courtesy of the Library of the National Museum of American Art and the National Portrait Gallery, Smithsonian Institution; Morand and Friese no. 81 as *Pictured Rocks of Lake Superior.*

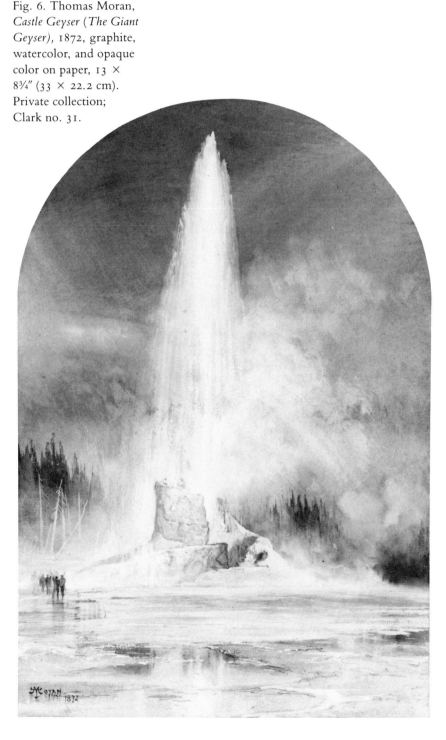

Fig. 6. Thomas Moran,
Castle Geyser (*The Giant
Geyser),* 1872, graphite,
watercolor, and opaque
color on paper, 13 ×
8¾″ (33 × 22.2 cm).
Private collection;
Clark no. 31.

position in two. The walls of the arch are the lightest area of the work, and their brightly mottled sides are echoed in the billowy cumulus clouds just above. The right foreground, dotted with boulders, vegetation, and two entwined pines, extends beyond the frame as if to invite the viewer into the scene. On the shoreline in the lower left a group of tiny Indians looks to an approaching ship on the horizon, and from that minuscule vessel rises the barest hint of a rainbow. This arching form, echoing the curve of the circular format of the print and the cave itself, is more sharply defined by its companion, the brighter half of a double bow that swings down from the left, ending in the strongly lit side of the Great Cave arch.

The presence of the rainbow in *The Great Cave* is not merely, of course, a compositional convenience. It was a favorite motif of Romantic painters, from Turner to Frederic Church, and it appears in a number of Moran's most important works. In *The Great Cave* the rainbow's arching form complements the cave's similar shape, but here, and in many other appearances in Moran's art, the rock arch's curve is also an earthly form of the same stability and harmony traditionally signified by the rainbow. Recalling the rainbow's biblical significance as a symbol of hope and reassurance, the Great Cave informs the prospective meeting of the Indians and their visitors. In *The Chapel Rocks* the arch may redeem the struggling swimmer and the tossing ship; it offers harbor and safety from the raging water and storm.[11]

Even in Yellowstone, an area other explorers saw as infernal (they gave its features such names as Devil's Glen, Devil's Slide, Devil's

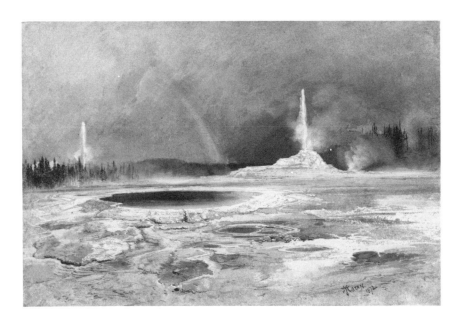

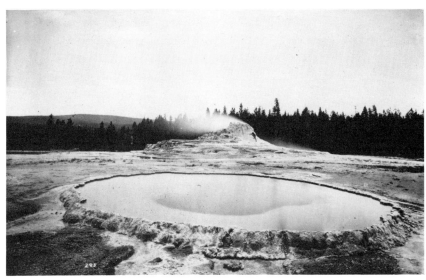

Hoof, Hell Roaring River, and Fire Hole Prairie), Moran created images of almost unspeakable beauty. His depictions of such places, even when he exploited their demonic potential, revel in the brilliant display of color, the nuances of tone and shade, and the majestic variety of natural beauty. In many of these Moran included rainbows in such ironic places as above "hellish" geysers. Both his views, for example, of the Giant, or Castle, geyser (1872, figs. 6 and 7) contain rainbows that enhance the refractive qualities of the steaming jets and accentuate the gemlike mineral deposits in ways no photograph could (fig. 8).[12] Here, as in so many of Moran's works, he concentrated on color: the iridescent blues, roses, and yellows surrounding the pools, the billowing gray steam rising against a deep blue-gray sky, and the icy white of the crater's calcareous build-up that echoes the ascending plume silhouetted against the deep forest greens of the firs beyond. In January 1873 *Scribner's Monthly* noted Moran's use of the rainbow in this context: "Mr. Moran's watercolors show a strong man rejoicing to run a race; and with all his senses alive for rich and strange and tender shimmering color, rainbow, and mist, with fleeting cloud, and more hues than Iris with her purple scarf can show. His love of form is strong as his love of color, and his lines betray the same innate grace of spirit, the same delicately moving mind. . . . The wild western desert has found in him a most faithful because most poetic voice."[13]

By including the rainbow in *Castle Geyser* and in other works such as *The Chasm of the Colorado* (1873–74, plate 2), Moran emphasized the chromatic spectrum of natural beauty, but perhaps more important, he

Fig. 7. Thomas Moran, *The Castle Geyser, Fire Hole Basin,* 1872, graphite, watercolor, and opaque color on paper, 7½ × 11″ (19.1 × 27.9 cm). The Thomas Gilcrease Institute of American History and Art, Tulsa, Oklahoma (0226.1363); Clark no. 32.

Fig. 8. William Henry Jackson, *The Castle Geyser, Fire Hole Basin,* 1871, photograph. United States Geological Survey Photographic Library (Jackson 109). Thomas Moran is the tiny figure climbing on the formation.

graphically conveyed the primal character of this land. He recognized its virgin quality, its seeming closeness to the origins of time and life, and by displaying the "fires of hell" as blessed by the bow of God, he demonstrated his awareness of the paradox of the West. There delicate beauty is coupled with raw sublimity; what appears to be a region of invincible strength is actually fragile and highly vulnerable to the onslaught of civilization. In his sensitivity Moran was like Turner; it has been said that Turner "transforms the rainbow into a powerful image of man's problematic relation to problematic Nature."[14]

Moran's most triumphal use of the arch came in his later oils. In his blistering *Fiercely the Red Sun Descending Burned His Way Across the Heavens* (1875–76, fig. 9), a scene from Longfellow's *Song of Hiawatha,* Moran recapitulated the rocky coast of Lake Superior.[15] Here in a fiery Turnerian display of sun and water the apocalyptic scene swirls as in a vor-

tex, the western light seems to emanate from an inferno, and the sky appears on the verge of bursting into storm. The jagged rocks along the shoreline offer little comfort to the seabound viewer (water is the only foreground), but the arched opening in the center of the composition beckons as a haven or a vantage point from which to watch the magnificent display.

Fiercely the Red Sun Descending anticipates the last decades of Moran's career, when he would return to the theme of the arch several more times in such large paintings as *From Fingal's Cave, the Island of Staffa* (1884–85, High Museum of Art, Atlanta), a scene Moran may have encountered on his visit to Scotland in 1882. Its blue-green profusion of surf, mist, and arching basaltic formation recalls *The Great Cave* in form if not in mood. *Sunset Near Land's End, Cornwall, England* (1909, Thyssen-Bornemisza Collection) is another arched Turnerian seascape, possibly inspired by the earlier painter's own view of Land's End, which appeared in his book of engravings *Picturesque Views on the Southern Coast of England* (1826). Another view, *Land's End* (1909, Private Collection) from the last years of Moran's life, again recalls the apertures of the Michigan shoreline, especially *The Chapel* rocks, but in this view the mood is threatening; even the arched enclosure within the rocky outcropping provides little protection from the elements.

THE TOWER

Moran's most frequent architectural metaphor may be the tower. This pinnaclelike element appears in a variety of incarnations in his land-

Fig. 9. Thomas Moran, *Fiercely the Red Sun Descending Burned His Way Across the Heavens,* 1875–76, oil on canvas, 33⅜ × 50¹⁄₁₆" (84.7 × 127.2 cm). The North Carolina Museum of Art, purchased with funds from the North Carolina Art Society (Robert F. Phifer Bequest).

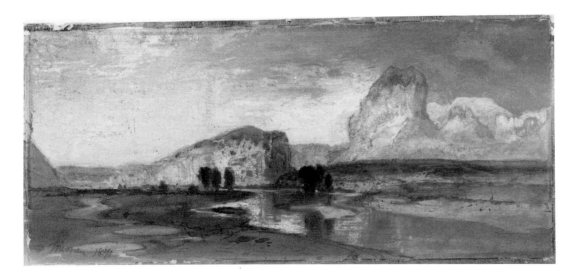

Fig. 10. Thomas Moran, *Green River (First Sketch in the West)*, 1871, watercolor on paper, 3¾ × 8½″ (9.5 × 21.6 cm). The Thomas Gilcrease Institute of American History and Art, Tulsa, Oklahoma (0236.882).

scapes, especially in his views of the American Southwest, where such configurations are prevalent. The tower, with its phallic conformation, could easily be interpreted in Freudian terms, especially in the context of the chasms with which it is so commonly coupled in Moran's art, but that approach does not seem appropriate to his work, either in regard to Moran's personality or to his historical and cultural milieu. Instead, he used the formation to evoke the peculiar character of the landscape; the many associations it invokes derive from the land itself and its effect on those who witnessed it.

Moran's first sketch of the West (1871, fig. 10), a watercolor drawn near the Union Pacific Railroad in Green River, Wyoming, exhibits the prominent buttes that line the river. They were to be a favorite subject, featured in as many as forty of Moran's canvases during the next thirty years. Indeed, the artist's Green River pictures would justify a study in themselves, so varied are they. From the first washy

sketch with its luminous transparencies to the rich oranges, pinks, azures, and purples of his later oil interpretations, as well as the expressive linearity of his many prints and drawings of the subject, it is obvious that Moran found the angled towers of the Green River continually inspiring and challenging.[16]

Although he varied his point of view frequently, Moran's favorite formations at Green River seem to have been Toll Gate Rock (or Castle Rock), the largest of the cascading cliffs at the Union Pacific stop, and its neighboring buttes, the Palisades. By 1870 they had already been photographed by both William Henry Jackson and Andrew Joseph Russell, and the latter's work was probably known to Moran through its publication in Ferdinand Hayden's *Sun Pictures of Rocky Mountain Scenery* (1870).[17] Like the photographers, Moran seems drawn to the forms' striking variegation, and it is this effect that most consistently characterizes his views (fig. 11). The buttes appear to rise out of the river or to be sliding

Fig. 11. Thomas Moran, *Cliffs of the Green River,* ca. 1872, wood engraving. From *Picturesque America* vol. 2, p. 175. Courtesy of the Library of the National Museum of American Art and the National Portrait Gallery, Smithsonian Institution.

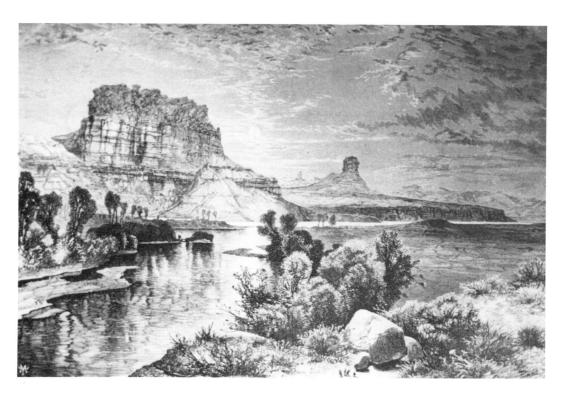

Fig. 12. Thomas Moran, *Tower Falls,* 1872, ink wash on paper, 5¼ × 6½″ (13.3 × 16.5 cm). Jefferson National Expansion Memorial, National Park Service (4287).

into it, and their stratified coloration, with dark tops and rough lighter sides, only accentuates the optical phenomenon.

Some scholars have suggested that these distinctive cliffs evoked a malevolent sublime to travelers in the mid to late nineteenth century.[18] Their assertion about the Green River seems exaggerated, however, especially when the documentary evidence is compared with that of other sites that were unquestionably viewed as satanic, threatening, and sublime, such as the Grand Canyon and Yellowstone. More common to the Green River were comments of delightful awe about the size of the cliffs, curiosity about their origins, and comparisons to architecture. In a typical remark a visitor to the site around 1870 noted that "it would seem as if a generation of giants had

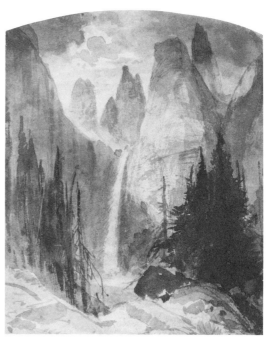

Fig. 13. Thomas Moran, *Tower Falls,* 1872, graphite, watercolor, and opaque color on paper, 12 × 8½″ (30.5 × 21.6 cm). The Thomas Gilcrease Institute of American History and Art, Tulsa, Oklahoma (0236.1457); Clark no. 54.

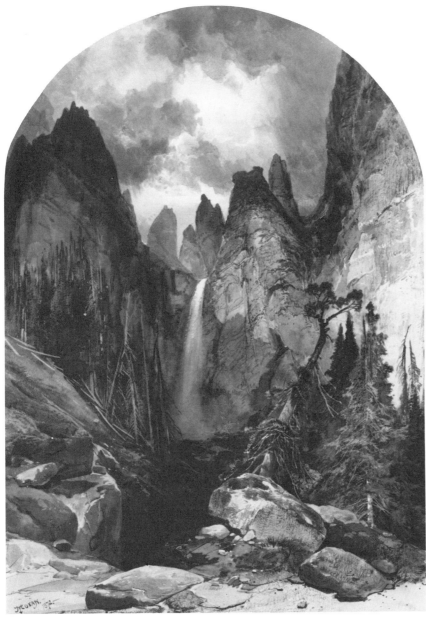

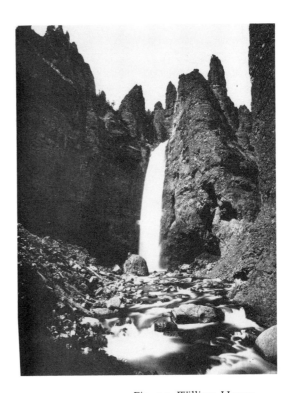

Fig. 14. William Henry Jackson, *Tower Falls,* 1871, photograph. United States Geological Survey Photographic Library (Jackson 78). The tiny, almost indistinguishable figure climbing on the large boulder at the base of the falls is Thomas Moran.

Fig. 15. Thomas Moran, *The Grotto Geyser, Fire Hole Basin* (correct title: *The Liberty Cap*), ca. 1872–73, graphite, watercolor, and opaque color on paper, 10¼ × 6¾″ (26 × 17.2 cm). The Thomas Gilcrease Institute of American History and Art, Tulsa, Oklahoma (0236.1360); Clark no. 42.

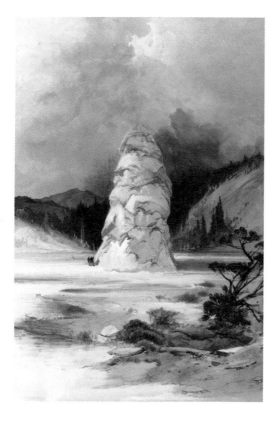

Fig. 16. William Henry Jackson, *The Liberty Cap*, 1871, photograph. United States Geological Survey Photographic Library (Jackson 204).

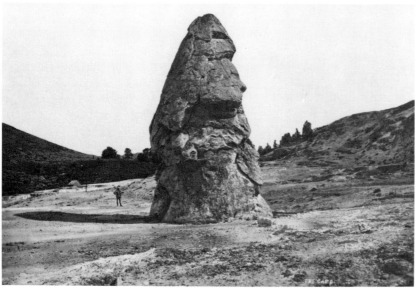

built and buried here, and left their work to awe and humble a puny succession."[19] This is a response to grand scale and unusual configuration but hardly to malevolence. The Green River towers' prominence at the railroad stop and their odd shapes and colors broke the monotony of long trips West, making them landmarks, important indicators of place in the unfamiliar and often featureless landscape through which the transcontinental line ran.

Moran found tower formations in great variety at Yellowstone as well, especially at Tower Falls, where the cascading water is crowned with a distinctive grouping. He knew of these even before he visited the region in 1871 through his work for *Scribner's Monthly,* and they became the focus of several wood engravings in that publication and of a number of painted and etched views in succeeding years.[20] Ferdinand Hayden called these formations "gloomy sentinels," but *Scribner's* author Nathaniel Langford was more descriptive:

For some distance above the fall the stream is broken into a great number of channels, each of which has worked a torturous course through a compact body of shale to the verge of the precipice, where they re-unite and form the fall. The countless shapes into which the shale has been wrought by the action of the angry waters, add a feature of great interest to the scene. Spires of solid shale, capped with slate, beautifully rounded and polished, faultless in symmetry raise their tapering forms to the height of from 80 to 150 feet, all over the plateau above the cataract. Some resemble towers, others the spires of churches, and others still shoot up as lithe and slender as the minarets of a mosque.[21]

Moran's later treatments of these towers were from two primary points of view, one from

below the falls looking up, a vantage that accentuates the height of the pinnacles (figs. 12, 13), and the other from the top of the falls, with the focus on one form, that known as the Devil's Hoof (figs. 41–44). Both were also photographed by William Henry Jackson, Moran's colleague in Yellowstone (figs. 14, 45), and later chapters will discuss their significance to commercial patrons.

A similar form in the Yellowstone that captured the attention of both Moran and Jackson was the extinct geyser known as the Liberty Cap (figs. 15, 16). This silent protrusion seems to rise from the valley floor at the foot of Mammoth Hot Springs, a reminder that the area's geologic activity had a long and explosive past. In several of Moran's interpretations the form stands as a totem, dwarfing the

Fig. 17. Thomas Moran, *Cliffs in the Grand Canōn,* ca. 1872, wood engraving. From *The Aldine* 6(March 1873):75. Courtesy of the Library of the National Museum of American Art and the National Portrait Gallery, Smithsonian Institution.

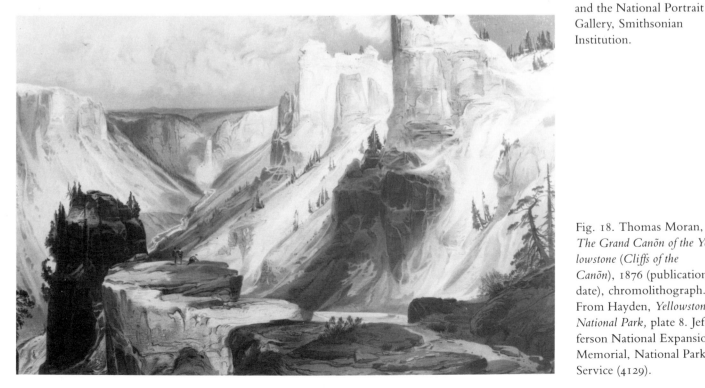

Fig. 18. Thomas Moran, *The Grand Canōn of the Yellowstone* (*Cliffs of the Canōn*), 1876 (publication date), chromolithograph. From Hayden, *Yellowstone National Park,* plate 8. Jefferson National Expansion Memorial, National Park Service (4129).

figures around it, physically and psychologically.

Moran also included what may be called tower forms in his great 1872 painting, *The Grand Cañon of the Yellowstone* (plate 1). The outcroppings of the canyon walls are much less noticeable at the site itself, and Moran's exaggeration of them in this and other versions (plate 5, figs. 17, 18) renders them another incarnation of the architectural motif. Contemporary reviews of the canvas describe the pinnacles as resembling "human architecture on a titanic scale" and "battlements piled up with Titan art, . . . awful trophies of the power of moving water."[22] In the painting these prominent formations not only delineate and anchor the sliding walls of the canyon but

also provide viewers with objects they can, in some sense, identify with. By emphasizing them as architecture, Moran enabled his audience to attach a degree of personal significance to his unusual scene and thus incorporate it into their own experience.

Although Moran produced a number of provocative examples of the tower motif in Yellowstone, his most prolific treatment of the subject came from the arid canyonlands of Utah and Arizona, which he first visited in 1873 with John Wesley Powell's survey. Towers, mesas, buttes, and cliffs abound in this region and appear consistently in Moran's depictions, not only because of their existence in nature but also because they are central to the land's essential character. In his first great

Fig. 19. Thomas Moran, *Valley of the Babbling Waters, Southern Utah* ca. 1874, wood engraving, 8⅞ × 12¾″ (22.5 × 32.4 cm). From *The Aldine* 7(March 1875):facing 307. The Thomas Gilcrease Institute of American History and Art, Tulsa, Oklahoma (1526.422); Morand and Friese no. 93.

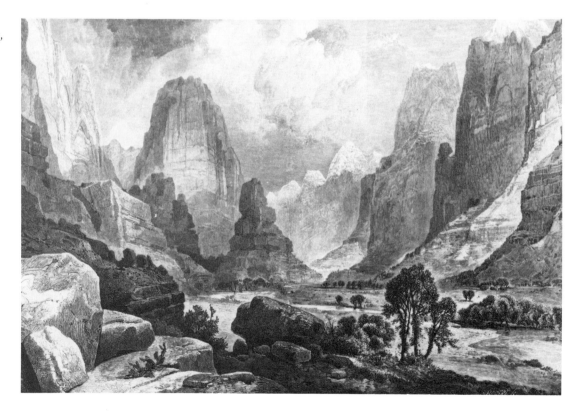

painting of the Grand Canyon, *The Chasm of the Colorado* (1873–74, plate 2), the tower is a key element to the image's meaning, and although this will be more thoroughly discussed in later chapters, it is important here to recognize the form's appearance in this major canvas.

As in his Green River pictures, almost all of Moran's depictions of the Virgin River in Utah focus on the prominent buttes that line the river (an area now included in Zion National Park). Often, as in his *Cliffs of the Rio Virgen* (1873, Cooper-Hewitt Museum), these forms are strikingly and evocatively colored; in other works they are highlighted by their monumental size in comparison with their surroundings, as in the wood engraving *Valley of the Babbling Waters, Southern Utah* (ca. 1874, fig. 19).

Biblical connotations, like phallic allusions, are unavoidable in the symbolism of towers, and considering the cosmic reading of geology in the mid to late nineteenth century, they are appropriate for Moran's art. Texts such as 2 Samuel would have appealed to Powell, Moran, and their contemporary Clarence King: "The Lord is my rock; . . . he is my shield, and the horn of my salvation, my high tower, and my refuge."[23] Biblical names were given to pinnacle formations throughout the West, reflecting the religious missions of many early settlers, such as the Mormons, and also the impression the sites conveyed. Most of the features in Zion are so christened, as are a number of those clustered in the Garden of the Gods, near Colorado Springs. Towers embodied cosmic significance for a variety of viewers, a fact Moran's art powerfully expressed.

Fig. 20. Thomas Moran, *Study of an Italian Pine in the Villa Borghese, Rome,* 1867, graphite and ink wash on paper, 13½ × 8¾" (34.3 × 22.2 cm). The Thomas Gilcrease Institute of American History and Art, Tulsa, Oklahoma (4533); Morand and Friese no. 93.

Fig. 21. Thomas Moran,
Solitude, 1869, lithograph,
20½ × 16″ (52.1 × 40.6
cm). The Thomas Gil-
crease Institute of Ameri-
can History and Art, Tulsa,
Oklahoma (1426.635);
Morand and Friese no. 14.

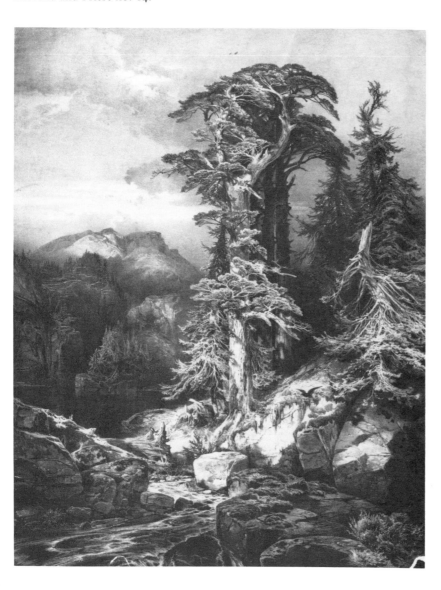

THE TREE

One of the least recognized of Moran's typo-
logical tools is the curving pine that appears in
many of his panoramic landscapes of the West.
It is the prominent vertical element in two of
his three large canvases that resulted from his
early expeditions, *The Grand Cañon of the Yel-
lowstone* (1872, plate 1) and *Mountain of the
Holy Cross* (1875, plate 3), as well as in other
works throughout his career. The most direct
source for Moran's distinctive twisting tree
was not in the American West at all; it was a
tree he first drew in 1867 at the Borghese Gar-
dens in Rome. Moran's original drawings of
the twisting forms remained in his studio col-
lection until his death and were the foundation
for central elements in many of his most im-
portant works.[24]

Study of an Italian Pine (1867, fig. 20), a
striking graphite-and-wash drawing, consti-
tutes a portrait of the tree, with the silhouetted
shape as the sole focus. Its slightly tilted angle
of vision, extreme contrast of the black curv-
ing trunk against the white of the paper, and
lacy foliage branching in three directions all
contribute to its exceptional quality. Such
concentrated views of nature were, of course,
fundamental to the Ruskinian method, but
Moran's use of the form as a prominent and
compositional element in a wide range of im-
ages implies that this singular specimen was of
special significance.

Portraits of trees were not unique to
Moran. Photographer Carleton Watkins pro-
duced a number of such works, his best-
known being *The Grizzly Giant* (ca. 1864), of
a massive redwood that Bierstadt later painted
(*The Great Trees, Mariposa Grove, California,*

1876, private collection). The Big Trees of California were well known by 1864, when President Lincoln set the area aside as a state preserve, and they became renowned for their extreme age as well as their enormous size. Writers such as Fitz Hugh Ludlow and Horace Greeley expressed opinions that the giant sequoias had sprouted anytime from the fall of Troy to the birth of Christ, pronouncements that endowed the United States with a lineage comparable to Europe's ancient history. Although Moran's tree is not one of those, of course, it does parallel the monumentality of its giant relatives, both in form and symbolism.[25]

The Italian tree was the focus of one of Moran's first lithographs, a beautifully drawn, evocative landscape entitled *Solitude* (1869, fig. 21), which has a pendant called *Desolation* (ca. 1869, Gilcrease Museum).[26] In *Solitude* the single twisting trunk of the Borghese tree has been entwined with another, a broken and battered white tree that appears to be dying. The two seem to cling together for support as they balance precariously on the rocky edge of a flowing stream, surrounded by tumbled boulders and fallen trees. Anthropomorphic associations are unavoidable, and the work, especially coupled with *Desolation,* thus becomes a memento mori. This reading is confirmed by Moran's highly stylized watercolor of 1896, published in Henry N. Dodge's sentimentalized *Christus Victor* (1926), in which the entwined trees of *Solitude* tower over a broken tomb in a churchyard. A single mourner stands, head bowed, facing the crypt, in a visual echo of Deuteronomy, "For the tree of the field is man's life."[27]

Versions of this form appear in a variety of Moran's works, but its most remarkable appearance is in the great canvases, *The Grand Cañon of the Yellowstone* and *Mountain of the Holy Cross,* where the tree is essential to the composition and the symbolism of the paintings. In the first (plate 1), the tree stands as a sentinel on the left, acting as that area's most significant element, echoing the verticality of the falls in the center and the dark rocks on the extreme right. It breaks the horizon line and becomes the only dark element in the upper portion of the canvas. A restatement of the Borghese tree, it is here altered only slightly in its greater curvature and tilt and in the exaggerated height.

In this, Moran's first large oil of the West, it is noteworthy that he would transplant Italian foliage to such a scene, especially in such elongated form. Just as previous artists had adapted American landscapes to European ideas to ally the New World with the Old, and just as the West itself was compared to Europe through its remarkable features, Moran may have been making a subtle yet direct reference to the older tradition and culture with his inclusion of the tree. It was in the monumental vistas of the West that the United States could rival the great artistic subjects and achievements of the Old World, and it was through these scenes that America could claim distinction and even superiority to them.

In *Mountain of the Holy Cross* (plate 3) the tree seems to surmount the rugged landscape from which it grows, transcending the obstacles in a triumphant display of perseverance. Here it is twinned not with a dying mate, as in *Solitude,* but with a living one, and the two, as they intermingle and cojoin at the top, are the closest objects to the sacred peak

Fig. 22. William Henry Jackson, *Balanced Rock, Garden of the Gods,* after 1880, photograph. Courtesy of the Colorado Historical Society (2163).

Fig. 23. William Bell, *Perched Rock, Rocker Creek, Arizona,* 1872, photograph. United States Geological Survey Photographic Library (U.S. Geographical Survey West of the 100th Meridian, exp. 1872, plate 14).

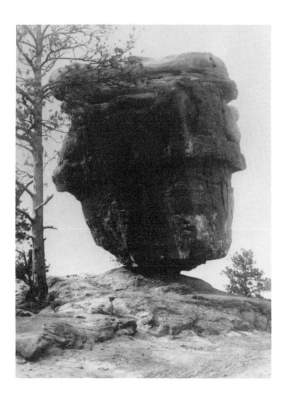 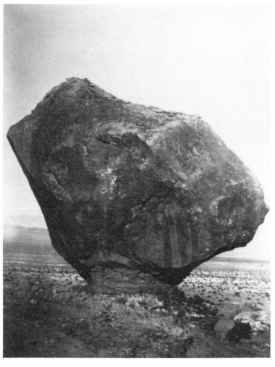

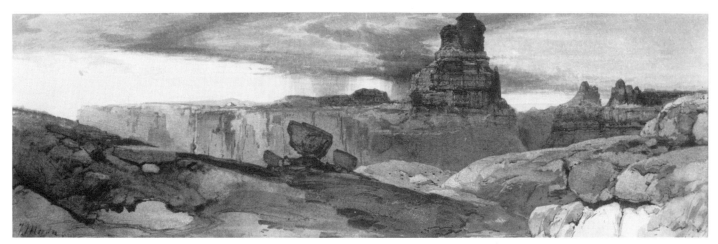

Fig. 24. Thomas Moran, *Shin-Au-Av-Tu-Weap, or "God Land," Cañon of the Colorado, Utah Ter.,* 1873, watercolor and graphite on paper 4¹³⁄₁₆ × 14⁹⁄₁₆″ (12.2 × 36.9 cm). National Museum of American Art, Smithsonian Institution, gift of Dr. William Henry Holmes (1930.12.42); Clark no. 133.

in the distance. As this work is overtly Christian and was, at the time, an important nationalistic symbol, it may be appropriate to recall Psalm 1: "And he shall be like a tree planted by the rivers of water, that bringeth forth his fruit in his season; his leaf also shall not wither; and whatsoever he doeth shall prosper." [28] In this incarnation Moran's tree is like a beacon, beckoning the weary pilgrim on his journey toward the shining symbol at the head of the valley.

THE ROCK

A prominent feature of the West, especially in the Grand Canyon area where there is little vegetation or soil cover, rocks naturally formed an important part of Moran's visual vocabulary. But apart from their existence in the physical world, these objects took on special cosmic significance, especially to geologists and such theoreticians as Ruskin. As with Moran's other themes of arch, tower, and tree, certain rocks stand out as typological devices in Moran's art, with their own formal and iconographic implications.

Like the tree portraits, there seems to have been a concurrent trend of rock portraits in the decades of the 1860s and 1870s. Photographers William Bell of the Wheeler survey, E. O. Beaman of the Powell expedition, William Henry Jackson of Hayden's, and Carleton Watkins all produced striking close-ups of so-called perched or balanced rocks, which became landmarks in desolate country and were remarkable for their seeming defiance of gravity (figs. 22, 23). [29] Although Moran seems to have depicted such forms with less scrutiny than he applied to his early tree drawings, he

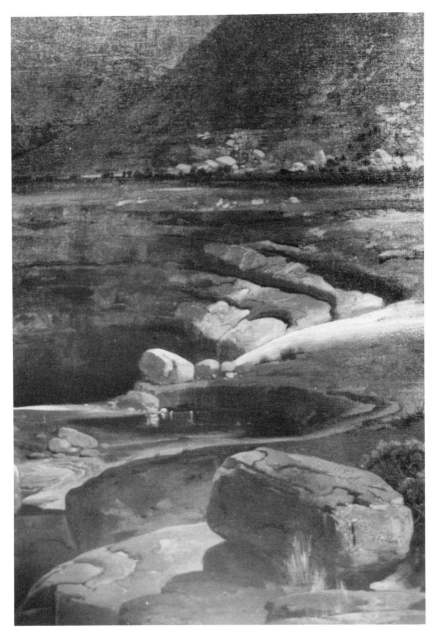

Fig. 25. Thomas Moran, *The Chasm of the Colorado,* 1873–74 (detail), oil on canvas, 84⅜ × 144¾″ (214.3 × 367.6 cm). National Museum of American Art, Smithsonian Institution, lent by the Department of the Interior, Office of the Secretary (L. 1968.84.2).

did include balanced boulders in a surprising number of views. A tiny version appears in *Grand Cañon of the Yellowstone* just below and beyond the tree, balanced tenuously on a protruding ledge where it echoes the forms of the surveyors in the center of the picture. More prominent appearances are in his Grand Canyon works, beginning with a watercolor, *Shin-Au-Av-Tu-Weap, or "God Land," Cañon of the Colorado, Utah* (1873, fig. 24), where the distinctive asymmetrical form is the central feature on the midground rise. In his largest canvas of the canyon, *The Chasm of the Colorado* (1873–74), the boulder makes several appearances, and each is perched precariously on the brink of the ledge (fig. 25).

The precariousness of these rocks is paradoxical, since the traditional connotation of the form, especially the biblical reference, is that of permanence, steadfastness, and strength.[30] Moran's use of the tenuously positioned boulder upsets the natural order, suggesting transformation, transition, and change. These attributes were, of course, predominant aspects of the West's natural history but were also of immediate concern in the 1870s as the region was being opened to industry, tourism, and settlement. In Moran's images from Powell's expedition, for ex-

ample, the artist may have been alluding to both past and future instability; the western canyons continually evolve through erosive forces, and as Powell theorized, limited water supplies inflict a constant state of uncertainty on any effort to live in the region. Although these concepts are more directly conveyed in other aspects of Moran's southwestern art, his perched boulders stand as a constant reminder of the mutability of man and even the instability of rock.

Moran's favored typological devices—the arch, tower, tree, and rock—are not necessarily metaphorical in all their varied manifestations, but they may often be so perceived. By including such distinctive features within the context of the western landscape, Moran was providing specific references to a number of sources, biblical, historical, and cultural, which helped his viewers to assimilate his message. His notion of his subjects' grandeur was celebratory, but while he extolled the wondrous beauty and strangeness of the West he knew, his view was tempered with his awareness of the unfathomable mysteries of its creation and of the awesome power of nature and man to provoke change and even destruction.

PART 2

THE YELLOWSTONE

3

THE HAYDEN GEOLOGICAL AND GEOGRAPHICAL SURVEY OF THE TERRITORIES

Thomas Moran first rose to national prominence through the fame of his first great painting of the American West, *The Grand Cañon of the Yellowstone* (1872, plate 1). This massive work (7 feet by 12 feet) was the first American landscape by an American artist to be bought by the United States government, and its unveiling closely followed the highly publicized designation of Yellowstone as the first national park.[1] Congress purchased the canvas in the spring of 1872 for $10,000 and hung it prominently in public view in the Capitol. The painting resulted from Moran's accompaniment of a well-known government survey of Yellowstone (the Hayden expedition), which, along with its association with the park and the Capitol itself, gives the work obvious national significance. As we shall see, however, other important cultural relationships add to the painting's richness and can contribute to its reputation as a major work of American art. Too, the *Grand Cañon of the Yellowstone* was Moran's first real visual challenge, and from it he emerged a mature artist with his own style. He found his subject in the Yellowstone, one from which he could achieve a synthesis of his early training in aesthetic theory and the styles of earlier artists, such as Turner and Hamilton, and express his developing understanding of the American landscape. Both achievements may be appreciated fully only when placed in the context of Moran's work, his experiences, and the historical events that surrounded and influenced his knowledge of the region.

The Grand Cañon of the Yellowstone is a powerful image in both scope and conception. It depicts a massive canyon in the heart of the region, a deep V-shaped gorge created by the Yellowstone River. Moran placed the focal point of the painting, the Lower Falls, slightly off center in the distance, framed with the sloping valley walls.[2] The falls are tucked into an immense depression, but they drop with a force sufficient to create a cloud of spray that functions as a vertical element, anchoring the strong angle of the valley. The cascading yellow walls are alternately smooth and jagged with protruding formations that reveal the geological substructure below the canyon's walls. The most prominent of these are the vertical basalt columns in the upper right, highlighted by their light cream coloration and brilliantly sunlit location, and also by their exaggerated size. Their verticality echoes the columnar spray and falls, and their color and proportional dominance establish them as the second focal point of the painting. Balancing that formation on the left is the lofty restatement of Moran's Roman pine, and along

Yellowstone Lake . . . is a scene of transcendent beauty, which has been viewed by but a few white men; and we felt glad to have looked upon it before its primeval solitude should be broken by the crowds of pleasure-seekers which at no distant day will throng its shores.

Charles Cook, 1870

the horizon the repetitive verticals are faintly echoed by the rising steam of distant geysers.

In the darker foreground Moran placed his most finely contoured details; deep brown rocks in the lower right reveal the veins, cracks, and crevices that so fascinated the geologists he worked with, and figures and animals place the subject historically. Fallen on the rocks in the lower left is a slain deer, and immediately to the right are three horses and two explorers who may be photographer William H. Jackson and Moran himself, seated with a sketchbook (fig. 26). Lurking in the shadows on the extreme left is a bear, perhaps indicating the inherent wildness of the site. Finally, prominently positioned on a central precipice, a minute scientist-explorer (Ferdinand Hayden) stands with an Indian in full regalia (plate 4).[3]

The Indian and fallen deer are provocative details. In his journal from the trip, the artist noted an overnight visit to the Crow Agency

in the Yellowstone area where he may have encountered Indians, but he did not elaborate.[4] Similarly, there is little commentary on Indians in the official documents of the expedition that might suggest their relationship to the explorers. The native American stands with his back to the canyon, facing outward, while the geologist looks into the gorge and gestures enthusiastically toward it. This may suggest the Indian's relinquishment of the land or a welcoming invitation to the viewer, but any interpretation of the native's presence should serve as a reminder that the "discovery" of Yellowstone had taken place long before the United States' expeditions. This figure, coupled with the slain deer (which is the only indication of human destruction in the scene), may foreshadow some of the more hidden implications of Moran's painting.

Moran is perhaps best characterized as a colorist, and the Yellowstone region provided him an unparalleled opportunity to display his talents. *The Grand Cañon of the Yellowstone* prominently exhibits the sulphurous yellow deposits that give the region its name, and they are offset and accentuated by ochers, sandstone oranges, deep greens and browns of the pines and rocks, and the white spray of the falls. It was for color that the painting received its highest acclaim; in contemporary commentary survey leader Hayden admired the basalt volcanic breccia and multicolored mineral deposits for "a brilliancy like the most delicate of our aniline dyes." He continued: "None but an artist with a most delicate perception of colors could do justice to the picture [the view]. The well-known landscape painter, Thomas Moran, who is justly celebrated for his exquisite taste as a colorist, ex-

Fig. 26. Thomas Moran, *The Grand Cañon of the Yellowstone,* 1872 (detail), oil on canvas, 84 × 144¼" (213 × 266.3 cm). National Museum of American Art, Smithsonian Institution, lent by the Department of the Interior, Office of the Secretary (L. 1968.84.1).

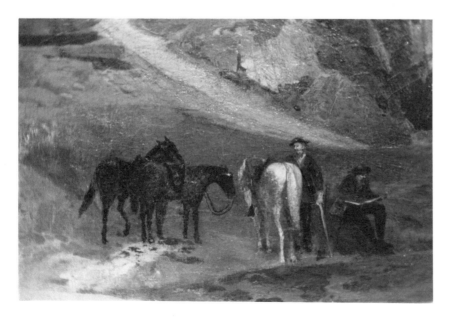

claimed, with a sort of regretful enthusiasm, that these beautiful tints were beyond the reach of human art."[5]

For all its facility, variety, and impressiveness, when Moran's 1872 painting is compared with his later, even larger reinterpretation of the subject, *The Grand Cañon of the Yellowstone* (1893–1901, plate 5), the early work seems pale and hard. The technique is quite different; the later work is a romantic, painterly display that evokes atmospheric effect rather than detail, and the earlier view seems overly linear by contrast, more like Moran's studio watercolors of the same period. This suggests that in the early version Moran was not only still developing his painting style but was also concerned with conveying his subject as clearly as possible. Yellowstone was, in the spring of 1872, just being introduced to Americans, and it was unlike anything most people had ever seen; it also had a history that approached mythical status. Through his clarity of line, color, and detail, Moran was conveying to his viewers something of the grandeur and uniqueness of the site but at the same time attempting to convince them, with easily identifiable elements, that such a remarkable place actually existed. By 1893, when the later work was exhibited at the World's Columbian Exposition as part of Wyoming's state entry, the Yellowstone had become a well-known and highly romanticized tourist attraction. The promise of the place, suggested by the enthusiastic gesture of the explorer in Moran's 1872 version, had been realized.

THE YELLOWSTONE

Though many considered the Yellowstone region a discovery in 1869–71, it had been known to mountain men, trappers, traders, and soldiers (not to mention Indians) from the time of John Colter, one of Lewis and Clark's men who remained in the West after that first expedition returned east in 1806. Colter passed through Yellowstone in 1807–1808, discovering at least one of the geyser regions, and his unbelievable stories made it legendary as "Colter's Hell." The tall-tale quality of his and other descriptions contributed to the area's mythic reputation in the East and sparked curiosity about the mysterious hell on earth, a fascination used to full advantage by Yellowstone's later promoters. Indeed, according to Aubrey Haines, a leading historian of Yellowstone National Park, the factual information brought back by the serious explorations of 1869, 1870, and 1871 was "a direct outgrowth of an earlier interest in the area's wonders."[6]

One example of that early curiosity was that of Capt. William F. Raynolds, whose expedition in 1859–60 was charged with determining the most passable routes from the Yellowstone River to South Pass and from the Wind River to the Missouri. Raynolds hoped to see the satanic area that his guide, Jim Bridger, described so vividly, but Bridger advised that it was beyond their charted course. Raynolds later wrote:

We were compelled to content ourselves with listening to marvelous tales of burning plains, immense lakes, and boiling springs, without being able to verify these wonders. I knew of but two white men who claim to have visited this part of

the Yellowstone Valley—James Bridger and Robert Meldrum. The narratives of both these men are very remarkable and Bridger in one of his recitals, describes an immense boiling spring that is the very counterpart of the geysers of Iceland. . . . I have little doubt that he spoke of what he had actually seen. The burning plains described by those men may be volcanic or more probably beds of lignite, similar to those on the Powder River, which are known to be in a state of ignition. . . . At no very distant day the mysteries of this region will be fully revealed, and though small in extent, I regard the valley of the upper Yellowstone as the most interesting unexplored district of our widely expanded country.[7]

Although he wrote that several years later, never having seen the unusual sights, it is one of the first official written descriptions of the area. The patent curiosity, the importance he ascribed to the region, and the certainty with which he looked to future knowledge of it challenged would-be explorers and the government to learn more. Ferdinand Hayden was a geologist with Raynolds, and it is possible that his later desire to explore the Yellowstone region derived from his experience with that survey. Although other sources have pointed to Nathaniel Langford's lectures in the winter of 1871 and publication of the Washburn-Doane expedition's experiences from 1870 as motivating factors for Hayden, it is more likely that his first interest in Yellowstone dates to this much earlier acquaintance.[8]

The systematic knowledge of Yellowstone finally achieved by the mid 1870s was a result of the efforts of three expeditionary groups that fulfilled Raynolds's expectations by providing definitive scientific and descriptive documentation: the Folsom-Cook-Peterson group, 1869; the Washburn-Doane party,

1870; and the Hayden survey, 1871. The Folsom expedition comprised only three men, but with their travels and their subsequent reports, they dispelled a number of long-standing rumors about the area's terrain, contributed a new map of the area, and promoted interest in further exploration. During the winter of 1869–70 Cook and Folsom collaborated on an account that they submitted to *The New York Times, Scribner's,* and *Harper's* magazines, but the publications claimed "they had a reputation that they could not risk with such unreliable material."[9] The story was finally published, however, in the summer of 1870 in a Chicago publication, *The Western Monthly.* It was the first magazine article about the Yellowstone, and in it we see an early glimpse of the sublimity with which the region became universally associated. Here too, as with Meriwether Lewis and others, we read of the familiar wish for a means of visual expression, words being inadequate to convey a sense of the landscape. At Yellowstone canyon, the site of Thomas Moran's great painting, Cook resorted to the convention of architectural metaphor to describe the scene before him:

We spent the next day at the falls—a day that was a succession of surprises; and we returned to camp realizing as we had never done before how utterly insignificant are man's mightiest efforts when compared with the fulfillment of the Omnipotent will. Language is entirely inadequate to convey a just conception of the awful grandeur and sublimity of this masterpiece of nature's handiwork. . . . Here the cañon is at least fifteen hundred feet deep, with an average width of twice that distance at the top. For one-third of the distance downwards the sides are perpendicular—from thence running down to the river in steep ridges crowned by rocks of the most grotesque form and color; and it re-

quired no stretch of the imagination to picture fortresses, castles, watch-towers, and other ancient structures, of every conceivable shape.[10]

Cook was, in fact, echoing the feelings of a previous unofficial visitor to Yellowstone, a doctor named Dunlevy, who had written a year earlier:

Tall spires of colossal grandeur which in beauty and symmetry are superior to any works of art; beetling cliffs of rock . . . turreted like castles and rolling away off in beautiful white pyramidal forms, were to be seen on every side. Language is not adequate to convey an idea of the marvelous beauty of the scenery, which is beyond the power of descriptions, and begets a wonderful fascination in the mind of the beholder who reverently gazes at the snow crowned summits, that seem as if 'they were to show how earth may pierce to Heaven and leave vain man below.' . . . We trust ere long some select party, well prepared and equipped, will be able to penetrate these wilds and reveal to the world its manifest beauties, existing as they do in all their pristine grandeur.[11]

Here, just as had earlier explorers of other regions, the writer struggled to convey his experiences in words and wished for a more evocative medium. In this instance the author asserted that the scene was beyond even the powers of art, comparing the scene instead to otherworldly ideals. Yet, with his hope for those who followed him to "reveal to the world its manifest beauties," Dunlevy implicitly suggested an attempt should be made to capture such extraordinary sights in visual form.

Such sentiments were apparently shared, because in 1870, two members of the Washburn-Doane party that toured the area that year produced the first drawings of Yellowstone (fig. 27). Private Charles Moore was part of the military escort for the primarily civilian group, and Walter Trumbull, son of Senator Lyman Trumbull of Illinois, was a journalist. Their sketches are amateurish but significant for their originality and for their influence on Moran's interest in Yellowstone.

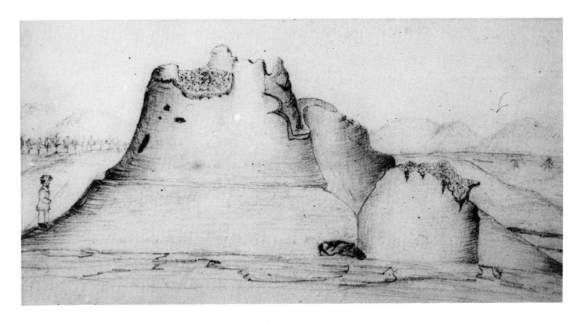

Fig. 27. Walter Trumbull, *Castle Geyser Cone,* 1870, graphite on paper. Yellowstone National Park, National Park Service.

That these individuals who had no artistic experience were moved to take pencil to paper in an effort to graphically capture the scenes testifies that Yellowstone's wonders are better suited to visual than to verbal portrayal. Indeed, where written and spoken descriptions were dismissed as exaggerated, the graphic images of the unusual features succeeded almost immediately in persuading a skeptical eastern public that there were lands to the west worthy of their attention. It is telling, for example, that *Scribner's* published the article illustrated by Trumbull and Moore even though it had rejected Cook and Folsom's account just a year earlier, declaring it unbelievable.

The article, "The Wonders of Yellowstone," which appeared in two parts in May and June 1871, was written by Nathaniel Langford, a prominent Montana citizen and member of the 1870 Washburn-Doane expedition. Although Langford's stature and the accompanying illustrations contributed a measure of credibility to his descriptions, his accounts of Yellowstone actually confirmed the fantastic reports of earlier visitors and contributed to its reputation as "the place where hell bubbled up." Langford seems to have been aware of this, but he found the satanic references appropriate to the region's character. Of a particularly dramatic rock formation he wrote:

One of our companions gave to these rocks the name of the 'Devil's Slide.' The suggestion was unfortunate, as with more reason perhaps, but with no better taste, we frequently had occasion to appropriate other portations of the person of his Satanic Majesty, or of his dominion, in signification of the varied marvels we met with. Some little excuse may be found for this in the fact that the old mountaineers and trappers who preceded us had been peculiarly lavish in the use of the infernal vocabulary. Every river and glen and mountain had suggested to their imaginations some fancied resemblance to portions of a region which their pious grandmothers had warned them to avoid. It is common for them, when speaking of this region, to designate portions of its physical features as 'Fire Hole Prairie'—the 'Devil's Glen'—'Hell Roaring River,' etc.—and these names, from a remarkable fitness of things, are not likely to be speedily superseded by others less impressive.[12]

Langford and the expedition he accompanied brought back more reliable information about Yellowstone than any of their predecessors, but just as important was their demonstration that more investigation was necessary. Upon the completion of his expedition, General Washburn rightly predicted that his party's initial discoveries "are likely and almost certain to lead to an early and thorough exploration of those mysterious regions under the patronage of the General Government and the Smithsonian Institution."[13] With such a foundation, Hayden's even more widely publicized efforts of 1871 could hardly fail to attract enthusiastic attention.

THE HAYDEN EXPEDITION TO YELLOWSTONE, 1871

Ferdinand Hayden's U.S. Geological Survey of the Territories was in its fifth year when Moran joined it on its way to Yellowstone. Hayden was a physician by profession but had become so interested in geology and paleontology that upon his graduation from medical school in 1853 he went to work for the leading paleontologist, James Hall, in the White River

Badlands. Exploring became Hayden's primary interest, and he spent the rest of the decade with expeditions throughout the Dakotas, Wyoming, and Montana.[14]

During the Civil War Hayden served as a surgeon in the Union Army, but afterward he began organizing his own survey teams to return to the Badlands.[15] He finally received the directorship of a government-sponsored expedition in 1867, when he was appointed geologist-in-charge of the Geological Survey of Nebraska, administered by the General Land Office.[16] The appropriation was only $5,000, but Hayden mustered additional aid in the form of a volunteer crew, livestock and supplies from the army, and surveying equipment from the Smithsonian Institution. His enterprising spirit was one of Hayden's most distinguishing characteristics, and it eventually placed him at the forefront of western scientific exploration.

In subsequent years, Hayden lobbied Congress for additional funding and launched expeditions to eastern Wyoming and Colorado, each time returning with an impressive array of geological, paleontological, and botanical specimens, many of which were given to the Smithsonian.[17] He also published reports to his superiors and articles in popular magazines, newspapers, and journals, which included topographical and geological data and scientific analyses commissioned from leading scientists of the day. Hayden's appreciation for public relations was one of his most important assets, and his prolific publishing, though sometimes criticized for its hastiness, would eventually distinguish him from the other three leaders of Great Surveys, Clarence King, J. W. Powell, and Lt. George Wheeler.

In 1869, this time under the auspices of the Department of the Interior and with an appropriation of $10,000, Hayden hired his first artist. Henry Wood Elliott was the private secretary to Joseph Henry, Secretary of the Smithsonian, with whom Hayden frequently corresponded.[18] Hayden's reports from previous seasons had been relatively brief, and he wished to expand them with landscape sketches. Although Elliott remained with Hayden for nearly three years, including the famous 1871 Yellowstone expedition, little is known about him as an artist. His abilities scarcely ranked with those of his more prominent associates, Sanford Gifford, who accompanied Hayden as a guest in 1870, and Thomas Moran, but Elliott contributed illustrations to two of Hayden's reports, those of the 1870 and 1871 seasons. Hayden's prompt employment of an artist, once he could afford one, indicates that he and his superiors recognized the need for visual accompaniment to his written text.[19] He understood that it was essential that he provide congressmen and other influential individuals with a literal view of the land he was covering, and his commitment to the idea contributed to his consistent ability to acquire greater appropriations than any other expedition leader.

Hayden did not stop with the employment of a graphic artist. In 1870, with instructions from the Secretary of the Interior to "secure as full material as possible for the illustration of your final report, such as sketches, photographs, etc.," he passed through Omaha on his way to Wyoming and called on William Henry Jackson, an enterprising young photographer whom he had met briefly the previous summer. He persuaded Jackson to join

the survey that year for nothing more than travel expenses, food and shelter, and the promise of adventure. The following year Jackson received a paid appointment, and he remained with Hayden as official photographer until the four Great Surveys were reorganized into the one United States Geological Survey in 1879.[20]

Hayden was already familiar with landscape photography's potential from his experience with the Raynolds expedition to the upper Missouri in 1859–60, which had included a photographer. Equally important, Hayden's rival Clarence King had been using photography to publicize his survey of the fortieth parallel since 1867, when he hired photographer Timothy O'Sullivan as one of his first employees. In 1869, King carried a bulky portfolio of O'Sullivan's prints around New York, Washington, Boston, and New Haven showing them off, an enterprise the ambitious Hayden was not likely to have missed. In that year too, Hayden himself compiled a group of photographs (by A. J. Russell) for a book of

western scenery, *Sun Pictures of Rocky Mountain Scenery,* and its publication the following year is an indication that photographic documentation was foremost in his mind at the time.[21]

Hayden recognized the potential of collaboration between artists and photographers early, and for the season of what was perhaps his most important expedition in the summer of 1871, he allowed a second artist to accompany his survey to the Yellowstone. Thomas Moran was invited, not as a government employee, as Elliott and Jackson were by then, but as a guest of the survey. The summer before, Hayden had accommodated another guest artist, the landscapist Sanford Gifford, and although Gifford's work for the survey seems to have been minimal, he did collaborate with Jackson, photographing and sketching in central Wyoming. Hayden invited him back for the 1871 season, but Gifford declined. For a brief period in late spring it appeared that Albert Bierstadt would accompany the survey with Moran. He did not, but Hayden's willingness to accommodate artists on his primarily scientific explorations indicates that he understood their importance for his success and for portraying the West.[22]

In the spring of 1871 Moran's friend Richard Watson Gilder, editor of the popular magazine *Scribner's Monthly,* asked Moran to illustrate Langford's article "The Wonders of Yellowstone." Moran was to work from Moore and Trumbull's primitive drawings from the previous summer, refining them to presentable form for the magazine (figs. 27, 28). This was probably Moran's first awareness of Yellowstone's remarkable scenes, and it surely aroused his interest in seeing the place

Fig. 28. Thomas Moran, after Walter Trumbull, *Castle Geyser,* 1871, wood engraving, 2⅞ × 5″ (7.3 × 12.7 cm). From *Scribner's Monthly* 2(June 1871):125. Courtesy of the Library of the National Museum of American Art and the National Portrait Gallery, Smithsonian Institution.

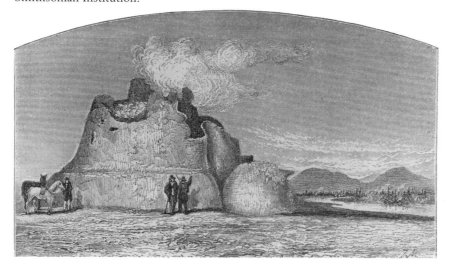

for himself. His opportunity was forthcoming. With a letter of introduction from Jay Cooke, the financier of the Northern Pacific Railroad, and loans of $500 each from Cooke and *Scribner's* publisher, Moran took the Union Pacific to Utah in July and joined Hayden's party in Fort Ellis, Montana, as it was about to enter the still mysterious region of the Yellowstone.[23]

In his first Yellowstone diary entry, Moran listed his colleagues: "Started from camp in company with Hayden, Jackson (the photographer), Elliot (draughtsman), [Anton] Schonborn (topographer), [George] Dixon (Jackson's assistant)."[24] What Moran did not mention, and may not have realized on his first day, was that as the Hayden team was embarking on its work, another group, a military reconnaissance team now known as the Barlow-Heap party, was heading on a parallel course. The two groups covered much of the same territory that summer, and while competing for the privilege of being first to systematically map the area, they shared a number of resources, especially in visual documentation. The Barlow-Heap survey included a draftsman named Wood and two photographers, employee Thomas J. Hine of

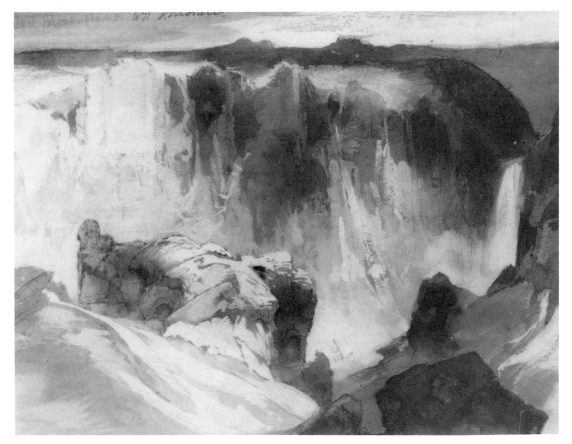

Fig. 29. Thomas Moran, *Yellowstone Cañon,* 1871, graphite and watercolor on paper, 8⅛ × 11⅛" (20.6 × 28.3 cm). Yellowstone National Park, National Park Service (8539); Clark no. 23.

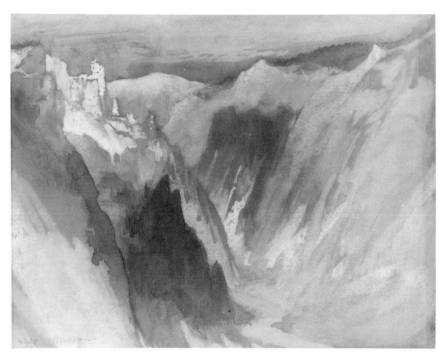

Fig. 30. Thomas Moran, *Red Rock* (*Yellowstone Canōn from Above Lower Fall*), 1871, graphite and watercolor on paper 8³/₁₆ × 10¹¹/₁₆" (20.8 × 27.1 cm). Yellowstone National Park, National Park Service (8543); Clark no. 25.

Chicago and a guest, J. Crissman of Bozeman.[25] When Crissman's camera fell off a cliff, Jackson provided him with a spare, and because Hine's negatives were destroyed almost immediately after the survey in the great Chicago fire of November 1871, Jackson replaced them in Barlow and Heap's personal collections and their official reports.[26] Although little is known about the Yellowstone work of Wood, Hine, and Crissman, it is important to acknowledge their participation and, perhaps more significant, to recognize that a large team of individuals was involved in the graphic portrayal of the region. By 1871 it had become clear to those planning expeditions that visual records were useful in understanding new territory and essential for conveying that understanding to others.[27]

Despite its thoroughness in naming Mo-

ran's colleagues, the Yellowstone journal is woefully brief and especially bereft of artistic commentary, such as the choice of subject matter, theoretical ideals, artistic problems, and methodology. When faced with what was to be his classic landscape of the region, the Grand Canyon of the Yellowstone, Moran summed up the days he spent there as "photographing and sketching around the Falls and Cañon."[28] He was obviously more visual than verbal, and we must look to his art to learn of his reaction to the region.

Moran's 1871 field drawings illustrate a development in his sketching style from the 1860s and are instructive in relation to *The Grand Cañon of the Yellowstone*. The watercolor sketches emphasize color; formations are blocked in and contours are carefully delineated, but there is little attention to fine detail (figs. 29–31). Similarly, in his pencil drawings Moran suggested form and space through contour line, with almost no chiaroscuro (fig. 32). He recorded color and contrast in cryptic notations, with initials for green, blue, and so on. Comparison with his Pennsylvania field sketches from six years earlier (i.e., *Sawkill Falls*, 1865, or *Vandermarte*, 1865, GIL) reveals that Moran had abandoned his meticulous Ruskinian style for more economical use of line and color. His mature sketching style was not only faster and more practical; it was also well suited to western topography. The dramatic geological features, expansive vistas, and lack of lush vegetation in the West required a new emphasis on the relationships of large areas instead of small details.[29] It seems too that Moran recognized he could quickly capture the coloristic effects in the washy sketches, the contours in the line drawings,

and fill in details later by referring to Jackson's photographs back in the studio.

Another important aspect of this change in style may be directly connected to the surveying effort. In his development toward line drawings Moran paralleled the topographical efforts of his cartographic colleagues. Just as the geologists sought to capture the character of the region in finely detailed contours on their charts and maps, Moran may have been making the same attempt in his drawings. The analogy relates not only to form but also to underlying purpose. Each was engaged in transposing the appearance of the natural world to paper, a transformation of place to two dimensions that could convey something of its special qualities to viewers far from the site.

As William Truettner has discussed and as Moran himself asserted more generally, the Yellowstone sketches, as well as his finished paintings, are examples of the higher order of Ruskin's aesthetic, that of conveying the true impression of a scene rather than the truth of minute detail.[30] In addition to the theoretical motivation behind Moran's approach, he was aiming far beyond Hayden's congressional mandate to "collect sketches"—a directive implying that the simplest, most straightforward documentary notation would suffice. Moran had far greater goals in mind, and because he was able to achieve his own ambitions rather than simply following the minimal instructions, his work had a much stronger influence on the legislators after the expedition's return in the winter of 1871–72. The sketches were useful both for Moran's composing of paintings and for Hayden's lobbying; they, along with Jackson's photo-

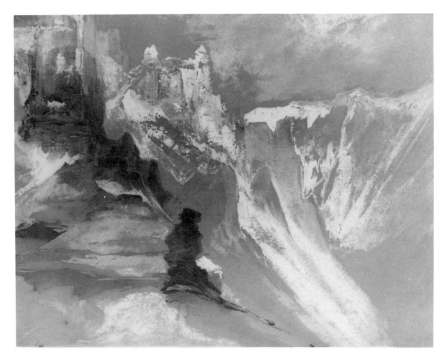

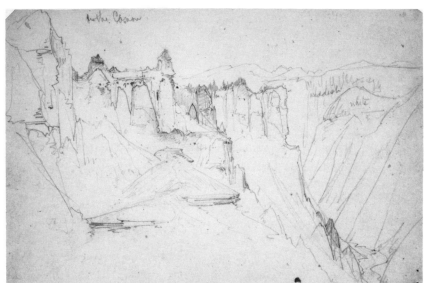

Fig. 31. Thomas Moran, *Yellowstone Canõn*, 1871, graphite and watercolor on paper, 10⅜ × 14⅛″ (26.4 × 35.8 cm). Yellowstone National Park, National Park Service (8544); Clark no. 24.

Fig. 32. Thomas Moran, *In the Canõn*, 1871, graphite on paper, 5⅛ × 7¾″ (13 × 19.7 cm). Jefferson National Expansion Memorial, National Park Service (4215).

graphs, had a profound effect on the way Yellowstone was initially perceived and ultimately utilized by the nation.

During the period of the Great Surveys, perhaps no team of artist and photographer was more productive than that of Thomas Moran and William Henry Jackson. They worked together during the 1871 Yellowstone survey, shared their results after the expedition, and developed a professional and personal relationship that continued until Moran's death in 1926. While Moran made scant reference to their activities in his journal ("Went to the Geysers. Helped Jackson during the day."), Jackson was somewhat more expressive.[31] In addition to his diaries, he included information, although limited, in his autobiography, *Time Exposure,* and in 1936 he wrote an article entitled "With Moran in Yellowstone." Jackson credited Moran with being very helpful, saying, "He was also as interested as the photographer himself in selecting the view points for each negative, having in mind, perhaps, the good use he could make of the photographs later in some of his own

Fig. 33. William Henry Jackson, *Yellowstone Cañon* (from Artist's Point), ca. 1871, stereograph. United States Geological Survey Photographic Library (Jackson 1521).

compositions."[32] This was an accurate presumption, of course; Moran valued photography highly and he utilized it frequently, sometimes in surprising ways. Although Moran and Jackson's association continued for many years, their first acquaintance in Yellowstone in 1871 was perhaps the most significant; the photographer learned much from his colleague, Moran profited greatly from the use of the photographs, and, finally, the United States as a whole benefited. The experience enabled both men to produce the first of their monumental western landscapes, and it provided the country with images that influenced the formation of its first national park.

The Grand Cañon of the Yellowstone was intended as a summation and synthesis of Moran's Yellowstone experience, and because no single extant drawing or photograph has been pinpointed as Moran's source for this important picture, it can be considered the cumulative result of his field sketches and Jackson's photographs from the expedition. Careful examination of those and more recent photographs of the site provide clues not only to the artist's methodology but also to the painting's cultural implications.[33]

It has always been assumed that Moran derived his image from a spot known as Artist's Point and that his painting is a relatively accurate rendition of the view from there. The few Jackson photographs that seem to correspond to Moran's composition (including those in his studio collection) and a recent one from Artist's Point, however, reveal that the artist altered the scene considerably, especially in its effects of distance and proportion (figs. 33–35).[34] In the painting the falls are pushed much deeper into space, the canyon walls have been

smoothed and opened into a more pronounced V shape, and the white towers on the canyon's right wall are noticeably enlarged. These discrepancies can be accounted for when we consider the painting not as a work produced from a single viewpoint, as is usually supposed, but as a compilation of a series of points of view from around the canyon. Moran acknowledged this himself, saying of the work:

Every form introduced into the picture is within view from a given point, but the relations of the separate parts to one another are not always preserved. For instance, the precipitous rocks on the right were really at my back when I stood at that point, yet in their present position they are strictly true to pictorial nature; and so correct is the whole representation that every member of the expedition with which I was connected declared, when he saw the painting, that he knew the exact spot which had been reproduced. My aim was to bring before the public the character of that region. The rocks in the foreground are so carefully drawn that a geologist could determine their precise nature.[35]

Thus, while emphasizing the veracity of his work, Moran admitted that he had manipulated his composition for pictorial effect.

A curious fact about Jackson's best-known views of the canyon is that although they have the same sloping walls that provide the V shape to Moran's image and similar relationships of rocky outcroppings and trees, they do not show the waterfall that is such an important focal point in the painting (figs. 36, 37). Furthermore, close inspection of the photographs reveals that the river is actually running in a different direction from that in Moran's view, away from the viewer rather than toward him. Modern photographs and careful

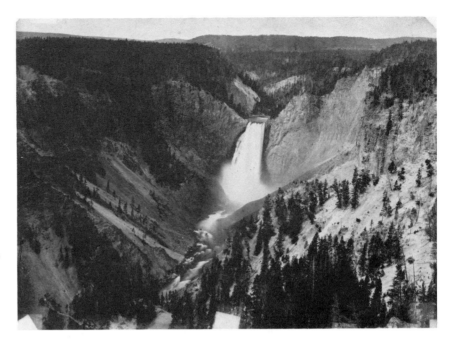

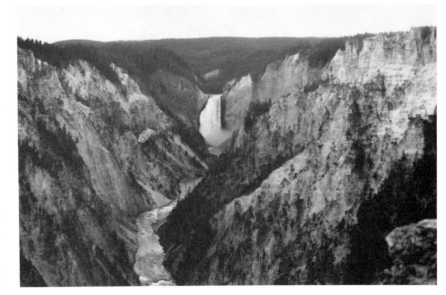

Fig. 34. William Henry Jackson, *Lower Falls of the Yellowstone River (400 feet)* (from Inspiration Point), 1871, photograph. Moran Studio Collection, The Thomas Gilcrease Institute of American History and Art, Tulsa, Oklahoma.

Fig. 35. *The Grand Canyon of the Yellowstone from Artist's Point,* 1989, photograph by the author.

Fig. 36. William Henry Jackson, *Yellowstone Canõn* (from above the falls), ca. 1871, photograph. United States Geological Survey Photographic Library (Jackson 88).

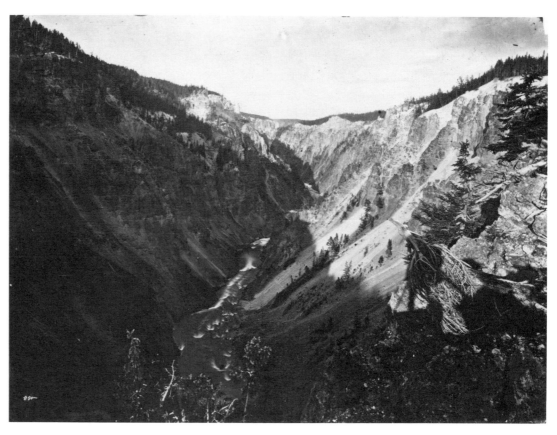

examination of the river's flow resolve the question. The photographs without the waterfall in view were taken from the top of the falls, looking toward Artist's Point, not from the point looking toward the falls. Furthermore, modern photographs of the falls from Artist's Point and the Jackson stereograph from there show that from this vantage point the canyon is much more rugged, much less open, than in Moran's painting (figs. 33, 35). They indicate that the painted canyon, with its sloping walls and falls in the center, was actually composed from photographs taken from the top of the falls rather than from the view from Artist's Point, in a sense inverting the entire scene. Moran reversed the order of the

natural world and presented a highly manipulated view of reality.

Other Jackson photographs that focus more closely on the falls parallel Moran's enlargement of the towerlike basalt pinnacles that dominate the canyon's walls. The rock forms are much more prominent in these photographs, and it seems that in looking at such close-ups for details, Moran also adopted their distorted proportions.

Other features further indicate Moran's manipulation of reality. As we have already seen, his transplantation of the twisted pine from Rome to the American West is intriguing, formally and iconographically. In the Yellowstone canyon painting, it presides over the far

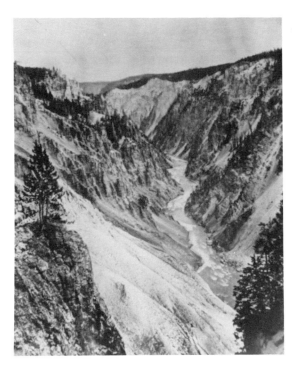

Fig. 37. William Henry Jackson, *Yellowstone Canõn* (from above the falls), ca. 1871, photograph. United States Geological Survey Photographic Library (Jackson 1204).

left, framing the view and breaking the horizon line. Through its curvilinear contrast to the straightness of the distant plateau it effectively directs the viewer's gaze back into the frame, and its height balances the bulk and verticality of the basalt towers on the right. Its gently sloping branches angle to the center, echoing the canyon wall's diagonal and pointing to the tiny figures below. Coupled with those "infiltrators," the contorted shape of the imported tree and the precarious balance of the rock just below and to its right implicitly suggest the paradoxes of western expansion. The progressive development of the West in the late nineteenth century that has been called its "commodification" had reached the Yellowstone; it was already being manipulated to suit a new purpose.[36]

In Moran's acknowledgment that he adjusted the relationships of the actual formations for aesthetic purposes, he alluded to what is perhaps the most important compositional feature of *The Grand Cañon of the Yellowstone,* that of the scope of the artist's vision. The canvas is a virtual panorama, encompassing a much wider view of the scene than would be possible even with a camera's wide-angle lens or the natural peripheral vision of an individual standing at the site. Moran used his artistic license to the fullest, not only in his multiple points of view and his transplanted typological motifs but also in his provision of a nearly 180-degree view.

Moran's rearrangement of the formal elements in *The Grand Cañon of the Yellowstone* suggests he was attempting a kind of control, or at least management, of the wildness of the place. The foreground in the lower left, complete with tree and *repoussoir* figures, was invented rather than being drawn from life; it does not appear in any of the sketches or photographs from the site. It is a conventional compositional device, added to enframe the vast gulf and to provide a vantage point from which to keep the expanse in perspective. Though Moran often painted scenes that are threatening in their enormity and precarious point of view, he more often than not provided the viewer a secure foreground from which to assimilate the scene.

Through a combination of a traditional romantic approach to nature and a modern scientific one, Moran was presenting a synthesis of his experience in his great picture. In this he was not unlike the surveyors whom he accompanied. In their transformation of expanses of rocks, water, and miles of ground into readable charts, maps, and diagrams rep-

resenting the summation of an area, the surveyors were providing a means of perceiving the totality of the land. The significant difference between their activity and Moran's work is that the surveyor's most important consideration was the transposition of the true proportions of geological and geographical relationships. Moran was truthful in his details, but he adjusted the relationship of the parts to unify his effect and initiate his viewers. Like a surveyor, however, Moran was attempting a visual appropriation; by compiling a series of views into a single image, he was imparting a sense of place. This act, with the manipulative component that contributed to the image's success, has direct correspondence to the great concurrent event, the formation of Yellowstone National Park.

THE RECREATION OF YELLOWSTONE: COALITION OF GOVERNMENT, INDUSTRY, AND ART

Despite the interest in Yellowstone in 1871, the national park might have been forever lost as a mere idea had the cause not been adopted by the one man who had the power to see it realized, Ferdinand Hayden. Hayden's connections with the Department of the Interior and the scientific community, his experience in lobbying Congress, his intimate knowledge of Yellowstone, and his ready access to the maps, photographs, and drawings of the region made him a perfect spokesman for the legislation. Even with all his efforts though, this important national act did not come about from the work of one man alone. While Yellowstone Park is today the best known of all

the national parks, its origins with a coalition of government, private corporations, and artists are not generally well understood. Through their collective efforts the region became popularly known and its legendary status was made factual, but also, and perhaps equally important, it was transformed from a remote hell on earth into America's wonderland in the public imagination. The change was facilitated by Moran's art, and conversely, it dramatically brought the painter and his work into public view.

Nathaniel Langford, author of the first *Scribner's* article on Yellowstone, Montana judge Cornelius Hedges, and Hayden all claimed in retrospect to have been the first to conceive of setting aside the area as a public preserve, but the idea may have actually originated with a far more intriguing source. On October 27, 1871, Hayden was sent a letter from financier Jay Cooke's Northern Pacific Railroad office in Philadelphia: "Judge Kelley has made a suggestion which strikes me as being an excellent one, viz.: Let Congress pass a bill reserving the Great Geyser Basin as a public park forever—just as it has reserved that far inferior wonder the Yosemite valley and big trees. If you approve this would such a recommendation be appropriate in your official report?" Judge Kelley (also known as Pig Iron Kelley for his domination of iron and steel legislation) was United States Congressman William Darrah Kelley of Pennsylvania, and it was Jay Cooke, along with *Scribner's,* who had subsidized Moran's first trip to Yellowstone. Kelley was a strong supporter of railroads, particularly the Northern Pacific, whose Philadelphia financiers, Jay Cooke and Company, he obviously knew well. The con-

gressman was, in fact, one of Cooke's most influential advocates and had even given an address on his behalf, "The New Northwest: The Northern Pacific Railway, in Its Relations to the Development of the Northwestern Section of the United States." In his talk, which expounded the northwestern railway's virtues, Kelley asserted that Yellowstone's attributes not only exceed "those of Niagara and the geysers of California, but rival in magnitude and extraordinary combination those of the Yo Semite, the cañons of the Colorado and the geysers of Iceland." Kelley's interest in creating a major tourist attraction that would be exclusively served by the Northern Pacific was certainly linked with his desire to foster the railroad industry and also one of his most important constituents, Jay Cooke. The banker probably approached Hayden with the idea because his lobbying efforts would be less controversial than if Kelley attempted to introduce the bill to Congress.[37]

Cooke was quick to make sure that the proposed park would benefit the railroad. Three days after writing Hayden, he wrote his engineer in Montana who was planning the main line:

It is proposed by Mr. Hayden in his report to Congress that the Geyser region around Yellowstone Lake shall be set apart by government as a reservation as park, similar to that of the Great Trees & other reservation in California. Would this conflict with our land grant, or interfere with us in any way? Please give me your views on this subject. It is important to do something speedily, or squatters & claimants will go in there, and we can probably deal much better with the government in any improvements we may desire to make for the benefit of our pleasure travel than with individuals.[38]

The reply affirmed the potential profit to the railroad, and Cooke immediately called Nathaniel Langford to Washington to assist in lobbying for the bill.[39] Langford's familiarity with the region was already well known from his publications and lectures following his visit there in 1870, but he was also affiliated with the Northern Pacific, and it was for his loyalty to the industry that Cooke called on him. The Northern Pacific's involvement in promoting Yellowstone National Park, through the legislation and beyond, was primary to both the region's development and that of the railroad. The company identified itself as "The Yellowstone Park Line" for the next half century, and its early investment in what it termed "Wonderland" proved to be one of the most important in its corporate history.

The progress of the park bill has been thoroughly explored by Yellowstone historians, most recently Aubrey Haines and Richard Bartlett, and its full complexity falls beyond the scope of this study.[40] As with the original idea for the park, a number of people claimed credit, ex post facto, for leading the legislation, but it seems clear that its passage was a collaborative effort of several congressmen—some with territorial interests, others with industrial ones (such as Kelley)—and influential individuals such as Hayden and Langford. It is, however, generally agreed that some of the credit must be given to William Henry Jackson's photographs and Moran's illustrations and watercolors, which Hayden showed to the legislators before the final vote.

Each member of the Senate and House Land committees was visited personally by Langford, Hayden, or Montana delegate William

H. Clagett. There is no doubt that Hayden distributed Jackson's photographs, although the rumor that they were bound in folio volumes and embossed with the recipient's name in gold seems unlikely. Hayden also took with him "curiosities" from different parts of the park and displayed them in the Capitol and at the nearby Smithsonian. Although these exhibits seem not to have been enumerated in the official records or in private correspondence, they certainly included photographs, sketches, maps, and other visual material.[41]

To help the cause Hayden arranged to have four hundred copies of Langford's 1871 *Scribner's* article (complete with Moran's illustrations from Trumbull's and Moore's sketches) distributed to the legislators. He also wrote a popularizing piece of his own that appeared in the magazine during the lobbying period, in February 1872, and he requested that copies be sent to key political dignitaries.[42] It too was illustrated by Moran, this time drawn from his own sketches from the 1871 trip. The first view in the article, *The Great Cañon and Lower Falls of the Yellowstone* (fig. 38), seems to be a glimpse of his great painting in progress; its awkward composition may reveal his initial conceptions for the finished oil.

Moran scholars have long agreed that the artist's watercolor sketches were among the curiosities shown to the congressmen in the lobbying process, but invariably they have lacked irrefutable evidence to support the supposition. Indeed, the congressional records fail to mention Moran's original work, no revealing letter from either Hayden or Moran has turned up, and most contemporary news reports comment only on Jackson's photographs. The only convincing citation until now has been Jackson's remark from 1929: "Moran has been the greatest painter of the Yellowstone, and it was his wonderful coloring, in pictures of canyons and hot springs, that made the convincing argument for their preservation for the benefit of all posterity."[43] Jackson later added, "Back in Washington, that winter of 1871–2, in the proceedings before Congress for the creation of the Yellowstone National Park, the water colors of Moran and the photographs of the Geological Survey were the most important exhibits brought before the Committee."[44] Despite Jackson's certainty about the facts, his comments were written fifty-seven years after the event and thus are subject to skepticism. But one contemporary article in *Harper's Weekly,* previously overlooked in the search for mention of Moran's work, does remark on "the original sketches" and admires their "brilliancy" of color. It seems clear that the writer was referring to Moran's watercolors:

A Bill of importance has passed the House of Representatives and will undoubtedly become a law. . . . Those who had been so fortunate as to see the original sketches by the artists who accompanied Dr. Hayden know how very beautiful as well as interesting the phenomena of the region are. . . . The mineral deposits from these springs [the geysers] adorn the region with a splendor of color and effect which is wholly unparalleled, and which can only be suggested by the brilliancy of the sketches taken upon the spot, and which are described with enthusiastic fidelity by Dr. Hayden in the *American Journal of Science and the Arts.*[45]

Although the writer seems to have been mistaken about Hayden's discussion of the drawings in the scientific journal, this commentary finally resolves that Moran's watercolors were

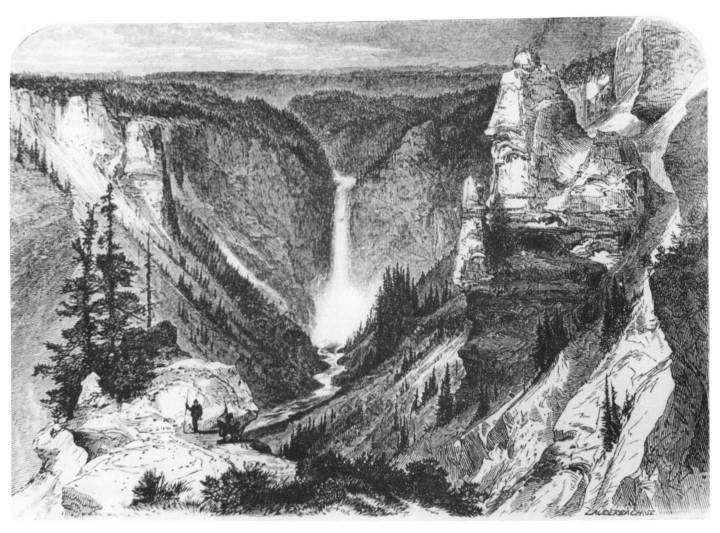

Fig. 38. Thomas Moran,
*The Great Cañon and Lower
Falls of the Yellowstone,* late
1871, wood engraving, 4⅜
× 6⅛″ (11.1 × 15.5 cm).
From *Scribner's Monthly*
3(February 1872):388.
Courtesy of the Library of
the National Museum of
American Art and the Na-
tional Portrait Gallery,
Smithsonian Institution.

indeed among Hayden's exhibited material and they played an important role in the passage of the Yellowstone Park Bill.[46]

The nationalistic implications of setting aside such a vast and remote tract of land "as a public park or pleasuring-ground for the benefit and enjoyment of the people" were not lost on either the individuals involved in the bill's passage or the popular press.[47] The rhetoric of the congressional debates and contemporary newspaper and magazine reports reveals that the first national park was understood as more than a novel idea for conserving a remarkable region; it had potential as a national symbol, a natural icon that would express the richness and uniqueness of America. In its announcement of the new park the day after the bill's passage by the House of Representatives *The New York Times* reported: "Perhaps, no scenery in the world surpasses for sublimity that of the Yellowstone Valley; and certainly no region anywhere is so rich, in the same space, in wonderful natural curiosities. . . . It is far from unlikely that . . . strangers may flock thither from all parts of the world to drink the waters, and gaze on picturesque splendors only to be seen in the heart of the American Continent."[48]

The journalists' and legislators' knowledge of Yellowstone was, for the most part, limited to what had been presented in the energetic lobbying campaign, and it is curious that nearly all accounts after February 1872 contain detailed descriptions of the wonderful scenery, as if the authors were personal witnesses. Their reports are written in overwhelmingly visual terms, usually in tones of reverence and awe, and the place is described not as the hell on earth that it had been considered even as late as the early spring but instead as a wonderland. By providing a way to visualize the region, Moran and Jackson's art had contributed to the park bill's speedy approval and dispelled disbelief, and it also suggested a vocabulary for describing the area and a way of attaching nationalistic significance to a place most Americans had never seen. This identification has, of course, persisted to the present. The visual information brought back from the 1871 Hayden expedition did not just contribute to that important aspect of America's self-definition; in the case of Yellowstone National Park it created it.

The concept of the national park as a natural American icon was perhaps most effusively presented in *Scribner's Monthly.* In an editorial in May 1872, editor Richard Gilder enthusiastically proclaimed:

We may rejoice at any measure tending to encourage the practice of doing our own pleasuring within our own borders. The recent Act of Congress concerning a singularly picturesque tract of land known as the Yellowstone region, will call attention to the unexampled richness of Montana and Wyoming Territories as a field for the artist or the pleasure tourist while it aims to ensure that the region in question shall be kept in the most favorable condition to attract travel and gratify a cultivated and intelligent curiosity. . . . Why should we waste ourselves in unpatriotic wonderment over the gorge of the Tamina or the Via Mala, when Nature has furnished us with the Grand Cañon of the Yellowstone, in which the famed Swiss ravines would be but as a crevice or a wrinkle? Why run across the sea to stifle and sneeze over the ill odors of Solfaterra, when we can spoil our lungs or our trowsers to better effect, and on an incomparably larger scale, with the gigantic boiling springs and geysers of Montana? And why strain and stiffen our backs in staring up

at Terni or the Schmadribach, which are but as side-jets and spray-flakes to the Titanic majesty of Wyoming Lower Falls?

Of the detailed wonders which we here only hint at, no reader of our Magazine for the last year or two will need to be reminded. It will not be forgotten that along with our descriptions and illustrations of this curious tract, the suggestion was made which has been carried out in the recent action of Congress. . . . When the North Pacific road, as we are led to hope will be the case, drops us in Montana in three days' journey, we may be sure that the tide of summer touring will be perceptibly diverted from European fields. Yankee enterprise will dot the new Park with hostelries and furrow it with lines of travel. That the life will for some time to come be frightfully rough, the inconveniences plentiful, and the dangers many and appalling, is likely enough. But that is just the spice which will most tickle the palate of our adventurous tourists and men of science.[49]

In addition to his use of imagery, Gilder's commentary reveals several significant aspects of the contemporary understanding of Yellowstone that are pertinent to Moran's relationship to the region. The most obvious is Gilder's promotion of the park for nationalistic and altruistic purposes. For him Yellowstone is a massive place of supernatural "wonders," set aside for the people's pleasure, and for both reasons it should be a focus of patriotic pride. That was the emphasis of Congress in its wording of the actual law, and it was a major theme of much of the early publicity about Yellowstone.

But along with its overtly philanthropic tone, Gilder's rhetoric suggests another line of reasoning, one more subtle but equally revealing in the way the park was perceived even as it was being created. In his references to the "Yankee enterprise" that would "dot the new Park with hostelries and furrow it with lines of travel," Gilder indicated the concurrent purpose for Yellowstone National Park. The capitalists (Jay Cooke and Company, and *Scribner's* itself) that underwrote some of the early exploration of the region (such as Langford's role in the Washburn-Doane expedition and Moran's trip with Hayden) and facilitated much of the legislative process understood Yellowstone as a place for profit rather than for scenic preservation or scientific research. For them the act of Congress was not to conserve the wonders, as is widely believed about the national parks today, but rather to attract people and their money to a tourist resort. The Northern Pacific Railroad, with its monopoly on train travel to northwestern Wyoming, had a vested interest in securing Yellowstone as a national attraction, and *Scribner's* was already profiting from its position as the exclusive popular publisher of images and information about the place. Indeed, corporate interest in Yellowstone not only facilitated the area's exploration and visual documentation but was also largely responsible for its designation as a national park and the transformation in the way the area was perceived. These acts, while of inestimable importance for the American public, would bring even larger profits to the private instigators. This corporate involvement was, as we shall see, also of primary importance to Moran's art.

President Ulysses S. Grant signed the Yellowstone park bill into law on March 1, 1872, and just three months later Congress purchased Moran's painting *The Grand Cañon of the Yellowstone*. In a number of sources the image has been credited with influencing the passage of the park bill, but as it was not com-

pleted until the end of April, after the law was passed, except in its woodcut form in Hayden's February article, it could not have influenced the congressional vote.[50]

Moran began the painting several months after he returned from Yellowstone in the fall of 1871.[51] He gave periodic progress reports to Hayden and in March indicated his desire for scientific criticism:

I cannot feel confident about it [the canyon painting] until *you* have seen it. In fact I cannot finish it until you have seen it, as your deep knowledge of nature and her workings would make your judgment on the truths of the picture of far greater value to me than that of any other man in the country. Your knowledge of cause and effect in nature, would point out to me many facts connected with the place that I may have overlooked, and if your duties or time would allow you to come and see the picture you would add another to the many great obligations I am under to you.[52]

He wrote again in April, saying that the painting would soon be finished but that he was "particularly anxious" for criticism of his geology.[53] Hayden apparently complied and later publicly testified to the painting's accuracy. As Moran anticipated, that was necessary to dispel skepticism; early viewers were dubious of the painting's color at the same time that they admired its visionary scope and technical virtuosity.[54]

On May 2 Moran unveiled his great canvas in New York at Leavitt's Art Rooms in Clinton Hall for a one-night showing that was apparently funded by *Scribner's* magazine. Significantly, the opening was attended not only by the publishers and editors who had supported Moran financially on his trip and in his illustration commissions but also by Hayden and

several prominent officials of the Northern Pacific, Moran's other patron. Just two months after the passage of the park bill, for which all these influential men had worked, this occasion must have been one of celebration and self-congratulation, with the magnificent painting as its centerpiece. In a letter written just before the opening, Gilder suggested the mood to Hayden and emphasized the importance of the event: "We have engaged Clinton Hall (Leavitt's Room, Astor Place, Mercantile Library Building) for Thursday evening, May 2nd. You *must* be here. The Northern Central [Pacific] people, the press—the *literati,* the artists—the rich people—will all be out in full force—we want to make a big strike! And we want you to answer questions and be one of the heroes of the night! I hope Gifford will be there—Why not bring your wife and make a grand spree of it! Write to me and say yes!"[55]

Although he had invited Sanford Gifford (who had accompanied Hayden in 1870), the artist was unable to attend. Gifford's comments to Hayden afterward, however, indicate the esteem with which Moran's work was regarded by the artistic community:

I was . . . very much disappointed that I was not able to see the picture—I returned to New York on Saturday of the week it was shown and immediately went out to see it, but was informed that it had just been sent or was just about to be sent to Washington. I was very sorry indeed to miss seeing Mr. Moran's work, which I have been told by very good author (Mr. [Gabriel] Munger who was with Clarence King several seasons) is excellent not only for its local truths, but as a work of fine art—I wanted very much to see an authentic picture of the remarkable region you describe so graphically.[56]

The New York showing was primarily for publicity and, as Gifford noted, Moran immediately shipped the painting to Washington hoping it would be seen and desired by members of Congress. On May 24 Moran wrote to Hayden asking him for the favor of his influence on Capitol Hill:

Since you were here before, I have succeeded in getting the picture placed in the old Hall of Representatives, and it has created quite a sensation there. It was quite evident that it was useless to continue its exhibition at the Smithsonian, so far as getting Congressmen to see it was concerned. Many of the members have expressed the opinion that Congress should purchase it. . . . Now the members have nearly all seen it, and the only thing remaining to be done is to bring the matter before the Joint Committee of Congress on the library, to find if they will introduce a resolution to that effect. I asked Dawes what he thought of the chances, and he made a favorable reply. Your assistance towards this end would be most valuable. I want your immediate influence with Dawes and Garfield in order to bring the matter before the House Committee, of which Mr. Peters is chairman, the other members being Wheeler and Campbell. . . . Whatever movements I make to bring it before Congress must be done immediately as so little of the session remains.[57]

Moran's political maneuvering was finally rewarded when Congress's Joint Committee on the Library agreed to purchase the painting, and the picture hung in the Senate wing until 1950, when ownership passed to the Department of the Interior.[58]

The Grand Cañon of the Yellowstone was the largest painting Moran had ever attempted, and in all of his correspondence he called it his Big Picture, a name as appropriate symbolically as it is amusing. Into this one painting Moran poured all his abilities, aspirations, experiences, and ideals. He revealed his concern for these matters in a surprisingly eloquent letter to Hayden in early March 1872:

The picture is now more than half finished and I feel confident that it will produce a most decided sensation in art circles. By all Artists, it has heretofore been deemed next to impossible to make good pictures of Strange and Wonderful Scenes in nature; and that the most that could be done with such material was to give topographical or geologic characteristics. But I have always held that the Grandest, Most Beautiful, or Wonderful in Nature, would, in capable hands, make the grandest, most beautiful, or wonderful pictures, and that the business of a great painter should be the representation of great scenes in Nature. All the characteristics attach to the Yellowstone region, and if I fail to prove this, I fail to prove myself worthy [of] the name of painter. I cast all my claims to being an Artist, into this one picture of the *Great Cañon* and am willing to abide by the judgement upon it.[59]

With that statement Moran came as close as he ever did to revealing his aesthetic philosophy and feelings about the West. From it we can gather that he did regard the fantastic scenery there to be the most exciting he had ever encountered, and he rationalized that if properly treated, the visual translation could be the culmination of an artistic genre. He also revealed that he considered himself worthy of the task as few other artists were, and thus all but pronounced himself the visual spokesman for the western survey effort. With such a picture that embodied his grandest aspirations, and the recent success of the park bill still fresh, it is not surprising that Moran approached Congress with the idea of its purchasing the work, and it is equally appropriate that it did so.

The Grand Cañon of the Yellowstone's novelty,

virtuosity, and complex associations allowed it to stand apart as an exemplar of painting, even by comparison with the so-called machine canvases of Albert Bierstadt and Frederic E. Church. In a review of the picture in June 1872, Gilder proclaimed it "the most remarkable work of art which has been exhibited in this country for a long time," and it was highly praised as a "magnificent tribute to American Scenery" by critics in leading newspapers and magazines.[60] And yet, the painting's formal qualities and the perception of Yellowstone as "the place where hell bubbled up," which dominated reports until just before the picture's unveiling, would seem to challenge such positive interpretations. The work depicts a giant hole, not a soaring mountain vista such as Bierstadt would paint, nor is it an overtly didactic nationalistic view such as Asher B. Durand's *Progress* (1853, Gulf States Paper Corporation, Tuscaloosa). It seems that Moran's manipulation of formal elements of the scene, his provision of identifiable objects and reassuring references to a more familiar landscape tradition, coupled with the transformation in popular attitudes toward the place that accompanied the park bill, succeeded in permitting the painting to be accepted as the paradigmatic image of the new wonderland.

Besides the contemporary reviews of the work, this interpretation is verified in early accounts of the park itself. Guidebooks of the 1880s presented the canyon as an embodiment of the spirit of the entire national park, and in describing the scene writers invariably referred not just to the natural setting, which many of them had never seen, but implicitly to Moran's more accessible image. As an ex-ample, a typical guide from 1888 ostensibly describes the place but instead seems to refer to the painting, because it mentions elements that are more prominent in the painting than in nature and also because of its continual use of exclusively pictorial metaphors and references.

[Nothing can compare with] the impressive beauty of the marvelously pictured rift through which the Yellowstone winds its way after its last grand leap. A narrow trail runs along the western edge, and there are many jutting points from which new vistas are opened through this enchanted land. The walls are in places perpendicular, though generally sloping; while at the bottom is the fretted and fuming river, a ribbon of silvery whiteness of deep emerald green. Along the bottom of the cañon are domes and spires of colored rock, some of them hundreds of feet in height, yet reduced to much smaller proportions by distance. On the apex of one of these pillars is an eagle's nest. In one place, near the top, a great rock spire, twice as high as the Trinity steeple, has split away from the mass of rock behind it, and seems to be ready to topple over into the abyss at any moment, so insecurely is it poised on the shallow shelf beneath. But the gorgeous coloring of the cañon walls is its distinguishing feature. The beholder is no longer left in doubt as to the reason for bestowing the name of Yellowstone upon this remarkable river. The beautifully saffron-tinted crimsons and greens are seen with all their gradations and blendings. Emerald mosses and foliage form the setting for dashes of bright rainbow colors. The yellows, due to sulphur deposits predominate; but the oxidation of iron through the many hot springs which send up their clouds of steam even here, provides a liberal sprinkling of reds. It seems as if a gorgeous sunset of a shattered rainbow had fallen into the abyss. With the grand grouping of crags and pinnacles, tinted walls, and the beautiful falls, the picture is one that once seen can never be forgotten.[61]

At the end of the passage the writer finally gives up all pretense of describing an actual location and calls the scene a picture. Ironically, following the lengthy exposition, a final caveat concedes that only a trip to the site can ever provide a full sense of the view's richness. Like the familiar shortcomings of language, even the best paintings are limited when compared with actual experience:

Language is but a clumsy thing with which to paint the glories of this wonder-place. The richest pigments of artists of largest fame have failed, and while men have smiled at the flaming canvas and said, "It is impossible," the baffled painter has grieved that his poor brush had failed to tell half the story of this exceeding loveliness.[62]

Although this commentary is exceptionally critical of Moran's efforts and assumes a great deal about the artist's feelings on the subject, it does refer specifically to the painting in a discussion supposedly about the place. Since the travel booklet's sole aim was to entice people to visit Yellowstone and not just look at the painting, it seems particularly significant that even for writers who purportedly had access to the park, Moran's painting was a better embodiment of the site and its symbolic and nationalistic implications than was a reference to the actual location.

A final confirmation of the richness of Moran's picture is found in the perceptive 1872 review by *Atlantic Monthly* critic Clarence Cook. After his discussion of the painting, in which he ranked Moran's picture second only to Church's *Niagara,* Cook concluded with the familiar nationalistic refrain, but with a revealing twist:

Perhaps, also, [the painting] appeals a little to the pleasure we all may have, and not be ashamed of it, in the fact that this wonderful place is not merely a bit of the continent, but is indeed, the private property of every man, woman, and child of us, being in the very middle of that generous tract of 3,578 square miles which by the energy and persistence of Professor F. V. Hayden, backed by good men and true in both Houses, . . . has been set apart forever as a public park for the people of the whole United States to walk abroad and recreate themselves.[63]

Cook's wording of his final line, that Yellowstone represented a chance "for the people of the whole United States to walk abroad and recreate themselves," seems particularly insightful. Yellowstone was not just a place of recreation but of re-creation, where things could be reshaped, reseen, and remade. Moran's painting represented no less an opportunity; in its summation of complex artistic conventions, personal experiences, and cultural events, it was a focal point around which Americans could re-create themselves, just as Yellowstone itself had been re-created.

4

THE NORTHERN PACIFIC RAILROAD

As we have seen, Moran accompanied Hayden's survey not as a government employee but as a guest. He assisted in the fieldwork and contributed landscape views to the official reports after the season's conclusion, but his presence in Wyoming that summer was purely a matter of courtesy, a response to a request to include him by the Northern Pacific Railroad and *Scribner's* magazine. Their patronage was vitally important to Moran's career and to the popularization and development of the West in the last half of the nineteenth century, and their involvement exemplifies much about that period of great cultural change in America.[1]

After the Civil War, with vast holdings of land and limited capital, American railroads energetically promoted the attributes of the regions through which their lines ran to entice investment and clientele. Their motivation was obvious; stockholders, passengers, and freight increased the railroads' income and the value of their sizable land grants. Their methods were elaborate, involving intense lobbying in Washington for better subsidies, making travel affordable to large numbers of Americans and immigrants, and extensively researching the agricultural, commercial, recreational, and cultural opportunities provided by their routes. Collectively the railroads launched some of the most extensive publicity campaigns of the century, calling for cooperation from a variety of resources including the powerful publishing industry and the federal government. In addition to advertising the appeal of western land, railroads became their own travel agents, publishing pamphlets, posters, and booklets that they distributed freely to the public. Although many of these advertisements were typographical in form, a number of them, especially in the last decades of the nineteenth century and in the early years of the twentieth, were illustrated to entice travelers visually. In the face of stiff competition, railroad managers recognized the value of showing their clients the land along their routes, and scenic views were the best means of doing that.[2]

In those and other ways railroads helped transform the West from a little-known, even feared, place considered unsuitable for polite society to one sought by thousands of settlers and enthusiastic tourists clamoring to visit the most remarkable parts of America. Moran's work was an integral part of the process, and his relationship with the railroad industry reveals much about his art and the change in the West's reputation.

One of Moran's two patrons of his first western experience, the Northern Pacific Railroad, was one of the most innovative railroad promoters. Although in 1871 only a small

portion was complete, track was planned all the way from Minnesota to Puget Sound along a line that included the Yellowstone valley, and the company was already aware of the area's potential for profit. It courted, for example, the noted journalist Samuel Bowles, author of the important guidebook *Across the Continent* (1866), for his advertising ability. Both Frederick Billings, chairman of the railroad's land committee, and Northern Pacific president J. Gregory Smith wrote Cooke several times of Bowles's usefulness. Billings proposed to send the writer on a trip along the Red River, saying, "Have had a long talk with Sam Bowles . . . to get him interested in the enterprise in every way. . . . Bowles is a power."[3] Smith further suggested that the journalist should be given $10,000 worth of railroad bonds and said, "From this time forth he is a warm friend of our road and is ready to publish anything that we desire. . . . We must help him. . . . This is a great point gained. He is a power."[4] It is unclear what became of the relationship, but the administrators' enthusiasm for Bowles's favors suggests that their concurrent involvement with Moran was based on the same desire for publicity.

At the same time the Northern Pacific's interest in Yellowstone itself was intensifying. Almost immediately after Jay Cooke took charge of the railroad's finances in 1869, the railroad publicly expressed its alliance with the region in a pamphlet that effusively reveals its motives.[5] Of the Yellowstone valley, it exclaimed:

Some valleys are beautiful. *This is grand.* It abounds in magnificent scenery, most excellent farm-sites and water-powers. The soil is very rich and fertile, timber very convenient, coal and iron

cropping out in abundance at different points, and at others evidence of rich deposits of copper, which the surrounding mountains are full of, and gold and silver-bearing quartz. In addition to this—if the Road is built in this valley, it will settle up so rapidly, and the whites will be in such force, that the Indians will be driven out of the Big Horn and Wind River valleys and mountains, and we shall thus have easy access to a section of country which, if half the tales told by mountaineers, explorers, and even Indians, are true, is teeming with gold and silver.[6]

Produced before the first substantive reports of the Yellowstone, this account is, of course, exaggerated and overtly propagandistic, but it indicates the region's value to the line and the need for objective confirmation of such accounts. The ambitious Cooke realized that Hayden's survey could be useful for obtaining that information and, equally important, for providing the pictorial documentation that would be a real advantage in substantiating his company's claims to prospective investors.

Moran's first letter of introduction to Hayden, written by A. B. Nettleton, Cooke's office manager, indicates the railroad's interest in the artist and the implicit relationship between the survey and the railroad:

My friend Thos. Moran, an artist of Philadelphia of rare genius, has completed arrangements for spending a month or two in the Yellowstone country, taking sketches for painting. He is very desirous of joining your party at Virginia City or Helena, and accompanying you to the head waters of the Yellowstone. I have encouraged him to believe that you would be glad to have him join your party, and that you would in all probability extend to him every possible facility. Please understand that we do not wish to burden you with more people than you can attend to, but I think that Mr. Moran will be a very desirable addition to your ex-

pedition, and that he will be almost no trouble at all, and it will be a great accommodation to both our house and the road, if you will assist him in his efforts. He, of course, expects to pay for his own expenses, and simply wishes to take advantage of your cavalry escort for protection. You may also have six square feet in some tent, which he can occupy nights We shall be pleased to receive occasional letters from you, telling of your expedition, your discoveries, your opinion of things, etc. and if there is any way in which we can serve you, be sure to let us know.[7]

The letter that Moran carried with him to the West contains more information: "Mr. Moran is an artist (landscape painter) of much genius, who desires to take sketches in the upper Yellowstone region, from which to paint some fine pictures on his return. That he will surpass Bierstadt's Yosemite we who know him best fully believe. He goes out under the patronage of Messrs. Scribner's & Co., Publishers, N.Y. and our Mr. Cooke on whom (as well as himself) you will confer a great favor by receiving Mr. Moran into your party when you start for the Yellowstone country."[8] Hayden's willingness to accommodate another individual on an already crowded trip, and this one an artist completely lacking in useful skills (Moran had never even ridden a horse), was certainly due in part to his own ambition. He surely conceived of using Moran's work for publicity and higher appropriations for his next season, but his acquiescence may also have resulted from a mutual agreement with railroad companies. The organizations were beneficial to each other; survey crews used the railways to move personnel and equipment, and the railroads profited from the information gathered by the explorers and from publicity of their work along the lines. Indeed, the

Union Pacific and Central Pacific railroads provided free transportation to Hayden's survey (the Northern Pacific was unfinished). Early in 1871 the Northern Pacific land commissioner arranged with the U.S. General Land Office for access to all the government survey information, and although Hayden was probably instructed to share his findings, he would likely have done so anyway.[9] Nettleton's letter on Moran's behalf makes it clear that Hayden's accommodation of the artist would be a "great favor" to Jay Cooke and the railroad, and the survey leader was always pleased to have such powerful forces in his debt.

Among his other duties, Nettleton was in charge of advertising Cooke's organization.[10] Since he and Cooke were both Philadelphians, it is not surprising that they would have known one of the city's most prominent landscape painters. Moran's conception of grandeur in landscape, already noticeable in his work of the 1860s, was surely not lost on these corporate magnates eager for a medium by which to strengthen their western enterprises. Indeed, their motivation was not lost on the press either; a reporter noted in the *Helena Daily Herald* on July 11, 1871, that Thomas Moran's presence in the Yellowstone area was "directly in the interest of the N.P.R.R. Company."[11]

The railroad also knew of Moran's potential from his illustrations in Langford's two-part *Scribner's* article from May and June 1871. The text acknowledged the Northern Pacific's connection with the area and concluded with a plug for the line: "By means of the Northern Pacific Railroad, which will doubtless be completed within the next three years, the traveler will be able to make the trip to Mon-

tana from the Atlantic seaboard in three days, and thousands of tourists will be attracted to both Montana and Wyoming in order to behold with their own eyes the wonders here described."[12] The article was published just before Hayden's party was to leave for Yellowstone, concurrent with Nettleton's letters introducing Moran. Langford may have suggested the artist to Cooke; he had gotten to know Moran while preparing the publication, and he wrote the banker in March, just after a discussion with his editors:

I wrote you this favour from paper in Scribner's & Co. office. Scribner & Co. are very much afraid that the engravings may be copied—they say that an artist could easily copy [them]. . . . They will send the engravings that appear in the May number, and soon after, the others.

In order to guard against unlawful copying, they have suggested that if the artist who drew them on wood, Mr. Moran on Norwich Street, can do your work as well as anyone else, it would ensure their safety to place them in his hands.[13]

This seems to suggest that Cooke wanted the illustrations for a railroad publication and had asked *Scribner's* to share the engravings. The need for the artist's involvement is unclear; perhaps Cooke required modifications to the woodblocks. In any event, Moran's name was obviously introduced to the railroad four months before Hayden's expedition and in a different context from simply Nettleton's friendship.

Langford was another publicity man courted by the Northern Pacific. Among the least-known aspects of his career, it parallels in some ways Moran's association with the industry. He had campaigned for Montana Territory governor in 1869, had helped organize the Washburn-Doane expedition to Yellowstone in 1870, and was the brother-in-law of two prominent collaborators of the Northern Pacific, Minnesota governor William R. Marshall and James Wickes Taylor. Doubtless it was through them that Langford first became aware of the opportunities presented by an alliance with the company.[14] From 1869 through at least 1872 Langford was subsidized by Jay Cooke and Company, discreetly employed to publicize the West and increase the value of the railroad's land assets.

In his diary of June 1870 Langford cited meetings with Cooke that may have been employment interviews, and he promptly returned to Montana to assist the Washburn expedition, an indication that Cooke had recommended the action and perhaps promised Langford favors for doing so.[15] A few months later he began to write up his experiences and soon became a speaker on the lecture circuit, gathering large crowds with his firsthand accounts of the wonders of Yellowstone. His eastern lectures on the subject, given in Washington (with Hayden in attendance) and New York in January 1871, were overtly propagandistic for the railroad. Langford concluded his remarks with:

What, then, is the one thing wanting to render this remarkable region of natural wonders, accessible? I answer, the very improvement now in the process of construction, the Northern Pacific Railroad, by means of which, the traveller crossing the rich grasslands of Dakota will strike the Yellowstone a short distance above its mouth, traverse for 500 miles the beautiful lower valley of that river with its strange scenery, and will be enabled to reach this region from the Atlantic seaboard within 3 days and can see all the wonders I have here described.[16]

Correspondence between Langford and Cooke indicates that the performances were highly orchestrated by his employers. Cooke instructed a secretary that January to summon Langford to Philadelphia to discuss his eastern tour.[17] Langford's reply reiterated his belief that Yellowstone would be sought by "thousands of tourists" who would ride the railroad, and he requested guidance for the content of his speeches:

Please write me on receipt of this, what you especially desire me to do—the nature of the lectures to be given—the principal points to be presented—where delivered, etc. I ask to be advised . . . that I may assure myself that I can serve the RR Co. as well as its officers and friends whom I have met in New York seem to think I can. And I should be very glad to deliver my lecture on the "Wonders of the Upper Yellowstone" in Philadelphia, that you may the better judge my fitness for a field so new to me. Can arrangements be made under the auspices of any of your Lecture Associations?[18]

In May 1871, Langford presented his remarks at Ogontz, Cooke's Philadelphia estate. In later months he served as a principal lobbyist for the Yellowstone legislation and represented the railroad's interests most effectively. Finally, in May 1872, only two months after the bill's passage, his loyalty was rewarded when he was appointed the national park's first superintendent, a position he used to facilitate railroad development of the area.[19]

Langford's involvement with the railroad and *Scribner's* magazine strongly suggests that Thomas Moran's relationship with those organizations was based on a similar agenda. Although the money that Moran received from Cooke and Company and *Scribner's* to make his trip was in the form of a loan, it is likely that it was given with the implicit understanding that Moran would return East and produce works of art that would, in their portrayal of the West, contribute to the profits of the corporations. This is substantiated by Moran's comment that it had not occurred to him until afterward that the magazine should have financed him.[20] Perhaps he had not been astute enough at the time to transact actual employment, but the illustrations the magazine commissioned from him after his trip were certainly enough to make him realize that *Scribner's* was, in fact, sending him to do its work. Less obvious to him perhaps was the benefit he was providing the railroad, but it seems clear that the railroad's involvement was no less direct.

The $500 Moran received from Jay Cooke and Company was apparently paid back in the form of art. The artist wrote Hayden in November 1872 that he was busy with, among other things, "an order from Jay Cooke for 16 watercolor drawings."[21] Although Moran was not explicit as to whether the art was repayment of the loan or a separate commission, it is generally agreed that it was part of the original arrangement with the railroad financier.

It has always been assumed that Cooke himself was at Moran's New York unveiling of his first Yellowstone painting, *The Grand Cañon of the Yellowstone,* but Cooke's papers dispute this. The day before the opening, railroad president Smith telegraphed, "Private exhibition of Moran's picture Thursday evening at Clinton Hall Astor Place. Don't fail to come." He wrote, however, two days later, "Sorry you could not have been there last evening to see Moran's picture of Yellowstone. . . . I felt so confident that I should see you last evening at the exhibition."[22] Never-

theless, a number of Northern Pacific 'people were there, including Smith, Cooke's brother Pitt, chief engineer Milnor Roberts, and A. B. Nettleton, undoubtedly to take advantage of the gathering of "the press—the literati, the artists—[and of course] the rich people" who would all be interested in the Northern Pacific's future in the Yellowstone area, as well as to see the monumental picture that their company had helped sponsor. The debut of such a grand visual testimony to the wonders of the West, especially one the railroad had had such an important role in bringing to fruition, offered the company an excellent opportunity for publicity.

Just as Moran was finishing his Big Picture, the Northern Pacific received an opportunity to publish its first full-scale illustrated guidebook. Corporate secretary Sam Wilkeson was already the author of a short book on the railroad's route and was enamored of the Yellowstone. Not one to shy from hyperbole, he had written Cooke of its charms in December 1871: "Nearly three years ago I told you with energy and feeling that the Yellowstone Valley was Paradise. Milnor Roberts' Report is in. I am putting it into type. That will confirm and justify my wildness of appreciation; for Roberts goes *wild* over the Yellowstone and he is an older and colder man than I. Jay Cooke, feel to the ends of your toes, that we have the biggest and finest thing on this earth."[23] In the spring of 1872 Wilkeson was negotiating with Harper's and Company publishers to elaborate his first book, and he wrote again to Cooke:

The Harper's are willing to publish an elegant edition of the Northern Pacific Railroad book commonly called *From Puget Sound to Lake Superior by*

Sam Wilkeson—to do the book full justice, and to illustrate it by their very best artists with say 12 engravings of Puget Sound scenery, Columbia River scenery, the Yellowstone Geysers, and the Dakota country including views of the Yellowstone and Heart River Valleys: to make the edition 5,000 *provided* that the said Wilkeson will guarantee the purchase of 2,000 copies.

One consideration makes this a desirable offer. The illustrations and text will largely be used in the Harper's Magazine and Harper's Weekly. You will get your Road superbly advertised *for nothing* in those first mediums having a combined circulation of 350,000.

The books will cost $1.00 each—they will be so well made. If you will give that guarantee, I will take off my coat—refuse to go to Puget Sound—abandon my wife and children—and "write for my life" for the great Railroad. What do you say, Jay Cooke?[24]

Unfortunately the publication (which surely would have meant a commission for Moran, who was already working for *Harper's*) seems not to have materialized from Wilkeson's enticing offer. The Northern Pacific's lavishly illustrated guidebooks would have to wait until finances were more secure and the line farther along.

That was to be a very long time. The demise of Cooke's banking house provoked the 1873 Panic, bringing personal bankruptcy for Jay Cooke and the halt of the line until 1879, when the company was reorganized and refinanced.[25] During the interim corporate attention focused on the maintenance of existing routes and financial revival, and there seems to have been little emphasis on advertising or promotion of future work.

Although greatly diminished by Cooke's departure and interrupted by the intervening years of crisis, the railroad's interest in Yellowstone art continued. When the tracks again be-

Fig. 39. Frank Jay Haynes (1853–1921), *Northern Pacific Exhibition Car,* ca. 1895, photograph. Montana Historical Society, Haynes Foundation Collection. This is not the exhibition car of 1882, but it is undoubtedly similar.

gan moving westward from Bismarck in 1879, the company invested heavily in promoting the Yellowstone River valley as an agricultural paradise and the park as a tourist attraction. Although the line did not reach the area until 1883, articles and testimonials about the richness of the area, the wonders of the park, and the imminent accessibility by the railroad began to reappear at least as early as 1880.[26]

In 1882 a deluxe exhibition car, a "Fair on Wheels," made a tour from Minnesota through many major cities of the East in a new publicity stunt for the railroad (fig. 39). Visited by 400,000 people who carried away more than 155,000 pieces of promotional literature, the "dainty pink" museum was billed as a "Novel Exhibition" of the Northern Pacific region. Among the displayed fruits, grains, minerals, stuffed animals, timber products, and potted plants were "illustrations of Western landscapes" and stereoscopic views. The photographs included the work of F. J. Haynes, photographer for the line since 1876, but it is unclear if there were paintings or drawings of any sort. Regardless of the na-

ture of the visual material, however, the display continued the railroad's visual emphasis that Moran and Jackson had begun.[27]

The lavish display car paled by comparison with the gala event staged in 1883. Called the Villard Excursion, after railroad president Henry Villard, who was the main instigator of the affair, the railroad's first great public statement about its western wonderland was a large and brassy affair, the most elaborate celebration that money could buy. To commemorate the completion of its line, the company sponsored a luxury excursion from New York to Puget Sound, with a stop at Yellowstone, for 365 individuals invited for their influence in politics and industry. They included President Chester Arthur; former president Grant, who had, in 1872, signed the park bill into law; delegations from Germany, England, and Austria; U.S. cabinet members; and a large number of congressmen, generals, governors, and wealthy easterners. The event, called "unique in the history of the planet," featured parades, banners, bands, servants, innumerable speeches, and, finally, a last-spike ceremony in a picturesque valley near Garrison, Montana, near the northern border of Yellowstone National Park.[28]

Each passenger was given at least two guidebooks ordered especially for the opening. They were written by Henry J. Winser, Northern Pacific bureau chief and the guests' guide at the park, and the railroad distributed them in various editions for the next decade. Villard, who supervised the publications, had written his own illustrated guide to the Pikes Peak region in 1860 and was well aware of their effectiveness in promoting tourism. Indeed, in 1883 alone the railroad distributed

2,500,000 pieces of promotional literature of various sorts.[29]

Near the park entrance in Livingston, Montana, the railroad station visually proclaimed the greatness of the railroad and its association with Yellowstone. A banner on one side of the building read, "Livingston—The Gate to Wonderland," and in the ladies' waiting room (and probably throughout the station), there were at least three oil paintings of Yellowstone scenery, each 10 × 13 feet.[30] Although the artists and subjects of these canvases have not been determined, their presence at this important event is significant. Such large paintings at the opening of the popular access to Yellowstone were appropriate reminders of the role art had played since Moran and Jackson provided railroad officials their first glimpse of Wonderland and helped them obtain their most important attraction.[31]

In subsequent years the Northern Pacific invested heavily in the region to attract passengers. The first permanent accommodations at the park (most notably the Old Faithful Inn, which is still in operation) were built with railroad funds, as were a number of other "improvements." Beginning with the books Villard ordered in 1883, the railroad began to publish illustrated brochures and annual guidebooks known as the Wonderland series. By 1893 corporate identity was so closely tied to the park that the railroad adopted a new logo with the words "Yellowstone Park Line" under the company name.[32]

One Northern Pacific brochure, published in the 1890s, depicted on its full-color cover an unusual scene from the top of Tower Falls (fig. 40). The rock pinnacle at the brink of the falls is a formation known as the Devil's Hoof,

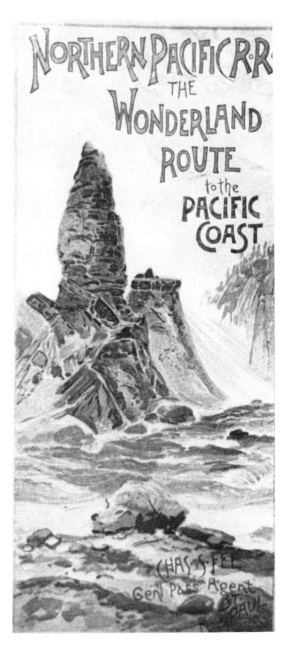

Fig. 40. Anonymous, after T. Moran, NPRR promotional brochure, ca. 1890, chromolithograph. Collection of Stanley L. Baker, Minneapolis.

named, according to Langford, for "its supposed resemblance to the proverbial foot of his Satanic Majesty."[33] The design, although redrawn by other hands, derives from Mo-

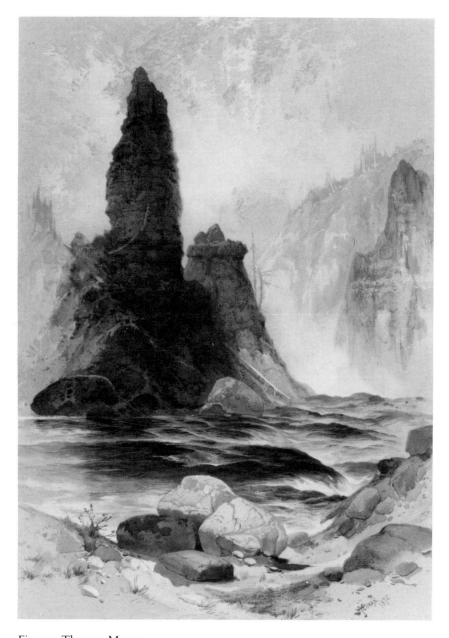

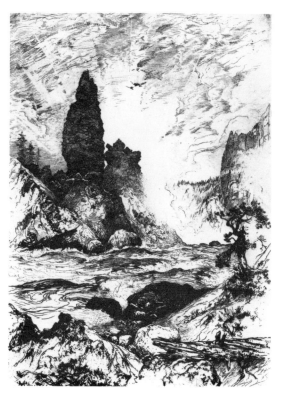

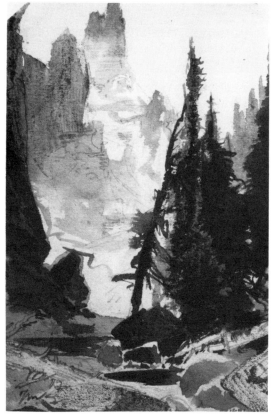

Fig. 41. Thomas Moran, *The Tower of Tower Falls* (*Canyon of the Yellowstone*), 1872, watercolor and graphite on paper, 15⅝ × 10¹³⁄₁₆″ (39.7 × 26 cm). National Museum of American Art, Smithsonian Institution, gift of Mrs. Armistead Peter, Jr. (1958.5.3).

ran's image *Tower of Tower Falls,* which he produced in several versions in a variety of media since 1872 (figs. 41–44). One of the watercolors had already been associated with the railroad as part of the series Moran made for Jay Cooke, but because of Cooke's departure in 1873 it is unlikely that his image would have been the source of the illustration.[34] The brochure's designers more probably referred to Moran's almost identical chromolithograph in Louis Prang's *Yellowstone National Park* (1876).

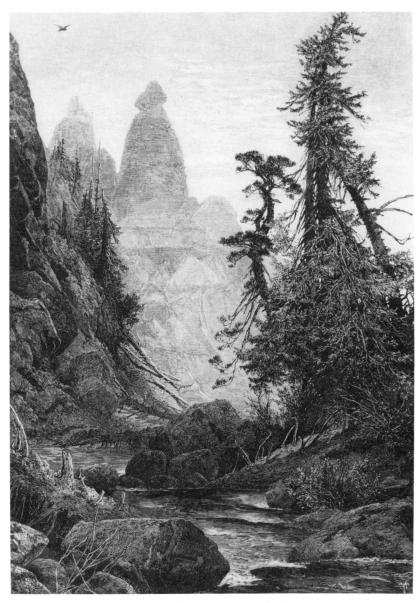

Fig. 44. Thomas Moran, *Tower Creek,* ca. 1873, wood engraving, 12¾ × 8¾" (32.4 × 22.2 cm). From *The Aldine* 6(April 1873):frontispiece. Collection of the author.

Fig. 45. William Henry Jackson, *Tower of Tower Falls,* ca. 1871, photograph. United States Geological Survey, Special Collections (Reston).

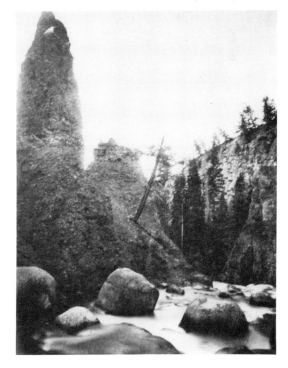

Fig. 42 (opposite, top). Thomas Moran, *Tower Falls, Yellowstone Park,* 1880, etching, 11⅛ × 7¾" (28.3 × 19.7 cm). The Thomas Gilcrease Institute of American History and Art, Tulsa, Oklahoma (1426.441); Morand and Friese no. 33.

Fig. 43 (opposite, below). Thomas Moran, *Tower Creek,* 1871, sepia wash on paper, 4½ × 6½" (11.4 × 16.5 cm). Jefferson National Expansion Memorial, National Park Service (4286).

Fig. 46. Anonymous, NPRR broadside, 1915, chromolithograph. California State Railroad Museum.

tourists and the corporations, a wonderland that promised unlimited rewards.

Although Moran's art was not used in the annual Wonderland publications, his influence on their illustrators and writers is evident. The first edition's description of the park in 1884, besides echoing previous accounts by proclaiming it "indescribable," also contains specifically pictorial terms that demonstrate the writer's familiarity with Moran's many views of the area. "Here is to be seen the most varied and lavish display of picturesque scenery. The Park unfolds a succession of pictures, each more striking than the other. There are serried snow-mantled mountains, profound cañons, mighty cataracts, verdant valleys, beautiful woods, sylvan streams, foaming cascades, and mirror-like lakes."[35] The cover of the 1897 edition depicts a fanciful scene of a long-haired nymph riding a bald eagle, its wings outstretched, framing a round moon. Below this whimsical attempt at national allegory is the great Yellowstone canyon. The landscape, while broadly rendered and brutally cropped, is a restatement of Moran's *Grand Cañon of the Yellowstone*. And in 1915, in a full-color poster, the canyon appeared as the focal point of a tastefully designed advertisement for "Pacific Coast Attractions via the Yellowstone Park Line," one of a series of railroad broadsides (fig. 46). Here again, the work is not Moran's, but the view is his composition and conception. The force of the 1872 composition as the paradigmatic image of Yellowstone National Park had not diminished and, indeed, had become one of the Northern Pacific Railroad's most important visual signatures.

With its proclamation that the Northern Pacific was "the Wonderland Route to the Pacific Coast," coupled with the prominent "Devil's Hoof," the brochure underscores the radical change in Yellowstone's reputation since the railroad's intervention. By 1890 the demonic perceptions of the place that had preceded the 1871 expedition were thoroughly transformed. Yellowstone had become, to the eager

5

THE PUBLISHING INDUSTRY

Moran's career as an illustrator was long and prolific. His early apprenticeship as a young wood engraver gave him useful background, and although he is best known for his colorful oils and watercolors, he was a dedicated commercial artist who worked equally effectively in the black and white printed media.[1] From approximately 1870 to 1885, Moran created an enormous body of published images, estimated at more than one thousand, and a great many were directly related to his work with the U.S. geological surveys.[2] Almost all of Moran's trips West were financed by commercial funding, much of it from publishers.

Late in his life Moran reflected on his career as an illustrator, saying it was a means of supporting himself and his family and stressing that commercial limitations posed "no hindrance to his art. . . . The real artist will express himself anyway."[3] He directly contradicted the prevailing critical theory that held

that reproductions, including those of even the best chromolithographers, compromised the integrity of original art. The principal advocate of this view, James Jackson Jarves, accused publishers of being little more than crass merchants bowing to the tastelessness of the middle class, even to the point of threatening the morality of American society. According to Peter Marzio, historian of the "democratic art" of nineteenth-century prints, this opinion was so widespread that the term "chromo-civilization" became a popular denigration of indiscriminate commercialism, which many perceived as pervasive in Moran's day.[4]

For Moran, however, illustration was always a respectable way of making a living, and he did seem to use the medium as an expressive vehicle. He sold illustrations of western landscapes and other regions to the most important and widely read publications, including not only *Scribner's, Harper's,* and *Century,* which led the popular field, but also *The Aldine, Frank Leslie's Illustrated Magazine,* and *The London Illustrated News* (to name only a few), as well as many books such as *Picturesque America, Picturesque Canada,* and geographical and literary texts. Many of his illustrations are qualitatively exceptional, sometimes rivaling his watercolors and oils in their evocation of a sense of place. Furthermore, because Moran worked as an illustrator concurrently with painting, his prints often contain valuable information about his working methods that is not available through other means of inquiry.[5] Although the paintings have been traditionally regarded as more indicative of Moran's vision, his published work is essential to understanding him as an interpreter of the western

What art can do . . . Mr. Moran has shown in his illustrations. . . . They open to us a world as wild as the one we see in dreams,—a strange and beautiful wonderland, and they are—but we will not bias the judgment of the reader with regard to them, he can see for himself what they are.

The Aldine, March 1873

landscape and to perceiving his larger relationship to American culture. Because illustrations were inexpensive and widely disseminated, they were the primary means by which the public viewed the West.

One of the most striking features of Moran's printed art, perhaps even more than his painted work, is its repetition. Identical works appear in completely unrelated publications as well as in ones in which the sharing of illustrations can be documented. Furthermore, Moran repeated his favorite themes and compositions in countless different works. Such duplication indicates the commercial artist's need for efficiency, and it also reveals the intensifying of ideas that only prolonged exposure to a subject will allow. What appears at first as redundancy is in fact a deepening of the artist's understanding. And, too, the appearance of the same works in different publications often reveals publishers' links to the U.S. geological surveys.

The industry was an essential agent in the promotion of the West; printed images increased general awareness, that awareness created a desire for additional information, and that desire brought profits for publishing houses. But the activity was one of mutual dependence; other western enterprises such as railroads needed the print medium for publicity, and publishers required the information they generated to fill their pages. Visual images, including those by Moran, were a vital component of the relationship.

SCRIBNER'S MONTHLY

In the fall after his Yellowstone expedition, Moran moved his family from Philadelphia to Newark, New Jersey, to be closer to New York publishers.[6] The decade of the 1870s was his most prolific as an illustrator, and the months immediately following his first trip West were some of his busiest. He was working his field sketches into finished watercolors and his first Big Picture, and he was inundated with requests for illustrations of the region. Some of the most important requests came from *Scribner's Monthly*. Moran traveled for other publications in subsequent years, but his early association with *Scribner's* was perhaps the most significant of his career. Moran produced hundreds of illustrations for the magazine and its subsidiaries (such as *St. Nicholas,* a children's publication) throughout the 1870s, largely through the instigation of his close friend and *Scribner's* managing editor Richard Watson Gilder.[7] As we have already seen, Gilder called upon Moran to create illustrations for *Scribner's* first Yellowstone article in the spring of 1871, and he was no doubt instrumental in arranging the financing of Moran's first trip West.

As a gesture of good faith for the $500 advance he received, Moran left his painting *Children of the Mountain* (1866, plate 6) with *Scribner's* publisher, Roswell Smith. It is one of his most ambitious prewestern paintings, depicting an idealized American wilderness. Moran had exhibited it in Paris at the Exposition Universelle in 1867, and it was generally recognized as one of his best paintings to that date. With its mountainous setting, its vividly colored turbulence of water and wind-tossed trees, the work was precisely the sort of romanticized landscape that appealed to such promoters as Jay Cooke and Company and *Scribner's,* inspiring them to envision similar views of Yellowstone. The loan of the painting was in fact a sale, according to Moran's

later notes: *The Children of the Mountain* was "bought . . . by Roswell Smith of Scribner's Magazine, that is I borrowed $500 from him with which to go on the Yellowstone expedition with Hayden and [left] the picture as security and I did not redeem it." [8]

Hayden's correspondence after the trip reveals much about the relationship between the survey and *Scribner's* and their collective use of Moran's art. In the fall of 1871 Gilder worked closely with Moran and Hayden on an article that finally appeared in February 1872 as a follow-up to Langford's. [9] Gilder made it clear in his initial letter that he perceived the efforts of the geological surveys as much more than a means of obtaining magazine copy: "Will you get us articles on the Badlands of Dakotah, and the wonderful unknown parts of the West? I think the Department [of the Interior] will look upon such articles as a part of the good work it is doing in exploring the far away and peculiar regions of our country. The object of these explorations is knowledge— and the people will more highly appreciate the work the Department is doing if its results are presented in a popular form. We will make a feature of these articles and illustrate them handsomely." [10] Gilder obviously recognized the national significance of Hayden's explorations and envisioned that his magazine would be the best way to convey this to the American public. He also realized that good illustrations were as important to the task as competent writing. In another letter Gilder listed the illustrations Moran was creating and reminded Hayden that his text about Yellowstone "should be as brief as possible . . . saying something about the interest it excited, then stating briefly that you propose to describe certain wonders not seen or not dealt with by

him [Langford in his earlier article]. The springs would occupy most of the article perhaps—but all the subjects presented in the feature should be sketchily and popularly treated of course. . . . You are doing us a great kindness . . . and if we helped you to the Yellowstone you can now do us a substantial favor. [11] In his reference to *Scribner's* helping the Hayden survey to Yellowstone, Gilder revealed his understanding of the relationship between the magazine and the survey. *Scribner's* publication of the Langford articles had brought Hayden's survey more popularity, and possibly more governmental support, than it would have otherwise received; the two enterprises were mutually dependent.

Gilder's awareness is substantiated by the controversy that arose over the expense of Moran's illustrations; Hayden wished to use them in his official report, and Gilder assumed that the survey would share the cost. Hayden refused to comply, no doubt pleading lack of funds and arguing that the magazine would never have gotten the images in the first place had he not allowed Moran to accompany him. Gilder ultimately conceded, and Hayden was permitted to copy the woodblocks without charge. The editor explained his conditions in January 1872:

The publishers of the monthly really cannot afford to go to such large expense for original illustrations without getting back part of it from some quarter. Even Harper's, with its immense resources and circulation has largely depended upon reproductions. And it cheapens the illustrations to have them appear in reports, etc. We hardly ever allow the wood-cuts themselves to go out of our possession, even temporarily. The cuts accompanying your article [Moran's illustrations] cost about $500 and we thought that Uncle Sam would be rich enough to pay at least half cost. But if it is a

matter that affects your own purse, we will imme-
diately pack up the blocks and send them to you
that you may have electrotypes taken as you de-
sire—*providing* that you guarantee us against
damage, and also against the use of the plates in
any publications save your report. . . .

 We will express the blocks to you to morrow.
Now in this matter the publishers have acted
promptly upon my suggestions and I look to you
to stand by me my dear Dr.! If in the future we can
get back some of this western money, legitimately,
from the government, I hope you will help to that
end—and that you will do all in your power to
make the fourth of my articles full, graphic, and
successful.[12]

Twelve of the sixty-four illustrations in Hay-
den's 1871 report were thus provided free
from *Scribner's*. Moran did not receive addi-
tional payment for their use, or for any of the
multiple uses to which the illustrations were
subsequently put.

 Of all the leaders of the Great Surveys, none
was a more prolific writer or more enthusias-
tic businessman than Hayden. His correspon-
dence is full of letters from publishers, print-
ers, and lithographers, as well as people to
whom he had sent his reports and articles. He
often gave maps, information, and Jackson's
photographs to publishers and editors with-
out charge. He did not comply with Gilder's
request for exclusivity of the Moran illustra-
tions but instead freely shared his electrotypes
with others in exchange for publicity.[13] In re-
turn, publishers often made copies of their
work available to Hayden and to the influential
individuals he specified. *Scribner's* was more
than obliging in this courtesy; Gilder provided
free copies to many congressmen during the
lobbying for the Yellowstone park bill.

 Hayden had included illustrations in only
one of his previous reports, that of the 1870
season, when he used twenty small woodcuts
drawn by Henry Elliott.[14] Of those, only a
few are views; the majority are schematic ren-
derings of geologic strata. In 1871, however,
Yellowstone's scenery and Moran and Jack-
son's success persuaded him to expand his pic-
torial documentation. He was also influenced
by his competitors; illustration of expedition
reports increased in the early 1870s, and ex-
panding reproduction technology was mak-
ing illustrations affordable for tight-budget
productions such as government publications.

 As Gilder predicted, Moran's illustrations
also reappeared in the Wonders or Travels se-
ries, in this case in James Richardson's *Wonders
of the Yellowstone* (1872), one of the first guide-
books to the new national park.[15] Most of his
fourteen wood engravings in the volume are
from Hayden's February 1872 article, but sev-
eral date to Langford's from the spring of
1871. The text is largely quoted from them as
well, but Hayden's report and those of other
explorers such as Doane and Barlow are also
mentioned. Moran's contribution is only
briefly acknowledged in the preface, but as in
the earlier *Scribner's* articles, the importance of
the Northern Pacific Railroad's promise of
easy tourist access is discussed fully on the
first page, again emphasizing the railroad's
part in the coalition to promote the region.

 Although Richardson's volume is a conven-
tional guidebook, it does chronicle the trans-
formation in attitude toward Yellowstone that
occurred during the two years that *Scribner's*
had been reporting on the area. By accompa-
nying the illustrations with verbal pictures in
the form of architectural metaphors and by as-
serting that the sights described were beyond

description, Richardson indirectly suggests the significance of Moran's work and lays the foundation for his most important message. His repeated use of vocabulary such as "wonders" and "Wonderland" echoes the recent park-bill publicity and indicates that such terminology was becoming permanently associated with the park, replacing the earlier hellish vocabulary. The change is reflected in the styles of the three writers quoted in Richardson's book. Langford's early remarks emphasize the terrifying gorges, dangerous boiling springs, and satanic characteristics. Hayden's are more laudatory, toning down the horror with appreciation and scientific interest. Richardson's remarks, coming after the official acceptance of the park, are suffused with the unsurpassed wonder of the place. They each wrote of Yellowstone canyon:

Langford, early 1871:

The brain reels as we gaze into this profound and solemn solitude. We shrink from the dizzy verge appalled, glad to feel the solid earth under our feet and venture no more, except with forms extended, and faces barely protruding over the edge of the precipice. The stillness is horrible. Down, down, down, we see the river attenuated to a thread, tossing its miniature waves, and dashing, with puny strength, against the massive walls which imprison it. . . . The sense of danger with which it impresses you is harrowing in the extreme. You feel the absence of sound, the oppression of absolute silence.[16]

Hayden, early 1872:

No language can do justice to the wonderful grandeur and beauty of the Grand Cañon. . . . The entire mass of the water falls into a circular basin,

which has been worn into the hard rock, so that the rebound is one of the magnificent features of the scene. . . . It is a sight far more beautiful, though not so grand or impressive as that of Niagara Falls.[17]

Richardson, late 1872:

It has no parallel in the world. Through the eye alone can any just idea be gained of its strange, awful, fascinating, unearthly blending of the majestic and the beautiful; and even in its visible presence, the mind fails to comprehend the weird and unfamiliar, almost incredible scenes it reveals . . . [yet] when the light falls favorably on these blended tints the Grand Cañon presents a more enchanting and bewildering variety of forms and colors than human artists ever conceived.[18]

With the Richardson publication, *Scribner's* continued to promote interest in the region after the formation of the national park. By encouraging the perceptual transformation of Yellowstone into Wonderland, the publishers demonstrated their ability to influence public opinion through an effective conjunction of government and private enterprise, text and image.

GUIDEBOOKS

Guidebooks to the West, such as Samuel Bowles's widely read *Across the Continent* (1866), had been published throughout the nineteenth century, but they steadily gained popularity throughout the 1870s with the completion of the transcontinental railroad. Railroads sometimes printed their own and at other times relied on the work of independent publishers who worked with some financial underwriting from the industry. For their

own publications the railroad companies often employed writers and artists, but they also frequently borrowed illustrations rather than commissioning original work. Because his expeditions had produced such a variety and because he was generous with his resources in return for publicity, Hayden was often called on to share his survey's material.

As early as February 1872, Hayden contributed to such an endeavor by providing the author of the earliest guide to western rail travel, George Crofutt, with text about Yellowstone and several of Jackson's photographs. Crofutt not only used them but also printed several of Moran's compositions in hackneyed copies; their poor quality indicates that he may have circumvented accepted channels of acquisition and pirated woodcuts from existing reproductions. Nevertheless, Crofutt's appreciation of Hayden's generosity reveals his enthusiasm for providing the American public with some of its first detailed information about visiting the West:

Dr.—I have concluded to have engraved and in fact have already given it out—one of your Yellowstone views. It is no. 200—the Valley of the Yellowstone with mountains in the distance white with snow. . . . Now I will be pleased to have you write me the description—as you proposed—I shall not limit you to space. . . . In giving the view to the artist I instructed him to *do his best* in engraving this view, as all depends upon their being *well done*. Thanking you . . . and assuring you that my *world* will always be open to you which I solicit you to use freely.[19]

Crofutt's publication in 1872, *Crofutt's Trans-Continental Tourist Guide,* was, perhaps not surprisingly, strongly supported by the railroad industry, with the book for sale in all

trains and stations along the Union-Central Pacific line. The text contains glowing accounts of railroad progress and the trains' luxurious accommodations, as well as descriptions of scenery along their routes, accompanied by a surprising variety of woodcut illustrations. Later editions were more publicly underwritten by railroad interests, and they included increasing numbers of images. Crofutt's 1883 version contained the aforementioned Yellowstone view by Jackson, which had appeared in the guide since the mid 1870s, along with two of Moran's woodcuts from the 1871 and 1872 *Scribner's* articles and Hayden's report for 1871.[20] Moran's art of the early 1870s had brought the western landscape to Americans; now his art was being used to bring Americans to the landscape.

The relationship between Hayden and John B. Bachelder, author of *Popular Resorts and How to Reach Them* (1873), is another example of the dependence of the early popularizers of the West on the information and illustrations provided by the U.S. geological surveys. Bachelder was an independent publisher but by necessity worked with official agencies, railroads, and others for his guide's content. He wrote Hayden in 1875 about a revised edition:

Through the courtesy of Hon. W. W. Curtis I am in receipt of a copy of your report of the United States Geological Survey of the Yellowstone Region. . . . In answer to a letter to Mr. Curtis asking if electrotypes of the cuts with which it was embellished were attainable, I have received from him your letter with a favorable answer.

In the next edition of my book I want to introduce an article on the Yellowstone Region, but never having been there I desire to draw largely upon the text of your report. It will probably be a

long time before the "Yellowstone National Park" will become a much frequented Popular Resort. Yet there are those who would like to visit it and for such and to popularize this wonderful section of the country I have decided to refer to it. . . . Is it possible to get there by public conveyance from Chicago? Is the excursion practicable under any circumstances for ladies? That the scenery is sublime I am assured. How about shooting and fishing? Can I recommend it for a camping out party?[21]

Such ignorance of the very places where he was presenting himself as expert guide was all too common. George Crofutt was one of the few who assembled his information from personal experience, but Bachelder's unfamiliarity with Yellowstone only points to the importance of Moran's art and the other information the surveys provided. Bachelder, like Crofutt, saw his role as that of popularizer and knew that through Hayden, and Moran's art, he would be able to promote an area he had never seen.

OTHER PUBLISHING RELATIONSHIPS

Moran's art of Yellowstone appeared in a number of other publications through more conventional channels. During the months following the 1871 expedition he was busy fulfilling several illustrative commissions, as he outlined to Hayden: "I have been intending to write to you for some months past but I have been so *very* busy with Yellowstone drawings, and so absorbed in designing and painting my picture of the *Great Cañon* that I could not find the time to write anybody. . . . I have made two large drawings of the Yellowstone for Harper's Weekly, one of the Great

Cañon of the Valley from the lower cañon. I am also engaged to the "Aldine" to make five or six large drawings for that paper, but I find but little time for drawings since I commenced the picture."[22] As he had with *Scribner's,* Hayden cooperated with the periodicals Moran mentioned, as well as others, sharing his expertise and resources. Although a thorough investigation of all the publications Moran illustrated, or to which the survey leader directly or indirectly contributed, would constitute a study in itself, an examination of some of the more prominent examples provides insight into the relationship between government and publishers and their collaborative use of Moran's art.

Moran's comment to Hayden about the commission for *Harper's* refers to the large woodcut illustrations that finally appeared in 1873 on a full tabloid page in R. W. Raymond's article "The Heart of the Continent: The Hot Springs and Geysers of the Yellow Stone Region." *Harper's Weekly* was one of the most popular nineteenth-century publications, known for its large woodcuts that adorned nearly every page. Its sister journal, *Harper's Monthly,* was a close competitor with *Scribner's* in the smaller magazine format. Although neither *Harper's* publication rivaled *Scribner's* in its use of Moran's art, the artist's records reveal that by the end of 1883 he had sold forty-one illustrations to the *Monthly* and five to the *Weekly.* [23]

Two of the four wood engravings in Raymond's article are obviously Moran works, *Grand Cañon of the Yellowstone River* and *Yellowstone River and Mountains.* The other two, *Hot Springs* and *Castle Geyser and Hot Springs Basin,* appear by their style to have been taken directly from Jackson's photographs by the

wood engravers, although they have been attributed to Moran by some scholars and the subjects are found in other Moran works.[24]

Coincidentally, in the introduction Raymond alluded to John Wesley Powell's expeditions along the Colorado River, which Moran was to join in 1873.

Within the last few months the explorations of several parties have made known the marvels of a hitherto untrodden region, unsurpassed in many respects by any other of equal extent in this country or the world. I refer to the great central watershed of the continent—the highest part of the Rocky Mountains isolated peaks excepted—whence flow to either sea the waters of the Snake and Columbia system on the west, and of the Yellow Stone and Missouri system on the east. I might almost add the Green and Colorado system, which rises not very far from the same neighborhood.[25]

As if to substantiate his words, Moran's second illustration for the article is a view of the Yellowstone Valley itself, drawn from one of Jackson's photographs, with his characteristic foreground and special trees. Here the flowing of the river is the focus as it branches out, seemingly to Raymond's cardinal points. The subject is very picturesque and is unusual in Moran's oeuvre. The valley lacks the distinctiveness of much of the rest of the Yellowstone region, and Moran tended to be drawn to the more dramatic sites. Nevertheless, the valley is in some ways more representative of the actual appearance of most of the region.

Several of the illustrations that Moran mentioned in his letter to Hayden were for yet another Yellowstone article, this time one that gave his art prominence over the text. *The Aldine* was a leader in the field of fine illustration; it was an art journal that made every effort to print the best images available with the latest technology. For Moran commissions from *The Aldine* meant an opportunity to present his work in one of the best formats of the time. For readers it meant the pleasure of seeing the finest woodcuts of western landscapes presented solely for their aesthetic appeal. Unlike many other illustrated monthlies, *The Aldine* seems to have had editors who worked directly with artists to acquire their art, rather than going through survey leaders or others to obtain electrotypes or photographs from which artists could work. When Moran produced illustrations for them he either drew from his sketches or from photographs in his collection that he had received from the expedition photographers.[26]

"The Yellowstone Region" appeared in *The Aldine* in March 1873, containing four Moran wood engravings that were presented as definitive evidence of the park's uniqueness: "The Yellowstone region evades description, and almost evades art. What art can do for it Mr. Thomas Moran has shown in his great picture painted for Congress, and in the illustrations which he has drawn for the present number of *The Aldine*. They open to us a world as wild as the one we see in dreams—a strange and beautiful wonderland, and they are—but we will not bias the judgment of the reader with regard to them, he can see for himself what they are."[27] Moran's view of *Hot Springs, Gardiner's River* in this article displays subtle nuances of tone not evident in his *Scribner's* illustration of the same subject. *Cliffs of the Cañon* (fig. 18) focuses on the soaring pinnacle forms that dominate the painting *The Grand Cañon of the Yellowstone* (plate 1), highlighting them in delicate linear brilliance against the sloping, muted canyon walls. Here they are even more

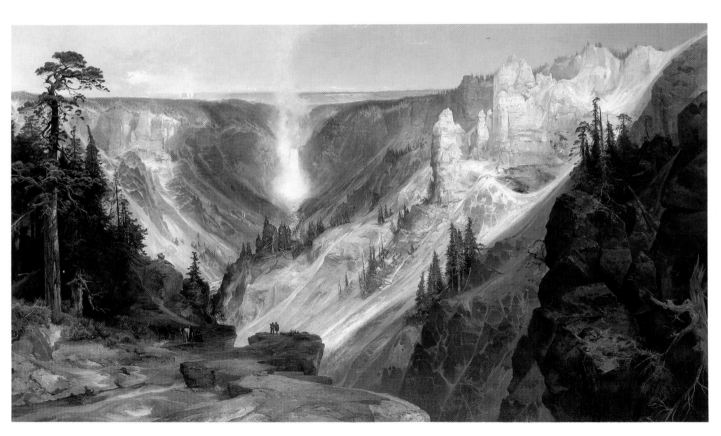

Plate 1. Thomas Moran, *The Grand Canõn of the Yellowstone*, 1872, oil on canvas, 84 × 144¼″ (213 × 266.3 cm). National Museum of American Art, Smithsonian Institution, lent by the Department of the Interior, Office of the Secretary (L. 1968.84.1).

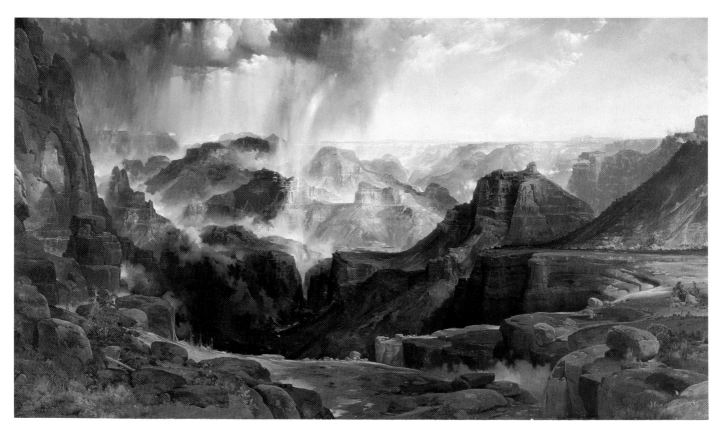

Plate 2. Thomas Moran,
The Chasm of the Colorado,
1873–74, oil on canvas,
84⅜ × 144¾″ (214.3 ×
267.6 cm). National Mu-
seum of American Art,
Smithsonian Institution,
lent by the Department of
the Interior, Office of the
Secretary (L. 1968.84.2).

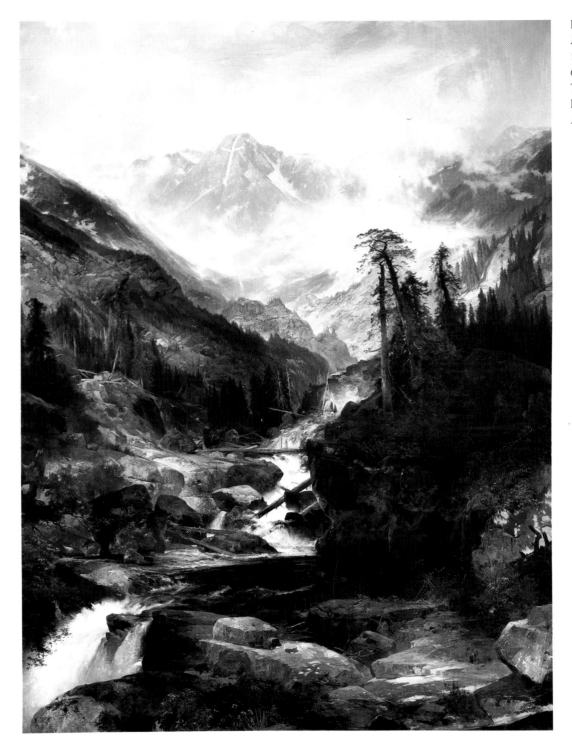

Plate 3. Thomas Moran, *Mountain of the Holy Cross*, 1875, oil on canvas, 82¾ × 64¾" (210.2 × 164.5 cm). The Gene Autry Western Heritage Museum, Los Angeles.

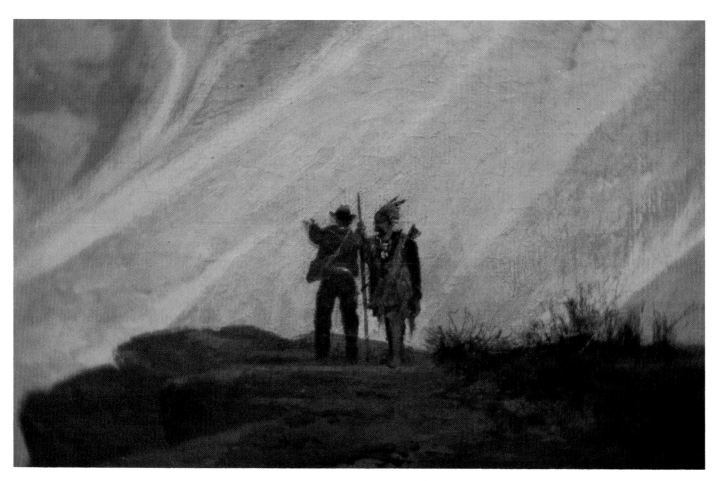

Plate 4. Thomas Moran,
The Grand Canõn of the Yellowstone, 1872 (detail), oil
on canvas, 84 × 144¼″
(213 × 266.3 cm). National Museum of American Art, Smithsonian
Institution, lent by the Department of the Interior,
Office of the Secretary (L.
1968.84.1).

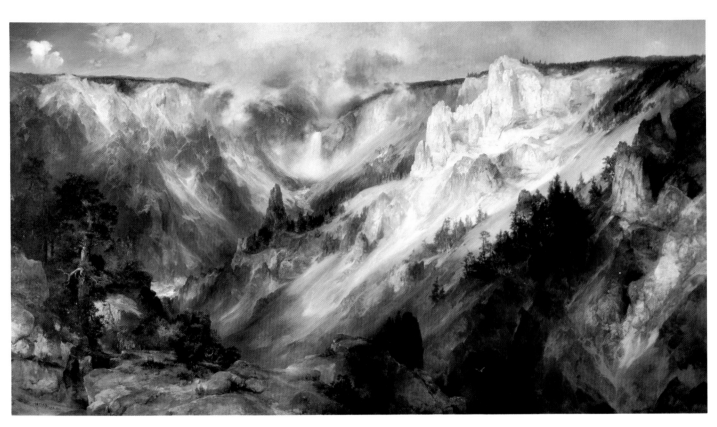

Plate 5. Thomas Moran, *The Grand Cañón of the Yellowstone,* 1893–1901, oil on canvas, 96½ × 168⅜″ (245.1 × 427.8 cm). National Museum of American Art, Smithsonian Institution, gift of George D. Pratt (1928.7.1).

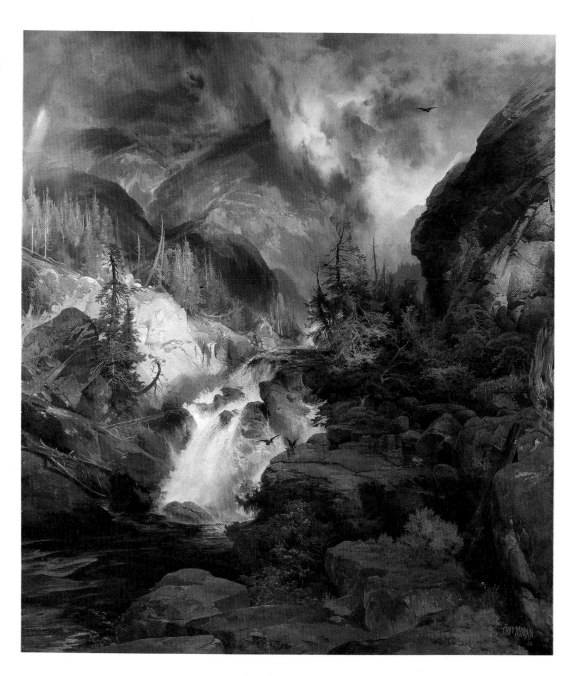

Plate 6. Thomas Moran,
Children of the Mountain,
1866, oil on canvas, 62⅓ ×
52″ (158.3 × 132.1 cm).
The Anschutz Collection,
Denver.

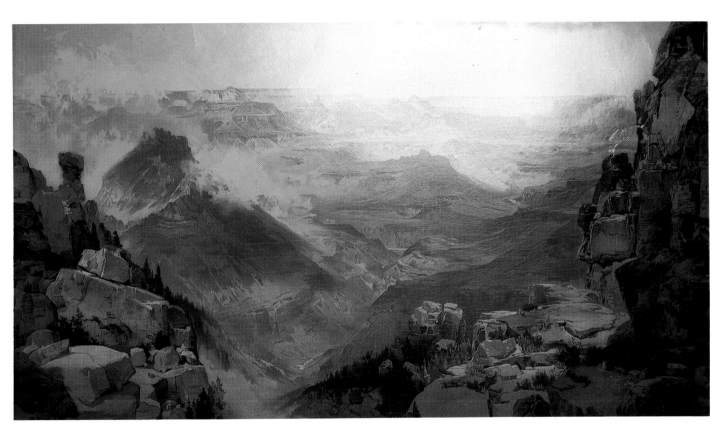

Plate 7. Gustave Buek, after Thomas Moran, *The Grand Canõn of the Colorado,* 1892, chromolithograph. The Thomas Gilcrease Institute of American History and Art, Tulsa, Oklahoma.

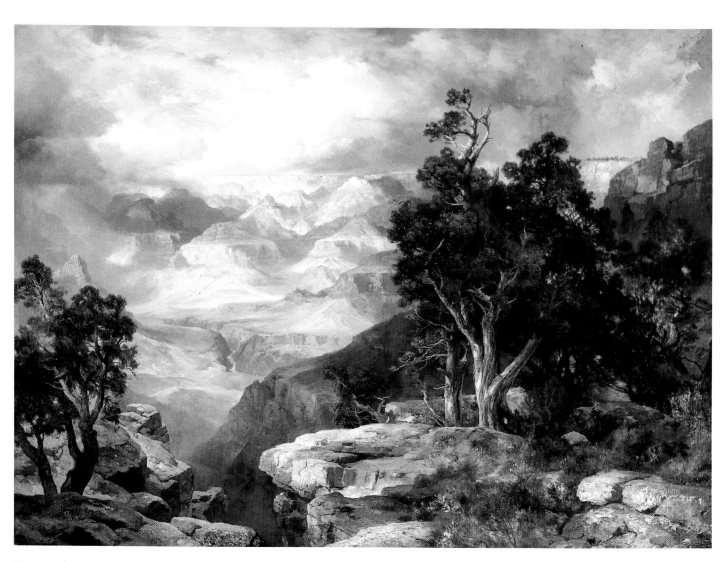

Plate 8. Thomas Moran,
Grand Canyon (*From Hermit
Rim Road*), 1912, oil on
canvas, 30½ × 40½" (77.5
× 102.87 cm). The Santa
Fe Collection of South-
western Art, Chicago.

exaggerated than in the oil, as they dominate the tiny explorers trudging to the overlook.

Although *The Aldine* produced only one Yellowstone article, Moran's contribution to the publication was considerable. It published some of his most highly refined illustrations, images that rival his best work in other media, technically and symbolically. In them, the nuances of tone, light, and shade come to life in the monochromatic and linear medium of wood engraving, glowing in their contrasts, dramatic in their compositions.

The Aldine's black and white reproductions were rivaled by only one other major publication. *Picturesque America* was in some ways even more elaborate, although it focused solely on well-illustrated articles of interesting places throughout the United States. Unlike the monthlies, this was a deluxe two-volume set, published by D. Appleton and Company, that was to some extent compiled from *Appleton's Journal,* an illustrated magazine similar to *Harper's Weekly.*[28] A number of Moran's illustrations highlighted *Picturesque America,* and its publishers also worked closely with the surveys for their information and images.

In the spring of 1872 Appleton and Company, like many publishers of the decade, was eager to provide readers an account of the new national park. Moran did provide one exceptional view that was specially engraved in steel, *The Upper Falls of the Yellowstone* (based on a composition found in two watercolors now in the Gilcrease and at the Philbrook Art Center, Tulsa).[29] But perhaps because he was busy completing his Big Picture, the editors called on Hayden to provide photographs from which their illustrator Harry Fenn could work. Although *Picturesque America* was supposedly edited by the famous William Cullen Bryant, Appleton editor O. B. Bunce did the real work. He also asked Hayden to prepare the text:

The Yellowstone photographs came duly to hand and Mr. Fenn has already made several drawings which are now in the hands of the engravers. The photographs of the other locations which you agreed to lend us have not been received. I write now especially to ask you if you will not undertake to prepare the article on the Yellowstone Valley. It will not be necessary for you to have Mr. Fenn's selections (which so far are Tower Creek, the Giant Geyser and two Yellowstone Lake views) because the article should describe all the leading features of the region, and will naturally include all the points illustrated. . . . Please try to find time to prepare this paper for us before you leave for the West.[30]

It seems, however, that Hayden did not ultimately comply, and for the preliminary article in *Appleton's Journal* Bunce was obliged to do the best he could with little information.[31] When it was issued in May 1872, Hayden complained at being left out of the story and received this interesting reply from Bunce:

Your letter of yesterday greatly distresses me. I knew your name ought to be connected with those Yellowstone men's, but I hadn't a single fact to go by, and I was in hope, ere the next illustrations were along, to be in receipt of your mss. and be enabled to make amends and do you justice. However, the June publications are merely preliminary and the complete and perfect article [will be] in "Picturesque America" [the book] and for this I have depended on you. Now, my dear sire, if the press has neglected you and done you injustice heretofore, why not make the journal the medium of setting you and your connection with the Park fully before the public. We will print what you may send us . . . and hereafter in the articles describing the cuts give you full credit and make the public recognize its indebtedness to you in the

matter. . . . If you absolutely can't prepare the article for "Picturesque America" please give us all the notes and memoranda you can. Call in and see me and use us freely and fully in furthering your wishes.[32]

Although Hayden did not, after all, write the final article for *Picturesque America,* he did turn the situation to his advantage by negotiating to exchange information for the use of Fenn's illustrations in his 1872 report.[33] The arrangement followed much the same course as the earlier one with *Scribner's,* with Bunce finally conceding access to the illustrations: "In regard to the Yellowstone engravings we certainly should much prefer them to reach the public for scrutiny [solely] through our journal and 'Picturesque America,' but as we are under obligations to the Department for the photographs we feel it is our duty to comply with your request for electrotypes. If we can have full credit in the reports for the electros we should be willing to furnish them at the cost of electrotyping, if otherwise, would the department be willing to share any portion of the expense of the engraving?"[34] Therefore, although Moran contributed only one view to *Picturesque America*'s treatment of Yellowstone, the precedent of cooperation was established between the U.S. geological surveys and the publisher, a mutually profitable relationship that would continue throughout the mid 1870s.

The most lavish extension of Moran's illustrative talent and the collaboration between publishers and the government came with his work for the chromolithographer Louis Prang from 1873 to 1875. Prang was perhaps the most important of the many American chromolithographers in the late nineteenth century. He usually commissioned original paintings directly from artists, and through his excellent reproductions he significantly influenced public taste by making color images available to a broad public. Although his firm also reproduced European masterpieces, Prang was especially interested in American art, and his popular *American Chromos* did much to promote appreciation for the landscape of this country, as well as to support the work of many artists.[35]

In 1876 Prang published fifteen chromolithographs of Moran watercolors specially commissioned for a large volume entitled *The Yellowstone Park, and the Mountain Regions of Portions of Idaho, Nevada, Colorado and Utah.* It was a deluxe, oversized portfolio designed primarily to exhibit Moran's virtuosity and to highlight the West's wondrous scenes. Even in its day the book was a prized commodity, selling for $60 from a limited edition of one thousand copies.[36] The *Times* of London asserted that "no finer specimens of chromo-lithographic work have been produced anywhere," and even the *Nation,* the publication that had denounced the "chromo-civilization" in 1874, decided to "commend that Mr. Prang was willing to undertake so costly an enterprise, the copying of such watercolors as these being one of the things that lithography is undeniably fitted to effect. . . . Having seen several of the original aquarelles prepared by Mr. Moran, we are prepared to testify to the remarkable accuracy of the rendering into chromolithographs, an accuracy which we do not think could have been surpassed in any country."[37]

As with the many examples of collaboration before, Hayden was again called on to supply text for Prang's portfolio, but this time it was to accompany Moran's art rather than

the other way around. Here for the first time, except in his original paintings, were Moran's western views in color, a fact emphasized in the volume's preface.

The brilliant, and, in one sense of the word, almost unnatural coloring of many of the most remarkable scenes in the great National Park is indeed one of its chief attractions; but at the same time it is also one of the greatest obstacles in the way of a successful publication. To delineate it faithfully it needs an artist of uncommon powers and yet of great sobriety in judgment. The publishers believe that in Mr. Moran the right man has been found for the right place. But even so the artist's brush must be upheld by the testimony of science. In this also the publishers have been fortunate, as the name of Professor Hayden, the eminent United States government geologist, who has been associated with Mr. Moran in the production of the work, is a sufficient guaranty for its scientific correctness.[38]

Also for the first time, perhaps, it was Hayden who was subordinated to the artist. He was brought in for his "association with Mr. Moran," only to certify the veracity of the chromolithographs.

Hayden's text reiterated the importance of color for appreciating Yellowstone and emphasized Moran's talent for conveying a sense of place not available through monochromatic media.

The exquisite scenery of Yellowstone National Park has become tolerably well known to the public by photographs and by illustrations in magazines and books. But however accurate these illustrations may have been, they were all wanting in one particular, which no woodcut, engraving or photograph can supply, and which, nevertheless, is of the greatest importance, especially in the case under consideration. All representations of landscape scenery must necessarily lose the greater part of their charm when deprived of color; but any representation in black and white of the scenery of the Yellowstone it may truly be said that it is like Hamlet with part of Hamlet omitted. . . . It is simply impossible to conceive of the character of the scenery, and even the most vivid description is utterly insufficient to give an accurate idea of it, unless accompanied by color illustrations. So strange, indeed, are the freaks of color which nature indulges in habitually, that it will no doubt require strong faith on the part of the reader in the truthfulness of both artist and writer to enable him unhesitatingly to accept the statements made in the present volume by the pen as well as by the brush. . . .

The sketches by Mr. Thomas Moran, who accompanied me on one of my expeditions, are not only of a high order of artistic merit, but they can be relied upon as exceedingly correct renderings of their subjects, interesting alike to the man of science, the lover of art, and the admirer of nature.[39]

Here again, even from Hayden, we hear the familiar lament that words, unaccompanied by visual images, are insufficient to describe the West's remarkable scenery. And here too is the proclamation that apart from an actual visit, Moran's works come closer to providing a sense of that scenery than any other medium. The *Nation*'s review of Prang's publication echoed this sentiment: "On the whole, the untravelled world is under vast obligation for these vivid reports of regions we shall not all live to see in any other form."[40]

Prang's order for the watercolors may have come as early as the fall of 1872, when Moran wrote to Hayden about four works he was producing for the survey leader. "The four drawings that I was to make for you are not all finished as yet, but I can complete them by the end of this week. The main reason why they are not all finished was because the exact subjects have not been fixed upon; and as the orig-

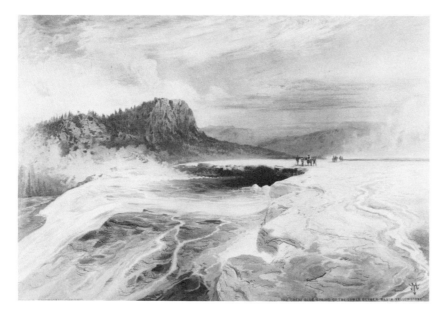

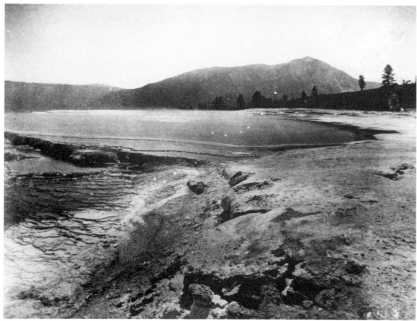

Fig. 47. Thomas Moran, *The Great Blue Spring of the Lower Geyser Basin,* 1876 (publication date), chromolithograph. From Hayden, *Yellowstone National Park,* plate 2. Jefferson National Expansion Memorial, National Park Service (4272).

Fig. 48. William Henry Jackson, *The Great Blue Spring of the Lower Geyser Basin,* ca. 1871, photograph. United States Geological Survey, Special Collections (Reston).

inal plan embraced more than four, I desire to again consult you before completing the four. As they are for the purpose of reproducing by Chromo, I should think that subjects in which color is the remarkable feature should be chosen."[41] These images may be the four chromos that appear in Hayden's final report, that for his 1878 season. They are the only color illustrations Hayden ever reproduced, but they appear to be identical to the versions Prang published, creating some confusion as to their origin and to the fate of those that Moran refers to in his letter. Perhaps he created them for Hayden but then included them in his group for Prang, who later passed them back to the survey. At any rate, Moran did not begin working on the Prang commission in earnest until early 1874. Fortunately some of the correspondence survives, and at least part of the chronology can be reconstructed. Prang contacted Moran late in 1873 "to paint twelve or more watercolor pictures of the Yellowstone country," and although there was a misunderstanding about payment for a different Prang project that Moran had already completed, the artist began the work on the landscape series in January 1874.[42]

As the title of the Prang volume indicates, the majority of the images are of Yellowstone subjects. Many closely correspond to paintings that Moran had previously produced for other patrons, such as the sixteen works known as the Blackmore watercolors, now in the Gilcrease Museum, as well as many of his wood engravings.[43]

In the plate entitled *The Grand Cañon of the Yellowstone (Cliffs of the Cañon)*, the artist recalled his great 1872 canvas with a portion of the earlier panoramic view that has similarities

to his *Aldine* illustration from 1873 (fig. 17). In the chromolithograph the white pinnacles are aggrandized to the point of appearing mannered and contrived. Hayden provided a two-page commentary with each of Moran's scenes, and in the one accompanying this work he appealed to the viewer's imagination through the convention of architectural metaphor: "The walls, in many places vertical, slope to the water's edge leaving no beach. In some places they are eroded into fantastic shapes, towers, spires, and Gothic columns; in others they present fortress-like fronts or long slides of brilliant-colored debris; while elsewhere they consist of massive rock separated by jointage resembling irregular masonry going to decay."[44]

Other images in the series reinforce Moran's reputation as an artist able to imbue geological formations with evocative emotional appeal. Several of his more successful compositions compare closely with Jackson's photographs, such as *Hot Springs of Gardiner's River; The Castle Geyser, Upper Geyser Basin; The Great Blue Spring of the Lower Geyser Basin* (figs. 47, 48); and *The Tower of Tower Falls*, the same work that the Northern Pacific Railroad later used for the design of a promotional brochure.[45]

Another of the chromolithographs, *Tower Falls and Sulphur Mountain* (fig. 49), is one of Moran's less known compositions, although he returned to it frequently. His comments on the back of one of the original watercolors indicate that his impressions of the place were a mixture of objective, scientific observations and romantic associations: "It is certainly [one] of the most weird and impressive scene[s] in the park. The Sulphur Mountain

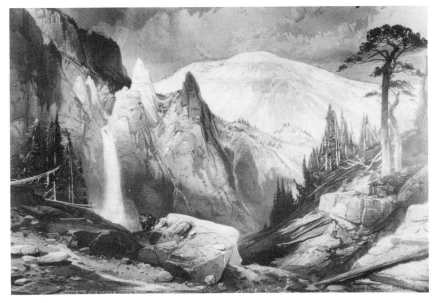

Fig. 49. Thomas Moran, *Tower Falls and Sulphur Mountain*, 1876 (publication date), chromolithograph. From Hayden, *Yellowstone National Park*, plate 6. Jefferson National Expansion Memorial, National Park Service (4269).

lies across the Yellowstone river which flows at its base. The snowy dome of the Mountain is supported upon a base of columnar basalt of great regularity and formation. The columns of which are about 40 feet in height. Beneath these columns lies a strata of calcerous deposit intermixed with a sulphur and iron given the most delicate and beautiful tints of red and yellow. This is again supported upon another mass of columnar structure."[46] The composition of *Tower Falls and Sulphur Mountain* was one of Moran's favorites, judging by his repetition of the subject in several media. There are three studio watercolors of this composition, one sepia wash drawing, a small gridded watercolor thumbnail that appears to be from Moran's sketchbook, and a wood engraving in *The Aldine*.[47] A related photo by Jackson (fig. 50) completes the treatment of the motif.

The four chromolithographs Hayden used in his 1878 report (*Mammoth Hot Springs, The Grand Cañon of the Yellowstone, Castle Geyser,*

Fig. 50. William Henry
Jackson, *Sulphur Mountain,*
ca. 1871, photograph.
United States Geological
Survey Photographic Li-
brary (Jackson 81).

and *The Great Blue Spring*) were the last offi-
cial appearance of Moran's work in his publi-
cations. For his cumulative report of twelve
years of expeditions (it was not issued until
1883, after the survey became part of the one
United States Geological Survey), Hayden in-
cluded four Moran chromolithographs. As
discussed above, he probably acquired them
from Prang in return for his written contri-
bution to the 1876 publication, although he
seems to have discussed them with Moran as
early as 1872. Unlike many of Hayden's other
relationships with publishers, the details of
this arrangement remain speculative, but con-
sidering his usual method of acquiring illus-
trations, these were probably obtained with
little or no cost to the survey. Nevertheless,
the full-color plates in this report were a reca-
pitulation and a testament to the importance
that Moran's work had had for Hayden, and
for Yellowstone itself over the years.

PART 3

THE GRAND CANYON

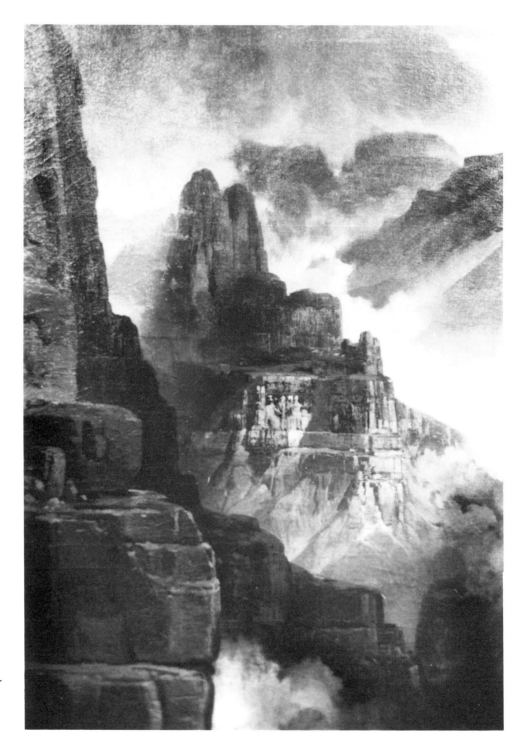

Fig. 51. Thomas Moran, *The Chasm of the Colorado,* 1873–74 (detail), oil on canvas, 84⅜ × 144¾″ (214.3 × 367.6 cm). National Museum of American Art, Smithsonian Institution, lent by the Department of the Interior, Office of the Secretary (L. 1968.84.2).

6

THE JOHN WESLEY POWELL EXPEDITION

"It is a great picture of a grand original; nevertheless, I venture to set up an *opposition* in the shape of another picture of a grand original of that wonderful interior region."[1] So wrote Milnor Roberts, the chief engineer of the Northern Pacific, to Jay Cooke in regards to Thomas Moran's first Big Picture, *The Grand Cañon of the Yellowstone,* after he attended the preview of that painting in May 1872. What Roberts seems to have been suggesting was that Moran paint a second great picture of the "grand original" (the land itself) that would be a companion to the first painting, and as Roberts was by this time well enough acquainted with Moran to approach him with such an idea, he may have in fact proposed it to the artist.[2]

The outcome of this intriguing suggestion was Moran's second Big Picture, *The Chasm of the Colorado* (1873–74, plate 2). It was unveiled in the spring of 1874 with comparable cere-mony to his first phenomenal success, and it too was purchased by Congress for $10,000 to hang in the Capitol opposite the earlier picture. Just as Roberts envisioned, Moran designed *The Chasm* as a pendant to *The Grand Cañon of the Yellowstone;* the two paintings share the same dimensions and each has as its focus a giant depression in the earth. Like the earlier canvas too, *The Chasm* depicts a place that had been described as hellish since as early as the sixteenth century. In his portrayal of what was perhaps the least understood region of the American Southwest, Moran again provided his impressions of the scene itself and, by implication, his profound understanding of a number of significant characteristics of the West and its development.

Unlike *The Grand Cañon of the Yellowstone, The Chasm* scene is uninhabited. No figures are included to act as a visual bridge to the yawning gulf of repetitious canyons below and beyond; we are left with only the sparse cactus, tiny gnarled trees, a snake, and a distant eagle as evidence of life in this desolate region. Nevertheless, a rocky foreground extending across the lower portion of the composition serves as a proscenium from which to view the expanse. A jagged wall frames the left and confronts us with the kind of towering masses that are echoed throughout the painting. Boulders from this wall cascade into the center, leading us to the right, and here, just past a vapor-filled cleavage in the rock, a rounding platform encloses an immense depression in the center of the painting. In wavelike layers the shelf ebbs from the brink, extending the ledge seemingly beyond the frame to the right.

The foreground gives way in the center, and

An inferno swathed in soft celestial fires, a whole chaotic underworld, just emptied of primeval floods and waiting for a new creative word, . . . a boding, terrible thing, unflinchingly real, yet spectral as a dream. . . . It flashes instant communication of all that architecture and painting and music for a thousand years have gropingly striven to express. It is the soul of Michael Angelo, and of Beethoven.

Charles Higgins, "The Titan of Chasms," 1897

the space plummets into a dismal abyss that is the darkest portion of the painting. Just beyond and directly above is the leading edge of a summer storm approaching from the left. The cloudburst creates a rising mist as it strikes the land, and over the blackest and deepest part of the canyon it meets the sun to form a partial rainbow. The verticality of this form as it falls into the recesses cuts to the core of the painting, deep into the chasm, effectively dividing the composition in two. Together with the enormous hole, the rainbow and accompanying shower become the focus of the work, and the activity of the storm is the enlivening force in the otherwise immutable scene.

Only in the immediate foreground is the viewer sure of his proportional relationship to this supernatural place. Here a snake writhes through the rocks, ironically reassuring as it provides a sense of scale for at least the first few feet, but just beyond and before the brink of the giant hole, the boulders give way to a smooth ledge dotted by puddles. At this level, and from here to the farthest reaches of the horizon, scale is indiscernible. The rocks perched on the edge of the first great drop could be either small or immense, a few feet away or fifty yards. The dead trees on the slope beyond the snake are thrown into high relief by the blackness of the chasm beyond; their brightness makes them seem near, but their minuscule size reveals them to be quite far. Just beyond the ledge a silvery thread winds its way, and it is suddenly astonishing to realize that this is not a tiny trickle in a gully a few feet deep but rather a large river miles below the foreground rim. In its neverending corrosive and erosive course, the river contin-

ues its work of millions of years, carving the dark vertical walls that make up the inner reaches of the canyons. The walls flanking the river here meet in a pronounced **V**, accentuating the depth of the gorge and opening just enough to allow water to meet water; the shower and rainbow above plunge into the deepest portion of the abyss.[3]

The sunlit areas and far horizon in the canvas's upper right are also proportionally misleading. Instead of being a few miles away as they first appear, the brilliant orange, yellow, and violet buttes could be fifteen or fifty miles from the rim, the farthest reaches as much as several hundred miles in the distance. Such spatial ambiguities may be disturbing (a criticism leveled by the earliest viewers of the painting), but they are generally accurate, as any visitor to the Grand Canyon can attest. The sheer distance of the expanse and the enormity of the depth are disorienting and dislocating, both in the painting and at the site, and it is through this dislocation that Moran conveyed his most insightful sense of the place. The viewer is forced to participate in order to see the work thoroughly; he must actively confront the ambiguity, reconstructing the space and the place for himself through the layers of painted rock and air into a world of personal identification. And as we shall see, this confrontation and the painting's discrepancies of scale and extreme contrasts are directly related to the work's cultural context.

The palette of *The Chasm,* with its preponderance of browns and murky ochers, appears somber when compared with the brilliance of its Yellowstone pendant. Yet, although it is dominated by the darkness of its foreground, *The Chasm* is actually a richly colorful work,

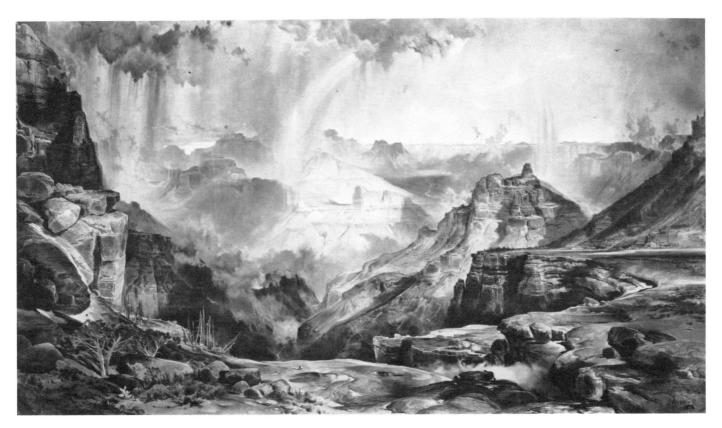

containing a livelier interplay of tones than the earlier picture. The deep blacks and umbers are punctuated with warm siennas and oranges, the cool grays are offset by the high-key blues and purples of the misty rain, and the atmospheric effects of luminous yellows, creamy oranges, and distant lavenders brighten the initial low-key effects and enhance the disparities of distance and scale.

As with many of his other paintings, Moran constructed *The Chasm* by combining elements recorded at the site with his favorite motifs borrowed from other times and places. Here again we see the ubiquitous tower, tree, rock, and arch, which appear in so many forms in his other works. They each have their respective formal and iconographic functions in this painting, and their presence adds richness to the already complex scene. The tower appears in *The Chasm* in various forms throughout the buttes and rocky outcrop-

pings, but it is most prominent just beyond the wall that frames the left edge of the canvas (fig. 51). It was not included in the preliminary charcoal drawing for the painting (fig. 52), so it seems that Moran added the form deliberately to the oil for its compositional and symbolic function in this work. In *The Chasm* this tower serves to lead us down from the height of the enclosure, and there it blocks our access to the string of canyons being deluged by the storm in the distance. In a brilliant detail, Moran highlighted the base of the tower with a sunbeam that illuminates what appears to be a sculptured classical frieze (fig. 53). The implications of such an anomaly are unclear; it may refer to the native people of the Grand Canyon, whom the painter knew through the Indians he encountered while traveling there and also through the rock pictures (pictographs) and carvings (petroglyphs) that adorn the region's countless rock

Fig. 52. Thomas Moran, Design for *The Chasm of the Colorado,* 1873, graphite on canvas, 84 × 144″ (214.3 × 367.6 cm). Underdrawing of painting; photograph courtesy of the Thomas Gilcrease Institute of American History and Art, Tulsa, Oklahoma (1616.627).

Fig. 53. Thomas Moran, *The Chasm of the Colorado,* 1873–74 (detail), oil on canvas, 84⅜ × 144¾″ (214.3 × 367.6 cm). National Museum of American Art, Smithsonian Institution, lent by the Department of the Interior, Office of the Secretary (L. 1968.84.2).

walls.[4] Again, however, the sense of scale is completely distorted. Real pictographs and petroglyphs are human scale, drawn or incised by individuals on smooth formations. Moran's frieze (if it can be called that) is, by association to its surroundings, of herculean size, even though it appears as a minute detail in *The Chasm*.[5]

Moran's twisted tree recurs in the two small specimens in the foreground, which struggle desperately to gain a foothold in the impenetrable rocky ledge. His tilted boulder here has one of its most repetitious appearances as it rests precariously on the rim in several locations within the painting, perilously balanced as a reminder of transition and change. The arch, here in the form of the rainbow, acts not only as the focal point for the entire painting but also as the redeeming symbolic element in a scene described upon its first exhibition as a "grand transformation scene gone wild."[6]

Moran's inclusion of the storm in the paint-

ing, a storm he actually witnessed at the site, has been seen by some recent critics as a negative element in the composition because, to them, it overshadowed the "more significant drama of the geology" and it seemed an unnecessary addition to an already overly sublime view. William Goetzmann, the author of the former opinion, even went so far as to say that Moran was "simplifying the stratigraphy to get everything into the picture," evidence that the artist "did not have the geological vision that could capture the true drama of the Grand Canyon."[7] Nevertheless, and quite apart from its source in Moran's own experience, the storm is essential to the meaning of the painting. The shower with its rainbow and the giant depression into which it pours are inseparable. Each requires the other for definition and completion, both in Moran's painting, where the two elements interact compositionally and symbolically, and in the land itself—the Grand Canyon and throughout the Southwest—where water is the very stuff of life. Recognizing that relationship is vital to understanding the picture and its subject. The torrent of the summer storm is a redeeming force in Moran's painting, as is the rainbow, the symbol of God's covenant and promise of life. Moreover, even as the falling rain is an element descending into what some have likened to Dante's inferno, it is also a rising form lifting out of the chasm and pointing toward the sun, the source of light and life. In this symbolic duality we see the essential character of water in the canyon; it is both a destructive and creative force. It erodes the rock, washing it away at the same time it shapes it anew into its myriad forms.

The juxtaposition of these opposing elements, the rock and rain, hole and rainbow,

and their complex interactive symbology form the central ambiguity and meaning of Moran's painting. The conjunction of these forms in the picture is parallel to the conflict of positive and negative forces in the Grand Canyon itself. It is in this paradox that the significance of *The Chasm of the Colorado* and its place in the history of the West are centered.

The formal and symbolic characteristics of the painting, the history of the Grand Canyon, and the circumstances of the creation of *The Chasm of the Colorado* suggest a deep and profound content to the work, historically and artistically. Moran's sensitivity to the subtleties of the opposing elements of rock and water in his visual expression of the place suggests a close relationship to the controversies in the early 1870s about the arability of the desert Southwest and points to Moran's personal relationship with John Wesley Powell, the principal proponent of the debate. Furthermore, the Congressional purchase of two enormous paintings of giant holes to be prominently displayed in the Capitol building as national icons is provocative, and the inherent conflict represented by the legislative act demonstrates the need for reinterpretation of Moran's artistic portrayal of the West as well as the perception of the region by Americans in the last decades of the nineteenth century. *The Chasm of the Colorado* may be seen as a microcosm of its "grand original" and of important and influential events in the development of the American West.

POWELL'S SURVEY

The Chasm of the Colorado, like *The Grand Cañon of the Yellowstone,* resulted from Moran's travels with one of the four Great Surveys. In this case it was the 1873 expedition led by John Wesley Powell, a former professor of natural history at Illinois Wesleyan University who had been exploring the Colorado River and its tributaries since 1867. Powell, a one-armed Civil War veteran whom his associates always referred to as "Major," would head the U.S. Geological Survey after its reorganization in 1879 (after the first director, Clarence King, resigned in 1881) and direct the American Bureau of Ethnology.[8] Powell's contribution to America's understanding of its West in the last decades of the nineteenth century was considerable, especially in his sympathetic studies of native Americans and his scientific and practical theory of arid land management, but he is usually more readily remembered for his daring descent of the Colorado River into the Grand Canyon of Arizona, a feat first accomplished in 1869 and repeated several times in the early 1870s. Nevertheless, as a number of historians have explained (most notably Wallace Stegner and Bernard De Voto), to perceive Powell only in terms of his river adventures is to grossly underestimate the importance of the man.[9] His geological, hydrological, and ethnological theories and his broader understanding of their intellectual, aesthetic, and practical applications were visionary. His ideas, especially his prophetic comprehension of water's relationship to life in the West, had farther-reaching implications for the entire country than most people realized in the early years of southwestern development, a dangerous underestimation that persists even today. Powell's warnings and suggestions were largely ignored in his time because of the economic and political problems they presented, and only now are a few of them being put to use. Nevertheless, his

complex and ever-growing understanding of the forces that shaped and controlled the land and life in the West informed his survey and influenced his associates. They found their ultimate visual expression in Thomas Moran's picture *The Chasm of the Colorado*.

Powell's first trip down the Colorado River in 1869 was perhaps the most important of his explorations, since it was the first successful attempt to run the complete expanse of the river's previously uncharted rapids and canyons, but he did not document the experience in either written or pictorial form. That is surprising, perhaps, because several of the previous attempts to explore the region of the Grand Canyon, expeditions Powell was well acquainted with, had included artists who extensively documented their experiences visually.[10]

Exploration of the Grand Canyon area dates all the way back to the mid sixteenth century, with the travels of Vásquez de Coronado, and it was continued sporadically by Spanish missionaries during the following two centuries. The first pictures of the country, however, were not produced until less than twenty years before Powell's survey. In 1849 the topographical expedition of Lt. James H. Simpson reached the Canyon de Chelly in what is now eastern Arizona, and in 1851 Capt. Lorenzo Sitgreaves explored part of the San Francisco Mountains and followed the Colorado River below the Grand Canyon. Both expeditions included artist Richard Kern, and his landscape views, although not specifically of the canyon, illustrated the official reports.[11] During the Pacific Railroad Surveys in 1853, Lt. A. W. Whipple reexplored Sitgreaves's route, accompanied by Heinrich Baldwin Möllhau-

sen, a German artist, writer, and friend of the famed geographer Alexander von Humboldt. Möllhausen produced a number of images to illustrate Whipple's report.[12]

Möllhausen was again in the region in 1857–58, with Lt. Joseph C. Ives (who was also with Whipple in 1853), on an even more ambitious mission, to explore the Colorado River, traveling upstream from Fort Yuma into the Grand Canyon, to determine the waterway's navigability. Although the treacherous course turned back their specially built steamship before they reached their goal, the group traveled overland and descended into the depths of the canyon, the first Americans ever to do so as part of an official expedition. Therefore, Möllhausen and his colleague F. W. von Egloffstein are credited as the Grand Canyon's first portrayers. They illustrated Ives's final report with more than seventy-five elaborate landscape etchings and lithographs; that document was probably the most influential for Powell as he prepared his own investigation into the canyon country.[13] Though the artists' work is highly stylized and bears little relation to actual appearance, it does represent an important precedent for the Powell survey, especially for Moran's pictorial work.

Powell wrote and illustrated the report of his first season on the river in later years with information gathered from subsequent trips, and he did not acquire the services of an artist until 1871. His survey was mostly privately supported and staffed by volunteers during its first three years (1867–69), and when it was finally federally funded in 1870 it was first administered by the Department of the Interior. Powell did not mount a full expedition that year, choosing instead to use the time to pre-

pare for a more comprehensive trip the following year. Therefore, when a clerical error put the survey under the authority of the Smithsonian in 1871, Powell's instructions for his season's preparations came from the Secretary of that institution, Joseph Henry.[14] He wrote Powell in March, "In accordance with the provisions of this act you will proceed with the Exploration employing such additional men and purchasing such additional instruments and stores as you may find necessary. You are further directed to employ a photographer who will take such views as may be useful in illustrating the topography, geology, etc. of the region surveyed."[15] Powell had already taken steps in that direction with his offer to a St. Paul photographer, Thomas Zimmerman, in early December 1870, but Zimmerman regretfully declined and, following Henry's orders, Powell was forced to look elsewhere.[16]

That spring he hired E. O. Beaman, a photographer recommended by the prominent New York photography supplier E. and H. T. Anthony and Company, where Powell purchased his camera equipment. Little is known of this artist either before his work for Powell or after, and he only stayed with the expedition for one season. Nevertheless he produced approximately 350 images from the experience, some of which Moran later used for his illustrations. During his short tenure Beaman was not merely a government employee but also a financial partner with Powell and Powell's brother-in-law and chief topographer for the survey, Almon Harris Thompson. In addition to using Beaman's photographs for lobbying and illustrating Powell's publications (in woodcut form), the three men agreed to sell

the Beaman photographs, primarily as stereographs, to the public and split the profits among them. When Beaman left the survey in January 1872, Powell purchased his negatives outright and subsequently entered into a similar agreement with his successors, selling photographs through the Jarvis Company of Washington, D.C., under the imprint "U.S. Topographical and Geological Survey of the Colorado River of the West by J. W. Powell and A. H. Thompson." In that way Powell publicized his survey through the popular visual medium and also provided monetary motivation to his photographer and made for himself a substantial, if perhaps questionable, income.[17]

In addition to Beaman, the 1871 expedition also included Frederick Samuel Dellenbaugh, a self-taught artist who later became the first historian of the Powell expedition. Although his artistic contribution was limited to topographical drawing and the occasional landscape view, he was useful for recording features such as petroglyphs and pictographs that could not be reached with the camera.[18] Even though artistic precedents had been established by previous explorers, Powell was never as committed to traditional artistic documentation as Hayden. Powell and Thompson were apparently much more interested in the immediate and tangible profit to be made through photographs. Since Dellenbaugh seems to have left after 1872, he apparently did not work with Moran, but his efforts during his time with the survey surely influenced Powell's desire to continue employing an artist.[19]

Beaman's departure caused a good deal of concern about his replacement. The photo-

graphic assistant, Walter Clement Powell (J. W. Powell's cousin, called Clem), was not capable of the job, and the boatman, John K. ("Jack") Hillers, who had taken an interest in the process, was not sufficiently trained to take over. In February Powell arranged to hire James Fennemore, a Salt Lake City photographer, and by March Thompson, who was in charge of the survey's winter base camp, was looking forward to his arrival. From Kanab, Utah, Thompson frequently wrote about the situation to Powell, who was in Washington lobbying for appropriations. In March he wrote, "Clem and Jack are doing well photographing. Got 30 views from Kaibab and Kanab Cañon—I think 20 of them are good. . . . Clem and Jack can make pictures I think, especially Jack. When we get Mr. Fennemore we will be pretty strong in the picture line." [20] And in May he followed with an update:

Fennemore has made say 80 negatives. Some fine views. I do not think he is much improvement on Beaman. Jack is really a better artist than either, that is [he] has better ideas as to what comprises a real representative view or a salable one even. Lacks a little in manipulation yet. I prophesy that Fennemore will weaken before he gets to the Grand Cañon. He and Jack are printing from negatives [taken] on the last trip. By next mail will send you a lot. I think Clem can take a pretty good picture. Am fitting him up so he can take pictures while F[ennemore] is in Mound Cañon. [21]

Thompson here reveals his mercenary interest in the photography, his appreciation of the aesthetic difference between a "real representative" view and a "salable one," and the careful screening of the images offered to the public. Another letter in May reveals more of Thompson's opinions as he sent Powell the promised photographs:

Think Fennemore's pictures are very frosty—generally he overexposes and overdevelops. . . . Jack is quite anxious that you should so arrange that he can work at photography through the Grand Cañon—I had rather have Jack (if he had more experience) than Beaman, Fennemore, and Clem combined—will work harder and select better, more characteristic, and more artistic views. Clem and Fennemore do not love each other much. Clem can take a pretty fair picture but is liable to scratch or otherwise spoil it. . . . Shall let him make sort of a specialty of views with the large single lens. If it is thought best to *push the pictures* in Grand Cañon, would bring out a new pair of Dallmyers tubes. [22]

Thompson went on to discuss the plans for the season's topographical work in the Grand Canyon but dismissed its importance as most of the work had already been done, saying, "The main work in the cañon [this year] is pictorial. We ought to run two photographers and push the trip right through. Two boats with seven men are enough to do the work in the shortest possible time—the third boat and crew is not needed unless we run *three photographic galleries*" (three photographers, Fennemore, Hillers, and Clem Powell). [23] With this statement Thompson demonstrated the priority that Powell was giving pictorial documentation by 1872. The primary exploration and basic mapping of the river system were essentially complete, and the time had come to disseminate the results through the visual and published media.

The pronounced interest in artistic documentation was not limited to Thompson. The Hayden survey's phenomenal success in the Yellowstone, Moran and Jackson's extraordi-

nary images, and the extragenerous congressional appropriations that Hayden subsequently received were surely inducement enough for Powell to attempt similar results.[24] In the spring of 1872, just after *The Grand Cañon of the Yellowstone* was revealed to the public and concurrent with the concern over his photographers, Powell offered Moran a place with his expedition that season. Unfortunately the artist had to decline because of his previous commitments to *Picturesque America,* but he expressed regret, saying, "I feel that I miss a glorious opportunity in not being able to take advantage of your generous offer."[25] Although the same commission prevented Moran from joining Hayden again, the artist later revealed to that survey leader another reason for not going to the canyon: "Colorado Powell was very much disappointed that I did not go with him last summer and he offered me great inducements, but the Yellowstone is my first love."[26]

The summer of 1872 had important developments, however, for the future of Powell's survey and Moran's art. Confirming Thompson's prediction, Fennemore became ill after three months and left the survey in July. During his short stay, however, he no doubt influenced the pictorial success of the expedition through the undetermined number of photographs he made and, even more important, by tutoring Jack Hillers, who succeeded him as chief photographer.

Powell had hired Hillers as a boatman early in 1871 in Salt Lake City. Although he had no formal artistic or photographic training, he eventually became a noted landscape photographer whom Carleton Watkins once praised as "a clean worker in which lies the great secret of Photography."[27] Hillers worked for Powell in this capacity from 1872 to 1879, and with the reorganization of the U.S. Geological Survey in 1879 he became chief photographer for the bureau, a post he retained until his retirement in 1900. His experiences of 1871 and 1872 are well documented in his published diaries, which are full of accounts of his photographic assistance to Beaman and Fennemore, and in them we see his growing interest in the process, if not the art, of portraying the scenery the survey encountered.[28] From them we also know that he may have seen Moran's work in the form of illustrations, as he noted in his entry for July 18, 1871: "Finished the irons and read Scribbner's Magazine." The current issue that Powell would have brought from the East would have been either May or June, each containing a Yellowstone article illustrated with Moran's images.[29] Whether he was familiar with Moran's work or not, Hillers was the photographer who worked most closely with the artist during his first visit to the canyon country in the summer of 1873, and it was Hillers's photographs that Moran referred to in his studio the following winter, as he finished painting *The Chasm of the Colorado.*[30]

Unfortunately, the extensive diaries kept by Powell's men during the first river descents were not continued after 1872, and the facts of Moran's participation in the expedition in 1873 must be pieced together from other sources. It seems that the artist had intended originally to accompany Hayden's expedition that summer, not Powell's. Moran wrote Hayden as early as January 1873, saying, "I shall be hard pressed to get through my work by the time of departure next summer," and in April, "am very anxious to see you in regard to the details of the summer's trip."[31]

Fig. 54. Thomas Moran, *Springville Canõn,* 1873, wood engraving, 10¼ × 7⅞″ (26 × 20 cm). From *The Aldine* 7(January 1874):14. Courtesy of the Thomas Gilcrease Institute of American History and Art, Tulsa, Oklahoma; Morand and Friese no. 84.

Because of Indian hostilities in Montana and Wyoming, Hayden's party planned to move south that season into Colorado, and Moran seems to have expected them to visit the canyon region along the borders of Utah and Arizona. He was most interested in this part of the proposed trip, writing to Hayden in late May, "I saw Wheeler's photos [actually Timothy O'Sullivan's from the Wheeler survey] from the Grand Cañon of the Colorado today. They are poor and Jackson will knock spots out of them."[32] But Hayden's plans either changed or Moran misunderstood the itinerary, because he wrote a regretful letter to Hayden at the end of June with the news:

I was very sorry not to have been able to see you before you left, in order that I might have had definite understanding of just where you would be able to go this season. There were a number of reasons which made it imperative upon me to reach the Grand Cañon of the Colorado this summer if it were possible to do so, and also to reach it at a time that would enable me to return East by the 1st of September. Under the impression that you would go there I made a number of contracts to furnish pictures of the region, amounting in all to about 100, but your last letter left me in doubt as to whether you would go there at all and in any event that you would not go down until the end of your season which would imply a very late return.

This served to render my chances of reaching that region very remote and although exceeding desirous of accompanying your survey this summer, I felt it obligatory on me to accept the offer made by Maj. Powell as the only chance of getting there within the limits of the time that I could give to it and I have agreed to accompany him. Mr. Colburn has also concluded to go. I hope that you will not feel that I do not appreciate your great kindness and the invaluable opportunity of seeing the region of your present survey; but my business relations with others and my intense desire to see

the Grand Cañon force me to change my original plan of accompanying you this summer.[33]

Thus did Moran decide to accompany Powell's expedition. Powell himself may have had added incentive to accommodate the artist. Earlier in the spring Riverside Press had responded to his manuscript narrative of his explorations (eventually published as a government document and as a separate book by the Smithsonian), with special concern for its illustration.[34] If Powell had not been already inclined to acquire the services of a first-rate artist, that would have seemed to require it.

The "Mr. Colburn" who accompanied Moran to the canyon was J. E. Colburn, a writer for *The New York Times* (fig. 1), who also traveled with commissions for *Picturesque America* and for his paper. Powell met the men

in Salt Lake City on or about July 8, and to-
gether they visited Brigham Young and a
number of other Mormon leaders. From there
they took the Utah Southern Railroad south
to the end of the line at Lehi and then went on
by stage to Springville, where Moran made
the sketches for his illustration of Springville
Canyon that appeared the following winter in
The Aldine (fig. 54). On July 15 and 16 they
climbed Mount Nebo, which Moran called
"the most magnificent sight of my life."[35]
Afterward Powell left the men with a guide,
and they continued south to meet Thompson
and Hillers and explore the area now known
as Zion National Park. It was Moran's first
visit to the Rio Virgin canyon, a region that
would provide him many future subjects, and
although there are a number of drawings from
the area dated 1873, at one point he reported
only that "the view was very fine and I made
one sketch."[36]

Moran hoped to run a portion of the river
with Powell's men but was not able to because
the little river mapping that remained was
scheduled for after his departure for the East.
Instead, he made several excursions along the
plateaus that overlooked the canyons and
worked later from Hillers's photographs of
the inner reaches of the canyon.

Hillers, Moran, and Colburn took an eight-
day trip to Mount Trumbull and on the way
got a good view of the Grand Canyon from a
spot known as Toroweap. The artist wrote his
wife an unusually descriptive passage about its
impression on him:

The whole gorge for miles lay beneath us and it
was by far the most awfully grand and impressive
scene that I have ever yet seen. . . . Above and
around us rose a wall of 2000 feet and below us a

vast chasm 2500 feet in perpendicular depth and ½
mile wide. At the bottom the river very muddy
and seemingly only a hundred feet wide seemed
slowly moving along but in reality is a rushing
torrent filled with rapids. A suppressed sort of roar
comes up constantly from the chasm but with that
exception everything impresses you with an awful
stillness. The color of the Great Cañon itself is red,
a light Indian Red, and the material sandstone and
red marble and is in terraces all the way down. All
above the cañon is variously colored sandstone
mainly a light flesh or cream color and worn into
very fine forms. I made an outline and did a little
color work but had not time nor was it worth
while to make a detailed study in color. We made
several photos which will give me all the details I
want if I conclude to paint the view. . . .

When we got back we found Maj. Powell had
arrived. . . . This afternoon the Major and I are
going up toward the Virgin River on a little trip to
see some lakes in caverns about 7 miles from here
and shall return this evening. Tomorrow morning
a party of 8 including Colburn, myself, and Powell
start for the Ki-bab [Kaibab] plateau to see the
Grand Cañon at that point. It is 3500 feet deep at
that point and I am inclined to think it is a finer
subject for a picture than the To-Ro-Weap view.
This trip will take 8 days and then I shall be ready
to come home.[37]

As eloquent as Moran was about his first
impression of the canyon, Colburn was more
expressive about Toroweap. In his *New York
Times* column he recounted both the history
of the region's exploration and the details of
their first trip to the rim. Significantly, besides
describing the route, baggage, and points of
interest, Colburn repeatedly emphasized the
character of the place, especially in comments
about water. In a more temperate region such
a common element would have been noted
only if a particularly beautiful waterfall or dif-
ficult crossing was encountered, but here mud

puddles left by the infrequent rains were both remarkable and essential to the group's survival. On the second day they found one that Moran described as "situated in as absolute a desert as I ever saw."[38] Colburn was more explicit:

[It was] a round hole surrounded by low volcanic elevations, where the drainage from a shower that, with great good fortune for us, had fallen two days before, had settled in quantity to the amount of fifteen or twenty hogsheads. The pocket has a rock bottom, and water remains in it until carried away by evaporation. . . . But we could go no farther, for the nearest water in the direction of the cañon was twenty-five miles away, and it was not certain that it might not be dried up, or as our Indian, Jim, expressed it in his language, 'have died,' in which case we should have to go seven or eight miles further, and out of our direct course to find a spring. . . .

[It] was so muddy that one could not see the bottom in a teaspoon full of it. But it tasted sweet, except a little clayey. The water [in another pocket they used at the next stop] was clearer, though discolored by organic matter. But it was thick with 'wigglers' or mosquito larvae, and 'tadpoles.' It was also bitter, and left a prickling sensation in the throat. Men and animals drank from the same pool.[39]

Colburn's preoccupation with water (it fills a good portion of his two articles written from the area) is, of course, characteristic of reports from desert regions, and the way the Indian personified the life-giving liquid is indicative of its importance to the native inhabitants. The irony, of course, is that the barrenness of the place, the endless rock without vegetation, was created by the action of water. Colburn recognized this as he compared the spectacle of the Grand Canyon with that of Niagara:

A mountain summit view is grand because of its vastness, and generally there is no impression like that made at Niagara, of force and power. At the Grand Cañon, the feeling of grandeur is not produced by power in activity, for the river is too far away, and forms too insignificant a part of the scene. Nor is it produced by the vastness of the chasm alone, for everyone has seen other things giving a more distinct impression of great extent or size. I think the feeling is one of awe and wonder at the evidence of some mighty inconceivable, unknown power, at some time terribly, majestically and mysteriously energetic, but now ceased. And yet the force that has wrought so wonderfully through periods unknown, unmeasured, and unmeasurable, is a river 3000 feet below.[40]

The river continued its work, carrying a flow equal "to the Ohio at Cincinnati," but was inaccessible to the thirsty men more than half a mile above.[41]

Unfortunately, Moran seems not to have written about the visit to Kaibab Plateau with Powell, and Colburn's brief mention of it in *Picturesque America* did not comment on the importance of having the survey leader with them. The Major's presence, however, as they took in the unparalleled view at the scenic overlook known as Powell's Plateau, was the highlight of the trip, and he surely provided the visitors with much more substantial information and enlightened impressions than they had received before. Powell was compelling and persuasive and, perhaps most important for Moran and Colburn, a persistent teacher. In addition to inspiring his men's trust and confidence in river descents, which were exceedingly dangerous and uncertain, Powell encouraged his crew to keep journals, frequently read aloud to them in camp, and continually shared his observations and thoughts

about the terrain they encountered. In the case of special guests such as Moran and Colburn, invited for the sole purpose of taking information back East, it seems certain that he would have shared with them his special way of seeing the canyon region.[42]

POWELL'S THEORIES

Powell, the son of an immigrant Methodist minister, grew up in a rural environment where learning was gained primarily from practical experience with the natural world and a love of books.[43] The observational and theoretical skills that he exhibited so energetically in his adult life grew out of those formative influences, and any interpretation of his accomplishments must incorporate their impact. From them he gained a fascination with the natural world, an appreciation for its higher significance, and the ability to translate these awarenesses into action. Powell's knowledge of the Grand Canyon and its surrounding country was more extensive, complex, and subtle than anyone else's of his time. He knew that the Grand Canyon was not simply a single gorge cut by a single river and that the surrounding territory should not be perceived as an easy division of farmland versus wasteland. Instead, the region was composed of myriad canyons, rivers, plateaus—arable, irrigable, and arid land—and Powell knew that any real understanding of the area must be equally multidimensional. His comprehension of its origins and characteristics was geological, geographical, and also practical and philosophical, theological and theoretical. All of this is evident in his writings, and because of his brief but no doubt productive time

spent with Moran in the region, it is also evident in the painting *The Chasm of the Colorado*.

Powell's most important contribution to the American understanding of its land was his comprehensive theory of arid terrain and its management. His ideas on this subject were profoundly innovative and extremely controversial. He recognized early in his western explorations, just as Colburn did on his first visit, that water, or the lack of it, was the key to the region, and he worked tirelessly to promote national policies that would acknowledge the special problems presented by the desert Southwest while creating new ways of addressing them. In his early reports Powell was terse and primarily descriptive, saying, for example, "The region of country embraced in this exploration is cut by profound gorges, traversed by towering cliffs, and receiving but a very small amount of rain. Much of it is a desert country. . . . The extent and character of such valleys as may be redeemed by irrigation has been noted."[44] In his cumulative expeditionary report, issued in 1875 in quarto form and illustrated by thirty-one Moran illustrations, Powell was much more expansive. Throughout the volume numerous descriptions combine analysis and vision, all pointing to a larger conception and appreciation of the whole:

It is easy to see that a river may cut a channel, and leave its banks steep walls of rocks; but that rains, which are evenly distributed over a district should dig it out in great terraces is not so easy to perceive.

The climate is exceedingly arid, and the scant vegetation furnishes no protecting covering against the beating storms. But though little rain falls, that which does is employed in erosion to an

extent difficult to appreciate by one who has only studied the action of water in degrading the land in a region where grasses, shrubs, and trees bear the brunt of the storm. A little shower falls, and the water gathers rapidly into streams and plunges headlong down the steep slopes, bearing with it loads of sand and for a few minutes, or a few hours, the district traversed by brooks and creeks and rivers of mud. . . . In a country well supplied with rains so that there is an abundance of vegetation, the water slowly penetrates the loose soil, and gradually disintegrates the underlying solid rock, quite as fast as, or even faster than it is carried away by the wash of the rains, and the indurated rock has no greater endurance than the more friable shales and sandstones; but in a dry climate, the softer rocks are soon carried away, while the harder rocks are washed naked and the rains make but slow progress in tearing them to pieces.[45]

Elsewhere he was more poetic:

Climb the cliff at the end of Labyrinth Cañon and look over the plain below and you see vast numbers of buttes scattered about over scores of miles, and every butte so regular and beautiful that you can hardly cast aside the belief that they are works of Titanic art. It seems as if a thousand battles had been fought on the plains below, and on every field the giant heroes had built a monument compared with which the pillar on Bunker Hill is but a mile stone. But no human hand has placed a block in all those wonderful structures. The rain drops of unreckoned ages have cut them all from the solid rock.[46]

Those passages demonstrate Powell's command of language and the art of manipulating it to serve his greater goal. He deliberately used rhetoric that matched the land's character, emphasizing that it was a land of extremes in which solid rock is broken not by rain in the cumulative sense but by rain drops, the smallest particle. He refers to the water as "de-

grading," "disintegrating," and "dissolving" the rock, all terms connoting destruction, but elsewhere he refers to irrigation water's potential to "redeem" the land, a creative and sacred act of renewal. He cast the slow work of nature into metaphysical terms, pointing to the earth and to the heavens as the source of its power, and juxtaposed the most unlikely elements in the process, just as Moran did by contrasting light and dark, rock and rain, chasm and rainbow, in his picture. Most important, Powell saw the philosophical aspects of the land as inseparable from their practical application; the two approaches were inextricably entwined.

Powell published his definitive statement on desert land management in 1878, but because he was gathering data and conceiving his ideas when he worked with Moran in 1873, his theories may be considered relevant, even critical, to the artist's conception of the region as expressed in *The Chasm of the Colorado*.[47]

The salient feature of the land west of the hundredth meridian, from the middle of the plains states of Texas, Oklahoma, Kansas, Nebraska, and the Dakotas all the way to the Sierras in California, is its lack of moisture. As a rule this area—comprising two fifths of the United States—receives less than twenty inches of rainfall per year, the minimum for successful agriculture. The problem is not fertility; by the 1870s the Mormons in Utah had already proved that the dry land could be bountiful when irrigated. Instead, the amount of available water for irrigation and the difficulty of distributing it adequately are the critical factors.[48]

The national Preemption (1841) and Homestead (1862) acts strongly encouraged settlement of the farthest reaches of the continent,

even before accurate land-use surveys could be completed. The first allowed anyone to settle on a plot before it was surveyed and subsequently purchase it for a nominal amount; the second provided free title to anyone who would live on and work an unallotted, surveyed, 160-acre tract for five years.[49] They were a useful means of providing for the settlement of the eastern half of the country, where that amount of land could support a family, but as Powell pointed out early, it was highly impractical in the West, and increasingly so the farther west one went. The arid land was simply not suited to making a living on such a small acreage, even with adequate access to water, an attribute most of the land did not have. Nonetheless, for various reasons, that fact was either unknown to or ignored by policymakers in Washington and the thousands of settlers who flooded the region beginning in the mid-1860s. By the time Powell began his work, the effects of the problem were already evident. Widespread corruption of the land filing system allowed large corporations to gain control of massive amounts of land—and the water it contained—and small farmers not fortunate enough to have their own water source were often forced to buy it from the monopolies for exorbitant prices. Even then they could hardly survive on the small allotment; in the arid region, or in the subhumid zone (semiarid) during dry years, the 160-acre quarter section (two square miles) would barely support four cows.[50] As a result, the disparity increased between those who had water and those who did not, between those with enough land to make it profitable and those without.

As a result of his scientific explorations, farming experience, and analytical skills, Powell understood the larger implications of those problems, and he devoted large amounts of time to developing alternatives to the unworkable system. His arid-lands report (1878) was a practical proposal to rectify the disparities of both water availability and land ownership in the region. Summarized simply, his plan divided the usable arid lands into three categories: irrigable (agricultural), pasturage (nonirrigable, but useful for herding), and timber. The first two were the most important for settlement. Powell boldly suggested that they be divided not into conventional rectilinear plots, which gave all the water to a lucky few, but instead along topographical lines, allowing water access to the greatest number. The plots would also differ from eastern homesteads in size; pasturage tracts with minimal water would be 2,560 acres. Irrigable plots, by contrast, would be 80 acres, 80 acres less than an eastern farm because that was all one family could feasibly irrigate. Furthermore, irrigation and herding would be organized into districts and managed in common. Title to water rights would be attached to the individual farms, but control of the water would be the province of the district, and ranches would be unfenced, with herds roaming together. Cooperative use of the land and water would be essential to everyone's success.[51]

His plan, of course, went against the independent freeholder system and the entire federal bureaucracy that supported it. It was, in fact, practically communistic, or at least socialistic in some aspects, and it was highly objectionable to certain interested groups, most notably the private corporations and large landholders that had vested interests in maintaining and profiting by the current system. It

was also fraught with implementation difficulties, as Powell recognized:

> Many of the settlers are actually on the ground, and are clamoring for some means by which they can obtain titles to pasturage farms of an extent adequate to their wants, and the tens of thousands of individual interests would make the problem a difficult one for the officers of the Government to solve. A system less arbitrary than that of the rectangular surveys now in vogue, requiring unbiased judgment, overlooking the interests of single individuals and considering only the interests of the greatest number, would meet with local opposition. . . . The surveyors themselves would be placed under many temptations, and would be accused—sometimes rightfully perhaps, sometimes unjustly, of favoritism and corruption, and the service would be subject to the false charges of disappointed men on the one hand, and to truthful charges against corrupt men on the other. In many ways it would be surrounded with difficulties and fall into disrepute.[52]

His solution was to allow the district members to subdivide the land themselves, reasoning that the interests of greedy individuals would be counteracted by the group. This again, of course, smacked of communism; even though it was inherently democratic, it denied the existing provisions for land ownership according to free will.

Powell's proposal was attacked from all fronts. In addition to the vocal opposition of those already strongly vested in the system, several factors worked to the plan's disadvantage. One of the most important was what Stegner has called the Gilpin mentality, after the famed popularizer of the West, Colorado's first governor, William Gilpin. Gilpin had, through lectures and publications in the 1860s and early 1870s, almost single-handedly transformed the American public's image of the West from "the Great American Desert," as it had been dubbed by early explorers, into a mythic paradise, "the Great American Garden." He was supported by the misconception, popular at the time, that "rain follows the plow," a dangerous notion that climate would change with the influx of civilization.[53] Perhaps the most important contribution to the general skepticism of Powell's ideas was the record rainfall and bumper crops seen throughout the arid and semiarid regions in those years. Powell's wisdom, that the rain would ultimately fail and the land would return to its characteristic dryness, was dismissed on all levels as pessimistic and bad for business. As Stegner wrote, promoters and western politicians envisioned a West "full of settlers, full of trainloads of immigrant farmers, full of new tracks, new roads, new towns rising on the prairie." Powell's proposal was resoundingly denied.[54]

The 1880s and 1890s proved him right and the overoptimistic boosters disastrously wrong, but by that time it was too late. A series of droughts, farm failures, and financial panics ensued, the first in a series of such cycles that culminated in the Great Depression. Powell took no satisfaction in this, but he was vindicated in his knowledge that the land itself always has the final word. This is perhaps the most important aspect of his understanding of the West and, as we shall see, of Moran's painting: in the end the land will assert its dominion over the fate of its inhabitants, and any successful relationship must be based on understanding and accommodating its essential character.

THE CHASM OF THE AGES

In his writings Powell explained geological facts and explored the land's usefulness, but he also expressed something of their awesome mystery that no pure scientist could explain. In his 1875 report he used the ageless metaphor of Genesis as he expounded on the classifications of strata: "Some [rocks] are soft; many very hard; the softer strata are washed out; the harder remain as shelves. . . . One might imagine that this was intended for the library of the gods; and it was. The shelves are not for books, but form the stony leaves of one great book. He who would read the language of the universe may dig out letters here and there and with them spell the words, and read, in a slow and imperfect way, but still so as to understand a little, the story of creation." [55] This is not only the scientist interested in the formation of his geology; here Powell is also teacher, preacher, and neophyte, seeking to convey his impressions of the grand drama he perceived. The passage suggests that any interpretation of his work about the canyon region can be read, just as he himself read the rock, as fact, as symbol, and as prophecy.

That Powell was able to share his vision with Moran is evident in *The Chasm of the Colorado.* The composition of the painting, with its pronounced intersection of land and water in the center, the prominence of the water pockets in the foreground, and the silvery river winding its way through the depths, would seem enough to emphasize the relationship of rock and river and indicate that Moran was fully aware of Powell's erosion theories. But the more complex symbology of the painting suggests that Moran and Powell shared an even deeper understanding of the Grand Canyon that is related to the lesson of the arid-land theory and to Powell's reading of the canyon as a great book. Powell himself said as early as 1869, "For two or three years I have been engaged in making some geographical studies in the mountains to the east and north of the Colorado Basin, and while pursuing them the thought grew into my mind that the cañons of this region would be a Book of Revelations in the rock-leaved Bible of geology. The thought fructified, and I determined to read the book; so I sought for all the available information with regard to the cañon land." [56] With that provocative statement Powell gave us another key to the canyon and to Moran's painting. Many of the compositional elements within *The Chasm,* besides being characteristic of the region of the Grand Canyon, are important theological symbols that appear in both Revelation and Genesis. The serpent, eagle, rock, tower, and the storm with its rainbow all figure prominently in these biblical texts and may be seen as essential indicators of meaning in Moran's picture. Equally significant are the colors, the varied and vivid hues of vermilion, purple, green, and brown, which echo the Scriptures' emphasis on color. In the canyon and the Book of Revelation, for example, the rivers seem to run with blood; Powell, in his writings, describes how the rivulets in the wake of a shower were quickly reddened with the colored sandstone they dissolved and ran directly off the canyon walls and into the river, turning everything in their path a brilliant crimson.

Perhaps most revealing of all is Powell's own conclusion to his 1875 final report. Although lengthy, its significance for Moran, and for Powell, requires full quotation:

We have looked back unnumbered centuries into the past, and seen the time when the schists in the depth of the Grand Cañon were first formed as sedimentary beds beneath the sea; we have seen this long period followed by another of dry land—so long that every hundreds or perhaps thousands of feet of beds were washed away by the rains; and, in turn, followed by another period of ocean triumph, so long that at least ten thousand feet of sandstones were accumulated as sediments, when the sea yielded dominion to the powers of the air, and the region was again dry land. But aerial forces carried away the ten thousand feet of rocks, by a process slow yet unrelenting, until the sea again rolled over the land, and more than ten thousand feet of rocky beds were built over the bottom of the sea; and then again the restless sea returned, and the golden purple and black hosts of heaven made missiles of their own misty bodies—balls of hail, flakes of snow, and drops of rain—and when the storm of war came, the new rocks fled to the sea. Now we have cañon gorges and deeply eroded valleys, and still the hills are disappearing, the mountains themselves are wasting away, the plateaus are dissolving, and the geologist in the light of the past history of the earth, makes prophecy of a time when this desolate land of Titanic rocks shall become a valley of many valleys, and yet again the sea will invade the land, and the coral animals build their reefs in the infinitesimal laboratories of life, and lowly beings shall weave nacrelined shrouds for themselves, and the shrouds shall remain entombed in the bottom of the sea, when the people shall be changed, by the chemistry of life, into new forms; monsters of the deep shall live and die, and their bones be buried in the coral sands. Then other mountains and other hills shall be made into beds of rock, for a new land, where new rivers shall flow.

Thus ever the land and sea are changing; old lands are buried, and new lands are born, and with advancing periods new complexities of rock are found; new complexities of life are evolved.[57]

With this climactic conclusion Powell summarized his perceptions and emotions at the Grand Canyon. The passage's rhythmic cadences and symbolic allusions have their source not only in the Bible but also in the land itself. For Powell the endless cycles of birth and death, of renewal and disintegration, were made manifest in the Grand Canyon. To him it was the panorama of the ages.

Appropriately, the last illustration in Powell's 1875 report is a woodcut version of Moran's *Chasm of the Colorado* (fig. 55). Shortly after the painting's completion, the survey leader wrote: "It required a bold hand to wield the brush for such a subject. Mr. Moran has represented depths and magnitudes and distances and forms and color and clouds with the greatest fidelity. But his picture not only tells the truth, it displays the beauty of the truth." He went on to describe the details of the picture and concluded with an intriguing comment:

The painting is called "The Chasm of the Colorado," and rightly. The Grand Cañon of the Colorado is yet to be painted. The view selected is from a point many miles away from the cañon itself and at a place where the side of the plateau had been deeply eroded by a cataract stream, and it is probably a better picture for that reason. There are more interesting elements in this point of view than there would have been had a point of view been selected where the gorge itself would have been the principal feature.

When the Grand Cañon of the Colorado is painted the artist must stand by its raging waters and look up at its towering walls, and be overwhelmed by the gloomy grandeur of its depths.[58]

While Powell may have been making a scientist's distinction in saying that Moran had painted the chasm instead of the canyon, he may also have been revealing a more personal belief. By insisting that the Grand Canyon

could not be painted without descending to its depths, Powell, who had run the treacherous river a number of times, studying the canyon from the inner recesses, may have been asserting that such a rite of passage was required to comprehend the place thoroughly. Moran's painting, with its panoramic vista across the canyon, could only suggest that passage. And so, perhaps, will the geologist always consider the layman's view, no matter how informed, for only one who has read the ages by studying his way layer by layer through the strata can claim the fullest revelation.

Moran's painting did, nevertheless, make a dramatic impression on its first viewers. As William Truettner has pointed out, the criticism of *The Chasm* was somewhat more mixed than for the Yellowstone picture, which had been almost unanimously acclaimed, although most praised the later painting's grandeur of vision and its technical merits.[59] The reviews that found the picture troubling are the most interesting; although they first appear simply negative, some of them, much more than those that praise the painting unequivocally, reveal a surprising sensitivity to the work's most important characteristics.

The Chasm's primordial qualities were not completely acceptable to a public accustomed to works of art that did not challenge their preconceptions, but the critics' reference to this aspect of the painting, even when they regarded it as negative, indicated that the more profound issues of the work—and of the "grand original"—had been successfully captured in visual form. These reviewers called the painting everything from "the wildest, and . . . [most] diabolical scene man ever looked upon" and "Dante's Inferno" to "a

Fig. 55. Thomas Moran, *The Grand Chasm of the Colorado,* ca. 1873, wood engraving, 4⅛ × 7⅛″ (10.5 × 18.1 cm). From *Scribner's Monthly* 9(February 1875):408. Courtesy of the Library of the National Museum of American Art and the National Portrait Gallery, Smithsonian Institution.

grand transformation scene gone wild."[60] Others were more subtle, with the most provocative comments coming from Moran's friend at *Scribner's,* Richard Watson Gilder, and Clarence Cook of *Atlantic Monthly,* who had each written perceptive reviews of the Yellowstone painting two years earlier. The two writers, although uncomfortable with many aspects of *The Chasm of the Colorado,* were drawn to its disturbing qualities. Gilder wrote:

It is awful. The spectator longs for rest, repose, and comfort. . . . The long vista of the distant table-land suggests a sunny place of refuge from all this chaos and tumult. But for the rest there is only an oppressive wildness that weighs down the senses. You perceive that this terror has invaded the sky. Even the clouds do not float; they smite the iron peaks below with thunderous hand; they tear themselves over the sharp edges of the heaven-defying summits, and so pour out their burdens in showers of down-flying javelins.[61]

Such terminology seems to come straight

from Revelation. Gilder of course recognized this, noting the painting's "reverential feeling for Nature," and he concluded with a comparison of *The Chasm* and *The Grand Cañon of the Yellowstone:* "This later picture is a more daring attempt; it shows the growth of the artist's mind and powers. But its subject is less fortunate, because less pleasing. It is more crowded with 'effects' and therefore, will seem to lack that firm unity which distinguishes the earlier picture; but in treatment, handling, and management of color, this is even more satisfactory than the first; and like that, it grows in power on the beholder, haunting his memory like the solemn music of a psalm." [62] Gilder, in acknowledging that *The Chasm*'s scenery was "less pleasing" than that of the richly colorful and more conventional Yellowstone painting, was not suggesting that the canyon view was less successful than its predecessor but rather that it took more effort on the part of the viewer to appreciate its unusual beauty— what Powell called "the beauty of the truth." What might be considered negative criticism was in fact admiration, a recognition that although *The Chasm of the Colorado* was more difficult than the Yellowstone picture, its rewards, which would come with time and understanding, would outweigh those of the earlier work.

Clarence Cook, who was more willing to condemn the painting for what he considered its artlessness, was the most direct in drawing parallels between the painting's subject and its epic qualities. He likened *The Chasm* to Dante's descriptions of hell, quoting a passage from *The Inferno* as a verbal analogy to the picture, and he emphasized this with his own judgment, "Here there is no loveliness for hundreds of miles, nor anything on which the healthy human eye can bear to look (the scientific eye excepted), and this scene is only the concentrated ghastliness of a ghastly region." But even in his criticism Cook could not ignore the power of the image, and he resorted to Powell's style: "The river in working its way down to the lower level (where it is seen in one or two places shining in its bed like a harmless silver snake) has acted with the caprice of water, and eating into and around the rock has left the most fantastically shaped hills, hillocks, crags and islands, so that the aspect of things is as if a raging ocean had suddenly turned to stone, and the billows stood fixed, with icebergs and leviathans caught in their huge swing and play." [63] Cook here repeats the same kind of ancient metaphor that Powell proclaimed to be the soul of the Grand Canyon. But he finally determines that Moran's picture lacks redemption, concluding, "The only aim of art is to feed the sense of beauty; it has no right to meddle with horrors and desolation." Even with that final condemnation, however, Cook, perhaps more than any other, pointed to the essential issue of the painting.

The question of redemption, finally, is at the center of *The Chasm of the Colorado,* literally and figuratively. Powell's terms for the action of water in the desert were not accidental; it could either "degrade" or "redeem," according to divine or human intervention. It could erode the land, in flash floods or in a gradual wearing of the soil, evaporate so dramatically as to wither everything, or come in sufficient amounts as to allow for the creation of a variety of forms of life. The land was one of extremes, physically and socially, with the great

disparity of fortunes to be made or lost. In Moran's image the duality is there as threatening—the storm and the winding river—and as creative, when these two acts of water create new life and new forms.

When Clarence Cook in 1874, or William Truettner one hundred years later, pointed to the painting's subject as a "demoralized land," or "lack[ing] in redeeming inspirational appeal," they were each overlooking the central element in *The Chasm of the Colorado*.[64] The rainbow, which appears only partially in the center of the painting, is the potential redeeming force of the maelstrom. Its source is the confluence of the life-giving elements of water and light, where, as found in Genesis, it is the symbol of God's covenant with man after the Flood: "And it shall come to pass, when I bring a cloud over the earth, that the bow shall be seen in the cloud: And I will remember my covenant, which is between me and you and every living creature of all flesh; and the waters shall no more become a flood to destroy all flesh."[65] And too, it is found at the end of the Bible in Revelation as part of the throne of Christ the Judge at the Last Judgment, where it acts as a warning to unrealized potential, the failure of man to fulfill his part of the covenant.[66] Moran's rainbow is only a partial one, pointing to the unfinished state of the task. It may be completed, redeeming the land and its inhabitants—perhaps according to Powell's suggestions for arid land management—or it may be dissolved in the fury of destruction.

The promise inherent in the rainbow, and implicit in the unresolved tension of the picture, may provide clues to the remaining question, that of why the United States Congress would choose such an ambiguous and paradoxical image to hang in the Capitol as a national symbol, opposite Moran's other painting, *The Grand Cañon of the Yellowstone*. The issue is problematic in part because of the difficulty in pinpointing the defining features of American self-perception at any time in history. Therefore, instead of springing from a single theory, the answer may be found in, or as a combination of, several possibilities, just as any interpretation of *The Chasm* must be. Unfortunately, as with the earlier picture, the records that could provide some information about the issue (the minutes of the Joint Committee on the Library, the legislative body in charge of the acquisition of works of art for the Capitol) are missing and cannot be consulted for the debates about the purchase.[67]

Even more pronounced than the giant depression of Yellowstone canyon is the gaping negative space of *The Chasm of the Colorado*. The tremendous rift in the earth's crust, coupled with the apocalyptic storm, would seem to controvert any appeal to the Congress. The purchase of the Yellowstone picture may be explained as a visual commemoration of the country's first national park, as well as an appreciation of a much less difficult composition and concept, but that of *The Chasm* would appear at first to have as its primary logic the simple symmetry of acquiring a companion piece to the first work, identical in size and complementary in subject—another western American wilderness that had been recently conquered. The notion would have been supported by the already conventional argument that the wonders of the American West were a means by which the United States could distinguish itself from

Europe. Such analogies as "The Switzerland of America," for Colorado, as we have seen in metaphorical description, rely on familiarity with both the old and the new, and in 1874 the Grand Canyon was too far beyond tourist or settlement routes and perhaps too desolate to be useful for such an argument. Nevertheless, it was perceived as a place of distinction, albeit an uncertain one, which could represent the grandeur of America to the rest of the world. One early critic affirmed its inclusion in the pantheon of officially sanctioned wonders by asserting that Moran's painting "possesses an independence of character and originality that are purely American, in the best sense of that much abused word."[68] Such commentary also paralleled on a national level what Powell related to a universal one.

Although this way of seeing the painting— as another grand image of western American uniqueness—was certainly an important argument for its federal purchase, it does not, however, address the image's apocalyptic overtones and the tension of its central elements. Congress's acceptance of an enormous picture of a giant rift within the physical boundaries of the United States ten years after the Civil War seems to suggest, with the benefit of hindsight, that by 1874 the nation at last seemed capable of acknowledging its "faults," of recognizing that it was possible to live with them and even to turn them to advantage. Such an attitude is not the uncompromising nationalism of Manifest Destiny but instead one that could face the difficult realities presented symbolically by the Grand Canyon and Moran's image of it during a storm. The transformation in this instance occurs, poignantly, after a great conflict had torn the nation apart. After overcoming the most de-

structive schism in the nation's history, perhaps the United States could accommodate a variety of images of itself, including huge iconic portrayals of enormous fissures, without fear and with a sense of accomplishment and acceptance. The partial rainbow in the painting could be seen as it had been for centuries, as the redeeming symbol of survival and a challenge to the future. After its most harrowing trial the maturing nation may have been ready to contain and accept not only the grandeur of the Grand Canyon but its darker symbolic implications as well. Having made the rite of passage through the depths, the re-United States emerged shaken but with new understanding of itself.

A final, more pessimistic speculation, and one that is probably more accurate, is that as Congress purchased Moran's *Chasm of the Colorado,* it perceived the painting in the same way the nation perceived Powell's theory for arid-land management—by denying or ignoring its apocalyptic warning. Confronting the realities of Powell's proposal was too difficult; it would have meant restructuring an entire national system and, even more problematic, acknowledging that Gilpin and the thousands who ascribed to and invested in his rosy view of unending prosperity in the West were wrong. It was in their interest to dismiss Powell as a misguided doomsayer. In the same fashion, the unresolved tension, the impending judgment, inherent in Moran's painting could be dismissed. It was easier either to reject the work as artless or to embrace it as a great nationalistic icon, continuing the myth. The rainbow could continue to be the sign of the untarnished convenant and the West the pot of gold at its end. To do otherwise would have been devastating. But, as Powell in his

writings and Moran in *The Chasm of the Colorado* seemed to know, the land's ultimate authority cannot be denied. In the end it will assert itself and claim its dominion.

MORAN'S STUDIES OF THE CANYON, SOURCES, AND RELATED WORKS

The Chasm of the Colorado was not, of course, Moran's only artistic effort to result from his experiences with Powell's expedition in 1873. The painting was the culmination of a series of field sketches and studio drawings, and he produced many related works of the canyon region that reveal the artist's working method and his response to the area.

As we have seen in *The Grand Cañon of the Yellowstone,* Moran's method of composing major works was to assemble a single view from a variety of vantage points and individual vignettes, often rearranging proportions and relationships to create what he called his "impression." The result was faithful to the original in its parts but was actually a composite of Moran's own making. Although this process is remarkably apparent when the Yellowstone picture is compared with the field sketches, photographs, and the canyon itself, it is not so easily perceived in *The Chasm of the Colorado.* The Grand Canyon's similarity from a multitude of locations complicates the comparison of modern photographs with Moran's composition, and it makes determining his manipulations more difficult.

Unlike the Yellowstone picture, Moran left a record of his preliminary study for *The Chasm.* This work (fig. 52), known today only from a photograph left in Moran's studio and from its reproduction in Thurman Wilkins's

Fig. 56. Jack Hillers, *The Grand Cañon of the Colorado (from Toroweap),* 1873, photograph. United States Geological Survey Photographic Library (Hillers 902). The figure looking out over the view is Thomas Moran. The middleground buttes compare closely with those in *The Chasm of the Colorado.*

1966 biography, seems to be the highly detailed underdrawing of the final oil rather than a separate preparatory study.[69] The drawing reveals that several important changes were made after Moran began to paint. The central area of the oil, the V-shaped gorge into which the shower pours, is vague and undefined in the charcoal. And too, the left side of the work is different. The vertical wall enframing the composition is there, but not the distinctive tower in the middle distance.

With that in mind, it is instructive to examine the painting's progress for what it indicates about the sources. Moran wrote to Hayden as early as October 1873 that he was at work on

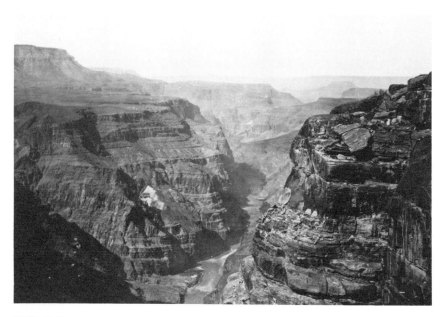

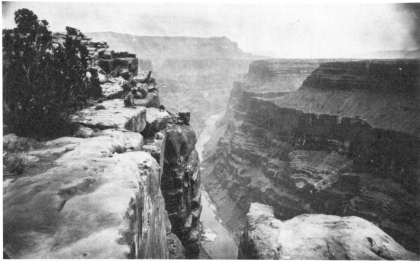

Fig. 57. Jack Hillers, *The Grand Canõn of the Colorado,* 1873, photograph. United States Geological Survey Photographic Library (Hillers 62).

Fig. 58. Jack Hillers, *The Grand Canõn of the Colorado,* 1873, photograph. United States Geological Survey Photographic Library (Hillers 431a).

the design and "it promises splendidly." That was followed a month later with, "I heard that Powell had returned to Washington. I would very much like to see his photos and also those that you made the last season. . . . I have not yet touched paint to the Colorado Chasm, but have finished the design for it in charcoal."[70] Powell did bring Moran the desired photographs at Thanksgiving, but obviously, all but a few details of the final composition were already in place. Thus Moran did not, in fact, use Hillers's photographs (figs. 56–58), except at the very end of the conceptual process. That has not been previously recognized, but it is an important point, in part because it sets this painting apart—the artist relied heavily on photographs for most of his other major works—and also because it places even greater significance on the sketches that formed the basis for *The Chasm* (figs. 59–63).

Moran began painting soon after the late November visit, and he wrote Powell in mid-December with the news that it was going well: "I have been pretty constantly at work on the Big Picture for the last two weeks and it has progressed wonderfully for the time and promises all that I could desire of it. I have got our storm in good."[71] He also promised to send a photograph of the charcoal drawing, as Powell had been "highly delighted with the design" and had commissioned Moran to paint another large picture of the Grand Canyon for himself.[72]

Although the dating of Moran's drawings is often tentative because the artist signed and dated many of them late in life, there are a few that are certainly from the 1873 visit to Powell's Plateau, the site Moran visited with Powell that was to become the basis for the view depicted in the large oil. As Truettner has

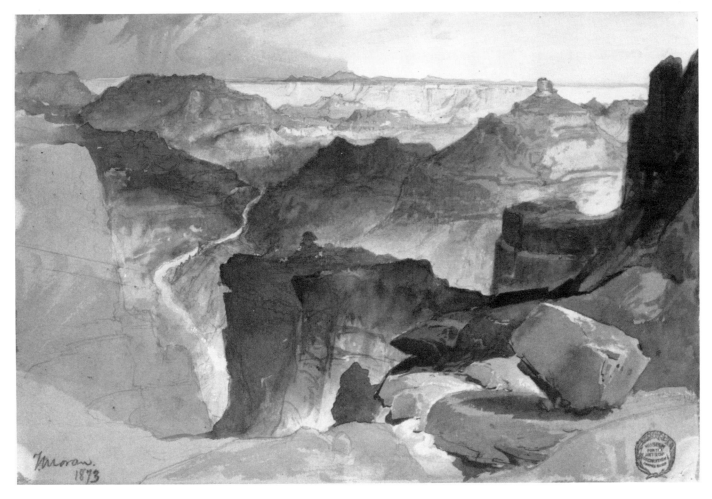

Fig. 59. Thomas Moran, *From Powell's Plateau,* 1873, graphite and watercolor on paper, 7½ × 10½″ (19.1 × 26.7 cm). Courtesy of the Cooper-Hewitt Museum, Smithsonian Institution, Art Resource, New York (1917.17.26); Clark no. 107.

noted, three of these, two watercolors and a detailed line drawing (figs. 59–61), follow the general contours of the oil and contain several of the painting's prominent features, most notably the rainstorm that plays such an important role. But although the two watercolors seem to be studies for the right quarter of the painting and contain the distinctive balanced rock, which appears in almost the same position on the canvas, the rest of their compositions, as well as most of that of the Cooper-Hewitt line drawing, seem at best distantly related to the final work except in their inclusion of the storm. The sharp vertical of the gorge through which the river winds in the painting is missing in each of these, as is the entire left foreground. The rounded amphitheater that is such a central feature in the oil is absent; its counterpart in the studies is only a sharp vertical drop from the ledge with little of the enclosing quality of the painted version.

A finely drawn contour sketch entitled *Foot of To-ro-weap* (1873, fig. 62) does contain a prominent, V-shaped gorge with a river flowing through it that corresponds closely to the central fissure of *The Chasm*.[73] It is significant, however, that while the pronounced V shape is the focal point of this drawing, the rain pouring into it is not included. Moran and Powell shared the sight of the all-important storm at Powell's Plateau, not at Toroweap.

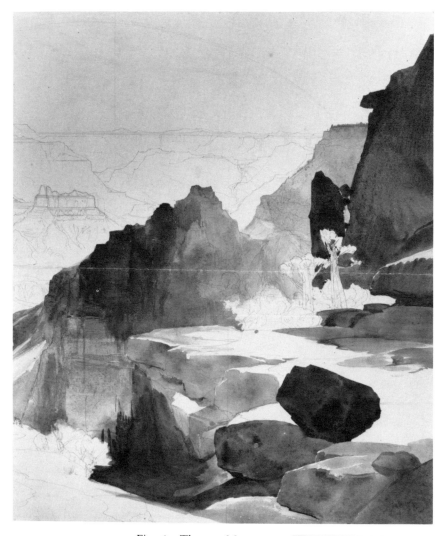

Fig. 60. Thomas Moran, *Grand Canōn of the Colorado,* 1873 (detail), graphite and watercolor on paper, 18 × 30″ (45.7 × 76.2 cm). The Thomas Gilcrease Institute of American History and Art, Tulsa, Oklahoma (0235.880); Clark no. 114.

We therefore may conclude that the fusion of the deluge and the gorge in *The Chasm of the Colorado* was created by the artist, deliberately and with conscious symbolic purpose.

The flatness and uniformity of the distant mesas in the Toroweap drawing differ from the undulating ones in *The Chasm,* so it seems that Moran looked to another study for the distant pastel buttes. Although such forms are common to the canyon and many of Moran's drawings, the constellation that corresponds most closely to *The Chasm* may be found in another pencil sketch simply titled *Grand*

Fig. 61. Thomas Moran, *Grand Canōn from Mu-Av Canyon* (diagrammatic sketch, *Grand Canōn in Rain,* 1873, graphite on paper, 10¾ × 15″ (27.3 × 38.1 cm). Courtesy of the Cooper-Hewitt Museum, Smithsonian Institution, Art Resource, New York (1917.17.28).

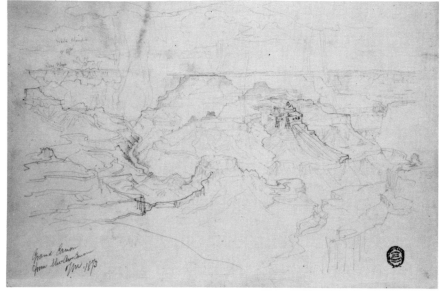

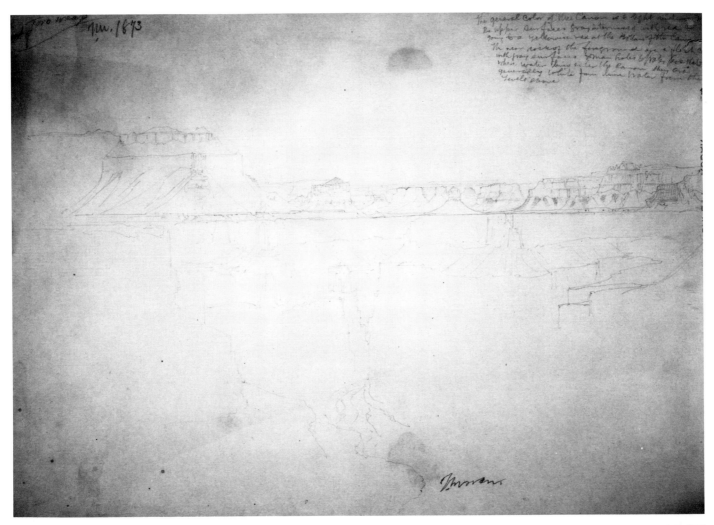

Fig. 62. Thomas Moran,
Foot of To-Ro-Weap, 1873,
graphite on paper, 10¹³⁄₁₆ ×
14¹⁵⁄₁₆″ (27.5 × 37.9 cm).
Jefferson National Ex-
pansion Memorial, Na-
tional Park Service (4233).

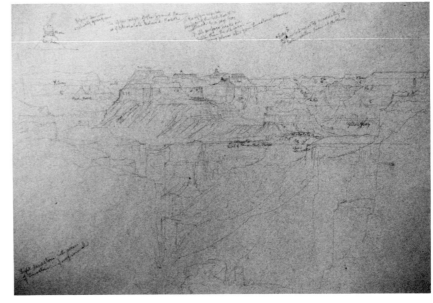

Fig. 63. Thomas Moran,
Grand Canŏn, 1873, graph-
ite on paper, 10¾ × 14⅞″
(27.3 × 37.8 cm). Jefferson
National Expansion Me-
morial, National Park Ser-
vice (4236).

Fig. 64. Jack Hillers,
*Marble Pinnacle, Kanab
Canyon,* 1873, photograph.
United States Geological
Survey Photographic
Library (Hillers 71b).

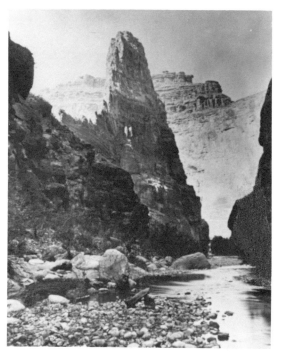

the geological formations of the drawing appear to be those from the Grand Canyon, not Yosemite, and their similarities to elements in *The Chasm of the Colorado* seem to place the work with the 1873 drawings from the canyon region. Here is the tall vertical wall with the tower, and although the drawing's tonal values differ somewhat from the final version, the similarity to the grouping in the oil suggests that it is another source for the painting.

An even more interesting source for this tower may be Hillers's photograph *Marble Pinnacle, Kanab Canyon* (1873, fig. 64). The shape of the formation is similar, and the two works are linked by the curious friezelike figures that grace the painted tower. Moran reproduced

Fig. 65. Thomas Moran,
Kanab Canōn, ca. 1874,
wood engraving, 10 × 6⅝″
(25.4 × 16.8 cm). From
Picturesque America vol. 2,
p. 511. Courtesy of the Library of the National Museum of American Art and the National Portrait Gallery, Smithsonian Institution.

Cañon and tentatively dated 1873 (fig. 63). A concentrated study of buttes, this work has almost no foreground, and the color notations are restricted to the far reaches of the plateau. The form that appears as the terraced, sunlit mountain in the center of *The Chasm* may be traced to the fine contour just to the upper right of center in the drawing. The source of the broader, sloping, and equally bright mountain just behind this form in the painting is found in the drawing in the same position, but slightly farther to the left.

The left side of *The Chasm,* with its tall rock wall and accompanying tower form in the middle distance, corresponds in some ways to a sepia wash drawing, problematically entitled *Sentinel and El Capitan, Yosemite* (1873, JNEM). Moran had visited Yosemite only briefly, in the summer of 1872. Furthermore,

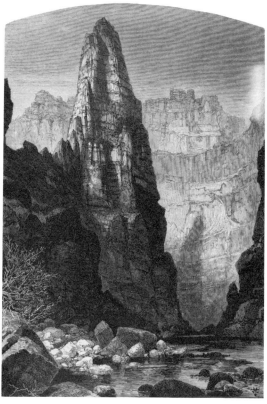

this composition in several illustrations (figs. 65–67); one, drawn for *Scribner's Monthly,* contains several figurelike forms around the pinnacle's wall that resemble those of the painting.[74] Although vague and obscured by their sketchy handling and small size, in the engraving the forms look like three bound nude figures, reminiscent of Michelangelo's *Slaves.* Such features could perhaps be dismissed as coincidental, except that they do not reappear in the very similar *Picturesque America* illustration or the much later painting *Mist in Kanab Canyon* (1892, fig. 68). Interpretation of these suggestive heroic forms must remain speculative, but their presence within the natural towers of the Grand Canyon region implies that Moran was emphasizing the epic quality of the landscape, the timeless saga of transition and change he found within its formations.

This range of sources demonstrates that like his earlier Big Picture, *The Grand Cañon of the Yellowstone,* Moran's *Chasm of the Colorado* is a composite image. Moran drew from a great variety of material, including his own experiences, impressions, knowledge, sketches, and Hillers's photographs. The final result is a work that expresses his understanding of the subject, distilled and elaborated through a veil of memory, and conveys an awareness that only time and contemplation can provide.

In conclusion, we have seen that *The Chasm of the Colorado* is a richly complex and profoundly evocative work of art that requires a comprehensive interpretation of its formal qualities, technical manipulations, and inextricable connection to the social, cultural, and philosophical currents of its time. An awareness of its multidimensional meanings pro-

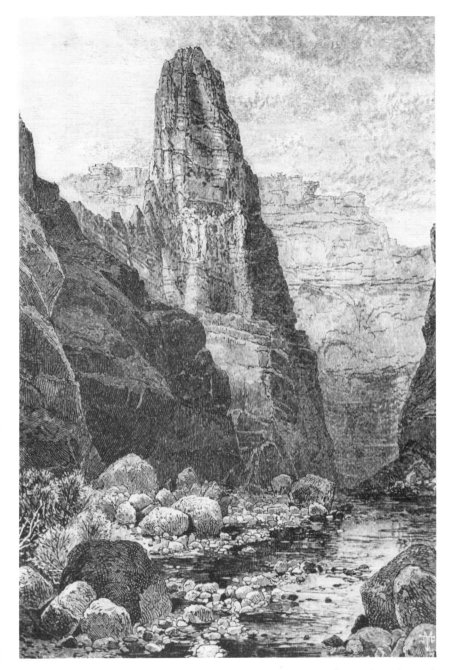

Fig. 66. Thomas Moran, *Marble Pinnacle in Kanab Canõn,* ca. 1874, wood engraving, 5½ × 3⅝" (13.9 × 9.2 cm). From *Scribner's Monthly* 9(March 1875): 529. Courtesy of the Library of the National Museum of American Art and the National Portrait Gallery, Smithsonian Institution.

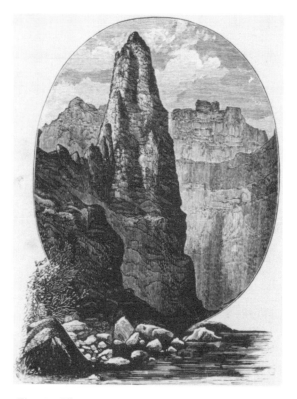

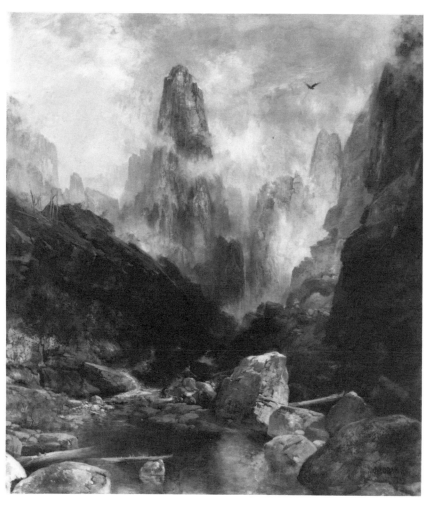

Fig. 67. Thomas Moran (attrib.), *Knob [Kanab] Canyon,* n.d., wood engraving, approximately 6½ × 4½″ (16.5 × 11.43 cm). From *Tourist Tickets from Chicago and St. Louis to the Rocky Mountains,* Passenger Department, Chicago and Alton Railroad, 1884. Warshaw Collection of Business Americana, Archives Center, National Museum of American History.

Fig. 68. Thomas Moran, *Mist in Kanab Canyon, Utah,* 1892, oil on canvas, 44⅜ × 38⅜″ (112.7 × 97.4 cm). National Museum of American Art, Smithsonian Institution, bequest of Bessie B. Croffut (1958.5.3); Clark no. 30.

motes a new respect for Moran as an artist of undeniable sensitivity to the visual world and to the world of ideas, elevating the work itself far above the level of simply another grand landscape with nationalistic significance. For Moran and Powell the Grand Canyon was a metaphor of universal proportions, one that could have profound implications for a nation still struggling, after the Civil War, to understand itself. *The Chasm of the Colorado* was a visual representation of a land that somehow made the idea of its incomprehensibility comprehensible. Moran, following Powell's literary and geological lead, embraced the complexities inherent in both the place and the metaphor, resisted the American temptation to oversimplify, and made the unresolvable conflicts that belong to the canyon and his culture the subject of his work. Rejecting simple resolution, he recomposed a chaotic landscape without denying the chaos.

7

POPULARIZING
THE GRAND CANYON

Although the Grand Canyon's popularity was much slower in coming than Yellowstone's for many reasons, its early promotion by publishers and railroads who used Moran's art was instrumental in creating the area's widespread appeal in this century. As Moran explained to Hayden, he accompanied Powell's 1873 expedition to satisfy his personal desire to see the Grand Canyon but especially to acquire material for illustrative commissions. Though Powell was not as active a promoter as Hayden, he also worked with the publishing industry, sharing photographs freely and arranging to use Moran's woodcuts in his official report. He accommodated journalist J. E. Colburn on his 1873 expedition, and he provided other publishers with his copies of Moran's engravings in exchange for the free publicity they offered him.

As Hayden had before him, Powell acquired Moran's illustrations for his report by writing a series of articles for *Scribner's Monthly*. Editor Gilder wrote to Powell in the summer of 1874, soon after *The Chasm* was unveiled, asking him for popular essays that Moran would illustrate. Gilder said that "Moran has already made some stunning pictures," and he provided a detailed list of events and items he wished Powell to describe, including "two or more incidents of a blood-curdling nature." He wrote later with a reminder, "We are very desirous to make a splendid show with these articles and to this end would like to lead off in the January no. with them. . . . Please start out with a narrative—and make the story as vivid and realistic as possible. . . . The engravings are stunning! Moran has done his best."[1] The Major was known for his scientific inclination, and Gilder's request for exciting stories was probably to prevent him from writing an excessively technical piece.

The result was one three-part article, "The Cañons of the Colorado," and two single ones, "An Overland Trip to the Grand Cañon" and "The Ancient Province of Tusayan," which closely correspond to Powell's report, and they do emphasize the adventurousness of the expedition. The first series was illustrated with thirty-three wood engravings, at least twenty-four of which were Moran's, and the second article included six of his views. Significantly, however, according to the extensive correspondence from *Scribner's* about the survey's use of the images, the magazine seemed to have learned a lesson with Hayden and provided a formal contract and financial requirements for Powell's access to the illustrations.

Major Powell will write for Scribner's Monthly two or three articles, say of 15 or 20 pages each—

Of all places on earth the great canyon of Arizona is the most inspiring in its pictorial possibilities.

Thomas Moran, "American Art and American Scenery," Santa Fe Passenger Department guidebook, 1902

Fig. 69. Thomas Moran, *The Grand Canõn at the Foot of To-Ro-Weap, Looking West,* ca. 1874, wood engraving, 5⅞ × 4¹⁵⁄₁₆″ (14.9 × 12.5 cm). From *Scribner's Monthly* 9(March 1875):526. Courtesy of the Library of the National Museum of American Art and the National Portrait Gallery, Smithsonian Institution.

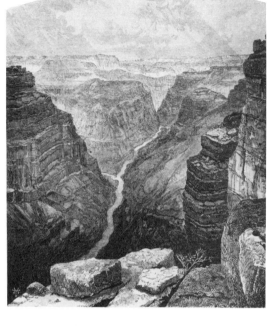

Fig. 70. Thomas Moran, *Grand Canõn from To-Ro-Weap, Looking East,* ca. 1874, wood engraving, 5 × 3¼″ (12.7 × 9.5 cm). From *Scribner's Monthly* 9(March 1875):528. Courtesy of the Library of the National Museum of American Art and the National Portrait Gallery, Smithsonian Institution.

one or two of the articles to be of personal adventure and descriptive of the scenery and life in Colorado, the other an article on the Indians of the region. He will also furnish Scribner & Co. for use in Scribner's Monthly twelve engravings on wood of Indian subjects, all without any cost to said Scribner's and Co., except the sum of 500 dollars for said articles. . . . Scribner's & Co. will expend two thousand dollars in executing other illustrations, mostly of landscapes for use in the magazine with said articles—but said illustrations shall become the property of Maj. Powell and he shall be entitled to the wood blocks or original engravings (after use in the magazine) on payment to Scribner & Co. of the sum of one thousand dollars. . . . Maj. Powell shall also be entitled to use all said illustrations in his government report before their appearance in the magazine.[2]

After he met restrictions the woodblocks were Powell's to use as he desired, and he did reproduce them a number of times, as did *Scribner's* in subsequent special publications.

Moran's contributions to this series are more evocative and carefully drawn than their predecessors in Hayden's article, and even though a large number of them are based on Hillers's and Beaman's photographs, they bear the unmistakable delicacy of line coupled with the strength of conception that characterizes Moran's best style (figs. 55, 66, 69–72). Because of *The Chasm of the Colorado*'s prominence, it is perhaps surprising that a woodcut version of the painting did not appear in Powell's *Scribner's* series until the end of the second installment of "Cañons of the Colorado" (fig. 55). Several compositional differences between it and the final painting suggest that the print is a glimpse of the work in progress, closer in composition to the charcoal underdrawing than to the finished oil.[3]

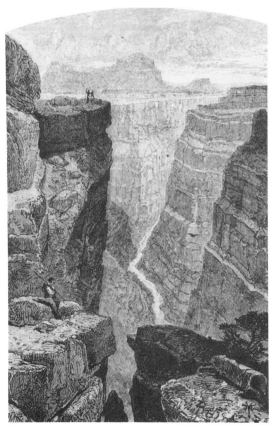

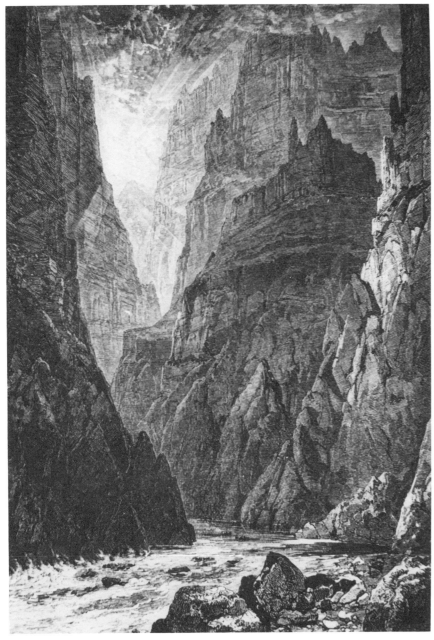

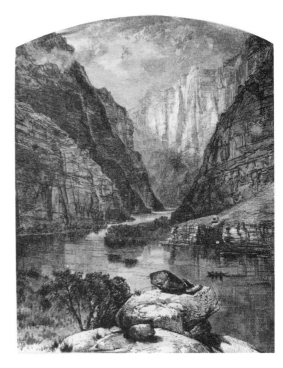

Fig. 72. Thomas Moran, *The Gate of Lodore,* ca. 1874, wood engraving, 5½ × 4⅜″ (13.9 × 11.1 cm). From *Scribner's Monthly* 8(January 1875):300. Courtesy of the Library of the National Museum of American Art and the National Portrait Gallery, Smithsonian Institution.

When he portrayed the canyon from the river's level, Moran frequently included the boats that the Powell survey had used, as well as tiny figures. In most of these, such as *The Gate of Lodore* (fig. 72), the minuscule evidences of life in the cavernous route of the river indicate the immensity and drama of the canyon itself and allude to the essence of Powell's and Moran's understanding of the region. They reflect the Major's comment that the canyon could be

Fig. 71. Thomas Moran, *The Grand Canōn of the Colorado,* ca. 1874, wood engraving, 7¼ × 4⅞″ (18.4 × 12.4 cm). From *Scribner's Monthly* 9(March 1875):524. Courtesy of the Library of the National Museum of American Art and the National Portrait Gallery, Smithsonian Institution.

known only through passage; its secrets would be revealed only to one willing to undergo the treacherous journey into its depths.

Moran himself referred to this in a letter to Powell in which he provided unusually outspoken criticism of the *Scribner's* articles. The artist complimented the descriptive passages as "strong and vigorous" but found the whole lacking in

one element that is always telling and interesting in connection with adventure and that is the expression of the impression and feelings under trying or unusual circumstances. You do not once (if I recollect aright) give your sensations even in the most dangerous passages, nor even hint at the terrible and sublime feelings that are stirred within one as he feels himself in the stony jaws of the monstrous chasm. It seems to me that the expression of these impressions and thoughts tend to realize to the reader the descriptions and are almost as necessary as the descriptions themselves. I know that you will forgive this plain criticism because you know I wish your articles to have the greatest success.[4]

Although Moran had not actually embarked on the river trip himself, he had traveled within the Utah canyons and had undoubtedly discussed the interior Grand Canyon experience with Powell's crew. He understood the region's dangers and delights and recognized the importance of conveying its character to unfamiliar readers or viewers, whether through paint or the written word.

When *Scribner's* publishers later reused one of the Moran engravings from the Powell article for an 1879 portfolio "of the choicest illustrations which have appeared in our magazines," they chose not that of *The Chasm of the Colorado* but rather the second of the two large views, the one entitled *Grand Cañon of the Colorado,* which is a vertical view from deep within the canyon walls (fig. 71).[5] Perhaps they simply preferred the more pronounced sublimity of this image, and indeed, it is in some ways a more successful image than the wood engraving of *The Chasm.* From its viewpoint along the river's banks, the staggered rugged cliffs and jagged walls fill the frame with texture and contrast and in the upper distance give way to a sunburst that illuminates the scene in a blazing crescendo of light. The space is more confined than the expansive *Chasm* view, but without the advantage of the painting's spectacular coloristic effects, the drama of this enclosed view is much more effective.

This same image was used again by the Atchison, Topeka, and Santa Fe Railway in 1892. Moran returned to the canyon that year on a long trip through the West with William H. Jackson, giving the railroad an opportunity to capitalize on the noted artists' work in the region. In addition to several of Jackson's photographs, printed with the new halftone technique, the company included Moran's woodcut as the culminating image in Charles Higgins's *Grand Cañon of the Colorado River,* one of the first guidebooks to the Grand Canyon.[6] It is unclear how the railroad obtained Moran's illustration, but since Powell contributed essays to the company's guidebooks, he may have also provided the wood engraving. As the only image in the older, more familiar medium, *The Grand Cañon of the Colorado* stands out, conveying the grandeur of the place more evocatively than the poorly reproduced photographs. Although Moran is not mentioned in the text, he is pictured at the

canyon in several of the photographs, most strikingly in the first, which shows him perched on the canyon's rim, overlooking the panoramic view, sketchbook in hand. In this continued sharing of his illustrations, the co-operative relationship among government, publishing, and the railroads came full circle. Moran's work seemed perennially applicable to popularizing the West for a variety of patrons.

As with Moran's Yellowstone illustrations, he did not limit his work to *Scribner's*. His other publishers, pleased with the work he had done on the first national park, commissioned more scenes of the West, including the canyonlands of the Southwest. *The Aldine* was one of his more important clients. From June 1872 to at least 1879 Moran contributed a minimum of thirty-nine illustrations to no less than sixteen *Aldine* articles, some of which are directly related to the Powell expedition.

In December 1873 Moran wrote the Major about one such assignment: "I'm awfully pleased with drawing on wood and have to work every night until one or two o'clock. Will send you the January no. of the Aldine with the three of my Utah drawings which are the best pieces of engraving that have ever been made from my drawings. . . . Springville Cañon is particularly fine."[7] These illustrations, filling the bulk of two pages in a short article entitled "Utah Scenery," are exceptional in their compositional effectiveness and technical execution. Although Moran obviously preferred *Springville Cañon* (fig. 54), it seems more contrived than the facing illustration, *Colburn's Butte in Kanarro Cañon* (fig. 73). The precipitous valley of *Springville Cañon* is

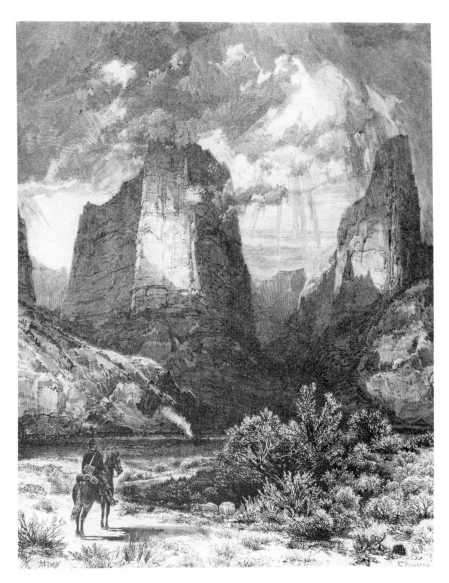

Fig. 73. Thomas Moran, *Colburn's Butte in Kanarro Cañon,* 1873, wood engraving, 10⅜ × 8″ (26.4 × 20.3 cm). From *The Aldine* 7(January 1874):15. Courtesy of the Thomas Gilcrease Institute of American History and Art, Tulsa, Oklahoma (1526.400); Morand and Friese no. 85.

Fig. 74. Thomas Moran, *Colburn's Butte, Utah,* 1873, graphite on paper, 6 × 7½" (15.2 × 19.1 cm). Jefferson National Expansion Memorial, National Park Service (4283).

spatially ambiguous, and the jagged peaks in the middle distance appear mannered and derivative of European precedents. Indeed, as if to underscore the similarity of the terrain of the two continents, the accompanying text reiterates the familiar claim, "The great and almost unknown West is full of such glorious subjects for painters as are to be found in the mountains, equaling, and in many respects exceeding anything to be found in Europe or elsewhere, there is little need of American landscape painters going abroad in search of the grand, the sublime, and the beautiful."[8]

The subject of the facing illustration, *Colburn's Butte,* was named for J. E. Colburn, Moran's companion on the Powell expedition. The view is of a solitary rock, rising from a river bank, and as such it relates closely to other tower themes in Moran's work. Here, however, and like the related views of Kanab

pinnacle such as *Mist in Kanab Canyon* (1892, fig. 68), Colburn's Butte also seems to take on a mystical quality. With the mounted observer in the foreground and the dramatic sunlight beaming down from above, the scene has a dramatic and supernatural quality that accentuates the symbology of the towering butte. The composition of *The Aldine* illustration may be traced to a wash drawing, *Colburn's Butte, Utah* (1873, fig. 74), and Hillers's photograph *Reflected Tower, Rio Virgen* (1873, fig. 75), which is more closely related.[9]

Although Powell himself had little involvement with Moran's commissions for *The Aldine,* they were, of course, facilitated by his accommodation of the artist on his survey and by the access he gave Moran to Hillers's photographs. More important, these fine wood engravings presented the artist's view of the canyon country more beautifully than any source other than his oils. As such they gave both Powell and Moran a showpiece that represented their collaboration. Moran seemed to understand that, and he produced some of his best images for the journal.

In the summer of 1872, after finishing his first Big Picture, Moran could have either rejoined Hayden for a second trip to Yellowstone or gone with Powell down the Colorado River, as he had been offered "great inducements."[10] Instead, his second trip West consisted of a hurried rail trip to California to collect images for E. L. Burlingame's article "The Plains and the Sierras," in *Picturesque America.* Although Moran created a number of drawings from the experience, including watercolors of Yosemite and its surroundings, many of his twenty-three illustrations in the article were derived from photographs ac-

quired from the U.S. geological surveys, particularly those by William Henry Jackson.[11]

The article in *Picturesque America* that portrayed the Powell expedition, however, was "Cañons of the Colorado," by J. E. Colburn, illustrated with six Moran views that are close to those in Powell's official report and three-part *Scribner's* article. Careful comparison reveals that although they are similar, the *Picturesque America* illustrations were produced independently; it was not uncommon for Moran to reproduce themes and compositions for different clients. This conclusion is verified by *Picturesque America*'s editor Bunce, who wrote Hayden after he had claimed the illustrations for his own reports, assuming they were from photographs he had supplied for the Burlingame article and for another by W. W. Rideing (which will be discussed in chapter 9 in regard to Moran's Colorado experiences). Bunce informed Hayden, "You are in error in supposing those illustrations to have been derived from the department [of the Interior] photographs. Or, if I recollect rightly a few of the subjects [in this article], including 'the cañon of the Colorado' were drawn from photographs received from Maj. Powell. All the rest were furnished by Mr. Thomas Moran from his sketches."[12] Bunce eventually provided Hayden with the ones he wanted, charging him $3,500 for electrotypes, and they appeared in Hayden's report for 1874.[13] The Moran views in the article seem to have been specially commissioned for the larger, exceptionally illustrated edition of *Picturesque America,* since they do not appear in the serial *Appleton's Journal* that preceded the final version.

Picturesque America was the most elaborate

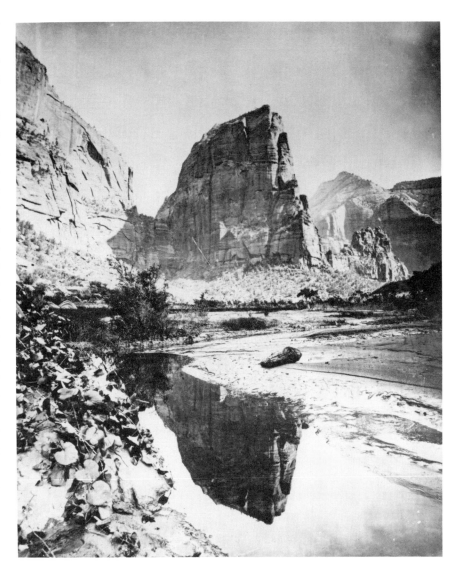

Fig. 75. Jack Hillers, *Reflected Tower, Rio Virgen, Utah,* 1873, photograph. United States Geological Survey Photographic Library (Hillers 73).

publication of travel imagery in America in the 1870s. Its beautifully bound volumes were considered the definitive treatment of the American landscape, and its appearance just two years before the nation's Centennial in 1876 graphically marked the United States' progress in exploration and the development of scenic wonders during its first century. The

prominence of Moran's art in its pages demonstrates that he was regarded as the best artist of his subject, and his contribution and that of the U.S. geological surveys were essential to the publication's success.

As with the Yellowstone, the promotion of the Grand Canyon region was vigorously pursued by other corporations that stood to profit from their association with the unique area. Of these the Atchison, Topeka, and Santa Fe Railway (Santa Fe for short) was one of the most ingenious in its methods. As did those of the Northern Pacific, Santa Fe's administrators looked to art as one of many ways to gain a share of the competitive railroad market. They were fortunate in that their company was for many years the only direct route to the Grand Canyon (after it reached there in 1901), and through that monopoly, Moran's continuing love of the canyon, and the efforts of the company's enterprising passenger agent, the corporation became in many ways the artist's most creative railroad patron.[14] Besides using his illustrations in guidebooks, it financed annual trips to the canyon, where Moran and other artists could stay in the railroad's hotel, El Tovar, and paint.[15] In this way the company acquired a sizable collection of paintings over the years, and they decorated stations, offices, parlor cars, and the railroad-owned hotels. Some of the images were reproduced on letterheads, ink blotters, and in chromolithographic reproductions that were distributed to passengers as souvenirs or printed as public advertising. The collection remains vital today and still includes one of Moran's views, a Grand Canyon oil from 1912 (plate 8).[16]

As early as 1877, a Santa Fe guidebook writer, T. J. Anderson, began the company's

use of Moran's art with an inquiry to Hayden about obtaining some of the survey's images for use in the line's promotional material: "There are some very fine engravings in your '74 report I think. The Boulder Cañon, Garden of the Gods . . . and others I cannot call to mind. Is it possible to obtain electros of items, if so I will be under great obligation. . . . The cuts of scenery will add greatly to the attractiveness of my 'Tourist.'"[17] He was referring to the *Picturesque America* engravings that Hayden purchased from Bunce. Anderson must have received a favorable reply, because a note, presumably by Hayden, at the bottom of the letter says, "Also send 1871 report and see what cuts will be needed for a issue of another edition." As usual Hayden was eager to share the results of his past successes as well as his present work, and he used Moran's art to smooth the way.

The Santa Fe line did not extend into Arizona until the late 1880s, and until it completed the spur to the Grand Canyon in 1901, the trip had to be made by stagecoach from Flagstaff. Nevertheless, in 1892 Moran took a summer-long excursion through the West with his son Paul and William Henry Jackson, and at least part of the travel was underwritten by the Santa Fe Railway. As Wilkins reports, "In return for the trip Moran agreed to assign to the Santa Fe the copyright on a single canvas, to be reproduced for publication."[18] The painting, entitled simply *The Grand Cañon of the Colorado* (fig. 76), has had a rather circuitous history, but it seems likely that the oil itself was never actually owned by the railroad. It was originally painted in 1892 but, according to Wilkins, was retouched by Moran at El Tovar in 1908, resulting in two dates on

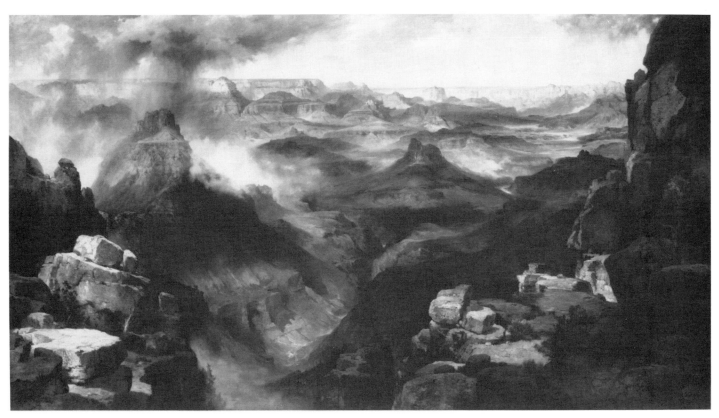

the canvas. It seems to have then hung at the headquarters of the U.S. Geological Survey in Washington for a number of years, but it is unclear what prompted its exhibition there or who owned the work during that time. The painting then returned to El Tovar and was purchased in 1919 by George Lorimer of the *Saturday Evening Post* for exhibition in the Philadelphia offices of that company.[19] Lorimer's son later donated the work to the Philadelphia Museum of Art, where it remains today.

Although the 1892 view is in many ways a restatement of Moran's great canvas of 1873–74, the two paintings differ significantly. The earth tones of the 1892 Grand Canyon painting are similar, but its mood is softer and lighter and much less threatening than *The Chasm* (plate 7). Moran also enframed the earlier view to keep its vastness in control, but in the later work the right side dominates with a rocky wall that blocks access in that direction. Here there is no secure foreground; instead the ground gives way immediately to a tremendous gorge that then moves deeply into the canyon's recesses and away into the distance along the river's path. Whereas in the earlier work the chasm is the darkest and gloomiest part, in this view the canyon is filled with light, color, and detail. The storm too is transformed. What in the first oil is a dark, ominous advance from the left is here

Fig. 76. Thomas Moran, *The Grand Cañon of the Colorado*, 1892–1908, oil on canvas, 53 × 94″ (134.6 × 238.7 cm). Philadelphia Museum of Art, gift of Graeme Lorimer.

depicted as the aftereffects of a misty summer shower, which do more to brighten that corner than to obscure it.

The primary difference between the two compositions is one of openness. The early canvas, with its terrifyingly deep central gorge and encircling mesas, has the effect of requiring a fundamental rite of passage for its viewer to reach the canyon floor. The far vistas are blocked by massive cliffs and buttes, making comprehension, much less knowledge, a major undertaking. The later work, although it depicts a riverbed equally as deep and distant as its predecessor's, opens the way for ingress through sloping walls that would require physical, but not profound psychological, exertion. The point of view in *The Chasm* places the viewer on the same level as the rock itself; we have ostensibly already begun our entrance into the depths. The vantage of the 1892 painting, even without a secure foreground, is aloft; we sense that we are at a convenient scenic vista and that we may choose to descend or turn away. The rigorous confrontation of *The Chasm* of the Colorado has been replaced by a tourist's view.

Since Moran produced many such visual depictions of the Grand Canyon, this particular painting would not be especially remarkable were it not for the Santa Fe's investment in it. The corporation reproduced it in chromolithography (plate 7) and in travel publications, and it was displayed at El Tovar. The railroad's lithography commission also introduced Moran to Gustave H. Buek, artist and vice president of the American Lithography Company of New York, who became a lifelong friend and neighbor of Moran's as well as a long-time associate of the Santa Fe Railway.

In later years Buek reproduced a number of other chromolithographs for the railroad, traveled with Moran to the Grand Canyon on its trains, and wrote two articles about the artist.[20]

Unfortunately the Santa Fe's extant records on Moran begin in 1904, so documentation of the 1892 lithographic commission is limited, and since Buek did another chromo of a Grand Canyon painting by Moran for the Santa Fe in 1912, references to the works are often unclear as to which was being discussed. Nevertheless, the 1892 painting, like all of Moran's work reproduced or purchased by the Santa Fe Railway, was utilized for distribution or exhibition by the Passenger Department and is evidence of its interest in using visual imagery for public relations.

In 1901, when the railroad finally reached the canyon, the Santa Fe began funding regular trips there for writers and artists. This ingenious program supported the creation of works of art that portrayed the scenery of the company's routes and publicized its most important tourist attraction and was beneficial to all concerned. In the early years William H. Simpson, head of the railway's advertising department since 1895, was in charge of the arrangements, but the Fred Harvey Corporation was also involved. The restaurant and hotel division of the Santa Fe provided lodging, sight-seeing tours, and studio and exhibition space for the artists in hotels and shops. Simpson coordinated these services and also negotiated to exhibit the artists' work in the railroad's offices, stations, and the hotel, often exchanging the paintings for the artists' tickets and other expenses. Simpson became a close friend of Moran's, owning several of his

works personally, and he, as well as Buek, wrote about Moran and his art in the early years of this century.[21]

In 1901, presumably to celebrate the opening of the Grand Canyon line, Simpson arranged a special trip for Moran and twelve other artists, including George Inness, Jr., and Gustave Buek. They spent three weeks at the canyon, and Simpson noted that Moran "sketched scarcely at all, contenting himself with pencil memoranda of a few rock forms, and making no color notes whatever."[22] The artists also discussed the scenery and their perceptions of art extensively, but unfortunately Simpson did not elaborate on the content of the conversation, which must have been particularly enlightening, especially between Moran and Inness. Although this and a 1910 artists' trip received the most publicity, Moran returned to the Grand Canyon nearly every year until his death in 1926, undoubtedly meeting many other artists who received similar favors from the Santa Fe Railway.[23]

The Santa Fe curatorial files contain an extensive series of Simpson's correspondence about those arrangements, some of which is from Moran and his daughter Ruth, who traveled with her father in his later years. Though most of the letters are perfunctory, they provide insight into the association between the railroad and the artist during this period of fruitful collaboration. Most are devoted to the advertising department's payment of the Morans' expenses, but several revealing statements indicate the railroad's dedication to their continuing alliance. In a 1915 memo to the billing department Simpson wrote, "No doubt, you know that Mr. Moran and his daughter visit the Canyon regularly each year.

We have purchased several of his paintings and even if we should not purchase any more, the fact that he goes there steadily is of great advertising value. He constantly talks Grand Canyon when away from there." And in another letter he commented, "The Canyon pic-

Fig. 77. Anonymous illustrator, advertisement, early twentieth century. Union Pacific Railroad. California Railroad Museum.

tures he paints, which go into private homes and art galleries, also have an advertising value."[24]

Moran's transportation negotiations with the Santa Fe varied. Sometimes he obtained passage free of charge, but usually he had to pay at least part of his fare and lodging, especially after 1911, when the U.S. Transportation Commission revised its railroad regulations. Simpson always arranged a nominal rate for Moran and his daughter, with special accommodations for side trips, lodging, and studio space, but sometimes the artist traded pictures for those provisions. The 1909 exchange of an unspecified painting was typical. Ruth Moran wrote Simpson with the proposal, "If we should go through to California this spring . . . would the Santa Fe care to take a 14 × 20 picture, price $375—in exchange for R.R. fare?" The advertising agent replied to her father, "If you make the trip we will be glad to buy another picture and will also try to arrange reduced rates for yourself and daughter at El Tovar."[25]

Moran also loaned pictures to the company for exhibition at El Tovar and in the railway's corporate offices in Chicago as advertising for both himself and the Santa Fe, and the railroad sometimes acted as broker for the works, as in the case of the Lorimer painting.[26] Since these are almost invariably referred to in the corporate correspondence as "Moran's large Grand Canyon painting," without dimensions, it is difficult to determine which of his many views of the subject were displayed.

One of the paintings handled by the Santa Fe is still part of the railway's corporate collection. Moran painted *The Grand Canyon (The Grand Canyon from Hermit Rim Road,* plate 8)

in 1912, and the railroad purchased it in 1914, not from the artist but from Gustave Buek's American Lithographic Company, which had previously acquired it from Moran's Chicago dealer, Moulton and Ricketts Gallery. For $4,000, the Santa Fe received the oil and reproduction rights, along with 2,500 chromolithographs that the Passenger Department distributed. This chromolithograph, although rare today, may be found in a number of collections, and the unaltered versions display a tiny woodcut portrait of Moran in the lower left corner of the margin. In subsequent years the image was reproduced several times in the company's highly successful annual calendar, which had begun in 1906. Thus, like Moran's other illustrative commissions, this work was seen by millions of individuals throughout the United States in a popular colorful medium that brought the West into the home of the average American.[27]

The Santa Fe was not as prolific in its reproduction of Moran's works in guidebooks as other railroad companies (such as the Denver and Rio Grande and the Baltimore and Ohio, discussed in chapter 9), in part because by the time the line reached the Grand Canyon it was possible to print photographs in halftone. This made woodcut illustrations obsolete except for purely decorative purposes. The company did, however, produce several travel guides to the Grand Canyon, capitalizing on its relationship with the artist. The first were Charles Higgins's *Titan of Chasms* (1892) and *Grand Cañon of the Colorado River, Arizona* (1892), which went through several editions and displayed Moran's illustrations, along with contributions by Henry Farny and F. H. Lungren.[28]

Other companies that ran directly or indirectly to the Grand Canyon also began advertising their services in the early twentieth century. They seem not to have used Moran's art, but their promotional material reveals his influence and that of Jack Hillers. A typical ad designed to compete with the Santa Fe was produced by the Union Pacific Railroad (fig. 77). The color image echoes Moran's work in form if not in tone; it displays a panoramic view of the canyon itself, purposefully separated from the viewer by a neatly terraced viewing platform and safety balustrade. The colors of this image too are not nearly as threatening as those of Moran's *Chasm of the Colorado;* here the pastel pinks, oranges, and blues of the distant buttes in his oil suffuse the scene with a brightness of midday. The headline of the advertisement is even more telling: "Union Pacific: The New Way to See Grand Canyon National Park." By 1913 even the Grand Canyon had been symbolically fenced, made manageable and approachable.

Moran returned to the Grand Canyon nearly every year after the turn of the century until his death in 1926. He never seemed to tire of its vistas, its unending variety of moods, and its seemingly limitless potential for visual inspiration. He produced hundreds of interpretations of its scenery, and though each is different, they all refer to his first great version, *The Chasm of the Colorado*. For it was through this work that Moran first came to know the mightiest of canyons, to understand the panorama of the ages.

PART 4

THE MOUNTAIN OF THE HOLY CROSS

Fig. 78. William Henry
Jackson, *Mountain of the
Holy Cross,* 1873, pho-
tograph. United States
Geological Survey Photo-
graphic Library (Jackson
1276).

8

THE MOUNTAIN OF THE HOLY CROSS

The Mountain of the Holy Cross, a massive peak with a huge cross of snow cascading down its eroded side, was largely the stuff of legend until the summer of 1873 when the Hayden survey mapped and photographed it. Even at that relatively late date the remarkable formation, hidden deep in the Colorado Rockies, was seen as important physical evidence of the divine sanction of the American experiment. By accompanying Powell in 1873, Thomas Moran missed his opportunity to be one of its discoverers, but he traveled to the mountain with Hayden's expedition the following year, and the painting he created from the experience became one of his most direct visual statements about the relationship of landscape to American values.[1]

In contrast to Jackson's 1873 photograph (fig. 78), which shows little more than the peak itself, Moran's *Mountain of the Holy Cross* (1875, plate 3) presents the mountain as the object of a quest, an inspiration for a pilgrimage. It stands, in Emerson's words, "as an apparition of God," with the unmistakable cross at the apex of the vertical canvas, swathed in a halo of clouds at the far end of a deep, rocky valley. The misty blanket effectively separates the peak from the more terrestrial region below, accentuating its otherworldly quality and the sheer depth of the pictorial space. Color, too, emphasizes the separation; the foreground is a dark tangle of greens and browns, but the mountain and the distant valley are painted in bright pastel hues ranging from rosy pink and soft blue to delicate grays and yellows. Although that chromatic range is characteristic of distant mountain vistas, Moran enhanced it to heighten the effect of two different worlds.

As he had in earlier works, the artist emphasized the enormity of space by an ambiguity of scale; the middle ground appears at first to be within a few hundred feet of the rocky foreground, but the tiny pines in the area reveal a much greater distance. With that recognition, the space suddenly telescopes outward, making the cross seem farther away than first imagined and indicating to the viewer the seriousness of any undertaking to approach it. Indeed, in the painting the cruciform mountain seems accessible, if at all, only by a long journey through the circuitous lower valley. Passage is denied, however, by the rugged creek bed and the mountains that cascade into its valley from both sides. On the right the twisted pines that reappear throughout Moran's oeuvre block access, and on the left the winding creek is littered with obstacles of boulders and fallen logs. The stream of "holy water" that flows from the cross is obviously

The noblest ministry of nature is to stand as the apparition of God. It is the organ through which the universal spirit speaks to the individual, and strives to lead back the individual to it.

Ralph Waldo Emerson, *Nature*, 1836

the only upward route, but it is a mazelike path that would require continual crossing of the torrent to make any progress toward the peak. The theme of pilgrimage, both literal and metaphorical, that these characteristics convey provides an aesthetic, symbolic, and historical framework for the painting. The concept is particularly relevant to Moran's own experience with the mountain, to the painting's early history, and to perceptions of the place itself.

As many scholars have demonstrated, one of the most important elements of nineteenth-century American thought was the projection of Christian doctrine onto nature and, by extension, onto nationalism. This philosophy pervaded everything from the writings of Emerson and William Cullen Bryant to the governmental policy of Manifest Destiny, and it informed the work of countless landscape artists. In his 1855 "Letters on Landscape Painting," the painter Asher B. Durand wrote:

Fig. 79. James Cremer, *Memorial Hall, American Art Gallery, Centennial Exposition,* 1876, stereograph. Department of Prints and Photographs, Missouri Historical Society. *Mountain of the Holy Cross* is the large vertical work third from the left.

It is impossible to contemplate with right-minded, reverent feeling [Nature's] inexpressible beauty and grandeur, forever assuming new forms of impressiveness under the varying phases of cloud and sunshine, time and season, without arriving at the conviction that all which we behold is full of blessings, that the Great Designer of these glorious pictures has placed them before us as types of the Divine attributes, and we insensibly, as it were, in our daily contemplations to the beautiful order of his works learn to conform the order of our lives.

Durand linked his elevated conception of nature specifically with the American landscape:

I desire not to limit the universality of the Art, or require that the artist shall sacrifice aught to patriotism; but, untrammelled as he is, and free from academic or other restraints by virtue of his position, why should not the American landscape painter, in accordance with the principle of self-government, boldly originate a high and independent style, based on his native resources? ever cherishing an abiding faith that the time is not far remote when his beloved Art will stand out amid the scenery of his "own green forest land," wearing as fair a coronal as ever graced a brow "in that Old World beyond the deep."[2]

Durand was only one of many who expressed this philosophy in the years of its greatest importance, 1835–60, but as we have seen in chapter 1, Moran himself echoed similar sentiments as late as 1902 in his essay "American Art and American Scenery."

The prominent exhibition and critical acclaim of Moran's painting and Jackson's photograph at the 1876 Centennial Exposition in Philadelphia (fig. 79) demonstrate that such

ideas were still important cultural values as the country commemorated its first one hundred years. The image and its central themes of Christianity, pilgrimage, and the awesome power of water also, however, had special regional significance that the painting's first owner, Dr. William A. Bell, used to advantage in his business ventures. As with Moran's two federal paintings before it, recognizing *The Mountain of the Holy Cross*'s multiple associations enhances our understanding of it as an icon of American ambition and achievement.

THE MOUNTAIN

Although rumor persists that the Mountain of the Holy Cross was known to Coronado's men in the sixteenth century and had been named by Spanish missionaries, the earliest recorded accounts of the sacred mountain in the Colorado Rockies date to only a few years before its 1873 discovery.[3] The peak, which lies in an especially rugged range, had remained unknown because of its inaccessibility and because snow masked the cross for all but two to three months a year. It was surely known to Indians, mountain men, and prospectors, but it was not until 1868 that the writer Samuel Bowles reported glimpsing the Holy Cross from the summit of Grays Peak, some forty miles away. Although geologist William H. Brewer is sometimes credited with being the first to verify the mountain's existence from the same peak in 1869, Bowles's sighting predated Brewer's. Nevertheless, both reports indicate the interest in the mountain at the end of the 1860s, and each may have drawn Hayden's attention to the mountain. Neither Bowles nor Brewer seems to have gotten closer than the considerable

distance of Grays Peak, and Hayden's expedition was the first to see the cross at close range and acquire substantive information about its location, size, and appearance.[4]

William H. Jackson later wrote that he and his colleagues were intrigued by the mysteriousness of the Mountain of the Holy Cross. It was rumored that as one got closer to it, the cross would magically disappear as quickly as it had come into view. It seemed to be an apparition that could elude any pursuer. "No man we talked with had ever seen the Mountain of the Holy Cross. But everyone knew that somewhere in the far reaches of the western highlands such a wonder might exist. Hadn't a certain hunter once caught a glimpse of it—only to have it vanish as he approached? Didn't a wrinkled Indian here and there narrow his eyes and slowly nod his head when questioned? Wasn't this man's grandfather, and that man's uncle, and old so-and-so's brother the first white man ever to lay eyes on the Holy Cross—many, many, many years ago?"[5] The peak's concealing geography only added to its supernatural character and made it all the more compelling, even to men of science for whom unusual geological formations were commonplace.

Although Moran did not accompany the Hayden party to the mountain, several aspects of that expedition are relevant to his later experience with it and to the meaning of his painting. The most striking characteristic of the first trip, and of Moran's a year later, was the overwhelming difficulty of reaching the place. In August 1873 nine men, including Jackson, William Henry Holmes (the artist who had replaced Henry Elliott), and Hayden himself, proceeded together in the direction of the famed mountain.[6] They first tried to fol-

low Holy Cross Creek, but finding it impassable, they moved to the west ridge of the valley. This too proved impractical. Frustrated, they returned to the creek only to find that the fallen timbers, bogs, and huge rounded boulders known as roches moutonnées, or sheep-backed rocks, blocked their path. It was through sheer determination that they progressed to the base of the peak. Here they split into two groups, one to photograph the cross from its neighbor, Notch Mountain, the other to establish a surveying station at the top of Mount Holy Cross. When Jackson and two assistants, carrying close to one hundred pounds of equipment, finally attained Notch's summit, clouds obscured their view of the formation. The sun came out briefly, not brightly enough to photograph the cross but enough to tantalize the men with a glimpse of it and create a spectacular circular rainbow in the clouds below them. It was not until the next morning, appropriately a Sunday, that the weather cleared sufficiently to provide a clear view. Jackson apparently made one 11 × 14 and seven 5 × 8 exposures, and the resulting images have been acclaimed as the best depictions of the formation, even to the present day. That is partly because the snow pack that summer, even as late as August 24, was perfect for creating a clear cruciform shape—conditions that have perhaps never been equaled—and in this century part of the right arm of the cross has eroded somewhat, marring the clarity of the image.[7]

News of their achievement must have reached Moran soon after Hayden and Jackson returned east in the fall of 1873, and he was no doubt impressed with the feat and with the extraordinary photographs. Unfortunately, unlike the wealth of correspondence that reveals so much about the first two expeditions Moran accompanied, there is little record of his plans for his 1874 trip. It seems, however, that Hayden made special arrangements for Moran's visit. The artist did not arrive in Denver until mid August, after the survey was well under way, and a team was assembled specially to conduct him to the mountain. Indeed, even Jackson and Holmes were not included; their work there had been completed the previous year and they were needed with the main group elsewhere.[8] That accommodation underscores the esteem with which Moran was regarded (and no doubt Hayden's intent to profit from the publicity another picture could bring to his survey), and it emphasizes the pilgrimage nature of the trip. Though the Mountain of the Holy Cross was certainly a special discovery the previous year, it was sought as much for its potential as a well-located triangulation station as for its symbolic qualities and was only one of many mountains that the expedition encountered and documented. For Moran's journey in 1874, reaching the mountain was the sole purpose of the trip.

Of exceptional value in understanding Moran's own relationship with the mountain are several letters he wrote to his wife. Although they echo in many ways those of the previous summer, they reveal the artist's perception of the place and its special character.

We again started off over the Divide descending to Eagle River and followed down the stream over a most difficult road for 25 miles. This day our difficulties of travel commenced over rocks and fallen timber and ascending and descending some very high hills. . . . Wednesday we would camp about 5 miles further on in order to take a rest previous to starting for the valley at the foot of the moun-

tain of the Cross, for here our real difficulties were to commence.

Next day, Thursday, we began the ascent of the intervening mountain between us and the Roche Moutonnée Valley, and all of the hard climbing that I have experienced, this beat it. Almost perpendicular, covered with burnt and fallen timber, lying 3 or 4 deep. It was only by slow and persevering effort that the horses could get through and we had to walk a good part of the way. When we got to the top the view was perfectly magnificent. 2,000 feet below us lay the Moutonnée Valley with the Holy Cross Creek rushing through it and at the head of the valley the splendid peak of the Holy Cross, with the range continuing to the left of us. The descent into the valley was even steeper than the ascent had been but was freer from fallen timber. We got down all right and without accident, but Horror!!! the way up the Valley was infinitely worse than anything we had yet encountered. A swamp, covered with the worst of fallen logs and projecting through which were the Roche Moutonnée, or Sheep Rocks, rounded and smooth and slippery, varying from 10 to 40 feet high. We worked our way as best we could, without any serious accident, except one of the horses slipping off a rock about 20 feet and punching a hole in his belly, and fir bough striking me in the eye which hurt all that day but is all right again. Added to all this it rained on us all the time, making the logs and rocks extremely dangerous and slippery. . . .

The next day, Friday, I and Woods and Jim began the ascent of the Mountain [Notch], Delano feeling that he was not strong enough to stand the ascent. We started at 8 o'clock, on foot up the Valley over the same kind of ground I have mentioned, for 3 miles and then commenced the toughest trial of strength that I have ever experienced, with the steepness of ascent added to the usual difficulties. . . . After lunch we again started through the timber upward and 2½ o'clock were at 12,000 feet. Here we were in clear view of the Cross and although still 800 feet below where we intended to reach, we were all so tired that we concluded we had gone far enough. We rested half an hour and then started on the back track, getting back to camp in three hours. In the Valley is one of the most picturesque waterfalls that I have ever seen. I shall use it in the foreground of the picture. . . . Jim says that in all his experience he has never seen worse travelling. . . . I have not done much sketching, but have done a good deal of looking.[9]

Here in Moran's own experience is the painting's tortuous passage to the distant mountain. Filled with the broken logs and rounded slippery rocks, the path yielded its secret to only the most determined and persistent.

Moran discovered, as Jackson had the summer before, that the only satisfying view of the cross was from just one location, the summit of Notch Mountain directly opposite the formation. Only at the end of the journey was the cross visible, long after the group had passed through the valley at the base of the mountain.[10] That, of course, is in direct contrast to Moran's painting, where the valley frames the glorious cross in the distance. As we have seen, Moran never hesitated to combine views from various vantage points into a unified composition, even when it meant distorting facts. In his painting reality is completely manipulated; in this case he turned the mountain around in order to juxtapose it with the picturesque creek bed.

The difficulty of the trek may be why Moran did few sketches of the area, and since he apparently did none of the formation itself from Notch Mountain, he probably worked from Jackson's photograph for his painted view. A photograph from Moran's studio collection of a wash and ink drawing, dated 1874 (fig. 80), may provide a glimpse of the artist's developing conception in the painting's early stages, and a watercolor reproduced in Clarence Jackson's *Quest of the Snowy Cross* (1952)

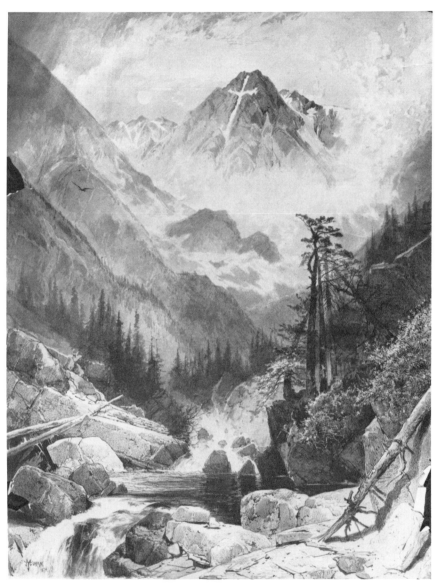

Fig. 80. Thomas Moran, *Mountain of the Holy Cross,* 1874, wash drawing with charcoal and ink on paper, dimensions unknown. Unlocated; photograph courtesy of the Thomas Gilcrease Institute of American History and Art (1616.625).

has the spontaneity of a preliminary sketch. In addition, there are at least five drawings of campsites along the way (JNEM) and two views of the approach to the mountain. The camp sketches, although not unique in Moran's oeuvre, are unusual, and their number emphasizes the pilgrimage nature of the trip; they illustrate Moran's own "pilgrim's progress."[11]

The first of the landscape drawings is entitled simply *Mt. Holy Cross* (fig. 81) and seems to be the vista Moran described as "perfectly magnificent"—that from 2,000 feet above the Moutonnée Valley with the mountain in the distance. The sketch's angle of vision is high and is similar to Jackson's photograph of the valley (1873, fig. 82), but in his drawing Moran deliberately inscribed the mountain with the prominent cross, even though it could not be seen from there. Perhaps Moran was already planning his composite painting; besides the usual color notes, inscribed on the sketch above the summit itself are the words "Very much larger." Even though Jackson's view seems to have been made from farther away than Moran's sketch, the peak in the photograph does not extend higher than its neighbor, Notch Mountain. By planning to exaggerate its size, the artist was already distorting the mountain for pictorial effect, a deliberate rearrangement of geology to achieve greater drama and symbolism.

Another Jackson photograph, taken from the valley floor, conveys the area's rugged character even more effectively, as well as the way the cross seems to disappear the closer one gets (fig. 83). This view compares closely to Moran's sketch of the valley with the wind-

Fig. 81. Thomas Moran, *Mt. Holy Cross*, 1874, graphite on paper, 10½ × 15″ (26.7 × 38.1 cm). Courtesy of the Cooper-Hewitt Museum, Smithsonian Institution, Art Resource, New York (1917.17.30).

Fig. 82. William Henry Jackson, [*From*] *Roches Mountain, near the Mountain of the Holy Cross*, 1873, photograph. United States Geological Survey Photographic Library (Jackson 1340).

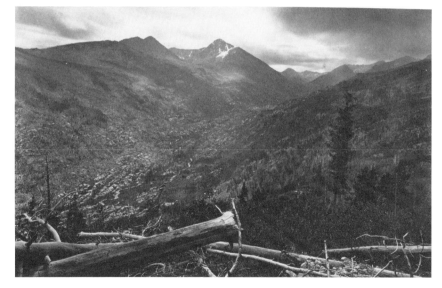

ing Holy Cross Creek (fig. 84). The drawing does not, however, include the "most picturesque waterfall" that he said he would include in his painting, nor does it emphasize the terrain's roughness. There may have been additional sketches, now lost, from which the painted valley originated, or Moran may have created it from his memory, imagination, or from other, unrelated images.

The painting's lower half shares features with several other valley compositions by Moran, such as *Children of the Mountain* (1866, plate 6) and an engraving entitled *A Storm in Utah* from *The Aldine*.[12] Both depict wild, rocky creek beds with waterfalls cascading from right to left into the lower foreground, and in each, battered wind-tossed trees act as central vertical elements. These trees compare closely to the tall twin pines in *The Mountain of the Holy Cross*, which anchor the rocky outcropping on the right. Here again is Moran's

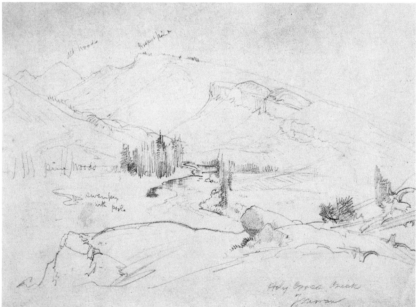

Fig. 83. William Henry Jackson, *Roches Mountain [Valley], near the Mountain of the Holy Cross,* ca. 1873, photograph. United States Geological Survey Photographic Library (Jackson 1379).

Fig. 84. Thomas Moran, *Holy Cross Creek,* 1874, graphite on paper, 9⅞ × 12¹³/₁₆″ (25.1 × 32.5 cm). Jefferson National Expansion Memorial, National Park Service (5858).

favorite twisted evergreen that derives from the 1867 Borghese Gardens drawing (fig. 20).

In *The Mountain of the Holy Cross* the entwined pines are compositionally important as a visual bridge between the two halves of the painting, and they add iconographic complexity. To some extent their gnarled trunks and contorted branches repeat the shape of the cross itself (recalling *Solitude,* 1869, fig. 21), and their height seems a testament that the difficult terrain from which they grow can be surmounted. Their weather-beaten appearance reminds, however, that the cost of that feat is significant.

The pines' survival and transversal of the two realms, together with the complementary theme of pilgrimage that pervades the painting, suggest that the cross and its promise of salvation can be attained, but only through suffering and perseverance. Redemption out of suffering is, of course, implicit in the symbol of the cross, according to Christian tradition, and such a triumph had specific relevance to Moran's own difficult experience with the mountain. For an image with national significance such as *The Mountain of the Holy Cross,* that concept had even broader implications. What it meant in Moran's time must be understood in the context of the culture to which the image and its message were directed.

THE MOUNTAIN AND THE NATION

The same juxtaposition of Christianized naturalism with American values that characterized Asher B. Durand's 1855 essay was applied to the Mountain of the Holy Cross by Samuel Bowles in his 1869 book, *The Switzerland of*

America. Recounting his glimpse of the cross from Grays Peak, Bowles maintained that the Colorado Rockies were superior to the Alps, and because of the sacred symbol they contained, the mountains were undeniable evidence of the Almighty's benevolent sanction of America.

The scene before us was ample recompense for double the toil. It was the great sight in all our Colorado travel. Its impressiveness—in overcomingness, it takes rank with the three or four great natural wonders of the world—with Niagara Falls from the Tower, with the Yosemite Valley from Inspiration Point. No Swiss mountain view carries such majestic sweep of distance, such sublime combination of height and breadth and depth; such uplifting into the presence of God; such dwarfing of the mortal sense, such welcome to the immortal thought. It was not beauty, it was sublimity; it was not power, nor order, nor color; it was majesty, it was not part it was the whole; it was not man but God that was about, before, in, us. . . .

 The snow whitened all [the mountains], covered many, and brought out their lines in conspicuous majesty. Over one of the largest and finest, the snow fields lay in the form of an immense cross, and by this it is known in all the mountain views of the territory. It is as if God has set His sign, His seal, His promise there—a beacon upon the very center and height of the Continent to all its people and all its generations . . . Nature everywhere in her original forms, her abounding waste of wealth, as if here was a great supply store and workshop of Creation, the fountain of Earth.[13]

Only on the North American continent did such a profound natural symbol appear, and Bowles, and others in succeeding years, interpreted it as a seal, a physical emblem confirming America's history and the divinely inspired work of its people.[14] Ernest Inger-soll, in *Crest of the Continent* (1883), echoed Bowles's sentiment:

It is the Mount of the Holy Cross, bearing the sacred symbol in such heroic characters as dwarf all human graving, and set on the pinnacle of the world as though in sign of possession forever. . . . As a prophecy during unmeasured generations, as a sign of glorious fulfillment during nineteen centuries, from always and to eternity as reminder of our fealty to Heaven, this divine seal has been set upon our proudest eminence. What matters it whether we write "God" in the Constitution of the United States, when here in the sight of all men is inscribed this marvelous testimony to his sovereignty![15]

 Although, and perhaps surprisingly, Moran apparently did not offer his Holy Cross painting to Congress as he had his previous two western oils, he considered the work a visual testament to just such sentiment. He finished the painting in the spring of 1875 and exhibited it first in Newark before sending it to New York's Schaus Gallery. From there it went to the Corcoran for the summer, where he hoped it would be purchased to hang with Frederic Church's *Niagara* and Bierstadt's *Mount Corcoran*. The purchase did not materialize, and he shipped it to show in Boston in the fall.[16]

 Moran's perception of *The Mountain of the Holy Cross* as a nationalistic image, closely linked to his congressional pictures, is substantiated by his plans to exhibit the three at the 1876 Centennial Exposition in Philadelphia. He asked Congress to loan his two paintings from the Capitol, and although he was ultimately refused, the debate is revealing for what it says about the two earlier pictures and what it implies about the later one. The

Library Committee recommended approval of the loan, with one member proclaiming,

We do not know of any paintings about this Capitol which are more characteristic, which are more strictly national, which would be more interesting or more instructive to submit to foreigners visiting this country than those pictures of Moran. [We] all feel that it would not be creditable for the United States, after a growth and existence of one hundred years, to have an exposition of this kind and invite all the great powers of Europe to be present without offering something worthy the name of art; and as it is quite in our power to contribute something worthy from the Capitol that would help the reputation of the country in that respect, we thought that we would accede to the request of the painter, who himself has offered to take charge of these works, which of course he himself is proud of and would do his best to protect, and to allow him to have these paintings conveyed to Philadelphia.[17]

Other congressmen objected that this would set a bad precedent and that the paintings' removal would "denude" the building. Suggestions were made to substitute other pictures (which would have been useless, of course, to Moran), ones that were more historical than geographical, but ultimately the motion was refused and all the Capitol's works of art remained in Washington. That was unfortunate because Moran's three monumental western paintings had never (and still have never) been exhibited together, and the artist undoubtedly recognized that the three paintings form a natural triptych, formally, geographically, historically, and symbolically. Even before he painted the *Holy Cross* he seems to have conceived of the three paintings together, as he remarked to a Denver reporter that he "considers the two paintings alluded to [*The Grand Cañon of the Yellowstone* and *The Chasm of the Colorado*] and the one about to be begun, three of the grandest subjects on this continent."[18] Indeed, as one reviewer noted at the 1876 fair, the Holy Cross painting was "more in the style of his monumental works in the Capitol" than several of the other landscapes Moran exhibited.[19]

Although the congressmen failed to acknowledge the trio's symbolism, their concern nevertheless centered on displaying the United States through works of art that would be representative of national values. It was clear that the Centennial Exhibition was to be a showcase of the nation's achievements and an exemplar of its most important characteristics and ideals. *The Mountain of the Holy Cross* was certainly important in that regard, but it would have been even more significant, visually and nationalistically, in the company of its two great predecessors.

The painting hung with other American paintings in Memorial Hall, the main art gallery (fig. 79), and was awarded a medal and diploma. Unfortunately there seems to have been little commentary on individual works of art in the massive exhibition, but an article before the opening expected *The Mountain of the Holy Cross* to "undoubtedly attract great attention."[20] The picture's size and unusual subject contributed to this, and viewers' interest would have been heightened because Colorado had just been made a state and was still relatively little known. Indeed, most of the painting's reviews at this and other exhibitions concentrated on the subject's location and its recent discovery. Some, however, perceptively commented on other aspects, such as *The Aldine*'s recognition of the effort that had gone

into its creation: "Mr. Moran has had far more to combat than can be understood by any others than those who have traversed the great ranges of the American Mid-Continent and Pacific Slope."[21]

Perhaps the most sensitive commentary was that of Henry Wadsworth Longfellow, who, upon seeing Moran's image, was inspired to write an elegy to his late wife. The poem, "A Cross of Snow," evokes the painting's implications of suffering and anguish in the context of Longfellow's sorrow.

In the long, sleepless watches of the night,
 A gentle face—the face of one long dead—
 Looks at me from the wall, where round
 its head
 The night-lamp casts a halo of pale light.
Here in this room she died: and soul more white
 Never through martyrdom of fire was led
 To its repose; nor can in books be read
 The legend of a life more benedight.
There is a mountain in the distant West
 That, sun-defying, in its deep ravines
 Displays a cross of snow upon its side.
Such is the cross I wear upon my breast
 These eighteen years, through all the
 changing scenes
 And seasons, changeless since the day
 she died.[22]

Longfellow's use of the painting as literary inspiration had an important precedent that may be relevant to Moran's work. As Gray Sweeney has convincingly explained, Frederic Church's *To the Memory of Cole* (1848, Des Moines Women's Club) is an evocative landscape containing a small cross that became the subject of a eulogizing sonnet shortly after its completion.[23] Such relationships between poetry and painting are hardly unusual, but in this instance the similar subject matter is intriguing. At his death Cole left an unfinished series that would have, in a sense, concluded the epic of his two other great pictorial cycles, *The Course of Empire* (1836) and *The Voyage of Life* (1840). Called *The Cross and the World,* the five images depicted a pilgrim's journey through life, often facing exceptionally difficult obstacles and always toward a great cross.[24] According to Sweeney, Church's memorial painting is a direct reference to Cole's series and to the older artist's metaphorical journey toward the fulfillment promised by the symbol of the cross.

It is not known whether Moran knew either Church's picture or Cole's oil sketches for the late series, but since other artists were using *The Cross and the World* as a model for moralizing landscapes well into the 1870s, he might have been aware of the parallels in the earlier works and his own.[25] This is not to suggest that Moran's *Mountain of the Holy Cross* was dependent on Cole's series or Church's picture but to confirm that the theme of the cross in the wilderness remained a viable artistic subject during Moran's time.

Church's great work, *The Heart of the Andes* (1859, Metropolitan Museum of Art), also contains, within the enormous, exotic panorama, a small cross being visited by two pilgrims. There too, just as in Moran's painting, the composition focuses on a central waterfall flanked by tall trees on the right, with a soaring mountain in the distance. Moran certainly knew this image; its 1859 exhibition was accompanied by unprecedented publicity and the work was discussed continually by the art community in the following decades as an exemplar of painting.[26] Furthermore, Thomas

Cole's early work known as *The Oxbow* (1836, Metropolitan Museum of Art) contains sacred symbols on the face of a mountain. As Matthew Baigell and Allen Kaufman have explained, the unusual clearings on the side of the distant hill approximate the Hebrew spelling of "Noah" and, when read upside down, the word "Shaddai," meaning Almighty.[27] Either of those references to America's fulfillment of the divine covenant after the flood reflects the geopious ideals of the mid to late nineteenth century. It is unlikely that Moran would have known the symbols' meaning, but their presence, inscribed on the mountain face, is a particularly important precedent for his painting.

The Mountain of the Holy Cross's religious implications, coupled with its nationalistic significance, were indirectly explored in the Reverend Phillip Sandhurst's lengthy guidebook to the fair, *The Great Centennial Exhibition*. Although the mention of the painting is brief, the final chapter summarizes the entire exposition as a testament to America's Christian principles, which Sandhurst believed were the sole reason for its success and that of the nation itself. His pious and ethnocentric editorial is, of course, typical of much mid-nineteenth-century clerical writing, but because he directed his remarks especially to the exposition, they are particularly indicative of the context in which Moran's painting was viewed.

The first reflection . . . at the Centennial Exhibition was this: The existence of such an Institution is possible only in a Christian country. . . .

That hundred years of history is as full of high achievement as any similar period in the history of any other nation. She suffered severely before she swept slavery from her shores, but it was done. She came to a loftier attitude of freedom through the second struggle than the first. She has won her way fairly to the vantage ground which she now occupies. . . .

The Centennial Exhibition teaches that Christian nations keep the front rank in the progressive march of mankind. . . . No one can look over the vast and varied products displayed . . . without being reminded that the principal resources of the world are today in the hands of Christian nations. . . . It will be found that in a material as well as moral sense, "righteousness exalteth a nation."

Should we not be thankful that Art has exercised her highest powers in the endeavor to place the Saviour and His passion properly before us? . . . Why should not He speak to us from the glowering canvases and the breathing marble as well as from the domains of nature and revelation?[28]

Although Sandhurst does not mention Moran's painting here by name, he surely viewed it as another example of divine presence in America, a "glowering canvas" on which "Art has exercised her highest powers in the endeavor to place the Saviour and His passion properly before us."

The minister's reference to suffering and growth during the Civil War and to other hardships of the first century points, however, to an even more profound connection between the Mountain of the Holy Cross and the picture's significance as a nationalistic icon. As Sandhurst demonstrated, even victorious national celebrations could not take place without reminders of the struggle that had gone before. The paradox inherent in this is critical to understanding Moran's painting, especially in the context of national ideals. The image of a cross, even on the face of a mountain in the

most remote Rockies, evokes the notion of suffering and cannot therefore represent a blessed, Edenic America of virgin purity. The country it speaks to is not the inviolate paradise depicted in the ideal world of so many earlier American artists. Instead, as Thomas Cole was obviously well aware, the cross symbolizes that knowledge, realization, or redemption may be attained only through painful change, an inevitable pilgrimage toward maturation that depends on growth through suffering. This is the central poignancy and significance of Moran's painting *The Mountain of the Holy Cross;* the work is not merely a romantic depiction of a sentimentalized Christian ideal, nor is it even the factual representation of a geological formation. In this painting, as in the two monumental canvases before it, the artist was making a profound and complex observation about the character

of a place. For America the implications of his cross on the mountain were no less terrible and miraculous than those of a crucifix; they were simply more consciously directed to a particular time and people.

THE MOUNTAIN AND MANITOU

The Mountain of the Holy Cross remained with Moran until 1879, when he sent it to England for exhibition. During this tour, in 1880, the painting was brought to the attention of Dr. William A. Bell (fig. 85), a wealthy British physician and capitalist who purchased the work to hang in Briarhurst, his Manitou, Colorado, home (fig. 86).[29] The painting's subsequent history as a promotional image for his Colorado enterprises reveals an additional complex of associations and suggests, perhaps even more than its nationalistic connotations, a specific cultural relevance for the work.

Throughout his life Bell (who should not

Fig. 85. Anonymous, *Portrait of Dr. William A. Bell,* ca. 1880, photograph. Special Collections, Charles Leaming Tutt Library, The Colorado College.

Fig. 86. Anonymous, *Briarhurst, Home of Dr. William A. Bell, Manitou, Colorado,* ca. 1880, photograph. Special Collections, Charles Leaming Tutt Library, The Colorado College. This is the first Briarhurst, before it burned and was rebuilt in the mid 1880s.

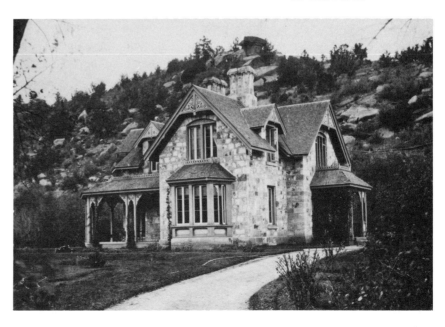

be confused with the William Bell who was a photographer for the Wheeler survey) maintained a residence in his native country, but the greater portion of his time, livelihood, and influence were centered in the American West. His first visit was in 1867 to see a new homeopathic medical school in St. Louis, but he managed to extend his stay by signing on with the Kansas Pacific Railroad survey.[30] Bell served not as physician but as the survey's photographer, an occupation he was totally unfamiliar with, but as he later wrote, it was the only job left.[31] His survey experiences gave him a broad view of the American West and an appreciation for the value of visual imagery, and they presented him with a new career that was to have significant influence on the West's development.

The Kansas Pacific survey was led by Gen. William J. Palmer, a Civil War veteran with a great deal of railroad experience, who used his connections on the 1867–68 expedition as the springboard for his own ambitious plans. Bell, already a man of influence in England, was intrigued with the underdeveloped West's commercial possibilities, and he formed an early alliance with Palmer to found, independently of the Kansas Pacific, what was to be the single most important corporation in Colorado's early history, the Denver and Rio Grande Railway. Like other lines, including Jay Cooke's Northern Pacific at approximately the same time, the D&RG was built on an elaborate structure of financing, construction, and promotional enterprises, a number of which had significant connections to Moran's art and the U.S. geological surveys.

Ferdinand Hayden later claimed that the D&RG "was started by friends of mine who

say, to this day, that they were stimulated to that enterprise by the report which was the result of that [his own 1867] expedition."[32] Those friends probably included Palmer, whose Kansas Pacific survey originated in Philadelphia, Hayden's hometown, and Robert Lamborn, also of the Kansas Pacific, who was to become one of the vice presidents of the D&RG. Hayden may have also been referring to another individual, Sir William Blackmore. Blackmore, a wealthy Englishman, was the principal financier of the D&RG in its first years and accompanied Hayden's second survey of Yellowstone in 1872.[33]

Blackmore was so impressed with the territory that he commissioned Moran to produce sixteen watercolors of Yellowstone's scenery as a memorial to his wife, who had died during the expedition.[34] These works, today in the Gilcrease Museum, are the only set of Moran's watercolors to survive intact, and like those owned by Jay Cooke, or *The Mountain of the Holy Cross* for Bell, they stand as indicators of the importance of visual imagery to the West's commercial developers. Blackmore and Bell were in close contact throughout the 1870s in both England and America, and Blackmore's collection may have been Bell's first introduction to Moran's work.[35]

After the Kansas Pacific survey with Palmer, Bell returned to England to begin promoting their new enterprise. One of his most important methods was the writing and publishing of books and pamphlets, such as his own *New Tracks in North America* (1869), a surprisingly comprehensive geographic, ethnographic, and historical study of the prerailroad West. The book was written specifically to entice English investment in the fledgling

D&RG, but it remains an important document of the period of early expansion into the Rocky Mountain and Southwest regions. Bell's text included what may be the first published mention of Powell's explorations and a complete reprint of the Major's report for 1869. Furthermore, the book was liberally illustrated with wood engravings and lithographs, many taken from Bell's own photographs, and it was the first of the railroad's many promotional efforts to bring investment and tourism to Colorado.[36] Bell's early recognition of the value of providing potential clients with visual and mental images was to be of primary importance in his later use of Moran's art.

The Denver and Rio Grande was planned as a north-south line from Denver to Mexico City that would connect various points in Colorado and New Mexico with both the transcontinental railroad and the Kansas Pacific. It received no federal land grants or appropriations, and although it did eventually receive a sizable amount of land from the state, its primary funding was private.[37] To acquire the capital they needed, Palmer, Bell, and Blackmore invented their market (as did Jay Cooke and other railroad barons) by ingeniously creating towns and special features along their line to entice tourists and traffic. The earliest and most important of these was the complex of Colorado Springs and Manitou, two communities founded solely for their potential to attract affluent settlers and visitors. Manitou, at the base of Pikes Peak and near the famed Garden of the Gods, was the picturesque site of a series of mineral springs, and on its incorporation in 1870, when the D&RG reached nearby Colorado Springs, it

became one of Colorado's most important resorts of the late nineteenth century. Called the "Saratoga of the West," it catered to a wealthy clientele of health seekers who came to obtain the famed cure of the mineral waters.[38] A number of western states, especially California, have springs that were ardently sought for their medicinal properties during the heyday of the "climatic cure" of the 1870s–90s, but in Colorado none could rival the luxuries of Manitou. Three exclusive hotels were completed as early as 1875, and "thousands of invalids," mostly victims of tuberculosis, or consumption, flocked to the place in the following decades.[39]

The salubrious qualities attributed to Colorado's climate and Manitou's springs were merely one example of the prevailing nineteenth-century emphasis on hydropathic therapy, the curative powers of water, and the more general claims of restorative climatology, but the Colorado Springs area was promoted with special vigor by the D&RG, physicians, and guidebooks during the period. Their efforts and the combination of dry rarefied air, the springs' variety of temperatures and chemical contents, and Manitou's special amenities made it the resort of choice for well-to-do consumptives. Manitou's status was due largely to William Bell's efforts, and the place's therapeutic character had important implications for Moran's *Mountain of the Holy Cross*.

Bell's training as a physician no doubt contributed to Manitou's credibility, but in 1874, presumably to strengthen the spa's reputation, Bell invited another English physician, Dr. Samuel Edwin Solly, to join the community.[40] Solly, himself a consumptive who recovered

his health in Manitou, eventually became president of the American Climatological Association and was enormously influential in promoting the curative effects of the Colorado resort. He specialized in pulmonary disease, the primary condition the water was credited with helping, and after his recovery he published an extensive analysis of the liquid. He appealed to vacationers but more directly to the health trade by claiming miracle cures at Manitou.

Besides merely pleasure-seeking travelers who come westward every year, there are thousands of invalids, suffering from a wide range of chronic diseases, who come on a pilgrimage in search of health. In many cases the relief obtained is surprisingly rapid. The asthmatic forgets in the quiet of undisturbed slumber his nightly suffocation; the victim of chronic bronchitis discovers a new lease of life, and after the lapse of a very brief period he finds it hard to realize that he has been so recently afflicted with a cough so distressing, so violent, or so dangerous. The sufferer from malaria, in that most obnoxious form called fever and ague, is glad to have found a land where fever and ague never come.[41]

Such descriptions abound in the literature of the period, to an extent that one guidebook of 1880 cautioned visitors to temper their expectations because Colorado and its offerings had been "too much written up."[42] Nevertheless, the banks of Fountain Stream in Manitou "were literally thronged" almost immediately upon the completion of the D&RG Colorado Springs line. At the ceremonial founding of the town William Palmer himself said, "If there were to be presented no other inducements why men and families should migrate to this spot, that of health alone is suffi-

cient."[43] In succeeding years thousands made the trip to Manitou's waters to be cured of their assorted sufferings, many of them staying to become permanent residents.[44]

Solly's use of the term "pilgrimage" in reference to the inundation of Colorado's sanitarium belt has some significance, of course. Many sufferers' journeys were not only difficult, but they were also quests for salvation from a lifetime of disease. Lacking a scientific cure for tuberculosis and related ailments, doctors frequently prescribed travel, especially to the dry, mountainous West, with the trip itself considered as therapeutic as the climate and mineral waters at its end. "If the strength of the patient is good, the journey should be made on horseback, or in an open carriage, and be pursued as long as the strength of the patient continues to improve," one physician advised, and another counseled that cruises were "not to be preferred . . . by any who have health and strength to travel by land." The exertions of such an effort were seen as the actual benefit; "Take them away and a journey over the desert to the Rocky Mountains would be scarcely more efficacious than the fashionable voyage to Europe."[45] A later writer lamented easy rail passage in a statement filled with irony for the D&RG's health resort at Manitou, "Before railroads penetrated here [Colorado], when it took thirty to forty days to make the journey, more desperate cases were cured than now; because the strain on the lungs, caused by the increasing rarity of the air, was so gradual that the slight lesions had time to heal."[46] Therefore, in the mid to late nineteenth century, seeking health frequently meant, besides partaking of mineral waters in luxurious baths and springs

at fashionable resorts, additional suffering in the form of a pilgrimage to reach the place of therapy.

By the final decades of the century, the use of water as purifying and therapeutic agent, physically and spiritually, already had a long history in America. According to Kathryn Kish Sklar, hydropathy, or the water cure, was an important medical practice that originated in England and held enormous appeal from 1845 to 1900, with more than two hundred such health centers established in the United States alone.[47] The underlying theory, which dated to ancient baths, was that water could effect a natural cure; the proper combination of bathing, drinking water, exercise, diet, pure climate, and so on could cure a whole host of ills, mental and physical.[48] Hydropathic spas, like their modern counterparts, were often luxurious resorts that appealed to the upper classes, a tendency capitalized on by the resort industry, including that of William Bell's Manitou (fig. 87). During the 1850s there was even a popular publication for this health-conscious subculture, *The Water Cure Journal,* with the motto "Wash and Be Healed," which presented hydropathy as an alternative to the often horrific invasive medical techniques of the period. Its fundamental concept was that the cure's spiritual benefits were inseparable from its purely physical aspects, and these derived from water's divine origins. One disciple's testimonial in *The Water Cure Journal* makes clear the source of the substance's curative power:

All hail to pure cold water
That bright rich gem from heaven;
And praise to the creator
For such a blessing given![49]

Hydropathic therapists also saw the cure holistically. One explained: "Every portion of the surface of our bodies is pierced with fountains. These fountains will run with foul water, so long as there are impurities within man, and with distilled water from the moment that these are expelled. Thus the nauseous effluvium that belongs to impurity is given us as a warning. The impurities of man come from within; the cleansing power of man also comes from himself. Disease is only filth." Another physician postulated that "uncleanliness of mind and body act and react, and perfect health of one is incompatible with an unhealthy state of the other."[50] That moralizing message, allied with the Victorian sanitation movement, appealed as much to conscience as to logic, but thousands took it to heart, including such notables as Tennyson, Ruskin, and Darwin in England and Americans Joseph Pulitzer, Julia Ward Howe, Longfellow, Harriet Beecher Stowe, and President Martin Van Buren.[51] Bruce Haley has explained, "All of them sought Health as a kind

Fig. 87. William Henry Jackson, *Manitou Soda Springs,* 1880s, photograph. Courtesy of the Colorado Historical Society (3066s). The soda springs have always been available for public drinking. The figures in the foreground are sharing the cup that was provided on a chain.

of Holy Grail." [52] Indeed, the history of American medicine reveals that religious principles, especially moralizing Christian ones, were at the root of nineteenth-century medical theory and practice. As one historian notes, "The rationalistic impulse in [nineteenth-century] health reform rhetoric was overshadowed by heavy doses of Christian perfectionism. Preaching the interconnections of the moral and physical life, health reformers agreed that man could not achieve success in one without total control over the other." [53]

Palmer and Bell founded Colorado Springs and Manitou on just such holistic principles. According to an early circular, "Any person may become a member of the Fountain Colony of Colorado who is possessed of good moral character and is of strict temperance habits, by the payment . . . of $100 which will be credited to him in the selection of such lots and lands as he may desire. The spot selected embraces the healthiest part of the healthful climate of Colorado." [54] The document went on to state that any violation of proper behavior, especially that of the moral-temperance clause, could result in the revocation of the citizen's deed. The community's identity as a place that attended to both psychic and physical health was established from the beginning.

The Manitou springs' therapeutic and spiritual reputation had a long history before their exploitation by the D&RG, which was frequently cited in contemporary promotional materials to substantiate the spa's appeal. One example, concurrent with *The Mountain of the Holy Cross*'s arrival in Colorado, emphasizes the sacredness of the springs to the native people.

The Indians regard with awe the "medicine" waters of these fountains as the abode of a spirit who breathes through the transparent water, and thus, by his exhalations, causes the perturbation of its surface. The Arapahoes especially attribute to the water-god the power of ordaining the success or miscarriage of their war expeditions; and as their braves pass often by the mysterious springs when in search of their hereditary enemies . . . they never fail to bestow their votive offerings upon the water-sprite in order to propitiate the "Manitou" of the fountain, and insure a fortunate issue to their "path of war." [55]

Even the name "Manitou" meant "Great Spirit of the Waters," although few people knew that William Blackmore had actually named the town. [56] The story continued with the legendary explanation of the differences between two kinds of springs at Manitou, the pure, clear spring and a malodorous one of sulfur. The myth, recounted as a dialogue between two men of different tribes, attempted to account for the relationship of two warring groups, but one allusion to the divine origin of the water and its use is intriguing.

Before he had satisfied his thirst, [the first Indian] raised in the hollow of his hand a portion of the water, and lifting it toward the sun, reversed his hand, and allowed it to fall to the ground—a libation to the Great Spirit who had vouchsafed him a successful hunt, and the blessing of the refreshing water with which he was about to quench his thirst.

"Why does a stranger," [the other] asked . . . "drink at the spring-head when one to whom the fountain belongs contents himself with the water that runs from it?"

"The Great Spirit places the cool water at the [head of] the spring," answered the hunter, "that his children may drink it pure and undefiled. The

running water is for the beasts which scour the plains."[57]

The distinction between the purity of the mountainous source of the stream and the impurity of the rivers on the plains below reinforces the emphasis Manitou's promoters placed on the fresh mountain air and the local water's healing qualities. In addition to the assorted amenities provided to the resident invalids, the spa included a bottling plant to package, ship, and sell the water to the less-fortunate low landers who were unable to make the journey, providing the purifying liquid to the widest possible community.[58]

The resort's message, both explicit and implicit, that health could be obtained by making a pilgrimage to the healing mountain waters, has direct parallels in Moran's *Mountain of the Holy Cross*. The theme of pilgrimage, with the Christian image of salvation as its goal, pervades the work, and the placement of the stream as the way to reach the cross is of primary significance. Moran deliberately recomposed what he saw at the site; he turned the mountain to allow the formation to be seen from the valley, making the stream appear to flow out of the snow of the cross. This holy water and its association with spiritual renewal obviously had special relevance to the health seekers who sought the healing waters at Manitou, where Bell brought Moran's painting in 1880.

Contemporary belief in the Mountain of the Holy Cross's restorative power is verified by the Reverend W. L. Gilman, a recovering consumptive in Colorado who made the long trip beyond Manitou to the mountain.

Weary and worn out with the hardships I had undergone, and the weakness of the recent illness assisting, I was in a condition of physical and mental depression almost to the limit of endurance. The day was heavy and a dense cloud of mist settled down over the mountain path, so that it was difficult to follow the trail. And this added to the gloom of my feelings. Suddenly a breeze lifted up the cloud of fog in which I was immersed, raising it so that it could almost be reached with the staff I carried and giving an uninterrupted view of the landscape for many miles. Right before me in the distance was the Mount of the Holy Cross. The Cross radiant in the sunlight and glowing with the exquisite purity of its colors translucent in white and heavenly blue, and the sight calmed and strengthened me as I thought how foolish and weak to repine in view of the glorious emblem and the promises with which it endows the human race.[59]

In his quest for health and salvation, this individual made the arduous pilgrimage and had been "calmed and strengthened," restored from his illness, by the special blessing of seeing the mountain.

Comparing the painting, with its water flowing from above, with Manitou's springs is ironic, of course. Springs bubble up from deep within the earth, a hellish source that contrasts directly with Moran's painting and with the heavenly blessings Manitou supposedly provided. Nevertheless, the picture appealed to the belief in the water's curative powers and in the cross's redemptive ones and became an important part of the D&RG's promotion of its health resort.

Shortly after purchasing *The Mountain of the Holy Cross,* Bell offered it for exhibition at his local church, St. Andrew's Episcopal, in the heart of Manitou. Two days a week he also

opened his home, Briarhurst (fig. 86), to the public and displayed the picture in a special skylit alcove.[60] The D&RG advertised this attraction in Denver and offered special rates for weekend trips. Briarhurst is near the head of Fountain Creek at the base of Pikes Peak, where "the native shrubbery and trees have been protected and cared for, shady walks have been cut through them, the dashing mountain brook, the *Fontaine Qui Bouille,* has been crossed with rustic bridges, and four acres of land captured from a state of rugged wildness have been tamed and beautified and made a blooming garden."[61] Invalids had only to ride the train from Denver, check into the luxurious hotels, and traverse the picturesque bridges to partake of the water's blessings and, symbolically, that of Moran's *Mountain of the Holy Cross.* Although the actual mountain was more than a hundred miles from Manitou, its special properties could be associated with the spa through the painting. If the sufferers could not go to the mountain itself, like Mohammed the mountain would be brought to them. The pilgrimage could end at Bell's front door.

The image's therapeutic power was directly associated with Manitou in many of the Denver and Rio Grande's guidebooks. One, *The Story of Manitou,* seems to summarize the spa's attributes and the significance of Moran's image there:

Here dwelt the Red Man, ere the cry
Of "Gold!" among these hills was heard;
Here towered the mountains to the sky,
And here the healing fountains pour'd.

Before the White Man's foot had trod
This sacred valley in the West,
The Savage took the gift from God
And named it, "Manitou, the Blest."[62]

As seen in his earlier large western paintings, Moran's art had multiple resonances and implications for the culture into which it was accepted. *The Mountain of the Holy Cross* was both sacred and profane, providing countless viewers with a visionary glimpse of the blessed mountain most of them would never see, at the same time contributing to the exploitation of the land itself and the vulnerabilities of a desperate public in search of health and salvation.

9

MORAN'S ART AND THE POPULARIZING OF COLORADO

As with his travels with Powell, Moran financed his 1874 expedition to the Mountain of the Holy Cross through illustrative commissions. And with his Yellowstone experience, he was already working on a series of Colorado views before this trip. These images and their use, and others Moran made after his visit, reveal additional information about the importance of his western views for Colorado's development.

As early as January 1873, *Picturesque America* editor Oliver Bunce contacted Ferdinand Hayden to write an article about the Rockies. They reached an agreement, but perhaps because of time constraints William H. Rideing, a *New York Times* reporter who accompanied Hayden that summer, finally wrote the piece.[1] Even though Moran had not visited the area, he had evidently pleased the editors with his work for E. L. Burlingame's article "The Plains and the Sierras" in 1872 and was chosen

to provide the illustrations for Rideing's text. The subject included the Garden of the Gods and other scenic attractions, among them the just-discovered Mountain of the Holy Cross, and Hayden provided Jackson's photographs for Moran to work from.[2]

Moran drew many of his wood engravings for Rideing's article directly from those photographs with little or no manipulation. Others, most notably *Mountain of the Holy Cross* (fig. 88), are distinctly different. Although Wilkins reports that Moran prepared his illustrations early in 1874, before his Colorado trip, this image is surprisingly similar to his finished painting and his other views of the mountain drawn after he had seen the peak.[3] Jackson's photographs do not contain the lush

Hither will come the painters, who need not go to Switzerland for snowy bergs, nor to Scotland for lochs, nor to Norway for splendid forests of pine and spruce. No mountains I know of abound in more that is picturesque; but it is always some phase of the *grand* rather than the *pretty.* The scenery is wild and savage and primeval, being the stock of which beautiful landscapes are made, rather than the culture of gentler airs.

Ernest Ingersoll, *Crest of the Continent,* 1885

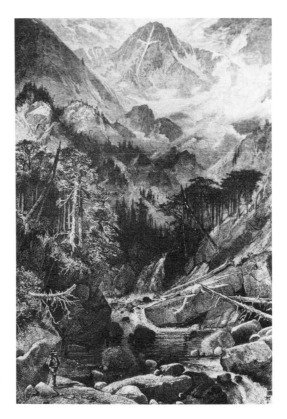

Fig. 88. Thomas Moran, *Mountain of the Holy Cross,* ca. 1873, wood engraving, 9½ × 6⅝″ (24.1 × 16.7 cm). From *Picturesque America,* vol. 2, p. 501. Department of Prints and Photographs, Missouri Historical Society.

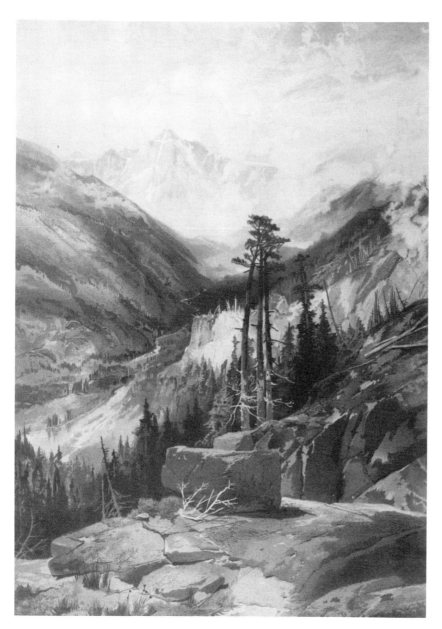

Fig. 89. Thomas Moran, *Mountain of the Holy Cross,* 1876 (publication date), chromolithograph. From Hayden, *Yellowstone National Park,* plate 10. Jeffer- son National Expansion Memorial, National Park Service (4136).

foreground that distinguishes both Moran's post-1874 works and the illustration. Depending on when the publication went to press, Moran may have created his published view after his trip, and if so, it is a glimpse of the painting's composition in progress.

Although they share the same basic conception, the illustration and the final oil differ in several ways. The wood engraving's format is narrower, the scene more crowded, and the mountain greatly exaggerated. The peak's location is much less clear than in his final version; the peak seems, even more than in the oil, to float supernaturally rather than being a distant yet achievable vision. The creek's angle as it plummets down the valley is less pronounced in the illustration, and Moran's twisted tree that provides vertical balance in the painted work is missing.[4] These differences all suggest an early version in which Moran was still working out details.

Presumably in return for sharing the photos, and just as he had earlier arranged for Fenn's wood engravings of Yellowstone, Hayden obtained eight of Moran's *Picturesque America* illustrations for his 1874 report. Although the report was was not actually issued until 1876, it was the first appearance of Moran's work in Hayden's publications since 1872. They were by far the most sophisticated views that had ever accompanied his reports, and typically, Hayden shared them liberally with others. Several may be found in later, unrelated publications, such as Union Pacific guidebooks and George Crofutt's many editions.[5]

Another version of *Mountain of the Holy Cross* appeared in chromolithography in Louis Prang's 1876 *Yellowstone National Park,* which

Hayden wrote (fig. 89). At first the print seems analogous to the 1875 oil, but they have significant differences. The foregrounds are quite similar, and in the print Moran's twisted trees still provide the main vertical element on the right, but for the chromo he replaced the rushing creek with the vista of Roche Moutonnée Valley. This raises the elevation dramatically and compares closely to Jackson's photo and Moran's sketch of the valley (figs. 81, 82). By drawing his view from this vantage point, Moran removed the peak from the viewer even farther than it appears in the painting. Nevertheless, the mountain actually looks easier to reach in the print, because the trail leads downward, a much less difficult direction than the upward path through the mangled creek bed in the painting.

As those few examples suggest, Moran's many images of Colorado appeared in a variety of publications, but their most prolific use was by the Denver and Rio Grande Railway. The company commissioned work directly from Moran, and like others before, it also solicited Hayden, Powell, and publishers for illustrations to use in guidebooks and promotional materials. Throughout the 1880s and 1890s, until photographic reproduction replaced wood engraving, the D&RG used Moran's work as the centerpiece of a variety of innovative publications, often focusing on the Mountain of the Holy Cross. Many of those illustrations appeared in the literature of other companies, but the Colorado line was the most energetic in the use of his art.

In 1881, shortly after William Bell bought *Mountain of the Holy Cross,* the D&RG facilitated Moran's return to the Colorado mountains with a special train trip along its route.

By then the line traversed a good portion of the state and the company was embarking on a serious publicity campaign. Through a series of coincidences and negotiations the trip also included John "Apple Jack" Karst, a noted wood engraver; author Ernest Ingersoll and his wife; and photographer William H. Jackson. Karst and Moran arrived from the East after just completing a similar excursion together along the Baltimore and Ohio Railroad. That trip was like the Colorado tour in both purpose and form; it was expressly orchestrated to create a guidebook and included promotional writer Joseph Gladding Pangborn and a B&O official.[6] Neither trip was a completely new idea; as early as 1859 the B&O had sponsored a special artists' excursion, and by the 1880s photographers and artists were regularly included in railroad publicity events like the Northern Pacific's Villard Excursion. For the 1859 trip, fifty artists traveled along the B&O in a specially equipped train, sketching, sight-seeing, and photographing "to make the beautiful scenery of the road known to the general public."[7] As with the B&O tours, the Denver and Rio Grande outfitted the group in a deluxe private train, conducted to the most picturesque sights along the lines.[8] They visited a good deal of the state: Colorado Springs and Manitou, of course, where they were presumably hosted at Bell's Briarhurst, the Garden of the Gods, and the various mountain towns of Colorado's interior. They were allowed to stop wherever they wished along the way to sketch and photograph especially scenic views.

Ingersoll had already met Moran in 1874, on Hayden's expedition. His account of their adventures on that trip, *Knocking Around the*

Rockies (1882), was accompanied by five Moran illustrations. During the D&RG excursion the writer was on assignment from *Harper's Monthly* to do an article on the San Juan silver mining region, but besides that, the 1881 trip provided him with material for another book, *Crest of the Continent: A Record of a Summer's Ramble in the Rockies and Beyond* (1885). Like Pangborn's *Picturesque B&O, Historical and Descriptive* (1882), it chronicles a train trip and extols the virtues of the railroad and its route. It contains sixteen wood engravings by Moran (many engraved by Karst), which derive directly from Jackson's photographs from the excursion. Several of Moran's most notable wood engravings in Ingersoll's book (such as *Toltec Gorge and Tunnel,* fig. 90, and *Chipeta Falls, Black Cañon of the Gunnison,* fig. 94) appear in D&RG publications. Since the railroad sponsored the trip it may have underwritten the book and commissioned the images, or the publisher may have dealt with the artist and shared them with the D&RG. At any rate, of Moran's many graphic images, those from this publication appear most frequently in a variety of the line's guidebooks, including *Rhymes of the Rockies, Across the Continent, Around the Circle, The Story of Manitou,* and *The Great Salt Lake,* all published in editions in the 1880s and 1890s.[9]

The railroad and Ingersoll adopted the already established conventions of travel literature as their guide, as well as inventing a few new approaches of their own. Their guidebooks make extensive use of metaphor, architectural and otherwise, to convey visual experiences to their readers, and often refer to art to explain their points. *Rhymes of the Rockies* was perhaps the most inventive of the book-

lets; its only text is poetry, musings on the railroad's scenery graphically illustrated by wood engravings, some by Moran.

In *Crest of the Continent,* besides glimpsing the new West from the view of a late nineteenth-century traveler, Ingersoll provides insight into several of Moran's subjects. One was the sublime Toltec Gorge, which Moran drew twice in watercolor and as a wood engraving:

Our train having halted, the Artist sought a favorable position for obtaining the sketch of Toltec Gorge which adorns these pages, the Photographer became similarly absorbed, and the remain-

Fig. 90. Thomas Moran, *Toltec Gorge and Tunnel,* early 1880s, wood engraving, approximately 5 × 3½″ (12.7 × 8.9 cm). From *Around the Circle Through the Rocky Mountains,* Passenger Department, Rio Grande Railway, 1890. Warshaw Collection of Business Americana, Archives Center, National Museum of American History.

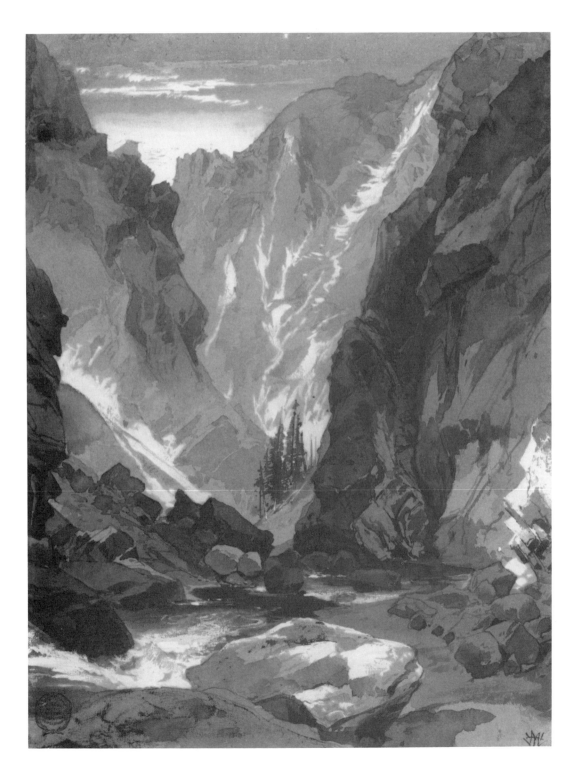

Fig. 91. Thomas Moran, *Toltec Gorge,* ca. 1881, ink wash, watercolor, and opaque color on paper, 12½ × 9½″ (31.8 × .2 cm). Courtesy of the Cooper-Hewitt Museum, Smithsonian Institution, Art Resource, New York (1917.17.68); Clark no. 158.

Fig. 92. William Henry Jackson, *Toltec Gorge and Tunnel,* ca. 1880s, photograph. Courtesy of the Colorado Historical Society (3186). Obviously, this winter view was not taken on the 1881 excursion, but its composition compares closely with Moran's depictions of the gorge.

ing members of the expedition zealously examined a spot whose counterpart in rugged and inspiring sublimity probably does not exist elsewhere in America. A few rods up the cañon a thin and ragged pinnacle rises abruptly from the very bottom to a level with the railway track. This point has been christened Eva Cliff, and when we had gained its crest by dint of much laborious and hazardous climbing over a narrow gangway of rocks, by which it is barely connected with the neighbor-

ing bank, our exertions were well repaid by the splendid view of the gorge it afforded.[10]

Neither of Moran's watercolors is dated, but both seem to have derived from this experience. He passed the site again in 1892, but as Thomas Fern has noted, he was on a regularly scheduled train and would not have had the chance to stop, climb over the rocks, and obtain his views.[11] *Toltec Gorge and Eva Cliff from the West* (ca. 1881, Cooper-Hewitt Museum) is handled much more broadly than *Toltec Gorge* (fig. 91), in similar fashion to Moran's Yellowstone canyon sketches, and depicts Eva Cliff from across the gorge, presumably from the level of the train track. The second view provided the basis for the woodcut (fig. 90) and is more finished and detailed than the other, perhaps because of its dependence on Jackson's photographs (fig. 92). Moran emphasized the gorge's narrowness in the illustration by cropping the sides of his composition slightly, and he lengthened it vertically by raising the point of view a little.

In *Rhymes of the Rockies,* the poem that accompanies Moran's image reflects on the site's atmosphere, emphasizing the passage of time it has witnessed.

Centuries pass. The deep drifted snows
Fade 'neath summer suns, and the stream
Widens the gorge and misty breath throws
High up black walls that silvery gleam.[12]

The text verbalizes the gorge's constant state of transition that is evident in Moran's addition of snowy crevasses in the cliffs and in the rushing water on the canyon floor.

Another point of interest was Black Can-

yon, a site that evoked contradictory responses from visitors. *Rhymes of the Rockies* called it "beautiful, imposing, sublime, and awful" and described it as "solid walls of God's masonry; walls that stand sheer two thousand feet in height and so close together that for most of the distance through the cañon only a streak of sky, sometimes in broad daylight, spangled with stars." The guidebook was quick to point out, however, that this awesome place could be "comfortably visited . . . for the iron horse of the Denver and Rio Grande Railroad has a pathway through the cañon and he draws after him coaches as handsome and pleasant as those which he draws on the level plain."[13] Jackson's photograph of the site during just such an excursion verifies the ease with which the gorge could be viewed (fig. 93).

Ingersoll's description of the place as bright and congenial belies the *Rhymes* description and indicates that their visit to Black Canyon must have been around noon:

The "Black" cañon . . . is not black at all but the sunniest of places. I cannot understand how the name ever came to be applied to it. No Kobolds delving in darkness would make it their home; but rather troops of Oreades, darting down the swift green shutes of water between the spume-wet bowlders, dancing in the creamy eddies, strug-

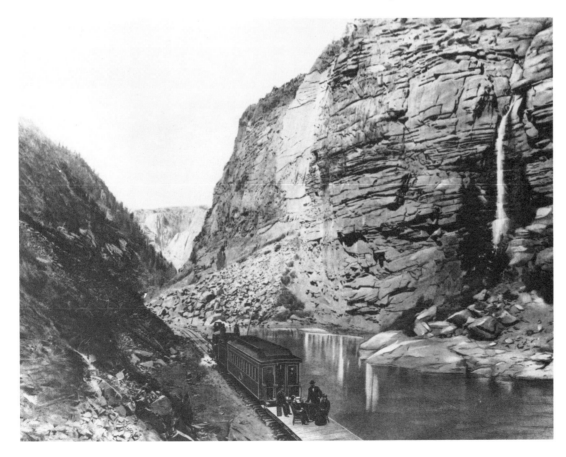

Fig. 93. William Henry Jackson, *The Black Cañon,* ca. 1881, photograph. Courtesy of the Colorado Historical Society.

Fig. 94. Thomas Moran, *Chipeta Falls, Black Canõn of the Gunnison,* 1881, wood engraving, approximately 10 × 6⅝″ (25.4 × 16.8 cm). From *Across the Continent by the Scenic Route,* Passenger Department, Denver and Rio Grande Railway. Warshaw Collection of Business Americana, Archives Center, National Museum of American History.

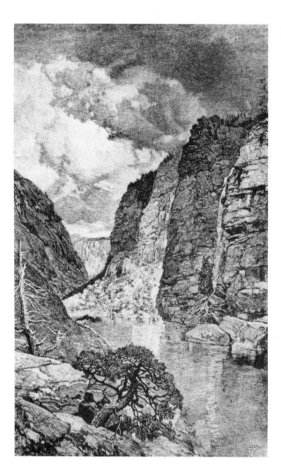

Fig. 95. *Across the Continent by the Scenic Route,* ca. 1880, guidebook cover, Passenger Department, Denver and Rio Grande Railway. Warshaw Collection of Business Americana, Archives Center, National Museum of American History.

gling hand over hand up the lace ladders of Chippeta Falls, to tumble headlong down again, making the prismatic foam resound with the soft tinkling of their merry laughter. All the Sprites of the cañon are beings of brightness and joy. The place is full of gayety.[14]

Moran's illustration, *Chipeta Falls, Black Cañon of the Gunnison* (fig. 94), depicts the gorge as neither black and narrow nor sunny and inviting. The sky is suffused with gray clouds, making the canyon somber, but it has none of the sublimity alluded to by the first text. Neither does it display the track that cuts directly through the floor, alongside the river.

In Moran's view, unlike Jackson's, the place is pristine, untouched by the invasive railroad and its tourists.

Of all the illustrations Moran created for the D&RG, none was reproduced as often as *Mountain of the Holy Cross.* It appeared in several versions in a range of publications issued by that railroad (fig. 95), and by others as well. Even companies with tracks running nowhere near Colorado, such as the Chicago and Alton Railroad, appropriated the image (fig. 96), effectively allying the line with its symbolic power. The mountain was a special attribute of an already remarkable area and could be adapted for a host of purposes. With the sacred peak adorning the pages of their

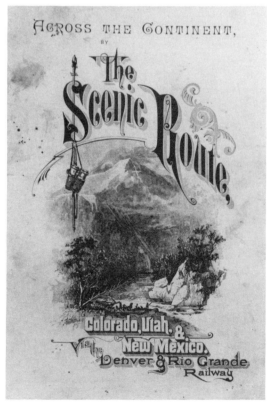

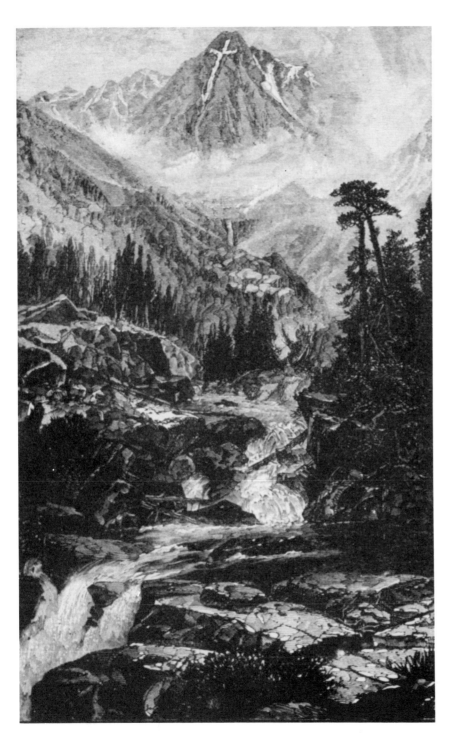

publications, the railroads could imply a relationship to an entire cultural movement.

The underlying rationale for their infiltration of the western wilderness had roots in the broad credo of Manifest Destiny, but it was even more specifically argued that railroads had a sacred duty to populate the West, bringing it into Christian civilization. This had been suggested as early as 1846: "The sooner we have railroads and telegraphs spinning into the wilderness, and setting the remotest hamlet in connection and close proximity with the east, the more certain it is that light, good manners, and Christian civilization will be come universally diffused."[15] That passage was quoted in an 1886 article that defended the railroads' role as a crusader even more vigorously:

It is thought and hoped that the railroads of this country will have no little to do in harmonizing the theological sects, and so in economizing the religious and financial forces of the church in the United States. . . . We therefore give the hand of

Fig. 96. Thomas Moran, *Mountain of the Holy Cross,* 1880s, wood engraving, approximately 6½ × 4½″ (16.5 × 11.43 cm). From *Tourist Tickets from Chicago and St. Louis to the Rocky Mountains,* Passenger Department, Chicago and Alton Railroad, 1884. Warshaw Collection of Business Americana, Archives Center, National Museum of American History.

Christian fellowship to the locomotive as a peacemaker, as harmonizing and economizing Christian forces. It brings new currents of thought to the cloister, hangs new pictures of holy faiths and life in the galleries of the old masters, and reveals a Christian kinship broader than any holy league and covenant. The railroad does vastly more than to work for commerce and dividends and civilization. It is an evangelist.[16]

That passage appeared in *The Magazine of Western History,* a Colorado publication that seems, by its profusion of articles on railroads, the D&RG in particular, to have been underwritten by that company. Intriguing is the quotation's emphasis on the railroads' promotion of Christian settlement and also the industry's importance as a harbinger of culture, even as a patron of art. The comment about railroads hanging "new pictures of holy faiths and life in the galleries of the old masters" was certainly a testament, if not a direct reference, to the D&RG's appropriation of Moran's *Mountain of the Holy Cross* as a new

Fig. 97. William Henry Jackson, [*The Mountain of the Holy Cross,* 1873], playing card issued by the Denver and Rio Grande Railway, ca. 1900. Collection of the author.

holy icon that would express Christian ideals and those of the new trinity, Commerce, Industry, and Progress.

Reflecting the D&RG's use of the image at Manitou Springs where it brought suffering pilgrims, the railroad's publications, especially *Rhymes of the Rockies,* coupled Moran's image with poetry that emphasized this holy mission. The 1887 edition read:

Where Nature's God hath roughest wrought;
 Where spring the purest fountains;
Where long ago the Titans fought
 And hurled for missles, mountains;
Where everlasting snows abide,
 And tempest clouds are driven
Along the solid granite side
 Of yawning cañons, riven
Deep in the Rockies' grandest pride
 That lifts its head to heaven
. .
The holy cross of Christian faith,
 Above the royal velvet
In beauty shines, an emblem wraith,
 High on the beetling helmet;
Its white arms stretching through the sheen
 Of silvery mist, are gleaming;
A talisman, the world to screen,
 Hope's symbol, in its seeming;
A wonder grand, a joy serene,
 Upon the ages beaming.[17]

With the poem's emphasis on the pure water, the hope the cross inspires, and the symbol's identity as a talisman, the railroad referred to the mountain's healing power and, by implication, that of Moran's image.

Rhymes of the Rockies and other booklets and promotional items (fig. 97) were distributed on the trains to help passengers pass the time, and they were also available free by mail. These guides promised sights to expect along

the route and became souvenirs in the days before cameras were widely available. Most important, however, the poems and accompanying illustrations, with their manipulations of reality, suggested ways to perceive the landscape. Through them the railroads and their commercialization of the scenic wilderness could be transformed into a beneficent force. The booklets were effective publicity, contributing to tourist traffic and to the intangible benefit of having the railroad considered vital to America's cultural, physical, and spiritual health.

The blessings of Moran's *Mountain of the Holy Cross* continued to be appropriated for a variety of purposes after the 1880s. Moran himself used the image on a Christmas card in 1883 and presented William Bell's daughter with a watercolor version as a wedding gift in 1894.[18] A 1903 D&RG publication, *With Nature in Colorado,* reproduced a vignette of Moran's 1875 painting accompanied by a passage from William Cullen Bryant's poem *Thanatopsis* that referred to "Communion" with nature (fig. 98). As late as 1906 the railroad produced an advertisement using the image that pronounced "Nature's Emblem of Christianity . . . One of the Many Wondrous Views Seen from the Trains" (fig. 99), a claim that had been made equally spuriously in the Union Pacific's promotional material in 1893.[19]

In the early 1920s Mount Holy Cross became an actual pilgrimage site and was promoted vigorously by *The Denver Post, The Rocky Mountain Herald* (fig. 100), and the D&RG.[20] The railroad provided discount rates to the Mountain of the Holy Cross Pilgrimage, Inc., and the Mount of the Holy Cross

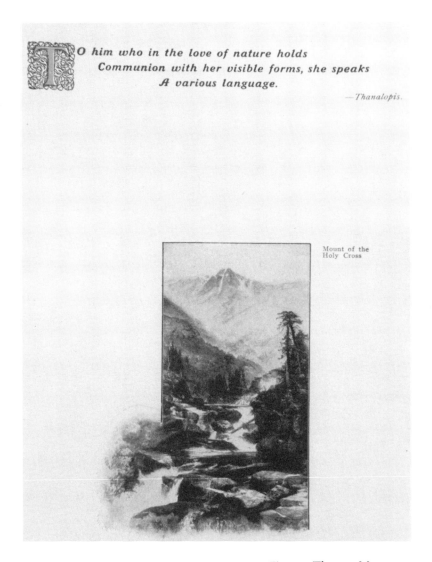

Fig. 98. Thomas Moran, *Mount of the Holy Cross,* 1875. From *With Nature in Colorado,* Passenger Department, Denver and Rio Grande Railway, 1906. Warshaw Collection of Business Americana, Archives Center, National Museum of American History.

Fig. 99. Denver and Rio Grande advertisement, 1906. From *Pacific Monthly*, 1906. The Thomas Gilcrease Institute of American History and Art, Tulsa, Oklahoma.

Fig. 100. Masthead, *Rocky Mountain Herald*. Courtesy of the Colorado Historical Society.

Association for annual trips to hear nonde-nominational religious services at the summit of Notch Mountain. Largely through the determination of those organizations a road, called Shrine Pass for its view of the cross, was graded, and permanent campsites were built at the foot of Notch Mountain and at its summit. The site was designated Holy Cross National Monument by President Hoover in 1929, an act that President Truman revoked in 1950 because of declining visitation and erosion of the cross's right arm, which marred the image.[21] Nevertheless, the mountain ap-

peared again in 1951 on a stamp commemo-rating Colorado's seventy-fifth anniversary (fig. 101), and it continues to fascinate visitors today.

The early beliefs in health and salvation that Moran's image embodied at Manitou Springs in the 1880s were even more vigorously pursued by the pilgrims of the 1930s. One example in *The Denver Post* is typical:

There is an unusual number of persons this year who are afflicted with serious maladies that have defied the best efforts of medical science; they hope that a sight of the Holy Cross, coupled with firm faith in divine power, will accomplish cures. Certainly such cures have resulted from the pilgrimages of the last two years, and that has increased the number of supposed "incurable" persons desirous of putting the matter to the test. How some of these visitors are to be got up the steep trail to the summit of Notch Mountain stands as an unanswerable problem, for there are several elderly women badly crippled with rheumatism. But there are plenty that have volunteered to assist in the climb.[22]

Other faith healings at the mountain included a radio pastor who conducted regular services from the summit, blessing mailbags full of handkerchiefs that would be mailed back to their owners.[23] The newspapers also emphasized the mountain's sanctity by publishing sensational stories about people who had attempted to mine at the foot of the cross. Invariably, of course, each had died either mysteriously or gruesomely. The early beliefs in the mountain's powers that Colorado's first railroad had promoted had been amplified and exaggerated with time.

Even today the D&RG has some contact with Thomas Moran's art through its corpo-

rate art collection. The company is presently owned by Thomas Anschutz of Denver, and one of his collection's centerpieces is Moran's painting *The Children of the Mountain* (1866, plate 6). This work, although painted before

Moran went west, was important for his career in the region. He had left it with *Scribner's* as collateral for his first trip to Yellowstone. Its addition to the Anschutz Collection appropriately joined the painting with one of Moran's early patrons, the Denver and Rio Grande Railway.[24]

The Mountain of the Holy Cross was a compelling image for Americans at the end of the nineteenth century and the early years of the twentieth. Its existence within the topography of the United States was of inestimable significance to a nation struggling to heal and define itself at a time of dramatic change. As in his earlier expressions of those transitions, Moran, in his *Mountain of the Holy Cross,* gave Americans not only a sense of place but also a richer sense of their corporate identity.

Fig. 101. Commemorative stamp, seventy-fifth anniversary of Colorado statehood. U.S. Postal Service, 1951. Collection of the author.

EPILOGUE

Thomas Moran's experiences with the United States geological surveys had far-reaching effects for the artist and the expeditions he accompanied and also for western developers, publicizers, visitors, and, indeed, for the West as a region and America as a nation. Through a complex relationship to the cultural events of the time, his western imagery reveals as much about the society it was directed toward as it does about the sensibilities of the artist who created it.

The act of surveying, literally "looking over" the land, is an appropriate context within which to consider Moran's art, because of his work with the government expeditions and its importance for his career and because his images give a sense of the particularity of the West's special places. His art is neither mere documentation nor pure fabrication. It is the incorporation of perception and conception; like a geologist's map it is a portrayal of the specificity of a place within the context of its relationship to a much larger whole. In Moran's case the whole was more than geographical and geological, it was also aesthetic, social, and commercial. It was through the conjunction of those disparate realms that he was able to convey to his audience something of the profound relevance of his subjects.

Moran's success in providing his viewers such an insight was not due merely to the artistic opportunities offered by the surveys, his illustrative commissions, or even his considerable artistic talent. It was, to some extent, the result of his ability to synthesize them with the West's popular appeal and, equally important, with a sense of truth. While he manipulated his scenes by combining elements from different points of view and by including metaphorical and allegorical details, Moran did succeed in portraying the true essence of the West. This truth lay not only in appearance; it also could be found in the larger implications of the subject. And although the popular conception of his pictures and even the places he depicted is overwhelmingly positive, his portrayal of them was not nearly so simplistic in its message.

Moran's most compelling and complex art presents a clear contrast to that of many of his contemporaries and predecessors. Represented by his three great subjects of the mid-1870s, his most revealing work, on close reading, does not reiterate the Edenic paradise longed for in early nineteenth-century writings and depicted by earlier artists. It is not the oversentimental attempt at historical landscape found in some of Thomas Cole's series; neither is it the cheap grace offered by Albert Bierstadt's facile depictions. Instead Moran's

three canvases give visual form to a personal and cultural struggle for self-definition in the West and in America in the last decades of a turbulent century.

When Moran first ventured west in 1871, the country was still healing from the divisive Civil War, and it looked west, in part as a means of reassessment, restoration, and redefinition after its most traumatic national event. What it found was alien in many ways, unfamiliar and hostile, but gradually, through the efforts of scientists and explorers such as those Moran accompanied, of industrial entrepreneurs such as Jay Cooke and William A. Bell, of popularizers such as Gilder, Bunce, and Prang, and, of course, the artists and photographers, the West became a familiar and profitable, if still exotic and unpredictable, extension of the United States that helped recreate the Union's identity and point it toward a new century.

Moran's three great oils form a natural triptych, formally, conceptually, and geographically, and when seen as such they reveal his profound understanding of the significance of the West as a microcosm of American culture and of universal ideas. With *The Grand Cañon of the Yellowstone* on one side, *The Chasm of the Colorado* on the other, and *Mountain of the Holy Cross* in the center, the images combine to suggest implications more profound than even the sum of their parts. As the first, *The Grand Cañon of the Yellowstone* demonstrated the potential for a conceptual transformation of the land from a demonic place of mystery into a wonderland to be enjoyed and exploited by millions. Yellowstone's change from a hellish place useful to no one into a haven for nature lovers and for private corporations intent

on profit is a classic American example of manipulating attitudes toward a product for marketing purposes. In Moran's painting, the artist's adjustment of physical and geological fact for the sake of pictorial effect closely parallels that rearrangement of perception.

The apocalyptic and prophetic *Chasm of the Colorado* suggested the inherent dangers and ultimate judgment that would come with careless management of the delicate western environment, at the same time that it offered a different kind of opportunity for development and the attempted control of reality. The Grand Canyon, in the heart of the desert Southwest, could exemplify the polarities of that climate and landscape and of the larger culture itself, and through his poignant juxtaposition of storm and canyon, rainbow and river, Moran implicitly conveyed the land's latent power to determine the fate of its inhabitants. Realized in the 1880s' mismanagement of the region's natural characteristics of drought and scarcity of vegetation, the painting's central tension, its prophecy for America, was proved true by the land itself.

As a culmination, *Mountain of the Holy Cross*, with its dual implications of suffering and salvation, represented the fulfillment of the earlier two potentialities and the possibility of redemption from them. The opportunity for both recreation of the self and judgment of the soul are implicit in the symbol of the cross, but in the sign, and in the journey suggested by the picture's formal composition, reconciliation is possible. Nevertheless, in the painting and at the place, arrival at the pinnacle is not easy; it can be attained only through travail, confrontation, and a difficult transition. For Moran and his companions

making the difficult ascent of the actual mountain, for the pilgrims seeking relief from suffering, for the corporations looking for a profitable symbol, and for the nation searching for reconciliation with the recent past, the legacy of history, and the promise of the future, the Mountain of the Holy Cross was the embodiment of a dream.

Together the three paintings form a trilogy about a culture and a place. Thomas Moran's West was both sacred and profane, a world of unspeakable beauty and limitless power. By creating a sense of place for his viewers in his images, he made the West an indelible part of the American consciousness, while reflecting that society back to itself.

NOTES

INTRODUCTION: VISUAL DOCUMENTATION OF THE GREAT SURVEYS

1. The best work on the pre-1860 military expeditions is William Goetzmann's *Army Exploration in the American West, 1803–1863* (New Haven: Yale University Press, 1959). For the Great Surveys see Mary C. Rabbitt's *Minerals, Lands, and Geology for the Common Defence and General Welfare*, vol. 1: *Before 1879* (Washington, D.C.: Government Printing Office, 1979) and Richard Bartlett's *Great Surveys of the American West* (Norman: University of Oklahoma Press, 1962). The full titles and leaders of the Great Surveys are: the United States Geological and Geographical Survey of the Territories, Dr. Ferdinand Vandiveer Hayden; the United States Geological Exploration of the Fortieth Parallel, Clarence King; the United States Geographical and Geological Surveys of the Rocky Mountain Region, John Wesley Powell and the United States Geographical Surveys West of the One Hundredth Meridian, Lt. George M. Wheeler. The last was technically military, but it

was managed similarly to the civilian expeditions and is treated as such.

2. J. S. Wilson, commissioner of the General Land Office, to Hayden, April 29 and May 10, 1867. Hayden Survey Correspondence, National Archives, Record Group 57, Washington, D.C. (hereafter abbreviated NA, RG 57). Cited in Bartlett, Great Surveys, pp. 10–11. The publications of the Great Surveys are voluminous. For a complete listing see Lawrence F. Schmeckebier's *Catalogue and Index of the Publications of the Hayden, King, Powell, and Wheeler Surveys,* U.S. Geological Survey Bulletin 222, Ser. G., Misc. 26 (Washington, D.C.: Government Printing Office, 1904).

3. From *Original Journals of the Lewis and Clark Expedition, 1804–1806,* ed. Reuben Gold Thwaites (New York: Arno Press, 1969), vol. 2, pp. 149–50. Lewis may be referring to Niagara Falls in the last sentence. The spelling is Lewis's.

4. A good introduction to the study of many of these artists is by Patricia Trenton and Peter H. Hassrick, *The Rocky Mountains: A Vision for Artists in the Nineteenth Century* (Norman: University of Oklahoma Press, 1983). For more about the pre-1860 expeditionary artists see Robert Taft, *Artists and Illustrators of the Old West, 1850–1900* (New York: Charles Scribner's Sons, 1953); Goetzmann, *Army Exploration;* William Goetzmann, *Exploration and Empire* (New York: Alfred A. Knopf, 1966); and J. Gray Sweeney, "The Artist-Explorers of the American West" (Ph.D. dissertation, Indiana University, 1975). This subject has been discussed in many books and articles but has received no definitive survey treatment.

5. For more on these processes see Robert Taft, *Photography and the American Scene: A Social History, 1839–1889* (New York, 1938; reprint ed., Mineola, N.Y.: Dover, 1964). Many of these themes are discussed by Elizabeth Lindquist Cock in "The Influence of Photography on American Landscape Painting" (Ph.D. dissertation, New York University, 1967). Probably because of the expense of original prints, they were generally reserved for special editions of photographs. The reports themselves differed in their reproduction

methods; both King and Wheeler printed lithographs from Timothy O'Sullivan's images, and Hayden and Powell usually used the less expensive wood engraving.

6. The lavish survey reports of the 1870s were preceded by the 1850s' twelve-volume railroad survey, which was the most thorough coverage of the West to that date and included woodcuts of specimens and colored landscape views. See *Reports of Explorations and Surveys to Ascertain the Most Practicable and Economical Route for a Railroad from the Mississippi River to the Pacific Ocean* (Washington, D.C.: Government Printing Office, 1855–60). Volume 2 is particularly relevant.

7. Many of these concepts are more thoroughly explored by Mary Panzer in "Great Pictures of the 1871 Expedition: Thomas Moran, William Henry Jackson, and *The Grand Canyon of the Yellowstone,*" in *Splendors of the American West: Thomas Moran's Art of the Grand Canyon and Yellowstone* (Birmingham: Birmingham Museum of Art, in association with University of Washington Press, 1990), pp. 43–58. See also Weston Naef and James Wood, *Era of Exploration: The Rise of Landscape Photography in the American West, 1860–1885* (Buffalo and New York: Albright Knox Gallery and Metropolitan Museum of Art, 1975).

8. Notable studies are by Linda Ayres, *Thomas Moran's Watercolors of Yellowstone* (Washington, D.C.: National Gallery of Art, 1985); Phyllis Braff, *Thomas Moran: A Search for the Scenic* (East Hampton, N.Y.: East Hampton Guild Hall Museum, 1980); Carol Clark, *Thomas Moran: Watercolors of the American West* (Austin: University of Texas Press, 1980); Thomas Fern, *The Drawings and Watercolors of Thomas Moran, 1837–1926* (Notre Dame, Indiana: Art Gallery of the University of Notre Dame, 1976); William Truettner, "Scenes of Majesty and Enduring Interest: Thomas Moran Goes West," *Art Bulletin* 58 (June 1976):241–59; Thurman Wilkins, *Thomas Moran: Artist of the Mountains* (Norman: University of Oklahoma Press, 1966). See also bibliography.

CHAPTER 1: MORAN'S AESTHETIC THEORY AND BACKGROUND

1. Thomas Moran, "American Art and American Scenery," in *The Grand Cañon of Arizona,* ed. Charles Higgins (Passenger Department of the Santa Fe Railway, 1902), pp. 85–87.

2. Thomas Cole, "Essay on American Scenery," *American Monthly Magazine,* new series, 1(January 1835):1–12, and Asher B. Durand, "Letters on Landscape Painting," *Crayon* 1(1855):34–35. Quoted in *American Art 1700–1960: Sources and Documents,* ed. John McCoubrey (Englewood Cliffs: Prentice-Hall, 1965), pp. 98–110, 112.

3. Wilkins, *Thomas Moran,* pp. 16–19. There was a large group of illustrious artists in Philadelphia at that time, such as James Hamilton, Thomas Birch, Thomas Sully, and John Neagle, as well as a good deal of older art, including that of Benjamin West and the Peale family, in private galleries and the Pennsylvania Academy of Fine Arts.

4. Although Moran himself later wrote, "[I] was never under any master," he credited Hamilton with having "extraordinary knowledge in art" and for giving him "wholesome advice." Wilkins, *Thomas Moran,* pp. 23–24. The most important sources for Hamilton's life and work are by John Sartain, "James Hamilton," *Sartain's Union Magazine of Literature and Art* 10 (1852):331–33; John I. H. Baur, "A Romantic Impressionist: James Hamilton," *Brooklyn Museum Bulletin* 12(Spring 1951):1–9; Arlene Jacobowitz, *James Hamilton, 1819–1878: American Marine Painter* (Brooklyn: Brooklyn Museum, 1966); and Constance Martin, *James Hamilton: Arctic Watercolors* (Calgary: Glenbow Museum, 1984).

5. Roger B. Stein, *John Ruskin and Aesthetic Thought in America, 1840–1910* (Cambridge: Harvard University Press, 1967); Linda S. Ferber and William H. Gerdts, *The New Path: Ruskin and the American Pre-Raphaelites* (Brooklyn: Brooklyn Museum, 1985); and Truettner, "Scenes of Majesty," pp. 241–59.

6. Ruskin to the Editors, *Crayon* 1(May 2, 1855):283. Cited in Stein, *Ruskin,* p. 33.

7. [John Ruskin,] *Modern Painters* (New York: Wiley and Putnam, 1847). The first edition of *Modern Painters* was issued in England in 1843, and volumes 1 and 2 were published in the United States in 1847. Ruskin himself was not named in this edition. Volume 3 was issued in 1848, number 4 in 1856, and 5 in 1860.

8. Stein, *Ruskin,* p. 41.

9. Ruskin, *Modern Painters* 1, pp. xxxi and xliii.

10. Ibid., vol. 4, pp. 18, 19, and 20.

11. This entire movement is beautifully discussed and illustrated by Ferber and Gerdts in *The New Path.* The quotation is that of Charles Herbert Moore, "The Fallacies of the Present School," *New Path* 1(October 1863):61. Cited in Ferber and Gerdts, *The New Path,* p. 31.

12. Ruskin, *Modern Painters* 4, p. 22.

13. Ruskin, *Modern Painters* 1, preface to 2nd ed., pp. xxvi–xxviii. Reynold's theories are found in his series of lectures at the Royal Academy, the famous *Discourses,* which were the most important foundation for late eighteenth- and early nineteenth-century approaches to art, especially in England and the United States.

14. Ruskin's quotation is from Samuel Sachs, "Thomas Moran: Drawings and Watercolors" (M.A. thesis, New York University, 1963), pp. 43–44. Cited in Truettner, "Scenes of Majesty," p. 254. The two met during Moran's 1882 England trip. Ruskin bought several etchings from Moran and his wife, Mary Nimmo, and ordered a copy of *The Yellowstone National Park* (Boston: Louis Prang, 1876; see chapter 5). Ruskin wrote Moran on December 27, 1882: "I do wish with my whole heart you could give up for a while all that flaring and glaring and splashing and roaring business— and *paint,* not etch—some quiet things like that little true landscape absolutely from nature." In February he reminded him, "And please, in some degree attend to what I wrote of the necessity of giving up flare and splash. Force yourself to show leaves and stones—such as God meant us all to be shaded by, and to walk on—and be buried under—till you see the daily beauty of these and make others see it." There is one final small note, "And please *do* mind what I said about a severer

and simpler sincerity of study." Moran papers, AAA, NTM 1, frames 652–54.

15. Stein, *Ruskin,* p. 23.

16. Jacobowitz, *James Hamilton,* p. 23.

17. Andrew Wilton, *J.M.W. Turner: His Art and Life* (New York: Rizzoli, 1979), pp. 82–83.

18. In George Sheldon, *American Painters* (New York: D. Appleton and Co., 1881), pp. 123–24.

19. Ibid., p. 125.

20. Moran, "Knowledge a Prime Requisite in Art," *Brush and Pencil* 12(April 1903):14. This and its relation to Ruskin are also explored by Truettner, in "Scenes of Majesty," p. 254.

21. Ruskin, *Modern Painters* 4, p. 16.

22. Moran, "Knowledge a Prime Requisite in Art," p. 15.

23. Ruskin, *Modern Painters* 4. Volumes 1 and 2 contain a good deal of this as well.

24. Stein, *Ruskin,* pp. 38, 41.

25. Stein notes the parallels among Ruskin, Powell, and King, including Powell's and Ruskin's penchant for reading the world as a book. See his chapter "Ruskin and the Scientists," *Ruskin,* pp. 178–81. For more on Powell's "rock-leaved Bible," see part three, on the Grand Canyon, below.

26. Ruskin, *Modern Painters* 1, preface to 2nd ed., p. xxxv.

27. Hamilton went to California in 1875, where he died in 1878. Baur reports that among his illustrations was a series for James Fenimore Cooper's stories. The works would presumably have been of frontier subjects. Baur, "A Romantic Impressionist," p. 8.

28. The reference to Humboldt and Jesse's comment on Hamilton are from John Charles Frémont's *Memoirs of My Life* (Chicago and New York: 1887), p. xv. See for example Hamilton's *Buffaloes Escaping Prairie Fire,* ca. 1856, oil on wood (reproduced in Jacobowitz, *James Hamilton,* fig. 14, p. 38), which was used to illustrate the *Memoirs,* opposite p. 136.

The only extensive account of the survey is that by Carvalho himself. Little record of the images themselves remains; the camera equipment was abandoned when the party nearly froze to death in

the mountains, and although the photographs were brought back and rephotographed by Mathew Brady, they too were destroyed by a fire in Frémont's home. See Taft, *Photography and the American Scene*, pp. 262–66; Baur, "A Romantic Impressionist," pp. 3–4; Solomon Carvalho, *Incidents of Travel and Adventure in the Far West, with Colonel Frémont's Last Expedition Across the Rocky Mountains: Including Three Months' Residence in Utah, and a Perilous Trip Across the Great American Desert to the Pacific* (New York: Derby and Jackson, 1857).

Frémont's official report for the 1853 expedition was never published because he was distracted by his presidential campaign in 1856.

29. Elisha Kent Kane, *The U.S. Grinnell Expedition in Search of Sir John Franklin, 1850–51* (New York: 1854); and idem, *Arctic Explorations: The Second Grinnell Expedition in Search of Sir John Franklin, 1853, '54, '55* (New York: 1856). For Hamilton's work see Martin, *James Hamilton*, pp. 9–10. Franklin's disappearance and the rescue efforts captured popular attention on both sides of the Atlantic. The quote may be found in *Dictionary of American Biography* 10(1933):256, cited by William Truettner in "The Genius of Frederic Edwin Church's *Aurora Borealis*," *Art Quarterly* 31(Autumn 1968):271. Truettner explores Church's awareness of Kane's arctic explorations, arguing that Kane's accounts directly inspired Church to journey north in 1859. He notes that a copy of Kane's *Arctic Explorations* may still be found in Church's library at Olana.

30. Sir John Franklin was one of many who sought a northwest passage through North America, and his disappearance in 1845 aroused international attention. In response to his wife's appeal for assistance in finding him, New York shipbuilder Henry Grinnell, cosponsored by the United States government, launched a rescue expedition in 1850. Martin, *James Hamilton*, p. 10. Kane was certainly familiar with the expeditionary art of his immediate predecessor, Lt. William Browne, the explorer-artist for the first Franklin rescue attempt, a British venture in 1848. Kane,

Grinnell Expedition, p. 171, cited in Martin, *James Hamilton*, p. 10. Kane may have thought of having Hamilton work up his sketches even before his 1850 departure. In his diary he wrote to his brother, "Let me make a picture for you without a jot of fancy about it and get 'H' to put it into colours if you can." Martin, *James Hamilton*, p. 13.

31. Letter from Hamilton, July 1, 1857, in William Elder's *Biography of Elisha Kent Kane* (Philadelphia: 1858), pp. 219–23. Cited in Jacobowitz, *James Hamilton*, p. 15.

32. Elder, *Biography of Elisha Kent Kane*, p. 216. Cited in Martin, *James Hamilton*, 13.

33. Most of Hamilton's watercolors of Kane's explorations are today in the Glenbow Museum in Calgary. See Martin, *James Hamilton*. Baur reports that among Hamilton's papers is a manuscript of a lecture on clouds that is "almost purely scientific in its analysis of their handling." Baur, "A Romantic Impressionist," pp. 5–6.

34. Alexander von Humboldt, *Cosmos*, trans. E. C. Otté, two vols. (New York: Harper and Brothers, 1850).

35. This point is made by Truettner in "The Genius of Frederic E. Church," pp. 268–69. See also Katherine Manthorne, *Tropical Renaissance: North American Artists Exploring Latin America, 1839–1879* (Washington, D.C.: Smithsonian Institution Press, 1989).

CHAPTER 2: LANDSCAPE AS METAPHOR

1. George Catlin, *Letters and Notes on the Manners, Customs, and Conditions of the North American Indians*, vol. 1 (London: 1841), p. 69.

2. Cited in Roderick Nash, *Wilderness and the American Mind* (New Haven and London: Yale University Press, 1967), p. 72.

3. James Fenimore Cooper, "American and European Scenery Compared," in *The Home Book of the Picturesque*, by Washington Irving et al. (New York: G. P. Putnam, 1852), pp. 52, 66, 69.

4. Horace Greeley, *Overland Journey from New York to San Francisco in the Summer of 1859* (New

York: C. M. Saxton, Barker and Co., 1860), pp. 311–12.

5. Quoted from *The New York Herald* as part of the newspaper article "Splendors of the West," Deer Lodge, Montana, *New North-West* March 16, 1872. Cited in Aubrey Haines, *Yellowstone National Park: Its Exploration and Establishment* (Washington, D.C.: National Park Service, 1974), p. 128.

6. The phrase "green old age" is from Clarence King, *Mountaineering in the Sierra Nevada* (Boston: Osgood and Co., 1872), pp. 41–43.

7. Indeed, Moran kept his portfolio of drawings throughout his career, using them over and over in the production of paintings and not parting with any until he made a gift of a large group to the Cooper Union in 1917. See *Drawings and Watercolors of the West: Thomas Moran from the Collection of the Cooper-Hewitt Museum of Design* (New York: Washburn Gallery, October 1974).

8. Although the *Song of Hiawatha* paintings are scattered, many of the original sketches for them are in the collection of the Gilcrease Museum. Henry Schoolcraft, ed., *Algic Researches: Report on the Geology of the Lake Superior Land District,* ca. 1850, part II, 124 n. Cited in Wilkins, *Thomas Moran,* p. 30. The survey report, by J. W. Foster and Josiah D. Whitney, is *Report on the Geology of the Lake Superior Land District,* part 1 (Washington, D.C.: Government Printing Office, 1851), p. 124 n., cited in J. Gray Sweeney, *Artists of Michigan in the Nineteenth Century* (Muskegon, Mich.: Muskegon Museum of Art, 1987), p. 34.

9. "The Pictured Rocks of Lake Superior," *Aldine* 6(January 1873):14.

10. Sweeney, *Artists of Michigan,* p. 36.

11. For an insightful essay on the subject see George P. Landow's "The Rainbow: A Problematic Image," in *Nature and the Victorian Imagination,* ed. U. C. Knoepflmacher and G. B. Tennyson (Berkeley: University of California Press, 1977), pp. 341–69.

12. Rainbows appear in most of Moran's water and falls paintings. For a brief discussion of the presence of rainbows in Moran's waterfalls, see the essay by Linda Hults, "Moran's *Shoshone Falls:* A

Western Niagara," *Smithsonian Studies in American Art* 3(Winter 1989):89–102.

13. "Thomas Moran's Water-color Drawings," *Scribner's Monthly* 5(January 1873):394.

14. Landow, "The Rainbow," p. 369.

15. Other important Moran oils based on the Michigan scenery are *The Great Cave, Pictured Rocks, Lake Superior, Michigan* (1873, unlocated, illus. in *Antiques Magazine* December 1976); *Hiawatha and the Great Serpents of the Kenabeek* (1867, Baltimore Museum of Art); *The Spirit of the Indian* (1869, Philbrook Art Center, Tulsa). See Sweeney, *Artists of Michigan,* pp. 33–39. *Fiercely the Red Sun Descending* is part of a series illustrating Longfellow's poetry. Sketches are at the Gilcrease, and Moran inscribed many with the poetry. The verso of the sketch for *Fiercely* (Gilcrease 0226.914) reads, "Burned his way along the heavens / Set the sky on fire behind him."

16. The number of canvases is derived from Darryl Patrick, "The Iconographical Significance in Selected Subjects by Thomas Moran," Ph.D. dissertation, North Texas State University, p. 64. Moran's many views of this subject are scattered widely. The Gilcrease owns at least four versions in pencil, watercolor, and etching; the Cooper-Hewitt has several; the JNEM and EHF each have versions. Of the oils, those owned by the Amon Carter (1874) and Stark (1879) museums in Texas are of the highest quality.

17. Ferdinand Hayden, *Sun Pictures of Rocky Mountain Scenery with a Description of the Geographical and Geological Features and Some Account of the Resources of the Great West; Containing Thirty Photographic Views Along the Line of the Pacific Railroad, from Omaha to Sacramento* (New York: Julius Bien, 1870). The Green River cliffs were also photographed by others, including Timothy O'Sullivan.

18. Patrick, "Iconographical Significance," chap. 4, pp. 64–85.

19. E. Burlingame, "The Plains and the Sierras," in *Picturesque America,* vol. 2, ed. William Cullen Bryant (New York: D. Appleton and Co., 1874), p. 174.

20. Nathaniel Langford, "The Wonders of Yellowstone," *Scribner's Monthly* 2(May, June 1871):1–17, 114–28. Moran's original wash drawings for the illustrations are in the Gilcrease Museum. See also *The Art of the Yellowstone, 1870–1872* (Tulsa: Thomas Gilcrease Institute of American History and Art, 1983).

21. Ferdinand V. Hayden, "Wonders of the West, II: More About the Yellowstone," *Scribner's Monthly* 3(February 1872):392. Langford, "Wonders of Yellowstone," pp. 8–9.

22. Unidentified clippings, Moran papers, AAA, NTM 4, frames 606, 616.

23. 2 Samuel 22:2–3. Psalm 18:2 repeats much of the passage.

24. Wilkins, *Thomas Moran*, plate between pp. 16 and 17; Truettner, "Scenes of Majesty," p. 252; and "Moran, His Sketches: Blueprints for Masterpieces," *American Scene* 16(2):21. Although it is placed in a different context, see Katherine Manthorne's discussion of the significance of trees in nineteenth-century landscape painting in "The Quest for a Tropical Paradise: Palm Tree as Fact and Symbol in Latin American Landscape Imagery, 1850–1875," *Art Journal* 44(Winter 1984):374–82.

25. For reproductions of several tree portraits by Watkins, see Naef and Wood's *Era of Exploration*, plates 24, 32, 33. Moran illustrated an article on the California redwoods just before he commenced his first large canvas, *The Grand Cañon of the Yellowstone*. See Isaac H. Bromley's "Wonders of the West: The Big Trees and the Yosemite," *Scribner's Monthly* 3(January 1872):261–77.

26. This was the artist's favorite lithograph, but the stone was dropped and ruined after only ten or twelve impressions. Anne Morand and Nancy Friese, *The Prints of Thomas Moran in the Thomas Gilcrease Institute of American History and Art, Tulsa, Oklahoma* (Tulsa: Gilcrease Museum, 1986), p. 73, no. 13. A different version of *Solitude*, reversed and altered, appeared in 1879 in Sheldon's *American Painters*, p. 127, and according to Wilkins, this woodcut was from a painting Moran worked on in the 1870s but did not finish until 1897, when he exhibited it with the title *Rocky Mountain Vista* at the National Academy (location unknown). Wilkins, *Thomas Moran*, p. 209.

27. Henry N. Dodge, *Christus Victor* (New York and London, 1926), facing p. 30. Deuteronomy 20:19.

28. Psalm 1:3.

29. This William Bell is not to be confused with the physician and vice president of the Denver and Rio Grande Railroad William A. Bell, who was also a photographer.

30. The biblical allusions to rocks are too numerous to mention, but one example is Psalm 18:2, "The Lord is my rock, and my fortress, and my deliverer; my God, my strength, in whom I will trust."

CHAPTER 3: THE HAYDEN GEOLOGICAL AND GEOGRAPHICAL SURVEY

1. In 1867 the House of Representatives adopted a resolution to commission Albert Bierstadt for "two paintings thoroughly American in character, representing some prominent feature of scenery or important event in the discovery or history of America." But it was not until 1875 that Congress purchased his *Discovery of the Hudson River* (ca. 1874), and in 1878 its companion piece, *Expedition Under Viscaino Landing at Monterey, 1601* (*Entrance into Monterey*, ca. 1878). Although they are still history paintings, they contain significant landscape settings. See Kent Ahrens, "Nineteenth-Century History Painting in the United States Capitol," *Records of the Columbia Historical Society* 50(1980):191–222; and *Art in the U.S. Capitol* (Washington, D.C.: U.S. Government Printing Office, 1878), pp. 160–61. Bierstadt and Moran seem to have been in competition for the sale in 1878; Moran hoped Congress would purchase his large oil *Ponce De Leon in Florida, 1512* (1877), instead of Bierstadt's *Entrance into Monterey*. A disgruntled Bierstadt wrote Hayden, "One of the pictures has been paid for and I do not think that the other can be moved without very much trouble. I know that Mr. Moran has attempted

and is at work upon this matter. Why he should try to have one removed when there is so much space outside I cannot tell. He may not be aware that seven years ago a unanimous vote was cast authorizing me to paint two pictures to fill these places, but if he or anyone else cares to refer to the records they will find this to be the case. I could at that time have had the money laid aside for that purpose, but as I could not fill the order for some years I found the use of the money then in the hands of the Library Committee. . . . Selfishness is the motto now and if I had chosen could have had at least 50 to $60,000 laid aside for my works. This fact is not appreciated and as I have an abundance to do I cannot afford to spend any time in Washington for this picture—and I do not care to paint any more pictures for the U.S. There is no profit in it. I can sell to private patrons all I can make for double what the Government will pay me, and the only thing to me at the time and now is the fact of having such a compliment paid me. Some people look upon the U.S. Capitol as the only place for their works." January 31, 1875, NA, RG 57, mfm. 623, roll 5, frames 771–75. Moran's work was rejected, and he noted in his ledger that Congress had "foolishly [bought] Bierstadt's poor picture of the Discovery of California." Moran papers, GIL. See also Wilkins, *Thomas Moran,* p. 111, and Nancy K. Anderson and Linda S. Ferber, *Albert Bierstadt: Art and Enterprise* (New York: Brooklyn Museum, 1991), pp. 48–53.

2. The falls here are the Lower Falls of the Yellowstone River; there is also an Upper Falls upstream, as well as a Tower Falls on Tower Creek, which Moran also painted.

3. Moran wrote Hayden about this: "I am desirous of placing you on horseback as one of the figures in the foreground. To do this will make it necessary for me to have a photograph of you, the head to be just the right size. A head alone would do, say this size [indicates with a small sketch]. If you have such a photo I would thank you very much for it." He did not, in fact, put Hayden on horseback, but we may assume it is Hayden standing with the Indian. March 11, 1872, NA, RG 57, mfm. 623, roll 2, frame 468. Later Moran admitted, "I am going to have a good portrait painter put in the portraits." Moran to Hayden, April 6, 1872, NA, RG 57, mfm. 623, roll 2, frame 506.

4. Moran, Yellowstone journal, July 16, 1871, Yellowstone National Park (YNP). In previous studies this journal has been listed as in the JNEM in St. Louis, but it has been transferred to the museum at the park.

5. Hayden, "Wonders of the West II," p. 392.

6. Haines, *Yellowstone National Park,* p. 45. Haines's well-documented book includes many early accounts of the area. See also Merrill J. Mattes, "Behind the Legend of Colter's Hell: The Early Exploration of Yellowstone National Park," *Mississippi Valley Historical Review* 36(September 1949):251–81.

7. U.S. Congress, Report of Brevet Brigadier General Wm. F. Raynolds, pp. 10–11. Cited in Haines, *Yellowstone National Park,* pp. 25–26.

8. Haines reports that Hayden was in the audience of Langford's Washington lecture on January 19, 1871. Haines, *Yellowstone National Park,* p. 94. Jackson concurred in his 1936 article, "With Moran in the Yellowstone: A Story of Exploration, Photography and Art," *Appalachia* 21(December 1936):151. See also *Geological Report of the Exploration of the Yellowstone and Missouri Rivers, by Dr. F. V. Hayden, Assistant, Under the Direction of Captain W. F. Raynolds, Corps of Engineers, 1859–60* (Washington, D.C.: Government Printing Office, 1869). The volume includes a large colored map that encompasses the park area, and much of it is completely blank.

9. Charles W. Cook, "Preliminary Statement to the Cook-Folsom Diary," *Haynes Bulletin,* December 1922, pp. 7–8. Cited in Haines, *Yellowstone National Park,* p. 48.

10. Charles W. Cook, "The Valley of the Upper Yellowstone," *Western Monthly* July 4, 1870, p. 64. The article has been reprinted a number of times. See Haines's bibliography in *Yellowstone National Park,* p. 163, n. 11, 12. The full names of the

group members are David E. Folsom, Charles W. Cook, and William Peterson.

11. Surgeon James Dunlevy accompanied a group of Montana volunteers under Capt. Charley Curtis of Fort Ellis in 1867. They ventured into Yellowstone because of curiosity, prompted by the acting territorial governor, Thomas Francis Meagher. "The Upper Yellowstone," Virginia City *Montana Post* August 24, 1867, cited in Haines, *Yellowstone National Park,* p. 35.

12. Langford, "The Wonders of Yellowstone," p. 7.

13. *Helena Daily Herald* November 14, 1870. Cited in Richard Bartlett, *Nature's Yellowstone: The Story of an American Wilderness That Became Yellowstone National Park in 1872* (Albuquerque: University of New Mexico Press, 1974), p. 187, n. 38.

14. The notable expeditions Hayden participated in were with Lt. G. K. Warren, of the Topographical Engineers, into Dakota, 1856–57, and Capt. W. F. Raynolds along the upper Missouri, 1858–59. See Gilbert F. Stucker, "Hayden in the Badlands," *American West* 4(February 1967):40–45, 79–85, and Bartlett, *Great Surveys,* pp. 6–7.

15. Stucker, "Hayden in the Badlands," pp. 40–45.

16. This survey was nominally of Nebraska, but Hayden's survey also included portions of Wyoming and Colorado east of the Rockies. Bartlett, *Great Surveys,* p. 12. To secure his position Hayden prevailed on General Humphreys, who had overseen the Raynolds expedition, and his Smithsonian friends, Joseph Henry and Spencer Baird. Hayden asked Baird to use his influence with the Senate. "I can accomplish so much if I get that place. . . . How much it would aid emigration to have a good scientific report about that region. . . . I could bring out a fine volume the first year." Hayden to Baird, Smithsonian Archives (SA), Spencer Baird papers, Box 9, March 10, 1867.

17. The agreement was that the Smithsonian was to share the specimens with the Land Office and was not obligated to keep them indefinitely. According to Joseph Henry's notes some were kept, others dispersed to colleges. SA, Joseph Henry papers, Record Unit 7001, Desk Diary, December 15, 1870.

18. Hayden's expedition was under the Department of the Interior, but he kept an office at the Smithsonian and was friendly with the administrators. I have found no written record of the hiring process and presume that the transaction was verbal.

19. Although Hayden praised Elliott's work in his 1870 report, saying, "Mr. Elliott, the artist, worked with untiring zeal, and his sketches and sections have never been surpassed for beauty or clearness in any country," the artist's work pales next to that of Moran or Gifford. He left his artistic career after 1871 for the seal industry in Alaska. Primary sources include Elliott's field sketches in the NA and at the USGS in Denver, a scrapbook at the USGS in Reston, Virginia, several letters in the SA (Joseph Henry papers), and a collection of papers in the Washington State Historical Society in Tacoma, which includes diaries, sketches, and correspondence.

Landscape illustration in U.S. government reports dates to the 1819–20 Long expedition, which included Samuel Seymour and Titian Peale. See Edwin James's *Account of an Expedition from Pittsburgh to the Rocky Mountains, Performed in the Years 1819 and '20,* vol. 14 of *Early Western Travels, 1748–1846,* ed. Ruben Gold Thwaites (Cleveland: A. H. Clark Co., 1905–1907). There were many later examples, most notably the eight-volume Pacific Railroad Survey report compiled in the early 1850s.

20. The quotation is from *Preliminary Report of the United States Geological Survey of Wyoming and Portions of Contiguous Territories (Being a Second Annual Report of Progress). Conducted Under the Authority of the Secretary of the Interior by F. V. Hayden, United States Geologist* (Washington, D.C.: Government Printing Office, 1871), p. 3. Sources on Jackson are by Peter B. Hales, *William Henry Jackson and the Transformation of the American Landscape* (Philadelphia: Temple University Press, 1988); Beaumont Newhall and Diana Edkins, *William H. Jackson* (New York and Fort Worth: Morgan and

Morgan and the Amon Carter Museum, 1974); William H. Jackson, *Time Exposure* (New York: G. B. Putnam and Sons, 1940; reprint ed., Albuquerque: University of New Mexico Press, 1987); and Clarence Jackson, *Picture Maker of the Old West: William Henry Jackson* (New York: Charles Scribner's Sons, 1947). It is interesting that Jackson was not paid in 1870 even though Hayden's budget that year was $25,000, a significant increase from previous seasons. Jackson wrote of the meeting in *Time Exposure,* pp. 187–88.

Although the geological survey act is sometimes referred to as a consolidation, it was actually a reorganization. Many of the goals of the four early surveys have been maintained to the present day, but the bureaucratic structure is entirely altered.

21. The Raynolds expedition listed J. D. Hutton as a topographer and artist, but Raynolds's diary entry for July 13, 1860, notes that "Mr. Hutton returned to Great Falls [of the Missouri] to obtain a photograph of them. . . . Mr. Hutton returned at night fall, having indifferently accomplished the object of his expedition." See U.S. Congress, The Report of Brevet Brigadier General Wm. F. Raynolds on the Exploration of the Yellowstone and the Country Drained by That River, S. Exec. Doc. 77, 40th Cong., 2nd sess., 1868, p. 109. Also cited by Taft in *Photography and the American Scene,* p. 268.

O'Sullivan was the first photographer hired by one of the Great Surveys. The idea may have been suggested to King by William H. Brewer on the 1866 California State Geological Expedition to Yosemite. Brewer later wrote of that season, "I talked much about the value of large photographs in geological surveys. I had taken a fancy to stereoptical views especially; and I thought the broken country about Lassen peak should be photographed, and could not be shown satisfactorily by drawings." Perhaps more influential, however, was the presence of Carleton Watkins, whom King later called "the finest photographer" he knew. Watkins accompanied King's 1870 ascent of Mount Lassen, and Andrew Joseph Russell was briefly with King unofficially in 1869. Naef and

Wood, *Era of Exploration,* pp. 51–52, 70, 83–84, 253, n. 78.

Jackson said Hayden wished "to inform Americans about America," and "No photographs had yet been published [of Yellowstone], and Dr. Hayden was determined that the first ones should be good. A series of fine pictures would not only supplement his final report but tell the story to thousands who might never read it." *Time Exposure,* pp. 187, 196.

22. The Hayden party was much larger in 1871, perhaps because of its unprecedented appropriation of $40,000. Bartlett, *Great Surveys,* p. 40; and William T. Jackson, "Government Exploration of the Upper Yellowstone, 1871," *Pacific Historical Review* 11(June 1942):187–99.

Gifford traveled in 1870 with fellow artists Worthington Whittredge and John F. Kensett, and he apparently did not meet Hayden until his arrival in Denver. There are few works by him from the survey, and what little is known of his experience derives mostly from Jackson's diaries and autobiography. See Ila Weiss, *Poetic Landscapes: The Art and Experience of Sanford Gifford* (Cranbury, N.J.: Associated University Presses, 1987). Regarding Gifford's camp scenes, Weiss does not mention a letter he wrote to Hayden: "I am very glad to hear that the 'Camp Scenes' promise to be so successful and I hope they will bring you a handsome profit for the outlay." January 6, 1871, NA, RG 57, mfm. 623, roll 1, frame 68. Gifford sent his regrets to Hayden in 1871: "You know how I intended to devote myself this summer to solid and solitary work, and how for its sake I resisted and refused all the temptations of the world, the flesh and the devil, and first and chiefly the one which came to me in the most fascinating and attractive shape—your invitation to go with you to the Yellowstone. . . . Could I have foreseen how the summer is likely to shape itself, how gladly would I have been your companion. . . . The photographs came all right from Omaha. I feel greatly obliged to you for this very valuable present. . . . They will remain a permanent and charming record of one of the most delightful of all my many summer ramblings. I hope Jackson

has got a better apprentice than he found in me last summer—but I doubt if he has a more willing one." Gifford to Hayden, July 14, 1871, NA, RG 57, mfm. 623, roll 1, frames 137–39.

The reference to Bierstadt is found in Moran's letter of introduction to Hayden from A. B. Nettleton: "It is possible, also, that Bierstadt may join you in Montana, before you start for the Yellowstone, but this is only a possibility." June 7, 1871, NA, RG 57, mfm. 623, roll 1, frames 120–22. Nettleton added, "That he [Moran] will surpass Bierstadt's Yosemite we who know him best fully believe." June 16, 1871, NA, RG 57, mfm. 623, roll 1, frames 128–29.

23. "The Wonders of Yellowstone" appeared in *Scribner's Monthly* 2(June 1871). Gilder was an important figure in the New York art world. In addition to his prominent position, he was married to artist Helena de Kay, who had studied at the Cooper Union. The Society of American Artists was founded at their home in 1877 (Moran was a charter member), and the Author's Club was founded there in 1882. The Gilders' friends included John La Farge, Augustus Saint-Gaudens, Stanford White, Walt Whitman, and others. Allen Johnson and Dennis Malone, eds., *Dictionary of American Biography* 4(1931):275–76. Wilkins (in *Thomas Moran,* p. 57) notes that Moran and Gilder were friends from boyhood. For more on their relationship see Moran's papers, AAA, NTM 1, frame 117. For more on Trumbull and Moore's drawings see Haines's *Yellowstone National Park,* p. 175, n. 176. Langford gave the drawings to Yellowstone National Park in 1903. Just whose idea it was for Moran to accompany Hayden's expedition is not clear, but it probably occurred to both Gilder and Moran during the months of work on the illustrations. Wilkins gives Moran the credit for initiating the proposal but cites no specific source. *Thomas Moran,* pp. 58–59.

Langford did not accompany Hayden's expedition in 1871, as was originally planned, but he went in 1872, as the superintendent of the new park.

24. Moran's Yellowstone journal, July 13, 1871

(YNP). For reasons unknown, Schonborn committed suicide in Omaha during the expedition's return East. D. R. Heap to Hayden, November 7, 1871, NA, RG 57, mfm. 623, roll 2, frame 168.

25. Bartlett, *Nature's Yellowstone,* p. 191.

26. Jackson, *Time Exposure,* pp. 199–200. D. R. Heap to Hayden, October 27, 1871, NA, RG 57, mfm. 623, roll 2, frame 154. J. W. Barlow to Hayden, November 9, 1871, NA, RG 57, mfm. 623, roll 2, frames 170–71, 194–95.

27. Crissman did sell his Yellowstone views locally. He advertised in Bozeman: "Magnificently Beautiful. All the principal scenes in the Wonderful Yellowstone Country, accurately photographed and handsomely framed, for sale at Crissman's Photograph Gallery Main Street Bozeman." Cited in Bartlett, *Nature's Yellowstone,* p. 235, n. 61.

Hayden's commission from the Secretary of the Interior reads in part: "You will be required to make such instrumental observations, astronomical and barometrical, as are necessary for the construction of an accurate geographical map of the district explored, upon which the different geological formations may be represented with suitable colors. As the object of the expedition is to secure as much information as possible, both scientific and practical, you will give your attention to the resources of the country. You will collect as ample material as possible for the illustration of your final reports, such as sketches, sections, photographs, etc." Columbus Delano to Hayden, May 1, 1871, NA, RG 48, Patents and Miscellaneous Division, vol. 6, pp. 176–77.

28. Moran's Yellowstone journal, July 29, 1871 (YNP).

29. The largest group of field sketches from 1871, including Moran's sketchbook and journal, now belongs to the National Park Service at Yellowstone. A few others are at GIL and JNEM. Anne Morand, curator at Gilcrease, is presently preparing a catalogue of Moran's sketches in public collections. The two styles may be seen together in Fern's *Drawings and Watercolors,* nos. 3–4, 7–8, 10, 16–22. Color reproductions of some of the Yellowstone sketches are in Fern's "Drawings

and Watercolors of Thomas Moran," *Artists of the Rockies and the Golden West* 3(Summer 1976):34–41.

30. Truettner, "Scenes of Majesty," pp. 241–59.

31. Moran's Yellowstone journal, August 9, 1871 (YNP).

32. Jackson, "With Moran in Yellowstone," p. 154. For a complete bibliography of Jackson's writings see Hales's *William Henry Jackson.*

33. Other than the field watercolors now at Yellowstone (Clark nos. 2, 13, 23–25), Clark cites two others, nos. 14 and 17, from a private collection that were probably used as sources for the painting. In a forthcoming catalogue of Moran's field sketches, however, Anne Morand challenges the dating of many of those works, dating them to Moran's trip west in 1892.

34. At least a portion of Moran's collection of photographs is at Gilcrease, and they are frequently annotated with his sketches and inscriptions.

35. Sheldon, *American Painters,* pp. 125–26.

36. This term, in my experience, comes from a personal conversation with William Goetzmann.

37. The most recent studies by Haines and Bartlett agree that although the issue is complex, the "agents of the Northern Pacific Railroad initiated the project to reserve the Yellowstone region as a park." Aubrey Haines, *The Yellowstone Story: A History of Our First National Park* (Yellowstone National Park: Yellowstone Library and Museum Association, 1977), p. 165. See also Richard Bartlett, *Yellowstone, A Wilderness Besieged* (Tucson: University of Arizona Press, 1985), p. 2.

The letter was from A. B. Nettleton (office manager to Jay Cooke) to Hayden, October 27, 1871, NA, RG 57, mfm. 623, roll 2, frame 155. The reference to Yosemite was in regard to its state park status—it was not made a national park until 1890, but it did set a precedent for the federal government to set aside parkland.

Kelley (1814–90) retired his judgeship in 1856 to run for Congress. He was finally elected in 1860 and served until his death. An outspoken advocate for industrial protectionism, he had no iron

or steel holdings but lobbied vigorously for high duties on iron and steel. *Dictionary of American Biography* 5(1962):299–300. Also Haines, *Yellowstone National Park,* p. 109. His speech, given at the American Academy of Music in Philadelphia, June 12, 1871, was reprinted in *The New York Tribune* the next day and was also published separately by the Northern Pacific. A copy may be found in the SA, NMAH, Warshaw Collection, #60, Box 86, Northern Pacific Railroad Publications. Haines reports that there is also a copy in the James Hill Library, St. Paul. It was derived in part from Doane's official report, which was available as a government document by March of that year. He probably also drew from the Langford *Scribner's Monthly* articles from May and June. Haines, *Yellowstone National Park,* p. 98.

38. Cooke to W. Milnor Roberts, October 30, 1871. Jay Cooke papers, PHS. Cited by Haines in *Yellowstone National Park,* p. 110; and Bartlett in *Nature's Yellowstone,* p. 207. I was unable to find this document myself at the PHS.

39. Haines, *Yellowstone National Park,* p. 110. Roberts's telegraphed reply from Helena read: "Yours October thirtieth and November sixth rec'd. Geysers outside our grant. [We] advise congressional reservation [of the park]. [I will] be in East probably before middle December." November 21, 1871, Jay Cooke papers, PHS. The punctuation is mine. Bartlett's transcription in *Nature's Yellowstone,* p. 208, is incorrect and misleading.

40. The bills, Senate 392 and House 764, were introduced to Congress by Senator Lyman Trumbull of Illinois and Delegate William H. Clagett of Montana on December 18, 1871. It was the Senate bill that passed both houses and was signed by President Grant on March 1. See the debates in *Congressional Globe,* December 18, 1871; January 22–23, 30; February 27, 29; March 5, 1872.

41. The description of bound volumes derives from Jackson's son, Clarence Jackson, *Picture Maker of the Old West,* p. 145. Hales believes that the personalized volumes never existed. Hales, *William Henry Jackson,* pp. 108–109; 312, n. 27.

Senator H. B. Anthony (as one example) verifies in a letter to Hayden that congressmen did receive the images: "I have received and have examined with great interest the photographs of the Yellowstone region, which you so kindly sent me and for which I give you my thanks." February 7, 1872, NA, RG 57, mfm. 623, roll 2, frame 369. Jackson's photographs may have been mass-produced for this purpose by Edward Bierstadt's New York photographic company. Bierstadt wrote Hayden: "I send you by mail to-day proofs of the three negatives received from Mr. Jackson, which I trust may be satisfactory. We can take right hold of the work at once, and can furnish the pictures almost as fast as required, can print at a rate of about 500 per day." February 3, 1872, NA, RG 57, mfm. 623, roll 2, frame 347. Kansas Senator Pomeroy mentioned in the debate that "there are photographs of the valley and the 'curiosities' which Senators can see." U.S. Congress, Senate, Senator Pomeroy speaking for the Yellowstone Park Bill, S. Res. 392, 42nd Cong., 2nd sess., January 22, 1872, *Congressional Globe.* Senator (later president) James Garfield also noted the display: "In accordance with a previous arrangement, went at 10:00 with Dr. Hayden to Smithsonian Institution to see the results of his geological exploration in the Valley of the Yellowstone." Entry for Sunday, February 4, 1872. *The Diary of James A. Garfield,* vol. 2, 1872–74, ed. Harry J. Brown and Frederick D. Williams (Lansing: Michigan State University Press, 1967), pp. 14–15. After the 1872 Yellowstone trip Garfield met with Hayden again: "Stayed at home until 3:00 when I went to the Smithsonian Institution and saw Professor Hayden's Yellowstone collection." Entry for December 22, 1872, *Diary,* p. 127. The Yellowstone map was produced in large quantities; lithographer Julius Bien wrote Hayden that 200 copies of it were completed. December 20, 1871, NA, RG 57, mfm. 623, roll 2, frame 275.

42. Hayden, "Wonders of the West II." The dissemination of the Langford article is cited by Hiram Chittenden in *Yellowstone National Park* (Norman: University of Oklahoma Press, 1966), p. 94. *Scribner's* editor Gilder reported to Hayden on his article: "Your list is received. But we have run short of the February nos. and send only to the following: Secretary Belknap, Secretary Delano, Senator Cowan, Congressmen Dawes, Ketcham and Garfield, Speaker Blaine, Mr. Clagett, Delegate from Montana, & Mr. Gastnell of the British delegation." Gilder to Hayden, January 24, 1872, NA, RG 57, mfm. 623, roll 2, frame 317.

43. William H. Jackson, *Pioneer Photographer: Rocky Mountain Adventures with a Camera* (Yonkers-on-Hudson, N.Y.: World Book Co., 1929), p. 101.

44. Jackson, "With Moran in Yellowstone," p. 157. Jackson was 94 when he published this article. Moran's daughter Ruth in her notes also mentioned that Hayden asked Moran to send a group of watercolors to Washington for the Yellowstone hearings. Moran papers, GIL.

45. "The Geysers of the Yellowstone," *Harper's Weekly* 16(March 30, 1872):243.

46. My careful examination of Hayden's two-part article reveals no mention of Moran's sketches. See F. V. Hayden, "The Hot Springs and Geysers of the Yellowstone and Firehole Rivers," *American Journal of Science and Arts,* 3rd ser., 3(February 1872):105–15, (March 1872):161–76.

47. U.S. Congress, Yellowstone debate, 42nd Cong., 2nd sess., February 27, 1872, *Congressional Globe,* p. 1243. The cultural implications of the idea of the national parks, which originated with Yellowstone, are fully discussed by Alfred Runte in *National Parks: The American Experience* (Lincoln and London: University of Nebraska Press, 1979).

48. "The Yellowstone Park Bill," *New York Times,* February 27, 1872.

49. [Richard Watson Gilder], "Culture and Progress: The Yellowstone National Park," *Scribner's Monthly* 4(May 1872):120–21.

50. Hayden, "The Wonders of the West II," p. 388. The Yellowstone Park Act may be found in 17 *Statutes at Large* 32 (1872) Title 16, *U.S. Code,* secs. 21, 22. The resolution to purchase the painting may be found in *U.S. Statutes,* 42nd Cong., 2nd sess., 1872, chap. 415, p. 362. This was an amendment to HR 2705. It was introduced to the

Senate on June 4 by Senator Lot Morrell and signed by President Grant on June 10. Unfortunately, the records of the Library Committee have been missing since at least the 1930s, preventing further search into the details of the purchase.

51. Wilkins says only that Moran began the work "several months after his summer journey" but reports that it took just two months to paint; *Thomas Moran,* pp. 68–69. Moran wrote Hayden on March 11 that he was nearly half finished, and he did not complete the painting until sometime between April 20 and 26. On April 20 he wrote again, "The Big Picture is finished except the figures, and the frame will be finished on Tuesday morning next." And on April 26, "I have the picture in the frame now and it looks *stunning.*" Moran to Hayden, March 11, 1872, NA, RG 57, mfm. 623, roll 2, frame 468; April 20, frame 526; April 26, frame 537.

52. Moran to Hayden, March 11, 1872, NA, RG 57, mfm. 623, roll 2, frames 468–70.

53. Moran to Hayden, April 6, 1872, NA, RG 57, mfm. 623, roll 2, frame 506.

54. "Professor Hayden, in an impromptu description of the picture given at the request of many persons present, showed point by point, the artist's devoted adherence to facts. Color, form, space, proportions, all were true; if the picture had no other merit it had this, that a mine of scientific illustration is to be found in it." Clarence Cook, "Fine Arts: Mr. Thomas Moran's 'Great Cañon of the Yellowstone'," *New York Tribune* May 3, 1872:4, col. 5.

55. Gilder to Hayden, April 27, 1872, NA, RG 57, mfm. 623, roll 2, frame 540. Moran had also invited Hayden: "The view will take place next Thursday afternoon and evening. . . . All the Directors of the N.P.R.R., Jay Cooke, Gen. Nettleton, and all New York will be present. I wish you could also be present, and hope your business engagements will permit it." April 26, 1872, NA, RG 57, mfm. 623, roll 2, frame 537. It has always been assumed (as in Wilkins, *Thomas Moran,* p. 3) that Jay Cooke himself attended the gala opening, but he did not. Several of the Northern Pacific people had seen the work just

before its completion, as Moran related to Hayden: "President [Gregory] Smith, Vice Pres. and Rice and part of the directors of the N.P.R.R. were over to see the picture yesterday and were decidedly enthusiastic over it." April 26, 1872, NA, RG 57, mfm. 623, roll 2, frame 537.

56. Gifford to Hayden, May 16, 1872, NA, RG 57, mfm. 623, roll 2, frame 563.

57. Moran to Hayden, May 24, 1872, NA, RG 57, mfm. 623, roll 2, frame 501. Secretary Joseph Henry noted the brief exhibition at the Smithsonian in his diary: "Morand [sic] the painter put up on the west wall of the large room his picture of the cañon of the Yellowstone. The name of the stream is probably derived from the colour of the face of the rocks which is stained with the wash of sulphur." May 8, 1872, SA, Joseph Henry papers, Record Unit 7001.

58. This work was joined in 1874 by its pendant *The Chasm of the Colorado* (1873–74), which will be discussed in the next section. The paintings were transferred from the Capitol to the Department of the Interior in 1950 because of lack of space. They still belong to the agency but since 1968 have been on indefinite loan to the NMAA, where today they hang together along with Moran's 1893–1904 reinterpretation of Yellowstone canyon. Although records are sketchy, the 1872 painting may have hung in several places—the Capitol Rotunda, the old Hall of Representatives, and in one stairwell—for about two years before finally being placed with the 1874 work on the upper floor of the Senate wing's North Lobby, just off the entrance to the Ladies' Gallery (between rooms S314, S313, and S312). The two works hung facing each other on arched walls in a domed space dominated by a large brass chandelier. In 1936 this hall was subdivided for the expanding Senate Press Room. For lack of an alternate location, the paintings were removed from the Capitol. The observation about the rotunda is from "Our Late Panic," *International Review* 1(January 1874):3. I am indebted to Barbara Wolanin, curator of the Office of the Architect of the Capitol, for her assistance with this information.

59. Moran to Hayden, March 11, 1872, NA,

RG 57, mfm. 623, roll 2, frame 468. Richard Gilder wrote of the size of the work: "I knew that the artist was going to paint a big picture, but I didn't know how big it would be. When I think of his carrying that immense canvas across his brain so long, I wonder that he didn't go through doors sidewise, and call to people to look out when they came near." "The Old Cabinet," *Scribner's Monthly* 4(June 1872):242. Although Moran and his painting are undoubtedly the subject of the short note, the artist is not named. Also quoted in Wilkins, *Thomas Moran*, pp. 68–69.

60. [Richard W. Gilder,] "Thomas Moran's 'Grand Cañon of the Yellowstone'," *Scribner's Monthly* 4(June 1872):251–52. The Moran papers at the AAA contain numerous clippings and reviews pertaining to the early reception of this work: NTM4.

61. *Three Grand Trips to the Yellowstone National Park with a Complete Round of All the Points of Interest in America's Wonderland* (New York: J. M. Jenkins, 1888), pp. 48–50. This also appears verbatim in *Raymonds Vacation Excursions: Three Grand Tours to the Yellowstone National Park* (Boston: 1887). NMAH, Warshaw Collection, Box 60, no. 4.

62. Ibid.

63. [Clarence Cook,] "Art," *Atlantic Monthly* 30(August 1872):246–47.

CHAPTER 4: THE NORTHERN PACIFIC RAILROAD

1. A number of secondary sources suggest that Hayden was interested in Moran's work before he received the letter of inquiry from Jay Cooke and Company in June 1871, but I have found nothing to support this theory.

2. The Land Department records of the Northern Pacific at the MHS are full of references to such publicity and schemes for increasing immigration to the Northwest. A letter from H. C. Fahnestock of the New York Northern Pacific office to Jay Cooke provides an example: "We are advertising in our dailies quite extensively, . . . es-

pecially in the weekly papers and magazines which fall into the hands of the wealthier and traveling classes. . . . We have also prepared a small lithographed circular which we send, . . . something of the same kind you might use to advantage to stir up the Philadelphia travelers." March 9, 1871, Jay Cooke papers, PHS. Minnesota's state secretary emphasized the value of illustrations: "The many letters which I daily receive both from Americans and foreigners, inquiring about lands in the N.W. portions of our state, suggests to me the idea that your co- might with profit to its [illegible] scheme immediately have prepared and published a small pamphlet, with illustrative maps showing the lands along the mail line and its branches in detail, i.e. the quality of soil, where there is timber, prairie, pine wood and the general lay of the land—where the land is surveyed and where subject to Homesteads and private entry, with appendix giving the Homestead and preemption law and all rulings of the Gov't Land Dept or questions arising under it. Such pamphlets would be very valuable, and should be printed in different languages. We would be glad to aid in circulating it, and in Europe I could do a good deal with it. Some practical Western man, with experience in land office matters, could best prepare the book—it should be a plain statement of facts with hints and suggestions such as I have given." Letter to A. B. Nettleton, March 31, 1871. Note by another hand: "Presented to Land Committee, May 11, 1871." NPRR papers, MHS, Land Department Letters, roll 1. See also James Blaine Hedges, "The Colonization Work of the Northern Pacific Railroad," *Mississippi Valley Historical Review* 13(December 1926):311–42.

3. Frederick Billings to Jay Cooke, March 14, 1871. Jay Cooke papers, PHS.

4. J. Gregory Smith to Jay Cooke, March 16, 1871. Jay Cooke papers, PHS.

5. Cooke's banking house had obtained control of the Northern Pacific in 1869 as a result of the railroad's mismanagement under its original 1864 charter. For an advance of $5 million, Cooke and Company received representation on the board and controlling stock interest. The funds made

possible the immediate laying of track, and the investment gave Cooke new incentive to promote the West. Louis T. Renz, *The History of the Northern Pacific Railroad* (Fairfield, Wash.: Ye Galleon Press, 1980), chapter 7.

6. *The Northern Pacific Railroad's Land Grant and the Future Business of the Road,* dated March 11, 1870. SA, NMAH, Warshaw Collection.

7. A. B. Nettleton to Hayden, June 7, 1871, NA, RG 57, mfm. 623, roll 2, frames 120–22.

8. A. B. Nettleton to Hayden, June 16, 1871, NA, RG 57, mfm. 623, roll 2, frames 128–29.

9. As early as 1869 Hayden wrote to Smithsonian official Spencer F. Baird, saying, "I have the aid of both Pacific Railroads [the Union Pacific and the Central Pacific] . . . for my future success pledged to me." November 20, 1869, SA, Spencer Baird papers, Box 9, folder: F. V. Hayden 2. In 1871 John S. Loomis wrote to the Land Committee, "I secured from the Commissioner of the General Land Office letters instructing the Surveyors-General of the different States and Territories to permit us the use of their records, plats and field notes, in advance, if necessary, of their reports of surveys to Washington, and to grant us every facility possible consistent with interest of the public service." May 30, 1871, NPRR papers, MHS, Land Department, mfm. roll 1, p. 6 of report.

10. In Jay Cooke's papers is the frequent statement "General Nettleton will attend to advertisements, etc." Jay Cooke to Harry Cooke, January 11, 1871, PHS.

11. "The Yellowstone Scientific Expedition," *Helena Daily Herald* July 11, 1871. Cited by Haines in *The Yellowstone Story,* p. 142. Another report went so far as to assert that Hayden's entire survey was "to cross from the head of the Yellowstone to that of Snake river and down to Fort Hall, surveying the entire route accurately, at the instigation of J. Cooke & Co., who contemplate running a branch road through this Pass to connect with the Central Pacific, if practicable." "Around Montana," *Helena Daily Herald* July 10, 1871.

12. Langford, "The Wonders of the Yellowstone," p. 128.

13. Langford to Cooke, March 16, 1871. Jay Cooke papers, PHS. Haines reports that Langford's personal diary of December 15, 1870 (in the Minnesota Historical Society), notes an appointment with "Thos Moran 61 Sherman Avenue, Newark, N.J." Haines, *Yellowstone National Park,* p. 177, n. 210.

14. The history of the expedition may be found in Nathaniel Langford's *Diary of the Washburn Expedition to the Yellowstone and Firehole Rivers in the Year 1870* (St. Paul: J. E. Haynes, 1905); Haines, *Yellowstone National Park,* pp. 59–99; Goetzmann, *Exploration and Empire,* pp. 403–406. Marshall (1825–96) served as governor from 1865 to 1869, and from 1874 to 1882 he was one of the state's first railroad commissioners. Jay Cooke and Company reportedly paid him a retainer to review Minnesota laws for their favorability to the railroad, to reserve the best land for its grant, and to lobby. Haines, *Yellowstone National Park,* p. 166, n. 53. Taylor (1819–93) was secretary of the Minnesota and Pacific Railroad in the mid 1850s and arranged a $5 million loan to the railroads that had been hurt by the 1857 panic. After 1869 he was agent for two other local lines. *Dictionary of American Biography* 4(1962):330, 333. Taylor also used his diplomatic influence to place Langford as Montana's collector of internal revenue. Haines, *Yellowstone National Park,* pp. 58, 166, n. 57. Taylor's papers are in the MHS, and there are numerous letters by him in the Jay Cooke papers, PHS.

15. Haines, *Yellowstone National Park,* p. 59.

16. From Langford's handwritten lecture manuscript (YNP), pp. 183–85. Cited by Haines in *Yellowstone National Park,* p. 97. Cooke apparently commissioned Langford to give twenty lectures for the Northern Pacific. In the West Langford spoke at the Helena Library Association on November 18, 1870, and a short time later gave the same speech in Virginia City. He then went on to tour the East before becoming ill and leaving the circuit. E. P. Oberholzer, *Jay Cooke: Financier of the Civil War* (Philadelphia: 1906), vol. 2, pp. 235–

36. In Washington Langford spoke at Lincoln Hall, with Speaker of the House James G. Blaine presiding. The New York speech was at the Cooper Union. Reviews include *New York Times* January 22, 1871:8, *New York Tribune* January 23, 1871, and Washington's *Daily Morning Chronicle* January 20, 1871. Cited by Bartlett, *Nature's Yellowstone,* p. 234, n. 41.

17. Handwritten note on verso of Langford's letter to Cooke, January 24, 1871, folder 12, Jay Cooke papers, PHS.

18. Langford to Cooke, January 29, 1871, folder 16, Jay Cooke papers, PHS.

19. For further mention of the lecture see Robert Fiske's letter from New York, *Helena Herald* May 26, 1871. Cited by Haines, *Yellowstone National Park,* p. 97. The new Superintendent Langford was immediately invited to make his initial inspection of the park with Hayden's 1872 survey, which was returning to the area that summer. Congress had been exceptionally generous with appropriations for the expedition, providing $75,000 to Hayden, $35,000 over the amount for the previous year. See Haines's *Yellowstone Story,* pp. 180–81; Bartlett, *Great Surveys,* p. 59.

20. Manuscript biography of Moran, probably by his daughter Ruth, Moran papers, AAA, NTM1, frame 190.

21. Moran to Hayden, November 24, 1872, NA, RG 57, mfm. 623, roll 2, frames 655–56. The misconception that Moran produced twelve watercolors for Cooke, rather than sixteen, has been repeated by several sources, notably Clark, *Thomas Moran,* p. 15, and Truettner, "Scenes of Majesty," p. 241. The error probably derives from an unpublished biographical sketch of Moran by Nina Spalding Stevens (GIL). Stevens's source is undocumented. In Moran's ledger book (GIL), he noted only "Jay Cooke's Drawings/ about 10 × 12." Of the sixteen works, only two have been definitively traced: *Minerva Terrace, Yellowstone National Park, Wyoming Territory,* private collection, Clark 51, and *Tower Creek, Yellowstone* (1872), which was recently discovered in an attic of the Pennsylvania State University, Ogontz

Campus, in Abington, Pennsylvania, Clark 53. John P. Driscoll, "Moran Watercolor Found in University Attic," *American Art Journal* 10(May 1978):111–12. As Clark reports, Cooke's severe financial problems in 1873 may have caused him to sell his collection, and the watercolors have since scattered. She does, however, point to at least seven additional works that may be from this group: nos. 29, 31, 36, 39, 49, 52, 65. Clark, *Thomas Moran,* pp. 42–43.

22. J. Gregory Smith to Jay Cooke, May 1 and 3, 1872, Jay Cooke papers, PHS. Cooke's engineer W. Milnor Roberts also wrote: "I went with Mrs. Roberts last night to see Moran's great picture of the Upper Yellowstone Valley (I had seen it once before in Newark and I regard it as a splendid success) and found there quite a crowd of admiring ladies and gentlemen; among them Mr. and Mrs. Pitt Cooke, Gov. and Mrs. Smith, Ge'l and Mrs. [G. W.] Cass, etc." Jay Cooke papers, PHS.

23. Sam Wilkeson to Jay Cooke, December 15, 1871. Jay Cooke papers, PHS.

24. Sam Wilkeson to Jay Cooke, April 22, 1872. Jay Cooke papers, PHS.

25. See Oberholzer, *Jay Cooke.* Also "Across the Continent: Opening of the Northern Pacific," *New York Tribune* September 8, 1883, reported that from the spring of 1870 to the spring of 1872 Jay Cooke sold about $30 million worth of bonds to finance the Northern Pacific's construction.

26. See the NPRR papers, MHS, Secretary's Department Clippings Scrapbook, 1866–1904 (M446), ten rolls of microfilm.

27. See Edward Nolan, *Northern Pacific Views: The Railroad Photography of F. J. Haynes, 1876–1905* (Helena: Montana Historical Society Press, 1983).

28. *Daily Minneapolis Tribune* August 24, 1883. Cited by Billington in Mohr's *Excursion Through America,* p. xliv. See Nolan, *Northern Pacific Views,* for several photographs of the festivities. The financial outlay came to a whopping $200,000, an investment, however important for public relations, that contributed to Villard's eventual dismissal. The best chronicle of the excursion may be Nicolaus Mohr's *Excursion Through America,* ed.

Ray Allen Billington (Chicago: Lakeside Press, R. R. Donnelley and Sons, 1973). Mohr's original text was *Ein Streifzug durch de Nordwesten Amerikas—Festfahrt zur Northern Pacific Bahn im Herbste* (Berlin: Verlag von Oppenheim, 1884). See also *Memoirs of Henry Villard* (Boston: 1904); James Blaine Hedges, *Henry Villard and the Railways of the Northwest* (New Haven: Yale University Press, 1930); and Katherine Villard Seckinger, ed., "The Great Railroad Celebration, 1883," *Montana: The Magazine of Western History* 33(Summer 1983):12–23. Among the distinguished guests were the minister of Germany; a delegation from Britain; leading officials from Austria, Sweden, Denmark, and Canada; and Jay Cooke and A. B. Nettleton. Richard Gilder was invited but apparently could not go and sent artist Henry Farny to represent *Century* magazine (formerly *Scribner's*). The guest list, including sample invitations, is in the Villard Excursion File, NPRR papers, MHS.

Excursions for promotional purposes already had a tradition in American railroads. In 1866 and 1867 galas for the two divisions of the transcontinental railroad were staged to celebrate their reaching the one hundredth meridian from the east and the summit of the Sierra Nevada from the west. (The 1869 Golden Spike ceremony was, of course, another.) See Anne F. Hyde, "A New Vision: Far Western Landscapes and the Formation of a National Culture, 1820–1920" (Ph.D. dissertation, University of California, Berkeley, 1988).

29. James B. Hedges, "Promotion of Immigration to the Pacific Northwest by the Railroads," *Mississippi Valley Historical Review* 15(1928–29):199. Winser's guidebooks were *Yellowstone National Park: A Manual for Tourists* (New York: G. P. Putnam's Sons, 1883) and *The Great Northwest: A Guidebook and Itinerary for the Use of Tourists and Travellers over the Lines of the Northern Pacific* (New York: G. P. Putnam's Sons, 1883). Henry Villard's was *The Past and Present of the Pike's Peak Gold Regions with Maps and Illustrations* (St. Louis: Sutherland and McEnvoy, 1860; reprint ed., ed. LeRoy Hafen, Princeton: Princeton University Press, 1932).

30. *Livingston Enterprise* September 6, 1883, cited by Haines in *The Yellowstone Story,* vol. 1, pp. 287–89. Also see the Villard Excursion File, 1883, NPRR papers, MHS, mfm. 258.

31. "Across the Continent: Opening of the Northern Pacific" and the Villard Excursion File, 1883, NPRR papers, MHS, mfm. 258.

32. Alfred Runte, *Trains of Discovery: Western Railroads and the National Parks* (Flagstaff: Northland Press, 1984), pp. 26, 28. See also the Warshaw Collection, NMAH, which contains a number of these Wonderland booklets, as well as an 1893 NPRR pamphlet that elaborates on the logo and its Chinese yin-yang symbolism. Collection 60, Box 86, Railroad Publications. The author of several of the Wonderland issues was Olin D. Wheeler, who was with the Powell survey in the early 1870s.

The best investigations into the railroad investment in the park are by Haines, *The Yellowstone Story,* vol. 2, chap. 13, and by Runte, *Trains of Discovery* and "Pragmatic Alliance: Western Railroads and the National Parks," *National Parks and Conservation Magazine* 45(April 1974):14–21. It was not until the early 1880s that even the most primitive accommodations were provided for visitors. The absence of roads, lodgings, and sources of food, other than hunting and foraging, meant that only the hardiest ventured into the area until these amenities were more developed. For an overview of this period see Haines, *The Yellowstone Story,* vol. 1, pp. 216–60.

33. Langford, "The Wonders of the Yellowstone," p. 9.

34. See Driscoll, "Moran Watercolor," pp. 111–12. For the watercolors see Clark, *Thomas Moran,* nos. 30, 53, 57, 59. For the etchings see Morand and Friese, *The Prints,* nos. 33, 34. The oil version has recently been discovered in Baltimore in a private collection. The composition also appeared in chromolithograph in the 1876 Louis Prang volume *Yellowstone National Park.*

35. *The Wonderland of the World* (Passenger Department, Northern Pacific Railroad, 1884), p. 32.

CHAPTER 5: THE PUBLISHING INDUSTRY

1. See Wilkins, *Thomas Moran*, especially pp. 20–23 from Miscellaneous notes, A25, Moran papers, GIL; T. Victoria Hansen, "Thomas Moran and Nineteenth-Century Printmaking," in Morand and Friese, *The Prints*, pp. 14–16; and Thomas P. Smith, "Thomas Moran's Painter-Lithographs," *Imprint: Journal of the American Historical Print Collector's Society* 15(Spring 1990):2–19.

2. Hansen estimates the number at closer to five hundred, but Fryxell and Ruth Moran both cite the higher total. My research tends to support their estimate. Hansen, in Morand and Friese, *The Prints*, p. 15; Moran, in Wilkins, *Thomas Moran*, p. 256; Fritiof Fryxell, ed., *Thomas Moran: Explorer in Search of Beauty* (East Hampton: East Hampton Free Library, 1958), p. 12.

3. Interview, *Pasadena Star-News* March 11, 1916:6. Cited by Wilkins in *Thomas Moran*, p. 152.

4. James Jackson Jarves, *Art Thoughts* (New York: Hurd and Houghton, 1871), p. 293. Peter C. Marzio, *Chromolithography, 1840–1900: Pictures for a Nineteenth-Century America* (Boston: David R. Godine, 1979), p. 1. The term was coined by E. L. Godkin in an article in the *Nation*, September 24, 1874.

5. Wilkins lists many more sources of Moran's illustrations, in *Thomas Moran*, p. 157, as does Morand and Friese's annotated bibliography, *The Prints*, pp. 237–43. They do not fully account for his printed work, however, and further study will no doubt reveal more. Wilkins notes that Moran was paid anywhere from $15 to $60, although occasionally as much as $100, and a good year would net him between $4000 and $5000. *Thomas Moran*, p. 76. See also Alan Pringle, "Thomas Moran: *Picturesque Canada* and the Quest for a Canadian National Landscape Theme," *Imprint: Journal of the American Historical Print Collector's Society* 14(Spring 1989):12–21. Moran's illustrative work was largely confined to his early career, 1853–83. By the mid 1880s his reputation allowed him to devote all his energies to painting. He painted during the day to take advantage of daylight and worked on his black and white illustrations at night. Since he drew directly on the woodblocks, there are no original drawings.

6. His residence in Newark was 61 Sherman Street. Wilkins, *Thomas Moran*, p. 67.

7. In his work for *Scribner's* in the 1870s Moran often worked from photographs of subjects he had never seen. Wilkins estimates the number at at least 339. See his *Thomas Moran*, p. 257, and Morand and Friese's *The Prints*, pp. 240–43. Moran wrote in his account book in November 1879, "This is probably the last drawing I shall ever make for *Scribner's*." Moran papers, 1877–82 ledger, GIL. The art editor for *Scribner's* was Alexander W. Drake, but the correspondence to Hayden regarding the art features is from Gilder.

8. Notes in Moran ledger 21, GIL. Also cited in *The Art of the Yellowstone 1870–1872*, p. 8, n. 7. Contemporary art critic Henry Tuckerman called the painting Moran's "last [most recent] and best work" and noted that "the 'children' are not of human birth; but the cataract, the storm-clouds, the rainbow, and the mist are effectively done." Henry Tuckerman, *Book of the Artists: American Artist Life* (1867; reprint, ed. James F. Carr, New York: 1966), p. 568.

9. Hayden, "Wonders of the West II," pp. 388–96. Langford originally planned to accompany the 1871 survey, and if he had gone he probably would have written the second article. As superintendent of the new park, Langford did accompany Hayden in 1872 and published his account the following year, which was partially illustrated by Moran. Nathaniel Langford, "The Ascent of Mt. Hayden: A New Western Discovery," *Scribner's Monthly* 6 (June 1873):129–57.

10. Gilder to Hayden, November 15, 1871, NA, RG 57, mfm. 623, roll 2, frames 179–80.

11. Gilder to Hayden, November 3, 1871, NA, RG 57, mfm. 623, roll 2, frame 180.

12. Gilder to Hayden, January 24, 1872, NA, RG 57, mfm. 623, roll 2, frames 314–18. Gilder wrote again on March 6, asking, "Haven't you yet

taken the casts from the three blocks? I am a little curious least something should happen to them!" Ibid., frame 454. Hayden acknowledged *Scribner's* assistance but referred to Moran only as a distinguished member of the expedition. Hayden, Preliminary Report (1872), p. 7.

13. As one of many examples, the associate editor of the Virginia City *Montanian* wrote Hayden about a book he was preparing: "Your kind letter is received. . . . Permit me to offer my thanks for your prompt answer and the generous tender of assistance made therein. The use of the electrotypes will enable me to present a book more worthy of the grand subject of which it deals and with a reduction in expense. . . . Your Reports are now attracting the kind of notice and will eventually be of incalcuable value to not only Montana, but the whole country and the limitless field of science." Harry J. Norton to Hayden, December 6, 1872, NA, RG 57, mfm. 623, roll 2, frame 669.

14. Although Sanford Gifford was along as a guest on the 1870 trip, he did not contribute to Hayden's report for that year.

15. James Richardson, *Wonders of the Yellowstone* (New York: Scribner, Armstrong and Co., 1872).

16. Langford, "The Wonders of the West," p. 12. Cited in Richardson, *Wonders of Yellowstone,* p. 78.

17. Cited in Richardson, *Wonders of Yellowstone,* pp. 78, 88.

18. Richardson, *Wonders of Yellowstone,* pp. 78, 83.

19. Crofutt to Hayden, February 16, 1872, NA, RG 57, mfm. 623, roll 2, frame 373.

20. "The Grand Geyser" and "The Giant Geyser" appear in *Crofutt's New Overland Tourist, and Pacific Coast Guide* (Omaha: Overland Publishing Co., 1883), pp. 104, 146. Crofutt published his 1872 guide himself, out of New York. His constant revisions often corresponded to title changes; the first edition was simply *Great Transcontinental Railroad Guide* (Chicago: George A. Crofutt and Co., 1869). Crofutt's guidebooks of the 1880s were published by the Overland Publishing Company of Omaha and Chicago, and the title page

prominently listed the railroad companies involved. They included the Union and Central Pacific, the Southern Pacific, the Burlington and Missouri, the Missouri, Kansas and Texas, the Kansas Pacific, and the Colorado Central railroads. See Fifer, *American Progress,* pp. 403–405, for a complete Crofutt bibliography.

21. John B. Bachelder to Hayden, February 22, 1875, NA, RG 57, mfm. 623, roll 5, frames 441–42. The guidebook was illustrated with 100 wood engravings. John Bachelder, *Bachelder's Illustrated Tourist's Guide of the United States: Popular Resorts and How to Reach Them* (New York: Lee Shepard and Dillingham, 1873). Subsequent editions were self-published in Boston.

22. Moran to Hayden, March 11, 1872, NA, RG 57, mfm. 623, roll 2, frame 468.

23. Wilkins, *Thomas Moran,* p. 257. Raymond's "Heart of the Continent" appeared in *Harper's Weekly* April 5, 1873:273–74. Moran also contributed illustrations to *Harper's Monthly,* although not nearly to the extent of his work for *Scribner's,* and they are not cited in Morand and Friese's bibliography. Some of the *Harper's* commissions include "In the Heart of the Hartz," 56(April 1878):684–96; James Whitman's "Down the Thames in a Birchbark Canoe," 62(January 1881):211–18; and Ernest Ingersoll's "Silver San Juan," 64(April 1882):689–704. This is a representative sampling only.

24. Wilkins, *Thomas Moran,* p. 257.

25. Raymond, "The Heart of the Continent," p. 274.

26. See Morand and Friese's bibliography in *The Prints,* p. 239. Some of Moran's collection of photographs is at GIL. The George Eastman House, Rochester, also has several stereographs that have Moran's sketches on the back.

27. "The Yellowstone Region," *Aldine* 6(March 1873):74–75. This was unfortunately left out of Morand and Friese's study. The subjects of the vignettes in the article are *Hot Springs at Gardiner's River; Cliffs in the Grand Cañon; Yellowstone Lake;* and *Tower Falls and Column Mountain* [*Tower Falls and Sulphur Mountain*].

28. *Appleton's Journal of Literature, Science and Art* was published from 1869 to 1876 as a large-format, highly illustrated weekly. It was redesigned in 1877 as a smaller, less well illustrated monthly entitled *Appleton's Journal: A Monthly Miscellany of Popular Literature* and ran until 1881.

29. Moran wrote Hayden that he thought this steel engraving was exceptionally well done: "Did you see the numbers (31 and 32) of Picturesque America that contain the views along the U.P. and C.P.R.R.? Would send you copies but they are too stingy to give me any. They made a steel plate of the Upper Falls of the Yellowstone for the work which was very well engraved. Would send you proof of that but they gave me but one copy. They are short sighted to be close about these things." Moran to Hayden, December 26, 1873, NA, RG 57, mfm. 623, roll 4, frame 62.

30. Bunce to Hayden, March 20, 1872, NA, RG 57, mfm. 623, roll 2, frame 481.

31. "Scenes in the Yellowstone Valley," *Appleton's Journal* 7(May 11, 1872):519–22.

32. Bunce to Hayden, May 2, 1872, NA, RG 57, mfm. 623, roll 2, frame 547.

33. See Hayden's *Sixth Annual Report of the United States Geological Survey of the Territories, Embracing Portions of Montana, Idaho, Wyoming and Utah: Being a Report of Progress of the Explorations for the Year 1872* (Washington, D.C.: Government Printing Office, 1873), plates 15, 34.

34. Bunce to R. V. Corven, acting secretary of the Interior, May 14, 1872, NA, RG 57, mfm. 623, roll 2, frames 405–406.

35. Prang took pride in his contribution to the quality of everyday life in America: "I have succeeded to raise the standard of . . . public taste and public appreciation for the beautiful." Marzio, *Chromolithography*, p. 101, quoted from Mary Margaret Sittig, "L. Prang and Company, Fine Art Publishers," Master's thesis, George Washington University, 1970, p. 154. See also Katharine M. McClinton, *The Chromolithographs of Louis Prang* (New York: Clarkson N. Potter, 1973).

36. Wilkins, *Thomas Moran*, p. 68. Moran actually produced twenty-four works for Prang. In his ledger (GIL) he wrote, "In all made 24 drwgs for Prang for his chromos of Yellowstone—used 15—Mr. Kirkpatrick of Newark later bought 2 of them." He was paid $100 each for at least twenty-one of the twenty-four. Clark, *Thomas Moran*, p. 45.

37. London *Times*, as reported by *Printing Times and Lithographer* (London) January 15, 1878:13. Quoted by Marzio, *Chromolithography*, p. 107. "Fine Arts," *Nation* February 15, 1877:107.

38. Ferdinand V. Hayden, *The Yellowstone National Park, and the Mountain Regions of Portions of Idaho, Nevada, Colorado and Utah* (Boston: Louis Prang and Co., 1876), preface.

39. Ibid.

40. "Fine Arts," *Nation* February 15, 1877:107.

41. Moran to Hayden, November 24, 1872, NA, RG 57, mfm. 623, roll 2, frames 655–56.

42. "Your note asking if I was open to take a commission to paint 12 or more water color pictures of the Yellowstone country, was received, but I have been too much occupied to reply until the present. In reply I would intimate that my previous transaction with you in a similar business was anything but satisfactory to *me,* inasmuch as I made to your *order* three illustrations from the American poets for which you were to pay me $75.00. When I sent them to you, you returned them, merely saying that you had concluded that the publication of the work would prove too expensive. That, of course, was not my business, and your declining to pay for the pictures you had ordered, was, to put it in the mildest form, taking unfair advantage of me." Moran to Prang, December 22, 1873. According to a later letter the problem originated with Moran's brother Edward. The artist agreed to accept the new commission February 7, 1874. Prang papers, HHC.

43. See Ayres, *Thomas Moran's Watercolors.*

44. Hayden, *Yellowstone National Park*, p. 33.

45. Morand and Friese, *The Prints,* nos. 33, 34.

46. Inscription on the verso of *Tower Falls and Sulphur Mountain.* Clark, *Thomas Moran*, p. 131 and no. 56.

47. The watercolors are found in Clark's *Thomas Moran,* nos. 55–57, 56 being the Prang commission. The wash drawing is small, $3\frac{1}{2} \times 5$

inches, presently at the JNEM (no. 4263). The thumbnail sketch, now at GIL, is the same size, formerly called *Spires of the Canyon* (no. 0236.760). The printed version is in "The Yellowstone Region," p. 75, entitled *Tower Falls and Column Mountain.*

CHAPTER 6: THE JOHN WESLEY POWELL EXPEDITION

1. W. Milnor Roberts to Jay Cooke, May 3, 1872, Jay Cooke papers, PHS.

2. Roberts was stationed in the West, overseeing the Northern Pacific's progress, but he did come east for conferences. He added in his letter, "I went with Mrs. Roberts last night to see Moran's great picture of the Upper Yellowstone Valley. (I had seen it once before in Newark and I regard it as a splendid success.)" May 3, 1872, Jay Cooke papers, PHS. Roberts may have also seen the work before its completion with several other railroad officers, as Moran noted to Hayden, April 26, 1872. NA, RG 57, mfm. 623, roll 2, frame 537.

3. This V shape is one of the most important differences between Moran's western work and those of the earlier Hudson River painters to whom he is often described as heir. The topic would comprise a separate study, but several of its major points can be suggested here. For the earlier school, the landscape was most frequently composed of wide, U-shaped, verdant valleys that result from old erosion and abundant moisture. These features provide a mood of balance and fertility in which man and, more broadly, a new America could grow and prosper. The desert Southwest, on the other hand, is dry and marked by extremes of climate and geology, such as the dramatic V-shaped canyons. The region is inherently hostile to habitation at the same time it is compelling for its primacy. It challenges the visitor, and a maturing America at the end of the nineteenth century, to find ways of reconciling with nature.

4. Moran helped Jack Hillers with many of his Indian photographs. See Don D. Fowler's *Western Photographs of John K. Hillers: Myself in the Water* (Washington, D.C.: Smithsonian Institution Press, 1989).

5. I am indebted to Jeremy Adamson for pointing out this detail to me. Powell discussed petroglyphs and pictographs extensively in his writings and certainly showed them to Moran. The frieze was also noted in reviews of the painting, including that of Knoedler and Company, which exhibited the work in May 1874. Moran papers, AAA, NTM 4, frames 604–605.

6. "Fine Arts," 1874, unidentified clipping, Moran papers, AAA, NTM 4, frame 606.

7. Goetzmann went on to say, "It took the efforts of a very different artist [William Henry Holmes] to ultimately picture it correctly." William H. Goetzmann and William M. Goetzmann, *The West of the Imagination* (New York and London: W. W. Norton and Co., 1986), p. 185. That Moran witnessed a storm when he was at the Grand Canyon is substantiated by its inclusion in one of the field sketches from 1873 (fig. 62) and from his mention to Powell during the painting of the picture that he had "got our storm in good." Moran to Powell, December 16, 1873, NA, RG 57, mfm. 157, roll 2. J. E. Colburn also remarked on the storm they had seen from Powell's Plateau in his article "The Cañons of the Colorado," *Picturesque America,* vol. 2, p. 510. Sweeney points to the storm as a reason for the painting's mixed reception: the storm "added a conventional note of sublime atmosphere, but the scene was already overwhelming, and the dark clouds only heightened this. Moran seldom ever again painted the canyon with so dark or stormy atmosphere." J. Gray Sweeney, "The Artists-Explorers," Ph.D. dissertation, Indiana University, 1975, p. 408.

8. See Wallace Stegner, *Beyond the Hundredth Meridian: John Wesley Powell and the Second Opening of the West* (Boston: Houghton Mifflin, 1953); John Terrence Upton, *John Wesley Powell: The Man Who Rediscovered America* (New York: Weybright and Talley, 1969); and William Culp Darrah, *Powell of the Colorado* (Princeton: Princeton University Press, 1951). Powell's first year of exploration was

privately funded by Illinois colleges, staffed by volunteers, and supplied by the War Department and the Smithsonian. In 1868, his similarly equipped Rocky Mountain Exploring Expedition surveyed Longs Peak in Colorado. For his first descent of the Colorado River system in 1869 he obtained free passage on the Union Pacific and the Burlington railroads. In both 1870 and 1871 he received $12,000 in federal grants (16 *U.S. Statutes,* 242; 16 *U.S. Statutes,* 503). In 1872 his grants increased to $20,000 (17 *U.S. Statutes,* 350), but in 1873 only $10,000 was allotted to finish his reports (17 *U.S. Statutes,* 513). That year was the last that Powell was supervised by the Smithsonian; after 1874 he was moved to the Department of the Interior. See Bartlett, *Great Surveys,* p. 226, passim.

9. Powell's seminal contribution was a report to the U.S. Congress, House, Report on the Lands of the Arid Region of the United States with a More Detailed Account of the Lands of Utah, by John Wesley Powell, H. Exec. Doc. 73, 45th Cong., 2nd sess., 1878, which was also reprinted by the Government Printing Office in 1878 and 1879. De Voto wrote the perceptive introduction to Stegner's *Beyond the Hundredth Meridian.*

10. The lack of an artist or photographer was probably due to budget restrictions. In his 1870 report Powell indicated his awareness of earlier explorations: "I sought for all the available information. . . . I talked with Indians and hunters, I went among the Mormons to learn what they knew of this country. . . . I read the reports of the United States Survey." "Report on Explorations of the Rio Colorado in 1869," in William A. Bell, *New Tracks in North America* (London: Chapman and Hall, 1870); reprinted in *Utah Historical Quarterly* 15(1947):21.

11. David J. Weber, *Richard H. Kern: Expeditionary Artist in the Far Southwest, 1848–1853* (Albuquerque: University of New Mexico Press, 1985).

12. An example of Möllhausen's work is *Rio Colorado near the Mojave Villages.* U.S. Congress, Senate, [Lt. A. W. Whipple,] Reports of Explorations and Surveys to Ascertain the Most

Practicable and Economical Route for a Railroad from the Mississippi River to the Pacific Ocean, 33rd Cong., 2nd sess., S. Exec. Doc. 78, vol. 3, part 1. Taft notes that in addition to Möllhausen, two other men, A. H. Campbell and Lt. J. C. Tidball, contributed illustrations to Whipple's report. *Artists and Illustrators of the Old West,* p. 27.

13. Ives reached the Grand Canyon on April 3, 1858. His description and the accompanying illustrations must have interested Powell greatly: "A splendid panorama burst suddenly into view. In the foreground were low table-hills, intersected by numberless ravines; beyond these a lofty line of bluffs marked the edge of an immense cañon; a wide gap was directly ahead, and through it were beheld, to the extreme limit of vision, vast plateaus, towering one above the other thousands of feet in the air, the long horizontal bands broken at intervals by wide and profound abysses, and extending a hundred miles to the north, till the deep azure blue faded into a light cerulean tint that blended with the dome of the heavens. The famous 'Big cañon' was before us; and for a long time we paused in wondering delight, surveying this stupendous formation through which the Colorado and its tributaries break their way." U.S. Congress, Senate, Report upon the Colorado River of the West, Explored in 1857 and 1858 by Lieutenant Joseph C. Ives, Corps of Topographical Engineers, Under the Direction of the Office of Explorations and Surveys, A. A. Humphreys, Captain Topographical Engineers in Charge, S. Exec. Doc., 36th Cong., 1st sess., 1861, pp. 98–99.

14. Powell explained this himself to the Committee on Public Lands in 1874. U.S. Congress, House, Geographical and Geological Surveys West of the Mississippi River, House Rept. 612, 43rd Cong., 1st sess., 1874. See also Stegner, *Beyond the Hundredth Meridian,* p. 123. Powell's first government report was not published until 1872. U.S. Congress, House, Survey of the Colorado River of the West, H. Misc. Doc. 173, 42nd Cong., 2nd sess., April 5, 1872. The cumulative report was published as U.S. Congress, House, Exploration

of the Colorado River of the West and Its Tributaries, Explored in 1869, 1870, 1871, and 1872, Under the Direction of the Secretary of the Smithsonian Institution, H. Misc. Doc. 300, 43rd Cong., 1st sess., 1875, and separately by the Smithsonian. The text, which often reads like an adventure story, has been criticized for failing to distinguish one season from another.

15. Henry to Powell, March 11, 1871, NA, RG 57, mfm. 156, roll 1. Also in SA, Joseph Henry papers, mfm. 186. The 1870 instructions, by contrast, included the hiring of an astronomer, an assistant, and a topographer, but no artist or photographer. July 18, 1870, NA, RG 57, mfm. 156, roll 1.

16. Thomas Zimmerman to Powell, December 16, 1870, January 7, and February 23, 1871, NA, RG 57, mfm. 156, roll 1.

17. For a biographical sketch of Beaman see William Culp Darrah, "Beaman, Fennemore, Hillers, Dellenbaugh, Johnson, and Hattan," *Utah Historical Quarterly* 16–17(1948–49):491–503; and *The West as America* (Washington, D.C.: Smithsonian Institution Press for the National Museum of American Art, 1991), pp. 345–46. William Welling numbers Beaman's photographs closer to 400. *Photography in America: The Formative Years, 1839–1900* (New York: Thomas Y. Crowell, 1978), p. 270. Because Beaman's work was absorbed into the survey's photographic stock after he left the survey, he is not always credited, making attribution of Moran's illustrative sources sometimes difficult. Several, however, may be determined, such as the photograph entitled *Gunnison Butte* (*Repairing Boats at Gunnison's Butte,* 1871) and Moran's illustration *Azure Cliffs of the Green River,* which appeared in "The Glories of Southern Utah," *Aldine* 8(January 1876):34. Fowler reports that the profits from survey photographs were divided, with Powell receiving forty percent and thirty going to Thompson and Hillers (and presumably Beaman during his tenure). Don D. Fowler, *Photographed All the Best Scenery: Jack Hillers's Diary of the Powell Expeditions, 1871–1875* (Salt Lake City: University of Utah Press, 1872), p. 7.

Darrah states that after Powell purchased Beaman's negatives, a duplicate set of negatives was later sold to the E. and H. T. Anthony Company, which produced the stereographs as well. "Beaman," pp. 492, 497. The Library of Congress, USGS in Denver, NA, and SA all have major collections of these photographs. Fowler reports that J. F. Jarvis also worked for a time for William Henry Jackson in Washington, D.C., *Photographed All the Best Scenery,* p. 8.

There are few records as to the amount of Powell's income from the photographs, but it totaled $4,100 for the first six months of 1874. Darrah notes that it was a joke in the capital that Powell financed his Washington home through picture sales. Darrah, *Powell of the Colorado,* p. 182, n. 7.

18. Darrah, "Beaman," pp. 497–98. Samples of Dellenbaugh's art may be found in his books and in several of the woodcuts in Powell's 1875 report, figs. 28, 48. Dellenbaugh's books are *The Romance of the Colorado River: The Story of Its Discovery in 1540 with an Account of the Later Explorations, and with Special Reference to the Voyages of Powell Through the Line of the Great Canyons* (New York and London: G. P. Putnam's Sons, 1902) and *A Canyon Voyage: A Narrative of the Second Powell Expedition Down the Green-Colorado River from Wyoming, and the Explorations on Land, in the Years 1871 and 1872* (New York and London: G. P. Putnam's Sons, 1908). Although Dellenbaugh provides much firsthand information, he is not a reliable historian and favors purple prose. In the late 1870s he traveled to Europe and studied art at the Royal Academy in Munich and under Carolus Duran in Paris. He obtained the crew's journals after the death of A. H. Thompson and used them to write his histories. They and his own papers are in the NYPL.

19. Although he is listed with Powell's crew for 1873, Dellenbaugh went to California after the 1872 season. He may be included because he spent the first months of the year working on Powell's map of the region. U.S. Congress, Geographical . . . Surveys West of the Mississippi (1874), p. 47. There is, however, evidence of Powell's continued

interest in artistic documentation. Walter ("Clem") Powell wrote from Illinois early in 1873 saying, "Have you engaged a draughtsman for next year's work? If not I take the liberty to suggest Mr. George Vaunest of this place. He is a practical hand with pencil or brush. Indeed I consider him quite skillful in this line. The science of topography he probably never studied. In sketching, outlining or copying he is expert." W. Powell to J. W. Powell, January 4, 1873, NA, RG 57, mfm. 156, roll 2, frame 63.

20. A. H. Thompson to Powell, March 11, 1872, NA, RG 57, mfm. 156, roll 1, frame 119. When Fennemore arrived Thompson wrote, "Your photographer Mr. Fennemore got in camp last night. . . . Photographic material not arrived. . . . Clem and Jack do good work photographing." Thompson to Powell, March 18, 1872, NA, RG 57, mfm. 156, roll 1, frame 124. In later years Fennemore said that he hesitated to take the job because he was secure with the photographic firm of Charles Savage in Salt Lake City, but "there was some lure in the offer [financial, no doubt, from the proposed sale of the photographs], and I finally accepted it." Darrah, "Beaman," p. 493.

21. Thompson to Powell, May 10, 1872, NA, RG 57, mfm. 156, roll 1, frame 124.

22. Thompson to Powell, May 20, 1872, NA, RG 57, mfm. 156, roll 1, frame 126. William H. Jackson may have done the printing and mounting of these photographs, as there is an itemized bill from him dated July 5, 1872, that lists charges for printing 4,288 stereographs and for mounting 549 others between March 10 and July 5. "Statement of expenditures for photographic apparatus and material, and also for the employment of a photographic artist, for the exploring expedition of the Colorado River of the West," J. W. Powell to Joseph Henry, December 12, 1872, SA, Joseph Henry papers.

23. Thompson to Powell, May 20, 1872, NA, RG 57, mfm. 156, roll 1, frame 126.

24. For the 1871 season Hayden received $40,000 for his survey, in 1872 $75,000. For the same seasons Powell received $12,000 and $20,000.

25. Moran to Powell, June 24, 1872, NA, RG 57, mfm. 156, roll 1. Moran did go west that summer, in a transcontinental rail trip to California for the publication. The result was his illustrations in E. Burlingame's "Plains and the Sierras."

26. Moran to Hayden, November 24, 1872, NA, RG 57, mfm. 623, roll 2, frames 655–56. Moran was not forgotten by the Hayden survey that summer. The group named him an honorary member and designated one of the three Grand Tetons "Mount Moran" according to a suggestion by *Scribner's* editor Gilder. Gilder to Hayden, May 23, 1872, NA, RG 57, mfm. 623, roll 2, frame 573. See also Wilkins, *Thomas Moran,* p. 73.

27. Hillers to Powell, San Francisco, December 15, 1873, NA, RG 57, mfm. 156, roll 2, frame 35. In this letter also, Hillers sends his regards, through Powell, to Colburn and Moran and asks, "How is our 'Grand Cañon of the Colorado Picture' progressing?" Also cited by Fowler in *Western Photographs of John K. Hillers,* p. 54.

28. Fowler, ed., *Photographed All the Best Scenery,* and Darrah, "Beaman," pp. 495–97.

29. Fowler, ed., *Photographed All the Best Scenery,* p. 51.

30. Hillers surely benefited from Moran's assistance in 1873. In addition to posing Indians for portraits, Moran probably provided compositional suggestions for landscapes. Hillers expressed a desire for this in a letter to Powell just before Moran joined the survey: "All good things come slow, so did the long wished for views of the Grand Cañon and Kanab Wash. I am pleased with a good many, but some are not up to the mark. I see where my fault lies, will try to avoid them in future. . . . I have to find out everything by actual experiments. . . . I am pleased with all the views I made in the Narrows. Prof. [Thompson] thinks that some of them are rich. I am deficient at printing them—I can't get at the trick to clean the shadows." Hillers to Powell, May 25, 1873, NA, RG 57, mfm. 156, roll 2, frame 34.

31. Moran to Hayden, January 28, 1873, NA, RG 57, mfm. 623, roll 3, frames 77–78, and April 4, 1873, roll 3, frame 263. Several diaries of Powell's men have been reprinted in the *Utah Historical Quarterly,* vols. 7 and 15–17.

32. Moran to Hayden, May 12, 1873, NA, RG 57, mfm. 623, roll 3, frames 351–52.

33. Moran to Hayden, June 28, 1873, NA, RG 57, mfm. 623, roll 3, frames 404–405. In a later letter to his wife, Moran outlined the commissions he had contracted for southwestern views: "70 drawings for Powell, 40 for Appleton, 4 for Aldine, 20 for Scribners . . . besides the water colors and oil pictures." Amy Bassford and Fritiof Fryxell, eds., *Home Thoughts from Afar: Letters from Thomas Moran to Mary Nimmo Moran* (East Hampton, N.Y.: East Hampton Free Library, 1967), pp. 41–42.

34. "We should propose that the book be illustrated by full page engravings and by vignettes for chapter headings, etc. which would make the book more complete and more intelligible." Hurd de Houghton to Powell, March 6, 1873, NA, RG 57, mfm. 156, roll 2, frame 36.

35. Moran to Mary Nimmo Moran, July 17, 1873, in Bassford and Fryxell, eds., *Home Thoughts from Afar,* p. 31. The Springville Canyon illustration appeared in "Utah Scenery," *Aldine* 7, no. 1(January 1874):14–15. Colburn said Springville was "so called from an immense spring from which flows a large brook, supplying water to a village of one thousand inhabitants in their houses, and enough water to irrigate a large city lot for each. . . . Our party, with several citizens, went twelve miles up Spanish Fork Cañon and made a camp where we remained two nights. The scenery is fine and Moran made several sketches." [J. E. Colburn,] "The Land of Mormon," *New York Times* August 7, 1873, p. 2, col. 3.

36. Moran to Mary Nimmo Moran, August 2, 1873, in Bassford and Fryxell, eds., *Home Thoughts from Afar,* p. 35. I have recently discovered that one of Moran's sketchbooks from this trip, thought to have been lost, is at YNP, mislabeled "Yosemite 1873." For the routes and personnel on each segment of the trip see Bassford and Fryxell, eds., *Home Thoughts from Afar,* p. 35; [J. E. Colburn,] "The Colorado Cañon," *New York Times* September 4, 1873, p. 2, cols. 1–3; Fowler, *Western Photographs,* pp. 47–49; and Wilkins, *Thomas Moran,* pp. 77–87.

37. Moran to Mary Nimmo Moran, August 13, 1873, in Bassford and Fryxell, eds., *Home Thoughts from Afar,* pp. 39–40.

38. Ibid., p. 37.

39. Colburn, "The Colorado Cañon," p. 2, col. 2.

40. Ibid.

41. Ibid.

42. Colburn, "The Cañons of the Colorado," *Picturesque America,* p. 510. The crew's journals are filled with references to Powell's interaction with the men, especially his reading aloud. As just one example, Clem Powell noted that the Major told them stories and read from Scott, Whittier, Shakespeare, and Longfellow throughout the 1871 season. A typical entry read, "We had a very good supper and a pleasant chat and smoke around a cheerful camp-fire, the Maj. telling us the history of the Shenemos." "Journal of Walter Clement Powell," *Utah Historical Quarterly* 16–17(1948–49):337.

43. Stegner's history is the most specific about this point and compares Powell's "homemade education" with that of Abraham Lincoln and Mark Twain, calling the determination of those men "less interesting as a personal than a regional experience." *Beyond the Hundredth Meridian,* pp. 8–17.

44. U.S. Congress, House, *Survey of the Colorado River of the West* (1872), pp. 2, 11.

45. Powell, *Exploration of the Colorado River,* p. 171.

46. Ibid., p. 174.

47. Powell, *Report on the Lands of the Arid Region.* Powell had introduced his ideas publicly in 1874 as part of a series of congressional investigations into the activities of the U.S. geological surveys.

48. Ibid., p. 11.

49. The Preemption Act allowed a settler to

take up lands prior to survey and to purchase the claim later at a nominal price. The Homestead Act required a minimum filing fee. In addition there were provisions for timber lands (Timber Culture Act, 1873) and desert lands (1877), and these, perhaps even more than the first two, were subject to fraud and abuse. For an excellent discussion of the legislation and its implications see Stegner's *Beyond the Hundredth Meridian*, pp. 212–42, and Darrah's *Powell of the Colorado*, pp. 221–36.

50. Stegner, *Beyond the Hundredth Meridian*, p. 222. In even worse cases certain groups owned the water rights to an area without owning the land, prompting still more corrupt distribution practices. Powell, *Report on the Lands of the Arid Region*, p. 40. Some of the methods of corruption are detailed by Stegner in *Beyond the Hundredth Meridian*, pp. 220–23.

51. Powell, *Report on the Lands of the Arid Region*, pp. 6–11, 19–23, 28–31.

52. Ibid., pp. 37–38.

53. Henry Nash Smith, "Rain Follows the Plow: The Notion of Increased Rainfall for the Great Plains, 1844–1880," *Huntington Library Quarterly* 10(1947):169–93, and *Virgin Land*, pp. 179–83. Hayden promoted these ideas in his writings, stroking the faction who would profit by the large-scale settlement of the West, especially the railroads. Gilpin's activities are legendary. For their relation to Powell see Stegner's *Beyond the Hundredth Meridian*, pp. 1–5, 237–38, passim.

54. Stegner, *Beyond the Hundredth Meridian*, pp. 235–40.

55. Powell, *Exploration of the Colorado River*, p. 194.

56. Powell's report in Bell's *New Tracks in North America*, appendix D, p. 559. Reprinted in the *Utah Historical Quarterly* 15(1947:21.

57. Powell, *Exploration of the Colorado River*, p. 214.

58. J. W. Powell, unidentified clipping, Moran papers, AAA, NTM 4, frame 608.

59. Truettner, "Scenes of Majesty," pp. 248–50.

60. Unidentified clippings, Moran papers, AAA, NTM 4, frames 597, 606, 607.

61. [Richard Watson Gilder,] "Culture and Progress: 'The Chasm of the Colorado,'" *Scribner's Monthly* 8(July 1874):373.

62. Ibid., p. 374.

63. Cook, "Art," pp. 375–77.

64. Ibid., p. 376; Truettner, "Scenes of Majesty," p. 250.

65. Genesis 9:14–15.

66. Revelation 4:3.

67. This information was provided by Barbara Wolanin, Curator, Office of the Architect of the Capitol.

68. Unidentified clipping, Moran papers, AAA, NTM 4, frame 608. This perception of the Grand Canyon is confirmed by the 1876 debate over Moran's request that Congress lend his two large canvases to the Centennial Exposition in Philadelphia. For more on this see chapter 8.

69. This supposition is based on Wilkins's measurements for this work—identical to the final oil—and the assumption that Moran would not produce a charcoal drawing on canvas of such dimensions. Wilkins himself shared this opinion in a recent letter to me. The drawing is signed (unusual for an underdrawing), perhaps because Moran sent a photo of it to Powell well before he finished the painting and may have wished to lay claim to the design. He did guard his secrecy, saying, "Have got impressions from the photo of the charcoal drawing and will send you a copy at once. Though I do not think it would be well to show it to anybody but very particular friends as I do not wish anybody outside the circle to have any preconceived idea of the pictures or the material of which it is composed." Moran to Powell, December 16, 1873, NA, RG 57, mfm. 156, roll 2.

70. Moran to Hayden, October 25 and November 25, 1873, NA, RG 57, mfm. 623, roll 3, frames 524, 597–98.

71. Moran to Powell, December 16, 1873, NA, RG 57, mfm. 156, roll 2.

72. Moran to Hayden, December 4, 1873, NA, RG 57, mfm. 623, roll 3, frame 630.

73. This drawing contains Moran's characteris-

tic color notations, which relate closely to the final painting: "The general color of the Cañon is a light Indian red. The upper surfaces gray intermixed with red and going to a yellowish red at the bottoms of the Cañon. The near rocks of the foreground are a flesh color with gray surfaces. Man holes and water pockets. Where water lines enter the Cañon they are generally white from lime water from the levels above." Another drawing, *Toquerville S. Utah* (1873, NMAA), also contains the central emphasis on a dark gorge.

74. Powell, "The Cañons of the Colorado," p. 529.

CHAPTER 7: POPULARIZING THE GRAND CANYON

1. Gilder to Powell, July 22 and September 23, 1874, NA, RG 57, mfm. 156, roll 2, nos. 193–94.

2. Scribner's to Powell, July 17, 1874, NA, RG 57, mfm. 156, roll 2, frames 190–92. See also the financial memorandum that lists each of the woodcuts and the price Powell paid for their use. NA, RG 57, mfm. 156, roll 4, frames 284–87. There are at least fifteen letters from *Scribner's* to Powell in this series. NA, RG 57, mfm. 156, roll 3, frames 249–61, 263–64, 267–69. Most of the views not by Moran appear to have been engraved directly from Hillers's and Beaman's photographs that Powell supplied to the publishers, and there are a few that seem to be from Dellenbaugh's hand. The three articles are "The Cañons of the Colorado," *Scribner's Monthly* 9(January–March 1875):293–310, 394–409, 523–37; "An Overland Trip to the Grand Cañon," *Scribner's Monthly* 10(October 1875):659–78; and "The Ancient Province of Tusayan," *Scribner's Monthly* 11(1875):193–213.

3. Several of these compositions were favorites of Moran's that he reproduced in different publications and other media. For example, *Repairing Boats at Gunnison's Butte* (Powell, "Cañons," p. 310), based on a Beaman photograph, was redrawn and published as *The Azure Cliffs of the Green River* in "Glories of Southern Utah," *Aldine*

8:34. *Side Gulch in the Grand Cañon* (Powell, "Overland," p. 531) derives from a drawing now at the JNEM, no. 4292, entitled *In the Grand Cañon*, 1873. Versions are also found in Colburn's *Picturesque America* article (p. 509) and in at least two oils, *Side Canyon of the Colorado* (1878, GIL) and *Glimpse of the Blue* (1917, private collection). A third painting of this subject was given to Powell, according to a letter from Moran: "I am just finishing a pretty large picture of the side gulch in the Grand Cañon. A great amphitheater with waterfall that I think will please you. The subject is based on the illustration opposite page 64 in your report." Moran to Powell, May 29, 1876, NA, RG 57, mfm. 156, roll 4, frame 238.

4. Moran to Powell, December 19, 1874, NA, RG 57, mfm. 156, roll 2, frame 174.

5. *Scribner's* editors wrote Powell: "We wish to make use of 'The Cañon of the Colorado.' . . . We want to make an electrotype of the block now in your possession, rather than from the electrotype of the magazine page, and if you will kindly send the block to us, by express, we will see that it is safely returned and will greatly oblige." Powell noted on the letter, "Block sent Mar. 24." It is interesting that they had to request the image from Powell since he had purchased the blocks. Scribner's and Company to Powell, March 27, 1879, NA, RG 57, mfm. 156, roll 19, frame 92.

6. Charles Higgins, ed., *The Grand Cañon of the Colorado River* (Chicago: Santa Fe Passenger Department, 1892).

7. Moran to Powell, December 16, 1873, NA, RG 57, mfm. 156, roll 2, referring to "Utah Scenery," *Aldine* 7(January 1874):14–15.

8. Ibid.

9. The wash drawing is presently at the JNEM (no. 4283), Clark, *Thomas Moran*, no. 105.

10. Moran to Hayden, November 24, 1872, NA, RG 57, mfm. 623, roll 2, frame 655–56.

11. *Picturesque America*, vol. 2, pp. 168–203. For a complete itinerary of Moran's 1872 trip, see Wilkins, *Thomas Moran*, pp. 74–76. For more on the survey photographs see my dissertation, "Creating a Sense of Place," pp. 359–61.

12. Bunce to Hayden, October 29, 1875, NA, RG 57, mfm. 623, roll 5, frames 1050–52.

13. Bunce to Hayden, November 5, 1875, NA, RG 57, mfm. 623, roll 5, frame 1054. Hayden reproduced all the Rideing article illustrations except one, *Chicago Lake*. Hayden's report for the 1874 season was not published until 1876.

14. Keith L. Bryant, Jr., *The History of the Atchison, Topeka, and Santa Fe Railway* (New York and London: University of Nebraska Press, 1974), p. 186. According to Danly, the first American railroad to promote itself through the visual arts was the Baltimore and Ohio, which, in the 1850s, began a series of illustrated travel guides and organized tours for artists to sketch along the line. Susan Danly and Leo Marx, eds., *The Railroad in American Art: Representations of Technological Change* (Cambridge, Mass., and London: MIT Press), p. 5.

15. El Tovar was technically owned by the railroad but managed by the Fred Harvey Company. See Bryant, *History of the Santa Fe*, p. 120.

16. See *The Santa Fe Collection of Southwest Art: An Exhibition at Gilcrease Museum* (Chicago: Santa Fe Railway, 1983) and Elizabeth Cunningham's "Corporate Collections: A Response to the Arts," *Artists of the Rockies and the Golden West* 11(Summer 1984):118–24. I am grateful to Paul Benisek and W. D. Woodburn, curators of the Santa Fe Collection, for sharing their files with me. Collections of "railroadiana" are scattered, with notable collections at the Colorado Railroad Museum in Golden and the California Railroad Museum in Sacramento. Many of the larger publications are considered books and are catalogued as such by libraries.

17. T. J. Anderson to Hayden, November 9, 1877, NA, RG 57, mfm. 623, roll 5, frame 379.

18. Wilkins, *Thomas Moran*, p. 198.

19. Ibid., pp. 205–206. The painting is reproduced in an article by Santa Fe publicity manager William Simpson, "Thomas Moran, the Man," *Fine Arts Journal* 20(January 1909):24, with the inscription "Loaned to El Tovar Hotel, Grand Canyon."

20. This 1892 view and another entitled *The San Francisco Mountains* are reproduced in Higgins, ed., *Grand Cañon of the Colorado River*. Gustave Buek's two articles are "Thomas Moran—N.A.: The Grand Old Man of American Art," *Mentor* 12(August 1924):29–37 (reprinted in part in Fryxell, *Explorer in Search of Beauty*, pp. 63–71), and "Thomas Moran," *American Magazine* 75(January 1913):30–32.

21. Other artists who received these favors included William R. Leigh, Oscar Berninghaus, Ernest Blumenschein, and Joseph Henry Sharp. In ten years the company acquired, by purchase or exchange, 262 paintings by various artists. See *Standing Rainbows: Railroad Promotion of Art of the West and Its Native Peoples* (Wichita: Kansas State Historical Society, 1981). In addition to the Buek articles cited above, see Simpson's "Thomas Moran, the Man," pp. 19–25.

22. Simpson, "Thomas Moran, the Man," pp. 23, 25.

23. "W. W. Bass chaperoned a party of thirteen artists to the Grand Cañon this week. The party included Thomas Moran, of New York, whose painting of a picture of the Grand Cañon is now famous; also Assistant Passenger Agent Simpson, of the Santa Fe at Chicago, and Nat Brigham, the Santa Fe's Grand Cañon lecturer." *William's News* (Arizona) 9(Saturday, May 25, 1901):2. The 1910 artists' excursion included Gustave Buek, Elliott Daingerfield, Ballard Williams, Edward Potthast, and DeWitt Parshall. See Nina Spalding Stevens, "Pilgrimage to the Artist's Paradise," *Fine Arts Journal* February 11, 1911:105–17, and Gustave Kobbe, "Artists Combine for Trip to Arizona," *New York Herald* November 26, 1911. The artists' works from the trip were exhibited together in 1911 in New York, Buffalo, Toledo, St. Louis, and Chicago.

24. General Advertising Agent [Simpson] to J. M. Connell, January 22, 1915. The second comment is in a letter to Ford Harvey, November 30, 1914. Moran curatorial file, SFR, Chicago. Similar statements are found throughout Simpson's correspondence.

25. Ruth Moran to Simpson, February 9, 1909, and Simpson's reply, April 16, 1909. Moran curatorial file, SFR. After 1911 the U.S. Transportation Commission prohibited free travel vouchers for noncompany personnel, the artists were charged greatly reduced rates for their transportation and lodging, and they consequently asked discount rates of the Santa Fe for their work.

26. For example, in a letter to Ruth Moran, Simpson requests that she "advise Fred Harvey, Kansas City, Mo., what price your father is willing to sell the large Grand Canyon painting now on exhibition at El Tovar. It's the one that used to hang in our city [ticket] office here. Mrs. Spear, in charge of the art room there, has had an inquiry." November 30, 1914. In the series of letters on this painting, most concern its shipment to El Tovar from Chicago. Moran curatorial file, SFR.

27. Personal conversation with curator of the Santa Fe Collection, W. D. Woodburn. See also *Standing Rainbows*. The details of the Buek transaction are surprisingly cryptic in the voluminous SFR Moran file. The date of purchase is also contradictory, but the evidence points to 1914. Buek confirmed the price and the source in a letter to Simpson, May 17, 1917. Moran curatorial file, SFR. An uncut version of the chromolithograph is supposedly at JNEM, although it was unavailable for me to inspect. I have also located one at the National Park Service office in Washington.

28. Charles Higgins, ed., *Titan of Chasms* (Chicago: Santa Fe Passenger Department, 1892), and *The Grand Cañon of the Colorado*.

CHAPTER 8: THE MOUNTAIN OF THE HOLY CROSS

1. I have previously published parts of this chapter and the following one. See my "Sacred and Profane: Thomas Moran's Mountain of the Holy Cross," *Gateway Heritage* 11(Summer 1990):4–23. The Mountain of the Holy Cross is about one hundred miles west of Denver at the head of the Sawatch Range. By car a distant view

of the formation is visible from Shrine Pass, a gravel road off Interstate 70 between Copper Mountain and Vail. The mountain itself can be reached from the turnoff to Camp Tigiwon between Red Cliff and Minturn on Highway 24, plus a strenuous hike of about five miles from the trailhead to the top of Notch Mountain. Fritiof Fryxell, "The Mount of the Holy Cross," *Trail and Timberline* 183(January 1934):3–14, and Robert L. Brown, *Holy Cross: The Mountain and the City* (Caldwell, Idaho: Caxton Printers, 1970), pp. 24–25, also provide directions.

2. Durand, "Letters on Landscape Painting," in *American Art 1700–1960,* ed. McCoubrey, p. 112. This theme is primary to the so-called American Mind School, which dominated American studies in the 1950s and 1960s. See Perry Miller, "Nature and the National Ego," in *Errand into the Wilderness* (New York: Harper and Row, 1964); Henry Nash Smith, *Virgin Land* (New York: Random House–Knopf, 1950), especially book 3; and Leo Marx, *The Machine in the Garden* (New York: Oxford University Press, 1964). The idea is especially well discussed in regard to American art in Barbara Novak's essay "The Nationalist Garden and the Holy Book," *Nature and Culture: American Landscape Painting 1825–1875* (New York: Oxford University Press, 1980), pp. 3–17.

3. The rumors are perpetuated in a relatively recent book on the subject. See Brown, *Holy Cross,* p. 21. Geologist and historian Fryxell, however, noted as early as 1934 that these claims "have little historic foundation and must therefore be regarded simply as interesting speculations." Fryxell, "The Mount of the Holy Cross," p. 5.

4. Although Bowles's book was not published until 1869, the same year that Brewer saw the mountain, his trip was in 1868. Samuel Bowles, *The Switzerland of America: A Summer's Vacation in the Parks and Mountains of Colorado* (Springfield, Mass.: Samuel Bowles and Company, 1869), p. 96. Brewer's earliest mention of it was in a letter to his wife, published in Edmund B. Rogers's *Rocky Mountain Letters 1869: A Journal of an Early Geological Expedition to the Colorado Rockies, by*

William H. Brewer (Denver: Colorado Mountain Club, 1930), p. 49. Brewer also mentioned it in a paper delivered on February 28, 1871, and published in *The Journal of the American Geographical Society of New York* 3:214. Cited by Fryxell, "The Mount of the Holy Cross," p. 5. Brewer is identified as William Brewster in Clarence Jackson's *Picture Maker of the Old West,* p. 182.

The Hayden survey's move into Colorado in 1873 was not determined by its quest for the Mountain of the Holy Cross but rather by the Indian hostilities in Wyoming and Idaho that prevented continued work there. Neither was the mountain sought solely for its symbolic appeal; it was a prime spot for a triangulation station. The 1873 survey is documented in several sources. Primary is Hayden's report, [Seventh] *Annual Report* (1874). See also "A Review by Dr. Hayden of the 1873 Survey," *New York Tribune* December 30, 1873:3; William Whitney, letter to *New York Tribune* December 30, 1873:2; *Rocky Mountain News* August 27, 1873:2; and William H. Holmes, "First Ascent of the Mount of the Holy Cross," *Ohio Archaeological and Historical Quarterly* 36(1927):517–27. Recent accounts include those of Mathias S. Fisch, "The Quest for the Mount of the Holy Cross," *American West* 16(March–April 1979):32–36, 57–58; and Clarence Jackson and Lawrence W. Marshall, *The Quest of the Snowy Cross* (Denver: University of Denver Press, 1952). I am grateful to Sarah Cohen of Yale University for sharing her seminar paper on the subject, from which many of these citations were acquired.

5. Jackson, *Time Exposure,* p. 216. "As one comes close to the cross it always disappears behind Notch Mountain." Ibid. This has been verified by numerous visitors, including the author, as well as by photographs of the mountain in the context of its surroundings. See Brown, *Holy Cross,* passim.

6. Hayden, [Seventh] *Annual Report* (1874). It is sometimes erroneously reported that Holmes was a member of the seminal 1871 Yellowstone expedition, but he joined Hayden's survey in 1872 after Elliott's departure. The best study on his career is by Clifford Nelson, "William Henry Holmes: Be-

ginning a Career in Art and Science," *Records of the Columbia Historical Society* 50(1980):252–78. Holmes's papers may be found in "Random Records of a Lifetime, 1846–1931 . . ." at the NMAA library. Holmes was among the men who ascended Mount Holy Cross, and thus he did not sketch the formation from personal experience. His drawing that appears in woodcut in Hayden's report (plate 18) was undoubtedly drawn from Jackson's photographs. In addition to Holmes's "First Ascent," see Roger W. Toll, ed., "The Hayden Survey in Colorado in 1873 and 1874: Letters from James T. Gardiner," *Colorado Magazine* 6(July 1929):146–56.

7. Details of the trip are from Jackson's *Time Exposure,* pp. 217–18. Jackson himself said that "since 1873 I have been back four or five times. I have used the best cameras and the most sensitive emulsions on the market. I have snapped my shutter morning, noon, and afternoon. And I have never come close to matching those first plates." Ibid., p. 218. Photographs of the dissolution of the formation, as well as of the cross with varying degrees of snow pack, may be found throughout Brown's *Holy Cross* and in Mark Klett et al.'s *Second View: The Rephotographic Survey Project* (Albuquerque: University of New Mexico Press, 1974), p. 31.

8. Wilkins, with apparently no more documentation than is available today, says that Moran "was in touch with James Stevenson [Hayden's chief assistant] during the winter, and Stevenson agreed to conduct him there, come summer, subject of Dr. Hayden's approval." Wilkins, *Thomas Moran,* p. 96. I have been unable to verify this in the primary material.

The secondary nature of the special team's activities within the survey's larger mission is emphasized in the contemporary reviews of Moran's painting *The Mountain of the Holy Cross,* in which it is reported that the artist visited the site not with the Hayden expedition but rather with "a group of friends." Miscellaneous reviews, Moran papers, AAA, NTM 4, frames 609–12. The excursion is also not mentioned in Hayden's report for the season. Moran listed his companions in a

letter to his wife: J. S. Delano (son of Secretary of the Interior Columbus Delano), W. L. Woods, James Stevenson (Hayden's primary assistant and director of field operations), a driver-packer, and a cook. Moran to Mary Nimmo Moran, August 10, 1874, in *Home Thoughts from Afar,* ed. Bassford and Fryxell, p. 45.

9. Moran to Mary Nimmo Moran, August 24, 1874, *Home Thoughts from Afar,* pp. 53–57.

10. An exception is the view from Shrine Pass. Fryxell notes that under good conditions the cross can also be seen from Loveland Pass and Grays Peak. "The Mount of the Holy Cross," pp. 3–5.

11. One example of Moran's other camp scenes is an etched view entitled *The Camp at Flaming Gorge,* in Powell, *The Cañons of the Colorado,* p. 299. It was also included in Powell's official report.

12. Though *Children of the Mountain* was sold to *Scribner's* publisher Roswell Smith in 1871, Moran undoubtedly kept his preliminary drawing for the composition. It is recorded in his ledger: "The Children of the Mountain, charcoal on paper, 52 × 62″ January 1865, put in studies for pictures." GIL (4026.4048), folder 212. *A Storm in Utah* may be found in *Aldine* 7(August 1874):175.

13. Bowles, *Switzerland of America,* pp. 95–96.

14. Another of the many examples is the Reverend John A. Zahm, who wrote in 1883: "Here truly, the heavens and earth declare the glory of God! Most eloquently do the mountains and hills speak of His wisdom and power; most sweetly do the ravishing scenes that are everywhere presented for our contemplation tell us of His beauty and love. How that great admirer of nature, that ardent lover of God in His works, St. Bernard, would have been carried away in ecstasy could he . . . have beheld that most wonderful of nature's works, the Mount of the Holy Cross, unique, not only on account of the pure, immaculate symbol of our salvation that it bears on high, but also on account of the numberless other beautiful and sublime visions it opens up to the eyes of the enraptured beholder!" In *Colorado: Its Past, Present and Future* (Notre Dame, 1883), p. 26.

15. Ernest Ingersoll, *The Crest of the Continent: A Record of a Summer's Ramble in the Rocky Moun-*

tains and Beyond (Chicago: R. R. Donnelley and Sons, 1885), p. 226.

16. Wilkins, *Thomas Moran,* p. 101. Moran mentioned the painting to Powell: "The Mountain of the Holy Cross has been on exhibition for some time and has received the highest praise from the artists and the public with a fair share of newspaper laudation. I know you have no interest in the subject for a picture and have therefore made no reports during its progress. Shall send you a photo as soon as I get some printed." Moran to Powell, May 10, 1875, NA, RG 57, mfm. 156, roll 3, frames 208–209.

17. U.S. Congress, House, 44th Cong., 1st sess., April 4, 1875, *Congressional Record* 4, pt. 3, p. 2185.

18. "Art Matters," *Rocky Mountain News* September 3, 1874:4, col. 2.

19. Phillip T. Sandhurst, *The Great Centennial Exhibition* (Philadelphia and Chicago: P. W. Ziegler and Co., 1876), p. 57. In addition to *The Mountain of the Holy Cross,* Moran exhibited a watercolor of the Hot Springs at Yellowstone, a Turnerian fantasy entitled *Dream of the Orient* (1876), *The Azure Cliffs of the Green River* (1875), *The Valley of the Rio Virgin* (1875), and *The Rock Towers of the Colorado* (1875, later retitled *The Glory of the Cañon,* GIL), and six drawings of subjects from Longfellow's *Song of Hiawatha.* Wilkins, *Thomas Moran,* p. 104.

20. Unidentified clipping, Moran papers, AAA, NTM 4, frame 609. Some accounts credit Moran with winning a gold medal, others report a bronze. In fact, to avoid controversy, the Centennial commission awarded medals of only one class. James D. McCabe, *The Illustrated History of the Centennial Exhibition Held in Commemoration of the One Hundredth Anniversary of American Independence* (Philadelphia, Chicago, and St. Louis: National Publishing Co., 1876), p. 843. Moran's diploma and his fair pass are in the studio collection (GIL).

21. "Moran's 'Mountain of the Holy Cross,'" *Aldine* 7(July 1875):379–80. There is a large collection of these reviews in Moran's scrapbook (EHF), also microfilmed, AAA, NTM 4.

22. Henry Wadsworth Longfellow, "The Cross of Snow" (1879), in *Major American Poets to 1914*, ed. Francis Murphy (Lexington, Ken.: D. C. Heath and Co., 1967), pp. 133–34. This poem was discovered among Longfellow's papers at his death in 1882.

23. J. Gray Sweeney, "Endued with Rare Genius: Frederic Edwin Church's *To the Memory of Cole*," *Smithsonian Studies in American Art* 2(Winter 1988):44–71. The poem, by Henry Webster Parker, appeared in *New York Tribune* June 5, 1848:4, and is fully quoted by Sweeney.

24. This series is primarily known through photographs of Cole's oil sketches. Besides Sweeney, "Endued with Rare Genius," see also James C. Moore, "Thomas Cole's *The Cross and the World:* Recent Findings," *American Art Journal* 5(November 1973):50–60.

25. Kevin Avery notes that the artist Jerome Thompson was working on allegorical paintings in the 1870s, using the model of Cole's *Voyage of Life* and *The Cross and the World*. See "Jerome Thompson (1814–1886)," in *American Paradise: The World of the Hudson River School* (New York: Metropolitan Museum of Art and H. Abrams, 1987), p. 145. Thompson also shared Moran's interest in Longfellow's *Song of Hiawatha,* and he produced a series of pictures based on it during the same decade.

26. See the catalogue entry for this painting in *American Paradise*, pp. 246–50, and Kevin J. Avery's "*The Heart of the Andes* Exhibited: Frederic E. Church's Window on the Equatorial World," *American Art Journal* 18(1986):52–72.

27. Matthew Baigell and Allen Kaufman, "Thomas Cole's *The Oxbow:* A Critique of American Civilization," *Arts* 55(January 1981):136–39.

28. Sandhurst, *The Great Centennial Exposition,* pp. 549–60.

29. Moran's 1879 ledger reads, "The Mountain of the Holy Cross was sent in May to Royal Academy Exh. in London and from there exhibition in Brighton in August. It is at this time still in England in charge of H. Graves & Co." (GIL

4026.4051). Bell purchased the work for $5,000. See Moran ledger, ibid.

30. Karen and William Current, *Photography and the Old West* (Fort Worth: Amon Carter Museum, 1978), p. 48. A contemporary source cites Bell's purpose in coming to the United States as recreational. See biographical entry in *History of the Arkansas Valley, Colorado* (Chicago: O. L. Baskin and Co., 1881), pp. 444–45.

31. Bell, *New Tracks,* pp. xv–xvi. Bell did learn to take photographs and apparently continued to serve in this capacity for at least part of the survey, but he also noted that "after we had been in the field but a short time, the return home of the physician of the expedition left that post open to me," p. xvi.

32. U.S. Congress, House, Geographical . . . Surveys West of the Mississippi (1874), p. 31.

33. See Herbert O. Brayer, *William Blackmore: Early Financing of the Denver and Rio Grande Railway and Ancillary Land Companies, 1871–1878* (Denver: Bradford Robinson, 1949), and Hayden, *Sixth Annual Report,* "Letter to the Secretary," p. 5.

34. Clark, *Thomas Moran,* p. 41. In Mrs. Blackmore's memory the Hayden survey named a Wyoming peak Mount Blackmore. In addition to their exhibition at the Gilcrease, the Blackmore watercolors were shown together at the National Gallery of Art in Washington in 1984. See Ayres, *Thomas Moran's Watercolors.* All sixteen are reproduced.

35. Many of Bell's papers are at CHS, and Blackmore's may be found in the State Historical Society of New Mexico, Santa Fe, and at CHS on microfilm. There is a great deal of correspondence between the two men in each. Blackmore committed suicide in April 1878 in part because of the D&RG's financial difficulties. Brayer, *William Blackmore,* vol. 2, pp. 259, 280.

36. Much of the early funding of the Colorado railroad and its enterprises came from English sources. Indeed, the Colorado Springs area became known as "Little London," and the entire

state "England beyond the Missouri." See Fifer, *American Progress,* p. 256. See also Robert G. Athearn, *Westward the Briton* (New York: Scribner's, 1953).

Bell mentions Powell on p. 453 of *New Tracks* and in appendix D: "Major J. W. Powell's Report on His Explorations of the Rio Colorado in 1869," pp. 559–64. Another notable publication of 1869 is William Blackmore's *Colorado: Its Resources, Parks, and Prospects as a New Field for Emigration* (London: S. Low, Sons and Marston, 1869).

Significant examples of the railroad's promotional materials are by William A. Bell, *The Colonies of Colorado in Their Relations to English Enterprise and Settlement* (London: 1874); William J. Palmer, *The Westward Current of Population in the United States* (London: 1874); and Palmer, *Recueil de Documents sur la Compagnie du Chemin de fer du Denver et Rio Grande et sur l'Improvements Compagnie qui s'y rattaché* (Paris: Typographie La Hure, 1874).

37. Brayer, *William Blackmore,* p. 2. By 1871 the D&RG, under the auspices of the subsidiary company National Land and Improvement, owned more than 9,300 acres in the Colorado Springs area. *History of the Arkansas Valley,* p. 430, and Fifer, *American Progress,* p. 254.

38. A. A. Hayes, *New Colorado and the Santa Fe Trail* (New York: Harper and Bros., 1880), p. 111. A branch line of the D&RG was extended to Manitou in 1880. See *History of the Arkansas Valley,* p. 440. One of the earliest books on the subject of western resorts is by Earl Spencer Pomeroy, *In Search of the Golden West: The Tourist in Western America* (New York: Alfred Knopf, 1957). See also Fifer, *American Progress,* pp. 255–71, and Marshall Sprague, *Newport in the Rockies: The Life and Good Times of Colorado Springs,* 4th rev. ed. (Athens, Ohio: Swallow Press and University of Ohio Press, 1987).

39. Fifer, *American Progress,* p. 257. See also Billy M. Jones, *Health Seekers in the Southwest, 1817–1900* (Norman: University of Oklahoma Press, 1967), p. 98, passim, and Henry Dudley

Teetor, "Manitou Springs, All Year Round," *Magazine of Western History* 11(November 1889):43–47.

40. "A Journal of Cara Georgina Whitmore Bell About Her Early Married Life in America, 1872–1876," manuscripts compiled by Archie and Mary Bell, Special Collections, Tutt Library, Colorado College (CC).

41. Samuel E. Solly, *Manitou, Colorado, U.S.A.: Its Mineral Waters and Climate* (London and St. Louis: J. McKittrick and Co., 1875). Solly was enormously prolific in promoting Colorado's climate. See bibliography.

42. Hayes, *New Colorado,* p. 109. The DPL, CHS, and CC have voluminous collections of these publications.

43. *Denver Tribune* July 31, 1871. The remarks of Robert A. Cameron, vice president of Fountain Colony (Manitou), included in the article, are even more explicit about the specific cures to be obtained.

44. *History of the Arkansas Valley,* p. 439. It has been estimated that fully one third of Colorado's total population originated as health seekers in the late nineteenth century. Fifer, *American Progress,* p. 265.

45. William Wood Gerhard, *Lectures on the Diagnosis, Pathology, and Treatment of Diseases of the Chest* (Philadelphia: Haswell and Barrington, 1842), p. 112, and Daniel Drake, *A Systematic Treatise, Historical, Etiological, and Practical, on the Principal Diseases of the Interior Valley of North America* (Cincinnati: Winthrop B. Smith and Co., 1850), pp. 174–75. Cited in Jones, *Health Seekers,* pp. 38–41. For similar advice see Frederick J. Bancroft, "About Health Resorts," *Magazine of Western History* 11(December 1889):171–73.

46. John Tice, *Over the Plains and on the Mountains: or, Kansas, Colorado and the Rocky Mountains, Agriculturally, Mineralogically, and Aesthetically Described* (St. Louis, 1872), pp. 153–54. Cited in Jones, *Health Seekers,* p. 181.

47. Kathryn Kish Sklar, "All Hail to Pure Cold Water!" *Women and Health in America,* ed. Judith Walzer Leavitt (Madison: University of Wisconsin

Press, 1984), pp. 246–54. I am grateful to my father, Dr. Barry Kinsey, for his assistance with this information.

48. Bruce Haley, *The Healthy Body and Victorian Culture* (Cambridge: Harvard University Press, 1978), pp. 16–17.

49. First stanza of a musical homily by Mrs. A. J. Judson, 1840s. It and *The Water Cure Journal* are cited by Sklar in "All Hail," p. 246. The journal's full title was *The Water Cure Journal and the Herald of Reforms: Devoted to Physiology, Hydropathy, and the Laws of Life.* In 1849 it boasted of having 10,000 subscribers. See Regina Markell Morantz, "Making Women Modern: Middle-Class Women and Health in 19th-Century America," in Leavitt, ed., *Women and Health,* p. 347.

50. The therapist is David Urquhart, quoted in Sir John Fife's *Manual of the Turkish Bath* (London: John Churchill, 1865), p. 16. Cited in Haley, *The Healthy Body,* p. 17. The physician is J. Milner Fothergill, *The Maintenance of Health: A Medical Work for Lay Readers* (London: Smith, Elder, 1874), pp. 25–26. Cited in Haley, *The Healthy Body,* p. 23.

51. Haley, *The Healthy Body,* pp. 16, 34; Jones, *Health Seekers,* p. 102; and Leavitt, ed., *Women and Health,* p. 247.

52. Haley, *The Healthy Body,* p. 13.

53. R. Morantz, in Leavitt, ed., *Women and Health,* p. 347. See also Ronald L. Numbers and Ronald C. Sawyer, "Medicine and Christianity in the Modern World," in *Health/Medicine and the Faith Traditions,* ed. Martin E. Marty and Kenneth L. Vaux (Philadelphia: Fortress Press, 1982), pp. 153–54, and Haley, *The Healthy Body,* passim.

54. "Prospectus of the Fountain Colony of Colorado," circular 3, 1872. Colorado Room information file: Fountain Colony, CC, Special Collections.

55. *History of the Arkansas Valley,* p. 438. In a modern parallel, today Ute Springs at Manitou pours from a sculptured Indian, just outside the door of the First Church of the Nazarene.

56. Brayer, *William Blackmore,* vol. 2, p. 85.

57. *History of the Arkansas Valley,* pp. 438–39.

58. Fifer, *American Progress,* p. 257. Although its operations have been terminated, the structure of the most recent bottling plant (ca. 1950) remains in Manitou today. Manitou's water was advertised in a variety of formats. For examples see Robert Shikes, *Rocky Mountain Medicine: Doctors, Drugs, and Disease in Early Colorado* (Boulder: Johnson Books, 1986).

59. W. L. Gilman, "The Mountain of the Holy Cross," *Magazine of Western History* 11 (November 1889):1.

60. "Lovers of the Beautiful," *Rocky Mountain News* September 22, 1880:8. Briarhurst burned in the mid 1880s, and Moran's painting was heroically saved by Mrs. Bell. Since she had to cut the picture out of its frame, it is a few inches shorter than Moran's congressional pictures. The house was rebuilt with the special alcove. (The layout of the first house is unknown to me.) Briarhurst remains a Manitou landmark; today it is an exclusive restaurant that retains much of its early history. Although the alcove is now a dining nook, a color reproduction of Moran's painting hangs prominently nearby.

In addition to Bell's weekly opening of his home to show off Moran's painting, guests were welcome at Briarhurst. One of the artist's companions on the Hayden survey, James T. Gardiner, stayed there in 1874 while making observations from Pikes Peak. Toll, ed., "The Hayden Survey in Colorado in 1873 and 1874," pp. 152–53.

61. *History of the Arkansas Valley,* p. 445.

62. S[hadrach] K. Hooper, *The Story of Manitou* (Denver: Denver and Rio Grande Passenger Department, 1892). The reference to the Savage's naming of Manitou is spurious; Blackmore chose the name.

CHAPTER 9: MORAN'S ART AND THE POPULARIZATION OF COLORADO

1. O. B. Bunce to Hayden, January 31, 1873, NA, RG 57, mfm. 623, roll 3, frames 81–82. The Rideing information is from Wilkins, *Thomas Moran,* p. 95. W. D. Rideing, "The Rocky Mountains," *Picturesque America,* vol. 2, pp. 482–511.

2. O. B. Bunce to Hayden, September 23 and December 11, 1873, NA, RG 57, mfm. 623, roll 3, frames 485–86.

3. Wilkins, *Thomas Moran,* p. 95.

4. The tree does appear, however, in another illustration from the article, *Frozen Lake, James Peak;* this time it is a restatement from two of his early lithographs, *Desolation* and *Solitude,* both from 1869. Morand and Friese, *Prints,* nos. 13, 14.

5. In the 1874 report Hayden acknowledged D. Appleton and Company's assistance but did not mention Moran and even implied that the images were done by Holmes, who did provide some of the views. Hayden, *Eighth Annual Report* (1876). Some scholars have reported that Moran drew the wood engraving of *Mountain of the Holy Cross* in Hayden's 1873 report from a Holmes watercolor. I have found nothing, either in the image itself, which is remarkably unlike Moran's style, or in the primary sources, to support that theory. I assume that Holmes drew it for publication himself. See Hayden, *Seventh Annual Report,* fig. 18. Moran's images in the 1874 report are *Monument Park, Colorado* (titled *Eroded Sandstones, Monument Park* in *Picturesque America*), pl. 3; *Gateway to the "Garden of the Gods"* (*Pikes Peak from the Garden of the Gods*), pl. 8; *Cathedral Rock, "Garden of the Gods"* (*Tower Rock, Garden of the Gods*), pl. 9; *Long's Peak and Estes Park, Colorado* (*Long's Peak from Estes Park*), pl. 11; *Boulder Cañon,* pl. 12; *Mountain of the Holy Cross,* pl. 15; *View in the Snowmass Group* (*Snowmass Mountain*), fig. 6; *Cascade on Rock Creek, Colorado* (*Elk-Lake Cascade*), fig. 8. *Boulder Cañon, Colorado* appeared in *Union Pacific Sketchbook: A Brief Description of Prominent Places of Interest Along the Line of the Union Pacific* (Omaha:

Passenger Department, UPRR, 1887), p. 85. Also in the guidebook is an exact duplication of Moran's wood engraving of Mammoth Hot Springs taken from *Aldine* 6(March 1873):74. *Long's Peak from Estes Park* may be found in George Crofutt's *Grip Sack Guide to Colorado* (Omaha: Overland Publishing Co., 1881).

6. J. G. Pangborn, *Picturesque B&O, Historical and Descriptive* (Chicago: Knight and Leonard, 1882). Moran was especially busy in the summer of 1881. He had moved, visited Niagara Falls in June, toured the B&O Railroad in late July, and headed for Colorado in late August. For more about the B&O trip see Wilkins, *Thomas Moran,* pp. 146–52.

The work from the Colorado trip was also destined for *The Colorado Tourist,* a publication jointly sponsored by a number of railroads. The editor was Robert Strahorn of the Union Pacific, but according to Moran's ledger, 1877–82 (GIL), the commission was directly from the D&RG. For a brief discussion of the trip negotiations see Wilkins, *Thomas Moran,* p. 152. The group's presence was noted in "Tour of Artists and Author," *Denver Times* September 21, 1881:3, in *Colorado Springs Gazette* August 23, 1881, and anticipated in *Rocky Mountain News* May 29, 1881:5, col. 1. Cited in Trenton and Hassrick, *The Rocky Mountains,* p. 373, n. 68–69; and Wilkins, *Thomas Moran,* p. 152, n. 12. This was a major commission for Jackson in particular; after his work with Hayden was finished in 1879 he set up a Denver studio and worked primarily for railroads in the 1880s. The D&RG was his best patron. See Hales, *William Henry Jackson,* pp. 144–50; and Naef and Wood, *Era of Exploration,* p. 226.

7. Porte Crayon [pen name of D. H. Strother], "Artist's Excursion over the Baltimore and Ohio Rail Road," *Harper's New Monthly Magazine* 19(June 1859):1–19. Also see Danly and Marx, *Railroad in the American Landscape,* pp. 5–6. John F. Kensett was among the artists.

8. Fern, *Drawings and Watercolors,* p. 70. Wilkins says that although the railroad provided a luxury train, the group was forced to make additional ac-

commodations for Mrs. Ingersoll, which resulted in their traveling in less spacious surroundings, two regular cars and a parlor sleeper. *Thomas Moran,* p. 152.

9. Ingersoll wrote Hayden in 1874 with his qualifications, including his interest in natural history, his talents as an observer, his expertise in taxidermy, his ability to sketch "objects of nature, but not landscapes," and his experience as a reporter. Ingersoll to Hayden, June 3, 1874, NA, RG 57, mfm. 623, roll 8, frames 557–59. Hayden listed Ingersoll as "naturalist." Hayden, *Eighth Annual Report,* p. 11. Ingersoll appeared with Moran in photographs from the trip; several may be found in Holmes's "Random Records," vols. 3 and 4, and one in Clark's *Thomas Moran,* p. 48. *Knocking Around the Rockies* first appeared in serial form and was finally published as a book in 1882.

Hales's erroneous dating of the *Harper's* article "Silver San Juan" leads him to presume incorrectly that Ingersoll rushed it into print immediately after his return from Colorado. Hales, *William Henry Jackson,* p. 316, n. 17. The article is illustrated with twelve of Moran's wood engravings drawn from Jackson's photographs.

Ingersoll, *Crest of the Continent: A Record of a Summer's Ramble in the Rockies and Beyond* (Chicago: R. R. Donnelley and Sons, 1885). Ingersoll's publishers acquired a number of Moran's woodcuts from sources other than the artist or the D&RG. At least eight had appeared in Powell's *Scribner's* article "Cañons of the Colorado" and in his 1875 survey report. Many depicted areas the 1881 trip did not include (the Grand Canyon was not accessible on the D&RG): *Gate of Lodore, Winnie's Grotto* (titled *Side Cañon of Lodore* in Powell's article), *Echo Rock* (Echo Park), *Gunnison's Butte* (*Repairing Boats at Gunnison's Butte*), *Buttes of the Cross* (*Toom-Pin Woo-Near Too-Weap*), *Exploring the Walls* (*Climbing the Grand Cañon*), and *Grand Cañon from To-Ro-Wasp* (*The Grand Cañon, at the Foot of To-Ro-Weap, Looking West*). The guidebooks are all publications of the Passenger Department of the D&RG and are generally undated. The Warshaw Collection, NMAH, no. 60,

"Travel and Tour Guides," contains many, as do the CRM, CSRM, and the Mercantile Library Association in St. Louis.

10. Ingersoll, *Crest of the Continent,* p. 118.

11. Fern, *Drawings and Watercolors,* p. 70. This is also discussed by Trenton and Hassrick in *Rocky Mountains,* p. 373, n. 72.

12. Patience Stapleton, "Toltec Gorge," *Rhymes of the Rockies* (Passenger Department, Denver and Rio Grande Railroad, ca. 1880s).

13. *Rhymes of the Rockies,* 3rd ed. (1887), p. 54.

14. Ingersoll, *Crest of the Continent,* p. 270.

15. The Reverend [Horace] Bushnell, "A Discourse: Barbarism, the First Danger," 1847, cited by William Barrows in "The Railway System of the West," *Magazine of Western History* 4(August 1886):430.

16. Ibid., pp. 430–31.

17. Will L. Vischer, "The Mountain of the Holy Cross," *Rhymes of the Rockies,* p. 45.

18. The original watercolor of the Christmas card is today owned by the Gene Autry Museum in Los Angeles, California. It is reproduced in color in my "Sacred and Profane," p. 17. The wedding painting is no. 153 in Clark's catalog. The blessing inherent in the gift was especially appropriate, considering the Bell family's connection to the image. See also Moran's ledger, folder 214, p. 87, GIL.

19. Denver and Rio Grande advertisement in *Pacific Monthly,* 1906. *Sights and Scenes in Colorado for Tourists,* 5th ed. (Omaha: Union Pacific Railway Co., 1893), p. 2.

20. The DPL's list of articles on this subject is too long to reprint here.

21. Letters from the associations may be found in Holmes's "Random Records," vol. 4, NMAA. One from Pilgrimage, Inc., was forwarded to Holmes by William Henry Jackson in 1928, and the one from the Association bears on its masthead a reproduction of Jackson's 1873 photograph.

The monument was made part of Holy Cross National Forest by Theodore Roosevelt in 1905. The act of May 15, 1950, made both the Mountain of the Holy Cross and the forest named for it

part of the White River National Forest. The area is still, however, referred to as Holy Cross Wilderness Area.

22. A. G. Birch, "Pastors Lead Party up Mountain Trail to Holy Cross Service," *Denver Post* June 20, 1930:7. Appropriately the service opened with the Sermon on the Mount.

23. Unlabeled clipping, Mountain of the Holy Cross file, DPL. See also, "Excellent Roads Lead to Base of Post Holy Cross Pilgrimage," *Denver Post* June 4, 1935; A. G. Birch, "Group of Seventy-five Braves Mountain Rainstorm to Reach Famous Shrine; Clouds Disappear as Pilgrims Near Summit," *Denver Post* July 8, 1935:5, cols. 3–7.

24. Correspondence with Elizabeth Cunningham, curator of the Anschutz Collection in Denver. See also Christie's sale catalogue, May 22, 1980, no. 78.

SELECTED BIBLIOGRAPHY

ARCHIVAL SOURCES

(AAA) Archives of American Art. Thomas Moran papers and Milch Gallery papers.

(AS) Anschutz Collection, Denver, Colorado. Curatorial files.

(CC) Colorado College, Tutt Library, Special Collections, Colorado Springs, Colorado. William Bell family papers, miscellaneous papers regarding early history of city.

(CH) Cooper-Hewitt Museum, Smithsonian Institution, New York. Moran drawings and watercolors.

(CHS) Colorado Historical Society, Denver, Colorado. William Bell papers, Denver and Rio Grande papers, William Henry Jackson photographic collection.

(CRM) Colorado Railroad Museum. Golden, Colorado. Railroad advertising collection.

(CSRM) California State Railroad Museum, Sacramento, California. Railroad advertising collection.

(DPL) Denver Public Library, Western History Division. Newspaper files.

(EHF) East Hamptn Free Library, East Hampton, New York. Moran papers.

(GA) Gene Autry Museum, Los Angeles, California. Curatorial files.

(GIL) Thomas Gilcrease Institute of American History and Art, Tulsa, Oklahoma. Moran studio collection, papers, ledgers, photographic collection, prints, drawings, paintings, and curatorial files.

(HHC) Hallmark Historical Collection, Hallmark Cards, Inc., Kansas City, Missouri. Louis Prang files.

(JNEM) Jefferson National Expansion Memorial (National Park Service), St. Louis, Missouri. Moran drawings, watercolors, prints.

(LC) Library of Congress, Washington, D.C. Department of Prints and Photographs, and Manuscripts Division.

(MHS) Minnesota Historical Society, St. Paul, Minnesota. Northern Pacific Railroad papers.

(MLA) Mercantile Library Association, St. Louis, Missouri. Railroad advertising collection.

(NA) National Archives, Washington, D.C. Record Group 57, U.S. Geological Survey records; Record Group 48, Patents and Miscellaneous Division; Still Pictures Division.

(NMAA) National Museum of American Art, Smithsonian Institution, Washington, D.C.

(NMAH) National Museum of American History, Smithsonian Institution, Washington, D.C. Warshaw Collection of Business Americana.

(NPS) National Park Service, Washington, D.C.; Yellowstone National Park; Grand Canyon National Park; and Jefferson National Expansion Memorial, St. Louis, Missouri (JNEM). Curatorial files, Moran Yellowstone journal, and prints and drawings collections.

(NYPL) New York Public Library, New York. Manuscript and Art Division.

(PHS) Pennsylvania Historical Society, Philadelphia, Pennsylvania. Jay Cooke papers.

(SA) Smithsonian Institution Archives, Washington, D.C. Joseph Henry papers, Spencer Baird papers.

(SFR) Santa Fe Railway Company, Chicago, Illinois. Curatorial files.

(SFRR) Santa Fe Railroad Collection of South-
western Art, Chicago. Moran correspondence.
(USGS) United States Geological Survey Head-
quarters, Reston, Virginia. Photograph
collection, Rare Book Room. Photographic Li-
brary, Denver.
(YNP) Yellowstone National Park.

CONGRESSIONAL DOCUMENTS, GOVERNMENT PUBLICATIONS

The Colorado River Region and John Wesley Powell.
Geological Survey Professional Paper 669.
Washington: U.S. Government Printing Office,
1969.
Cramton, Lewis C. *The Early History of Yellow-
stone Park.* Washington: U.S. Department of the
Interior, 1932.
"Lists of Congressional and Departmental Publi-
cations." *Checklist of United States Public
Documents, 1787–1901* I, 3rd ed. Washington:
U.S. Government Printing Office, 1911.
Schmeckebier, Lawrence F. *Catalogue and Index of
the Publications of the Hayden, King, Powell, and
Wheeler Surveys.* U.S. Geological Survey Bulle-
tin 222. Washington: U.S. Government
Printing Office, 1904.
U.S. Congress. House of Representatives. Debate
on Loan of Thomas Moran's Paintings. 44th
Cong., 1st sess., April 4, 1876, *Congressional
Record* 4:2185.
U.S. Congress. House of Representatives. Geo-
logical and Geographical Surveys. H. Exec.
Doc. 81, 45th Cong., 2nd sess., 1878.
U.S. Congress. House of Representatives. Report
on Yellowstone National Park. H. Rept. 26,
42nd Cong., 2nd sess., 1872.
U.S. Congress. House of Representatives. Report
upon the Colorado River of the West, Ex-
plored in 1857 and 1858 by Lt. Joseph C. Ives,
Under the Direction of the Office of Explora-
tions and Surveys, A. A. Humphreys, Captain,
Topographical Engineers, in Charge. H. Exec.
Doc. 90, 36th Cong., 1st sess., 1861.
U.S. Congress. Senate. Report of Brevet Briga-

dier General William F. Raynolds on the
Exploration of the Yellowstone and the Coun-
try Drained by That River. S. Exec. Doc. 77,
40th Cong., 2nd sess., 1878.
U.S. Congress. Senate. [Belknap, Secretary W.
W.,] Report on a Reconnaissance of the Yellow-
stone River, 1871. S. Exec. Doc. 66, 42nd
Cong., 2nd sess., II, April 18, 1872.
U.S. Congress. Senate. [Doane, Lt. Gustavus C.,]
The Yellowstone Expedition of 1870. S. Exec.
Doc. 51, 41st Cong., 3rd sess., March 3, 1871.

SELECTED SURVEY REPORTS

Listed are the government reports and miscella-
neous related publications of the Great Surveys,
arranged chronologically rather than alphabeti-
cally. The survey's secondary publications, such as
maps and abstracted reports, have been deleted.
Also included are miscellaneous related reports
not associated with Moran that contain useful
comparative illustrations and photography. For a
complete listing see Schmeckebier, above.

Hayden Survey

See also additional publications by Hayden in the
books and articles bibliography below.

1859
*Geological Report of the Exploration of the Yellow-
stone and Missouri Rivers, by Dr. F. V. Hayden,
Assistant, Under the Direction of Capt. W. F. Ray-
nolds, Corps of Engineers, 1859–60.* Washington:
U.S. Government Printing Office, 1869.
*On the Geology and Natural History of the Upper
Missouri: Being the Substance of a Report Made to
Lieut. G. K. Warren, T.E., U.S.A., by Dr. F. V.
Hayden.* Philadelphia: Sherman and Son, 1862.

1867–69
*First, Second, and Third Annual Reports of the United
States Geological Survey of the Territories for the
Years 1867, 1868, and 1869, Under the Department*

of the Interior. Washington: U.S. Government Printing Office, 1873. This comprises three reports published previously: "First Annual Report of the United States Geological Survey of the Territories, embracing Nebraska, by F. V. Hayden, U.S. geologist. Conducted under the authority of the Commissioner of the General Land Office," *Report of the Commissioner of the General Land Office for the Year 1867*. Washington: Government Printing Office, 1867, pp. 124–77. "Second Annual Report of the United States Geological Survey of the Territories, embracing Wyoming, by F. V. Hayden, U.S. geologist. Conducted under the authority of the Commissioner of the General Land Office," *Report of the Commissioner of the General Land Office for the Year 1868*. Washington: U.S. Government Printing Office, 1868, pp. 220–55. [Third Annual] *Preliminary Field Report of the United States Geological Survey of Colorado and New Mexico, Conducted Under the Authority of Hon. J. D. Cox, Secretary of the Interior, by F. V. Hayden, U.S. Geologist*. Washington: U.S Government Printing Office, 1869.

1870

Preliminary Report of the United States Geological Survey of Wyoming and Portions of Contiguous Territories (Being a Second Annual Report of Progress). Conducted Under the Authority of the Secretary of the Interior by F. V. Hayden, United States Geologist. Washington: U.S. Government Printing Office, 1871. Although this is called the second annual report, it is actually the fourth.

1871

Preliminary Report of the United States Geological Survey of Montana and Portions of Adjacent Territories: Being a Fifth Annual Report of Progress, by F. V. Hayden, U.S. Geologist. Conducted Under the Authority of the Secretary of the Interior. Washington: U.S. Government Printing Office, 1872.
U.S. Geological Survey of the Territories: Profiles, Sections and Other Illustrations Designed to Accompany the Final Report of the Chief Geologist of the Survey, and Sketched Under His Directions, by Henry W. Elliott. Washington: Department of the Interior, 1872.

1872

Sixth Annual Report of the U.S. Geological Survey of the Territories, Embracing Portions of Montana, Idaho, Wyoming and Utah: Being a Report of Progress of the Explorations for the Year 1872, by F. V. Hayden, U.S. Geologist. Conducted Under the Authority of the Secretary of the Interior. Washington: U.S. Government Printing Office, 1873.

1873

[Seventh] *Annual Report of the United States Geological and Geographical Survey of the Territories, Embracing Colorado: Being a Report of Progress of the Exploration for the Year 1873, by F. V. Hayden, U.S. Geologist. Conducted Under the Authority of the Secretary of the Interior*. Washington: U.S. Government Printing Office, 1874.

1874

[Eighth] *Annual Report of the United States Geological and Geographical Survey of the Territories, Embracing Colorado and Parts of Adjacent Territories: Being a Report of Progress of the Exploration for the Year 1874, by F. V. Hayden, U.S. Geologist. Conducted Under the Authority of the Secretary of the Interior*. Washington: U.S. Government Printing Office, 1876.

1875

Ninth Annual Report of the United States Geological and Geographical Survey of the Territories, Embracing Colorado and Parts of Adjacent Territories: Being a Report of Progress of the Explorations for the Year 1875, by F. V. Hayden, U.S. Geologist. Conducted Under the Authority of the Secretary of the Interior. Washington: U.S. Government Printing Office, 1877.
Descriptive Catalogue of the Photographs of the United States Geological Survey of the Territories for the Years 1869–1875, Inclusive. Washington: U.S. Government Printing Office, 1875.

Descriptive Catalogue of the Photographs of the United States Geological Survey of the Territories for the Years 1869–1875, Dept. of the United States Geological Survey of the Territories Misc. Publ. 5. Washington: U.S. Government Printing Office, 1875. Facsimile reprint, Milwaukee: Raymond Dworczyk, The Q Press, 1978.

1876

Tenth Annual Report of the United States Geological and Geographical Survey of the Territories, Embracing Colorado and Parts of Adjacent Territories: Being a Report of Progress of the Exploration for the Year 1876, by F. V. Hayden, U.S. Geologist. Conducted Under the Authority of the Secretary of the Interior. Washington: U.S. Government Printing Office, 1878.

Geological and Geographical Atlas of Colorado and Portions of Adjacent Territory. New York: J. Bien, 1877.

Geological and Geographical Atlas of Colorado and Portions of Adjacent Territory, by F. V. Hayden, U.S. Geologist in Charge. "Corrected to date and printed in accordance with an act of Congress approved February 9, 1881." New York: J. Bien, 1881.

1877

Eleventh Annual Report of the United States Geological and Geographical Survey of the Territories Embracing Idaho and Wyoming: Being a Report of Progress of the Exploration for the Year 1877, by F. V. Hayden, U.S. Geologist. Conducted Under the Authority of the Secretary of the Interior. Washington: U.S. Government Printing Office, 1879.

1878

Preliminary Report of the Field Work of the U.S. Geological and Geographical Survey of the Territories for the Season of 1878. Washington: U.S. Government Printing Office, 1878.

Twelfth Annual Report of the United States Geological and Geographical Survey of the Territories: A Report of Progress of the Exploration in Wyoming and Idaho for the Year 1878, by F. V. Hayden, U.S.

Geologist. Conducted Under the Authority of the Secretary of the Interior. Washington: U.S. Government Printing Office, 1883.

Powell Survey

Powell's early explorations from 1867 to 1870 were not funded by the U.S. government; therefore his official reports begin in 1872 with a review of his 1871 season. See other publications by Powell below.

1871

U.S. Congress. House of Representatives. Survey of the Colorado River of the West. Letter from the Secretary of the Smithsonian Institution, transmitting report preliminary for continuing the survey of the Colorado of the West and its tributaries, by Professor Powell. H. Misc. Doc. 173, 42nd Cong., 2nd sess., April 5, 1872.

1872

U.S. Congress. House of Representatives. Report of the Survey of the Colorado of the West. Letter from the Secretary of the Smithsonian Institution, transmitting a report of the survey of the Colorado of the West and its tributaries. H. Misc. Doc. 76, 42nd Cong., 2nd sess., January 31, 1873.

1873

U.S. Congress. House of Representatives. Geographical and Geological Surveys West of the Mississippi River. H. Rept. 612, 43rd Cong., 1st sess., 1874.

U.S. Congress. House of Representatives. Professor Powell's Report on the Survey of the Colorado of the West. Letter from the Secretary of the Smithsonian Institution, transmitting a report of Professor Powell on the survey of the Colorado River of the West and its tributaries. H. Misc. Doc. 265, 43rd Cong., 1st sess., May 2, 1874. Also published separately as *Report of Explorations in 1873 of the Colorado of the West and Its Tributaries, by Professor Powell, Under the Di-*

rection of the Smithsonian Institution. Washington: U.S. Government Printing Office, 1874.

Cumulative Report

U.S. Congress. House of Representatives. Exploration of the Colorado River of the West. H. Misc. Doc. 300, 43rd Cong., 1st sess., 1873–74. Also published as *Exploration of the Colorado River of the West and Its Tributaries: Explored in 1869, 1870, 1871, and 1872, Under the Direction of the Secretary of the Smithsonian Institution.* Washington: U.S. Government Printing Office, 1875. This report does not include an account of the second descent of the river in 1871–72. Chapters 1–9 of part 1, with six chapters added, were published in 1895 under the title *Canyons of the Colorado,* by John Wesley Powell.

1878

U.S. Congress. House of Representatives. *Report upon the Arid Lands of the United States, with a More Detailed Account of the Lands of Utah, by John Wesley Powell.* H. Exec. Doc. 73, 45th Cong., 2nd sess., 1878.

BOOKS, ARTICLES, AND DISSERTATIONS

"Across the Continent: Opening of the Northern Pacific." *New York Tribune* September 8, 1883.

Ahrens, Kent. "Nineteenth Century History Painting in the United States Capitol." *Records of the Columbia Historical Society* 50(1980):191–222.

"American Etching Indebted to Moran." *New York Times Magazine* September 19, 1926:14.

American Paradise: The World of the Hudson River School. New York: Metropolitan Museum of Art and H. Abrams, 1987.

"The 'American Scene' as Presented by Moran." *Washington Star* January 23, 1937.

"An American's Success in England." *New York Herald* September 4, 1882:8.

Anderson, Nancy K., and Linda S. Ferber. *Albert Bierstadt: Art and Enterprise* (New York: Brooklyn Museum, 1991), pp. 48–53.

"Art." *Appleton Journal* March 30, 1874:100.

"Art." *Appleton Journal* 13(April 24, 1875):568.

"Art at the Capitol." *Scribner's Monthly* 5(February 1873):499.

Art in the U.S. Capitol. Washington: Government Printing Office, 1878.

"Art Matters." *Rocky Mountain News* September 3, 1874:4, col. 2.

"Art: Moran's 'Mountain of the Holy Cross.'" *Aldine* 7(July 1875):379–80.

The Art of the Yellowstone, 1870–1872. Tulsa: Thomas Gilcrease Institute of American History and Art, 1983.

Athearn, Robert G. *Rebel of the Rockies: A History of the Denver and Rio Grande Railroad.* New Haven: Yale University Press, 1962.

———. *Union Pacific Country.* Lincoln and London: University of Nebraska Press, 1971.

———. *Westward the Briton.* New York: Scribner's, 1953.

Avery, Kevin J. "*The Heart of the Andes* Exhibited: Frederic E. Church's Window on the Equatorial World." *American Art Journal* 18(1986):52–72.

Ayres, Linda. *Thomas Moran's Watercolors of Yellowstone.* Washington, D.C.: National Gallery of Art, 1985.

Bachelder, John B. *Bachelder's Illustrated Tourist's Guide of the United States: Popular Resorts and How to Reach Them.* New York: Lee Shepard and Dillingham, 1873.

Baigell, Matthew, and Allen Kaufman. "Thomas Cole's *The Oxbow:* A Critique of American Civilization." *Arts* 55(January 1981):136–39.

Ballinger, James K. *Beyond the Endless River.* Phoenix: Phoenix Art Museum, 1979.

Bancroft, Frederick J. "About Health Resorts." *Magazine of Western History* 11(December 1889):171–73.

Barrows, William. "The Railway System of the West." *Magazine of Western History* 4(August 1886):430.

Bartlett, Richard. "From Imagination to Reality: Thomas Moran and Yellowstone." *Prospects: An Annual of American Cultural Studies* 3(1977):111–24.

———. *Great Surveys of the American West.* Norman: University of Oklahoma Press, 1962.

———. "The Hayden Survey in Colorado." *Colorado Quarterly* 4(Summer 1955):73–88.

———. *Nature's Yellowstone: The Story of an American Wilderness That Became Yellowstone National Park in 1872.* Albuquerque: University of New Mexico Press, 1974.

———. "Will Anyone Come Here for Pleasure?" *American West* 6(1969):10–16.

———. *Yellowstone: A Wilderness Besieged.* Tucson: University of Arizona Press, 1985.

Bassford, Amy O., and Fritiof Fryxell, eds. *Home Thoughts from Afar: Letters from Thomas Moran to Mary Nimmo Moran.* East Hampton, N.Y.: East Hampton Free Library, 1967.

Bauer, John E. "The Health Seeker in the Western Movement, 1830–1900." *Mississippi Valley Historical Review* 45(June 1959):91–110.

Baur, John I. H. "A Romantic Impressionist: James Hamilton." *Brooklyn Museum Bulletin* 13(Spring 1951):1–9.

Beadle, J. H. *The Undeveloped West; or, Five Years in the Territories: Being a Complete History of That Vast Region Between the Mississippi and the Pacific.* Philadelphia: National Publishing Co., 1873.

Bell, William A. *The Colonies of Colorado in Their Relations to English Enterprise and Settlement.* London: 1874.

———. *New Tracks in North America.* London: Chapman and Hall, 1870.

Benjamin, Samuel G. W. "American Painters: Thomas Moran and Joseph Rusling Meeker." *Art Journal* 5(1879):41–45.

———. *Art in America.* New York: Harper and Row, 1880.

———. "A Pioneer of the Palette: Thomas Moran." *Magazine of Art* 5 (February 1882):89–93.

Benson, Francis M. "The Moran Family." *Quarterly Illustrator* 1(1893).

Birch, Al G. "Group of Seventy-Five Braves Mountain Rainstorm to Reach Famous Shrine; Clouds Disappear as Pilgrims Near Summit." *Denver Post* July 8, 1935:5, cols. 3–7.

———. "Pastors Lead Party up Mountain Trail to Holy Cross Service." *Denver Post* June 20, 1930:7.

Blackmore, William. *Colorado: Its Resources, Parks, and Prospects as a New Field for Emigration.* London: S. Low, Sons and Marston, 1869.

Bowles, Samuel. *Across the Continent.* New York: 1866.

———. *The Switzerland of America: A Summer's Vacation in the Parks and Mountains of Colorado.* Springfield, Mass.: Samuel Bowles and Co., 1869.

Bradley, Frank. "Explorations in 1872: United States Geographical Survey of the Territories Under F. V. Hayden, Snake River Division." *American Journal of Science and Arts* 3rd ser. 6(September 1873):194–206.

Braff, Phyllis. *Thomas Moran: A Search for the Scenic.* East Hampton, N.Y.: East Hampton Guild Hall Museum, 1980.

Brayer, Herbert O. *William Blackmore: Early Financing of the Denver and Rio Grande Railway and Ancillary Land Companies: A Case Study in the Economic Development of the West.* Two volumes. Denver: Bradford Robinson, 1949.

Breuning, Margaret. "Thomas Moran." *Magazine of Art* 30(February 1937):114–15.

Bromley, Isaac H. "The Big Trees and the Yosemite: The Wonders of the West, I." *Scribner's Monthly* 3(January 1872):261–76.

Brown, Harry J., and Frederick D. William. *The Diary of James A. Garfield.* Lansing: University of Michigan Press, 1967.

Brown, Robert. *Holy Cross: The Mountain and the City.* Caldwell, Idaho: Caxton, 1970.

Bruhn, Thomas P. "Thomas Moran's Painter-Lithographs." *Imprint: Journal of the American Historical Print Collector's Society* 15(Spring 1990):2–19.

Bryant, Keith L., Jr. *History of the Atchison, Topeka, and Santa Fe Railway.* Lincoln and London: University of Nebraska Press, 1974.

Bryant, William Cullen, ed. *Picturesque America; or, The Land We Live In.* Two volumes. New York: D. Appleton and Co., 1874.

Bryant, William McKendree. "The Epic Landscapes of Thomas Moran." *Philosophy of Landscape Painting.* St. Louis: 1882. Pp. 271–76.

Buckley, Edmund. "Thomas Moran: A Splendid

Example of American Achievement in Art." *Fine Arts Journal* 20(January 1909):10–17.

Buek, Gustave H. "Thomas Moran." *American Magazine* 75(January 1913):30–32.

———. "Thomas Moran, N.A.—The Grand Old Man of American Art." *Mentor* 12(August 1924):29–37. Reprinted in *Thomas Moran: In Search of Beauty,* edited by Fritiof Fryxell, pp. 63–71.

Butler, Howard Russell. "Thomas Moran, N.A.—An Appreciation." *American Magazine of Art* 17(November 1926):559–60.

Cahn, Robert, and Robert G. Ketchum. *American Photographers and the National Parks.* New York and Washington: Viking Press and the National Park Foundation, 1981.

Candlin, Enid Saunders. "Art Is Not Nature." *Christian Science Monitor* March 6, 1886.

"Capitol Has Great Paintings by Moran, Who Died Yesterday." *Washington Evening Star* August 27, 1926.

Carvalho, Solomon. *Incidents of Travel and Adventure in the Far West, with Colonel Frémont's Last Expedition Across the Rocky Mountains: Including Three Months' Residence in Utah, and a Perilous Trip Across the Great American Desert to the Pacific.* New York: Derby and Jackson, 1857.

Catalogue of the Memorial Exhibition of Moran Watercolors. New York: Milch Gallery, 1927.

Catalogue of the Oils and Watercolors of Thomas Moran, N.A. New York: American Art Association, 1886.

Catalogue of Pictures by Thomas Moran, N.A., with Original Verses by Edith M. Thomas. New York: American Art Association and C. W. Kraushaar Art Galleries, 1897.

Catlin, George. *Letters and Notes on the Manners, Customs, and Condition of the North American Indians.* Two volumes. London: 1841. Reprint, New York: Dover, 1973.

Chittenden, Hiram. *Yellowstone National Park.* Norman: University of Oklahoma Press, 1966.

Clark, Carol. "Thomas Moran's Watercolors of the American West." Ph.D. dissertation, Case Western Reserve University, 1981.

———. *Thomas Moran: Watercolors of the American West.* Austin: University of Texas Press, 1980.

Cock, E. Lindquist. "The Influence of Photography on American Landscape Painting." Ph.D. dissertation, New York University, 1967.

Colburn, J. E. "The Cañons of the Colorado." *Picturesque America,* vol. 2. New York: D. Appleton and Co., 1874. Pp. 503–11.

———. "The Colorado Cañon." *New York Times* September 4, 1872:2, cols. 1–3.

———. "The Land of Mormon." *New York Times* August 7, 1873:2, col. 3.

———. "A Trip to the Cañon." *New York Times* September 4, 1873:2, col. 2.

Colorado: Its Past, Present and Future. Notre Dame: 1883.

Comstock, Helen. "In Recognition of Thomas Moran." *Connoisseur* 99(January 1936):38–39.

Cook, Charles W. "The Valley of the Upper Yellowstone." *Western Monthly Magazine* 4(July 1870):60–67.

[Cook, Clarence.] "Art." *Atlantic Monthly* 34(September 1874):375–77.

———. "Fine Arts: Mr. Thomas Moran's Great Cañon of the Yellowstone." *New York Times* May 5, 1872:4, col. 5.

Cope, Edward Drinker. "Ferdinand Vandiveer Hayden, M.D., LL.D." *American Geologist* 1(February, 1888):111–12.

Cortissoz, Royal. "Moran, a Pioneer in Our Landscape Art." *New York Herald Tribune* March 14, 1937.

Crofutt, George A. *Crofutt's New Overland Tourist and Pacific Coast Guide.* Omaha: Overland Publishing Co., 1883.

———. *Crofutt's Transcontinental Tourist's Guide.* New York: George Crofutt, 1871.

———. *Great Transcontinental Railroad Guide.* Chicago: George Crofutt, 1896.

———. *Grip Sack Guide to Colorado.* Omaha: Overland Publishing Co., 1881.

Cunningham, Elizabeth. "Corporate Collections: A Response to the Arts." *Artists of the Rockies and the Golden West* 11(Summer 1984): 118–24.

Cunningham, Sharon. *Manitou: Saratoga of the*

West. Manitou Springs: El Paso County Medical Society Auxiliary, 1980.

Current, Karen, and William Current. *Photography and the Old West*. Fort Worth: Amon Carter Museum, 1978.

"Current Opinion on Landscapes and Water-Colours." *Art Journal* 4(1878):94.

Daniels, Bettie M., and Virginia McConnell. *The Springs of Manitou*. Manitou Springs: Manitou Springs Historical Society, 1973.

Danly, Susan, and Leo Marx. *The Railroad in American Art: Representations of Technological Change*. Cambridge, Mass., and London: MIT Press, 1988.

Darrah, William Culp. "Beaman, Fennemore, Hillers, Dellenbaugh, Johnson, and Hattan." *Utah Historical Quarterly* 16–17(1948–49):491–503.

———. *Powell of the Colorado*. Princeton: Princeton University Press, 1951.

———, ed. "The Colorado River Expedition of 1869." *Utah Historical Quarterly* 15(1947):9–18.

Dellenbaugh, Frederick S. *Breaking the Wilderness: The Story of the Conquest of the Far West, from the Wanderings of Cabeza de Vaca to the First Descent of the Colorado by Powell and the Completion of the Union Pacific Railway*. New York and London: 1905.

———. *A Canyon Voyage: The Narrative of the Second Powell Expedition Down the Green-Colorado River from Wyoming, and the Explorations on Land, in the Years 1871 and 1872*. New York: 1908. Reprint, New Haven: Yale University Press, 1962.

———. *The Romance of the Colorado River: The Story of Its Discovery in 1540, with an Account of the Later Explorations, and with Special Reference to the Voyages of Powell Through the Line of the Great Canyons*. New York: 1902.

Denison, Charles. *Rocky Mountain Health Resorts: An Analytical Study of High Altitudes in Relation to the Arrest of Chronic Pulmonary Disease*. Boston: Houghton, Osgood, and Co., 1880.

Denver and Rio Grande Railway. *Health, Wealth, and Pleasure in Colorado and New Mexico*. Chicago: Belford, Clarke, and Co., 1881.

DeVoto, Bernard. *Across the Wide Missouri*. Boston: Houghton and Mifflin, 1947.

Dictionary of American Biography. New York: Charles Scribner's Sons, 1962.

Dodge, Henry N. *Christus Victor: A Student's Reverie*. New York and London: G. P. Putnam's Sons, Knickerbocker Press, 1926.

Draper, Benjamin P. "Thomas Moran, Painter, Adventurer and Pioneer." *Art in America* 29(April 1941):82–87.

Drawings and Watercolors of the West: Thomas Moran from the Collection of the Cooper-Hewitt Museum of Design. New York: Washburn Gallery, 1974.

Driggs, Harold R., and William H. Jackson. *The Pioneer Photographer*. New York: 1929.

Driscoll, John P. "Moran Watercolor Found in University Attic." *American Art Journal* 10(May 1978):111–12.

Eddy, Frederick W. "Thomas Moran's Color Notes Helped Make Yellowstone a National Park." *New York World* January 9, 1927:14.

Ewers, John C. *Artists of the Old West*. Garden City, N.Y.: Doubleday, 1973.

Ewing, Norma. "The Metamorphic Drawings of Thomas Moran." *Southwest Art* 17(October 1986):58–61.

"Excellent Roads Lead to Base of Post Holy Cross Pilgrimage." *Denver Post* June 4, 1935.

Exhibition of Water Color Sketches by Thomas Moran. Santa Barbara: Santa Barbara Art Association, Casa de la Guerra, 1926.

Exploring the American West, 1803–1879. Washington, D.C.: Department of the Interior, National Park Service, 1982.

Fairbanks, Jonathan L. *Frontier America: The Far West*. Boston: Museum of Fine Arts, 1975.

Fairman, Charles. *Art and Artists of the United States Capitol*. Washington, D.C.: U.S. Government Printing Office, 1929.

Farquhar, Francis P., ed. *Up and Down California in 1860–1864: The Journal of William H. Brewer*. New Haven: Yale University Press, 1930.

Ferber, Linda, and William Gerdts. *The New Path: Ruskin and the American Pre-Raphaelites*. New York: Brooklyn Museum and Schocken Books, 1985.

Fern, Thomas S. *The Drawings and Watercolors of Thomas Moran, 1837–1926.* Notre Dame: Art Gallery of the University of Notre Dame, 1976.

———. "The Drawings and Watercolors of Thomas Moran." *Artists of the Rockies and the Golden West* 3(Summer 1976):34–41.

Fifer, J. Valerie. *American Progress: The Growth of the Transport, Tourist and Information Industries in the Nineteenth-Century West, Seen Through the Life and Times of George A. Crofutt, Pioneer and Publicist of the Transcontinental Age.* Chester, Conn.: Globe Pequot Press, 1988.

"Finding Moran." *Art Digest* 2(August 1928):6.

"Fine Arts: The Yellowstone Landscape at Washington." *Nation* 15(September 5, 1872):157–58.

Fisch, Mathias S. "The Quest for the Mount of the Holy Cross." *American West* 16(March–April 1979):32–36, 57–58.

Forsyth, Robert. *Thomas Moran in Yellowstone, 1871: An Exhibition of His Prints, Drawings and Paintings Dealing with Yellowstone and Teton National Parks to Honor the Centennial of Yellowstone and the National Park System.* Fort Collins: Colorado State University, 1972.

Fossett, Frank. *Colorado: Its Gold and Silver Mines, Farms and Stock Ranges, and Health and Pleasure Resorts. [A] Tourist Guide to the Rocky Mountains.* New York: C. G. Crawford, 1879.

Fowler, Don D., ed. *Photographed All the Best Scenery: Jack Hillers's Diary of the Powell Expeditions, 1871–1875.* Salt Lake City: University of Utah Press, 1972.

———. *The Western Photographs of John K. Hillers: Myself in the Water.* Washington, D.C.: Smithsonian Institution Press, 1989.

Frémont, John Charles. *Memoirs of My Life.* Chicago and New York: 1887.

Fryxell, Fritiof M. "The Mount of the Holy Cross." *Trail and Timberline* 183(January 1934): 3–14.

———. "Thomas Moran's Journey to the Tetons in 1879." *Augustana Historical Society Publications* 2(1932):36–47.

———, ed. *Thomas Moran: Explorer in Search of Beauty.* East Hampton, N.Y.: East Hampton Free Library, 1958.

———, ed. "The Thomas Moran Art Collection of the National Parks." *Yosemite Nature Notes* 15(August 1936):57–60.

Gardner, James T. "Hayden and Gardner's Survey of the Territories, Under the Direction of the Department of the Interior." *American Journal of Science and Arts* 3rd ser. 6(October 1873):297–300.

Gerdts, William H. "The Paintings of Thomas Moran: Sources and Style." *Antiques* 85(February 1964):202–205.

Gerdts, William H., Louise Nelson, Samuel Sachs II, et al. *Thomas Moran, 1837–1926.* Riverside: University of California, 1963.

"The Geysers of Yellowstone." *Harper's Weekly* 16(March 30, 1872):243.

Gilbert, Grove Karl, ed. *John Wesley Powell.* Chicago: 1903.

[Richard Watson Gilder.] "Culture and Progress: The Chasm of the Colorado." *Scribner's Monthly* 8(July 1874):373–74.

———. "Culture and Progress: The Yellowstone National Park." *Scribner's Monthly* 4(May 1872):120–21.

———. "The Old Cabinet." *Scribner's Monthly* 4(June 1872):242.

———. "Thomas Moran's 'Grand Cañon of the Yellowstone.'" *Scribner's Monthly* 4(June 1872):251–52.

Gillespie, Harriet Sisson. "Thomas Moran, Dean of Our Painters." *International Studio* 79(August 1924):361–66.

Gilman, W. L. "The Mountain of the Holy Cross." *Magazine of Western History* 11(November 1889).

Glanz, Dawn. *How the West Was Drawn: American Art and the Settling of the Frontier.* Ann Arbor: University of Michigan Press, 1982.

"Glories of Southern Utah." *Aldine* 8(January 1876):34–35.

Goetzmann, William H. *Army Exploration in the American West, 1803–1863.* New Haven: Yale University Press, 1957.

———. *Exploration and Empire: The Explorer and the Scientist in the Winning of the American West.* New York: Alfred Knopf, 1966.

————. "Limner of Grandeur: William Henry Holmes." *American West* 15(May–June 1979):20–21, 61–63.

————. "William H. Holmes' Panoramic Art." Pamphlet. Fort Worth: Amon Carter Museum, 1977.

Goetzmann, William H., and William M. Goetzmann. *The West of the Imagination.* New York and London: W. W. Norton and Co., 1986.

Goetzmann, William H., and Joseph C. Porter. *The West as a Romantic Horizon.* Omaha: Joslyn Art Museum, 1981.

Graham, Douglas M. *Turner and Moran.* Denver: Turner Museum, 1977.

Greeley, Horace. *An Overland Journey from New York to San Francisco, in the Summer of 1859.* New York: 1860.

Gries, John C. "Geological Exploration as Related to Railroad Development in Kansas and the Western United States." *Earth Sciences History* 3(1984):129–33.

Haines, Aubrey L. *Yellowstone National Park: Its Exploration and Establishment.* Washington, D.C.: National Park Service, 1974.

————. *The Yellowstone Story: A History of Our First National Park.* Two volumes. Yellowstone National Park: Yellowstone Library and Museum Association, 1977.

Hales, Peter. *William Henry Jackson and the Transformation of the American Landscape.* Philadelphia: Temple University Press, 1988.

Haley, Bruce. *The Healthy Body and Victorian Culture.* Cambridge: Harvard University Press, 1978.

Hardy, Lady Duffas. *Across the Rocky Mountains.* New York: 1881.

Haupt, Herman, Jr. *The Yellowstone National Park.* New York: 1883.

Hayden, Ferdinand Vandiveer. *The Great West: Its Attractions and Resources.* Philadelphia: Franklin Publishing Co., 1880.

————. "The Hot Spring and Geysers of the Yellowstone and Firehole Rivers." *American Journal of Science and Arts* 3rd ser. 3(February 1872):105–15; (March 1872):161–76.

————. *Sun Pictures of Rocky Mountain Scenery, with a Description of the Geographical and Geological Features, and Some Account of the Resources of the Great West: Containing Thirty Photographic Views Along the Line of the Pacific Railroad, from Omaha to Sacramento.* New York: J. Bien, 1870.

————. "The Wonders of the West, II: More About the Yellowstone." *Scribner's Monthly* 3(February 1872):388–96.

————. *The Yellowstone National Park, and the Mountain Regions of Portions of Idaho, Nevada, Colorado and Utah.* Boston: L. Prang and Co., 1876.

Hayes, A. A. *New Colorado and the Santa Fe Trail.* New York: Harper and Bros., 1880.

————. "Vacation Aspects of Colorado." *Harper's New Monthly Magazine* 60(March 1880):542–57.

Hedges, James Blaine. "The Colonization Work of the Northern Pacific Railroad." *Mississippi Valley Historical Review* 13(December 1926):311–42.

————. *Henry Villard and the Railways of the Northwest.* New Haven and London: Yale University Press, 1930.

————. "Promotion of Immigration to the Pacific Northwest by the Railroads." *Mississippi Valley Historical Review* 15(1928–29):183–203.

Higgins, Charles A., ed. *Grand Cañon on the Colorado River, Arizona.* Chicago: Santa Fe Railway Passenger Department, 1892.

————. *The Grand Cañon of the Arizona.* Chicago: Santa Fe Railway Passenger Department, 1902, 1906.

A History of the Arkansas Valley, Colorado. Chicago: O. L. Baskin and Co., 1881.

Hogarth, Paul. *Artists on Horseback: The Old West in Illustrated Journalism, 1857–1900.* New York: Watson-Guptill, 1972.

Holmes, William H. "First Ascent of the Mount of the Holy Cross." *Ohio Archaeological and Historical Quarterly* 36(1927):517–27.

————. "Random Records of a Lifetime, 1846–1931 . . . in XX Volumes, Cullings, Largely Personal, from the Scrap Heap of Three Score Years and Ten, Devoted to Science, Literature,

and Art." Manuscript, National Museum of American Art.

Homer and Moran. Evansville: Indiana Public Museum, 1948.

Hooper, S[hadrach] K. *The Story of Manitou.* Denver: Denver and Rio Grande Passenger Department, 1892.

"How They Promoted the Mount of the Holy Cross." *Empire Magazine* 19(December 1976):10–15.

Hults, Linda C. "Thomas Moran's *Shoshone Falls:* A Western Niagara." *Smithsonian Studies in American Art* 3(Winter 1989):89–102.

Humboldt, Alexander von. *Cosmos: A Sketch of a Physical Description of the Universe.* Five volumes. London: 1847–52.

Hundley, Norris, Jr. *Water and the West: The Colorado River Compact and the Politics of Water in the American West.* Berkeley: University of California, 1975.

Huth, Hans. *Nature and the American: Three Centuries of Changing Attitudes.* Berkeley and Los Angeles: University of California Press, 1957.

Hyde, Ann. "A New Vision: Far Western Landscapes and the Formation of a National Culture, 1820–1920." Ph.D. dissertation, University of California, Berkeley, 1988.

"Idaho Scenery." *Aldine* 8(June 1876):195–96.

Ingersoll, Ernest. *The Crest of the Continent: A Record of a Summer's Ramble in the Rocky Mountains and Beyond.* Chicago: R. R. Donnelley and Sons, 1885.

———. *Knocking Around the Rockies.* New York: Harper and Brothers, 1882.

———. "Silver San Juan." *Harper's Monthly* 64(April 1882):689–704.

Irving, Washington, et al. *Home Book of the Picturesque.* New York: G. P. Putnam, 1852.

Jackson, Clarence S. *Picture Maker of the Old West: William Henry Jackson.* New York and London: Charles Scribner's Sons, 1947.

Jackson, Clarence S., and Lawrence W. Marshall. *Quest of the Snowy Cross.* Denver: University of Denver Press, 1952.

Jackson, Donald, ed. *Letters of the Lewis and Clark Expedition.* Urbana: University of Illinois Press, 1972.

Jackson, John Brinckerhoff. *American Space: The Centennial Years, 1865–1876.* New York: Norton, 1972.

Jackson, William Henry. *The Diaries of William Henry Jackson, Frontier Photographer.* Edited by Ann W. Hafen and Leroy R. Hafen. Glendale, Calif.: Arthur H. Clark Co., 1959.

———. "First Visit to the Cliff Dwellings." *Colorado Magazine* 1(May 1924):151–59.

———. "Photographing the Colorado Rockies Fifty Years Ago for the U.S. Geological Surveys." *Colorado Magazine* 3(March 1926):11–22.

———. *Pioneer Photographer: Rocky Mountain Adventures with a Camera.* Yonkers-on-Hudson, N.Y.: World Book Co., 1929.

———. *Time Exposure: The Autobiography of William Henry Jackson.* New York: Van Rees Press, 1940. Reprint, Albuquerque: University of New Mexico Press, 1986.

———. "With Moran in Yellowstone." *Appalachia* 21(December 1936):149–58.

Jackson, W. Turrentin. "The Creation of Yellowstone National Park." *Mississippi Valley Historical Review* 24(June 1942):187–206.

———. "Government Exploration of the Upper Yelllowstone, 1871." *Pacific Historical Review* 11(June 1942):187–99.

———. "The Washburn-Doane Expedition into the Upper Yellowstone, 1870." *Pacific Historical Review* 10(June 1941):189–208.

Jacobowitz, Arlene. *James Hamilton, 1819–1878: American Marine Painter.* New York: Brooklyn Museum, 1966.

James, Edwin. *Account of an Exploration from Pittsburgh to the Rocky Mountains, Performed in the Years 1819 and '20.* Vol. 14 of *Early Western Travels, 1748–1846,* edited by Ruben Gold Thwaites. Cleveland: A. H. Clark Co., 1905–1907.

James, George Wharton. *In and Around the Canyon.* Boston: 1911.

Jarvis, James Jackson. *Art Thoughts.* New York: Hurd and Houghton, 1871.

Jayne, Horace H. F. "Moran and his 'Florida Landscape.'" *Pharos: Bulletin of the Museum of Fine Arts* (St. Petersburg, Fla.) Summer 1964.

Jones, Billy M. *Health Seekers in the Southwest, 1817–1900.* Norman: University of Oklahoma Press, 1967.

"The Journal of Walter Clement Powell." *Utah Historical Quarterly* 16–17(1948–49).

Jussim, Estelle, and Elizabeth Lindquist-Cock. *Landscape as Photograph.* New Haven and London: Yale University Press, 1985.

Keene, Marie. "Moran." *American Scene* 14(1973).

King, Clarence. *Mountaineering in the Sierra Nevada.* Boston: 1872. Reprint, New York: C. Scribner's Sons, 1902, and W. W. Norton and Co., 1935.

Kinsey, Joni L. "Creating a Sense of Place: Thomas Moran and the Surveying of the American West." Ph.D. dissertation, Washington University, St. Louis, 1989.

———. "Sacred and Profane: Thomas Moran's Mountain of the Holy Cross." *Gateway Heritage* 11(Summer 1990):4–23.

Klett, Mark, Ellen Manchester, Joann Verburg, Gordon Bushaw, Rick Dingus, Paul Berger. *Second View: The Rephotographic Survey Project.* Albuquerque: University of New Mexico Press, 1984.

Kobbe, Gustave. "Artists Combine for a Trip to Arizona." *New York Herald* November 26, 1911.

Kramer, Howard. "The Scientist in the West 1870–1880." *Pacific Historical Review* 12(September 1943):239–57.

Ladegast, Richard. "Thomas Moran, N.A." *Truth* 19(September 1900):209–12.

Landow, George P. "The Rainbow: A Problematic Image." *Nature and the Victorian Imagination,* edited by U. C. Knoepflmacher and G. B. Tennyson. Berkeley: University of California Press, 1977. Pp. 341–69.

Langford, Nathaniel P. *Diary of the Washburn Expedition to the Yellowstone.* St. Paul: J. E. Haynes, 1905.

———. *The Discovery of Yellowstone Park, 1870.* St. Paul: 1892.

———. "The Ascent of Mount Hayden: A New Chapter in Western Discovery." *Scribner's Monthly* 4(June 1873):129–57.

———. "The Wonders of Yellowstone." *Scribner's Monthly* 2(May 1871):1–17; (June 1871): 113–28.

Lavender, David. *Colorado River Country.* New York: E. P. Dutton and Co., 1982.

Leavitt, Judith Walzer, ed. *Women and Health in America.* Madison: University of Wisconsin Press, 1984.

Levy, Benjamin. *Curecanti Needle Recreation Area Background Study.* Washington, D.C.: National Park Service, 1966.

Lewis, Meriwether, and William Clark. *Original Journals of the Lewis and Clark Expedition, 1804–1806.* Edited by Ruben Gold Thwaites. Eight volumes. New York: Arno Press, 1969.

Lindquist-Cock, Elizabeth. "Frederic Church's Stereoscopic Vision." *Art in America* 61(1973): 70–75.

———. "The Influence of Photography on American Landscape Painting." Ph.D. dissertation, New York University, Institute of Fine Arts, 1967.

Lindstrom, Gaell. *Thomas Moran in Utah.* Logan: Utah State University Press, 1984.

Loan Exhibition: Paintings and Etchings by Thomas Moran. Santa Barbara: Free Public Library, Faulkner Memorial Art Gallery, 1936.

A Loan Exhibition of Paintings by Thomas Moran, N.A., to Commemorate the Centenary of His Birth. New York: American Art Association and Newhouse Galleries, 1937.

Longfellow, Henry Wadsworth. "The Cross of Snow." *Major American Poets to 1914,* edited by Francis Murphy. Lexington, Ky.: D. C. Heath and Co., 1967. Pp. 133–34.

"Lovers of the Beautiful." *Rocky Mountain News* September 22, 1880:8, col. 3.

Ludlow, Fitz Hugh. *In the Heart of the Continent: A Record of Travel Across the Plains and in Oregon.* New York: Hurd and Houghton, 1870.

Mangan, Terry William. *Colorado on Glass: Colorado's First Half Century as Seen by the Camera.* Denver: Sundance, 1975.

Manthorne, Katherine. "The Quest for a Tropical Paradise: Palm Tree as Fact and Symbol in Latin American Landscape Imagery, 1850–1875." *Art Journal* 44(Winter 1984):374–82.

———. *Tropical Renaissance: North American Artists Exploring Latin America, 1839–1879* (Washington, D.C.: Smithsonian Institution Press, 1989).

Marcy, Randolph Barnes. *The Prairie Traveler: A Hand-book for Overland Expeditions, with Maps, Illustrations, and Itineraries of the Principal Routes Between the Mississippi and the Pacific.* New York: Harper Bros., 1859.

Marshall, James. *Santa Fe: The Railroad That Built an Empire.* New York: Random House, 1945.

Marx, Leo. *The Machine in the Garden.* New York: Oxford University Press, 1964.

———. "The Railroad-in-the-Landscape: An Iconological Reading of a Theme in American Art." *Prospects: An Annual of American Cultural Studies* 10(1985):77–117.

Marzio, Peter. *Chromolithography, 1840–1900: The Democratic Art; Pictures for a Nineteenth Century.* Boston: David R. Godine, 1979.

———. *The Democratic Art: An Exhibition on the History of Chromolithography in America, 1840–1900.* Fort Worth: Amon Carter Museum, 1979.

Mather, Stephen Tyng. "The Work of Thomas Moran." *New York Times* January 27, 1917:sec. 7, p. 10.

Mattes, Merrill J. "Behind the Legend of Colter's Hell: The Exploration of Yellowstone National Park." *Mississippi Valley Historical Review* 36(September 1949):251–82.

McCabe, James D. *The Illustrated History of the Centennial Exhibition Held in Commemoration of the One Hundredth Anniversary of American Independence.* Philadelphia, Chicago, and St. Louis: National Publishing Co., 1876.

McClinton, Katherine Morrison. *The Chromolithographs of Louis Prang.* New York: C. N. Potter, 1973.

———. "L. Prang and Company." *Connoisseur* 191(February 1976):97–105.

McCoubrey, John, ed. *American Art 1700–1960: Sources and Documents.* Englewood Cliffs, N.J.: Prentice Hall, 1965.

McDermott, John Francis, ed. *The Frontier Re-Examined.* Urbana: University of Illinois Press, 1967.

———. *Travelers on the Western Frontier.* Urbana: University of Illinois Press, 1970.

McShine, Kynaston, ed. *The Natural Paradise: Painting in America, 1800–1950.* New York: Museum of Modern Art, 1976.

Memorial Exhibition: Paintings and Etchings by Thomas Moran N.A. East Hampton, N.Y.: Clinton Academy, 1928.

Miller, Perry. *Errand into the Wilderness.* New York: Harper and Row, 1964.

Mohr, Nicolaus. *Excursion Through America.* Edited by Ray Allen Billington. Chicago: Lakeside Press, R. R. Donnelley and Sons, 1973.

Moore, James C. "Thomas Cole's *The Cross and the World*: Recent Findings." *American Art Journal* 5(November 1973):50–60.

The Moran Family. Huntington, N.Y.: Heckscher Museum, 1965.

"Moran: His Sketches, Blueprints for Masterpieces." *American Scene* 16(Summer 1975):18–24.

Moran, Ruth B. "The Real Life of Thomas Moran as Known to His Daughter." *American Magazine of Art* 17(December 1926):645–46.

———. "Thomas Moran: An Impression." *Mentor* 12(August 1924):38–52.

Moran, Thomas. "American Art and American Scenery." *The Grand Canyon of Arizona,* edited by Charles Higgins. Chicago: Passenger Department of the Santa Fe Railroad, 1902.

———. "A Journey to the Devil's Tower in Wyoming (Artist's Adventures)." *Century Magazine* 47(January 1894):450–55.

———. "Knowledge a Prime Requisite in Art." *Brush and Pencil* 12(April 1903):14–16.

Morand, Anne. "The Prints of Thomas Moran." *Gilcrease Magazine of American History and Art* 8(October 1986):16–29.

Morand, Anne, Nancy Friese, et al. *The Prints of Thomas Moran in the Thomas Gilcrease Institute of American History and Art, Tulsa, Oklahoma.* Tulsa: Gilcrease Museum, 1986.

"Moran's Mountain of the Holy Cross." *Aldine* 7(July 1875):370–80.

Morton, Frederick W. "Thomas Moran, Painter-Etcher." *Brush and Pencil* 7(October 1900):1–16.

Moure, Nancy Dustin Wall. "Five Eastern Artists Out West." *American Art Journal* 5(November 1973):15–31.

Muir, John. *Our National Parks.* Boston: 1901.

————. *Picturesque California: The Rocky Mountains and the Pacific Slope.* Two volumes. New York and San Francisco: 1888.

Murphy, Thomas D. *Seven Wonderlands of the American West.* Boston: L. C. Page and Co., 1925.

Naef, Weston, and James N. Wood. *Era of Exploration: The Rise of Landscape Photography in the American West, 1860–1885.* Buffalo: Albright-Knox Art Gallery, and New York: Museum of Modern Art, 1975.

Nash, Roderick. *Wilderness and the American Mind.* New Haven: Yale University Press, 1967.

"National Academy of Design Exhibition." *New York Times* March 24, 1873:4, col. 7.

National Parks and the American Landscape. Washington, D.C.: Smithsonian Institution Press, 1972.

Nelson, Clifford. "William Henry Holmes: Beginning a Career in Art and Science." *Records of the Columbia Historical Society* 50(1980):252–78.

Newhall, Beaumont, and Diana Elkins. *William H. Jackson.* New York and Fort Worth: Morgan and Morgan and Amon Carter Museum, 1974.

Nolan, Edward. *Northern Pacific Views: The Railroad Photography of F. J. Haynes, 1876–1895.* Helena: Montana Historical Society Press, 1983.

Novak, Barbara. *Nature and Culture.* New York and London: Oxford University Press, 1980.

————. "Thomas Moran and the Grand Canyon of the Yellowstone." *Honolulu Academy of Arts Journal* 1(1974):31–35.

Numbers, Ronald L., and Ronald C. Sawyer. "Medicine and Christianity in the Modern World." *Health/Medicine and the Faith Traditions,* edited by Martin E. Marty and Kenneth L. Vaux. Philadelphia: Fortress Press, 1982. Pp. 133–60.

Oberholzer, E. P. *Jay Cooke: Financier of the Civil War.* Two volumes. Philadelphia: 1906.

Ostroff, Eugene. *Photographing the Frontier.* Washington, D.C.: Smithsonian Institution Press, 1976.

————. *Western Views and Eastern Visions.* Washington, D.C.: Smithsonian Institution Press, 1981.

"Our Late Panic." *International Review* 1(January 1874):3.

"Painter of the Western Scene." *Antiques* 31(March 1937):136.

Palmer, William J. *Recueil de Documents sur la Compagnie du Chemin de fer du Denver et Rio Grande et sur l'Improvements Compagnie qui s'y rattaché.* Paris: Typographie La Hure, 1874.

————. *The Westward Current of Population in the United States.* London: 1874.

Pangborn, J[oseph] G[ladding]. *Picturesque B&O.* Chicago: Knight and Leonard, 1882.

————. *The Rocky Mountain Tourist.* Topeka: T. J. Anderson, 1877.

Panzer, Mary. "How the West Was Won: Reinventing the Myth of William Henry Jackson." *Afterimage* 16(March 1989):17–19.

Parker, Robert Allerton. "The Water-colors of Thomas Moran." *International Studio* 86(March 1927):65–72.

Patrick, Darryl. "The Iconographical Significance in Selected Western Subjects Painted by Thomas Moran." Ph.D. dissertation, North Texas State University, 1978.

Pattison, William D. "The Pacific Railroad Rediscovered." *Geographical Review* 53(January 1962):25–36.

"The Pictured Rocks of Lake Superior." *Aldine* 6(January 1873):14–15.

Pomeroy, Earl Spencer. *In Search of the Golden West: The Tourist in Western America.* New York: Alfred Knopf, 1957.

Porte Crayon [pen name of D. H. Strother]. "Artists' Excursion over the Baltimore and Ohio Railroad." *Harper's New Monthly Magazine* 19(June 1859):1–19.

Powell, John Wesley. "The Cañons of the Colorado." *Scribner's Monthly* 9(January–March 1875):293–310, 394–409, 523–37.

———. *Cañons of the Colorado*. Meadville, Penn.: 1895. Reprint, New York: Dover, 1961.

———. "An Overland Trip to the Grand Cañon." *Scribner's Monthly* 10(October 1875): 659–78.

Powers, Laura Bride. "Early Art of Thomas Moran Shown in Art Club Exhibit." *Santa Barbara Morning Press* June 16, 1925.

Pringle, Alan. "Thomas Moran: *Picturesque Canada* and the Quest for a Canadian National Landscape Theme." *Imprint: Journal of the American Historical Print Collector's Society* 14(Spring 1989):12–21.

Rabbitt, Mary C. *John Wesley Powell's Exploration of the Colorado River*. Washington, D.C.: U.S. Government Printing Office, 1981.

———. *Minerals, Lands, and Geology for the Common Defence and General Welfare*, vol. 1, *Before 1879*. Washington, D.C.: U.S. Geological Survey, Government Printing Office, 1979.

Rainey, Ada. "Artists Nature's Press Agents." *Washington Post* December 6, 1931:8.

Rasmussen, William M. S. "Art of the Nineteenth Century Government Explorations in the West: Changing Concepts of the Western Landscape." Master's thesis, University of Delaware, 1975.

Raymond, R. W. "The Heart of the Continent: The Hot Springs and Geysers of the Yellow Stone River." *Harper's Weekly* April 5, 1873:273–74.

Raymond's Vacation Excursions: Three Grand Tours to the Yellowstone National Park. Boston: 1887.

Renz, Louis T. *The History of the Northern Pacific Railroad*. Fairfield, Wash.: Ye Galleon Press, 1980.

"A Review by Dr. Hayden of the 1873 Survey." *New York Tribune* December 30, 1873:3.

Rhymes of the Rockies. Pamphlet. Passenger Department, Denver and Rio Grande Railroad.

Richardson, James, ed. *Wonders of the Yellowstone*. New York: Scribner, Armstrong and Co., 1872.

Rideing, W. D. "The Rocky Mountains." *Picturesque America*, vol. 2. New York: D. Appleton and Co., 1874. Pp. 482–511.

Riegel, Robert Edgar. *The Story of the Western Railroads*. New York: Macmillan, 1926.

Rogers, Edmund B. *Rocky Mountain Letters 1869: A Journal of an Early Geological Expedition to the Colorado Rockies, by William H. Brewer*. Denver: Colorado Mountain Club, 1930.

Rossi, Paul A., and David C. Hunt. *The Art of the Old West from the Collection of the Gilcrease Institute*. New York: Alfred Knopf, 1971.

Runte, Alfred. "The National Park Idea: Origins and Paradox of the American Experience." *Journal of Forest History* 21(April 1977):64–75.

———. *National Parks: The American Experience*. Lincoln and London: University of Nebraska Press, 1979.

———. "Pragmatic Alliance: Western Railroads and the National Parks." *National Parks and Conservation Magazine* 48(April 1974):14–21.

———. *Trains of Discovery: Western Railroads and the National Parks*. Flagstaff, Ariz.: Northland Press, 1984. Rev., Niwot, Colo.: Roberts Rinehart, 1990.

Ruskin, John. *Modern Painters*. Five volumes. New York: Wiley and Putnam, 1847.

Russell, Andrew Joseph. *The Great West Illustrated*. Omaha: Union Pacific Railroad, 1869.

Sachs, Samuel II. "Thomas Moran, Drawings and Watercolors." Master's thesis, New York University, 1963.

Sale of Paintings Belonging to Louis Prang. New York: American Art Association, 1892.

Sampson, John. "Photographs from the High Rockies." *Harper's Magazine* 39(September 1869).

Sandhurst, Philip T. *The Great Centennial Exhibition*. Philadelphia and Chicago: P. W. Ziegler and Co., 1876.

Sandweiss, Martha. *Pictures from an Expedition*. New Haven: Yale University Art Gallery, 1979.

Santa Fe Collection of Southwestern Art: An Exhibition at Gilcrease Museum. Chicago: Santa Fe Railway, 1983.

Sartain, John. "James Hamilton." *Sartain's Union Magazine of Literature and Art* 10(1852): 331–33.

"The Scenery of Southern Utah." *Aldine* 7(March 1875):305–307.

"Scenes of the Yellowstone Valley." *Appleton's Journal of Literature, Science and Art* 7(May 11, 1872):519–22.

Sears, John F. *Sacred Places: American Tourist Attractions in the Nineteenth Century.* New York and Oxford: Oxford University Press, 1989.

Seckinger, Katherine Villard, ed. "The Great Railroad Celebration, 1883." *Montana: The Magazine of Western History* 33(Summer 1983):12–23.

Sheldon, George. *American Painters.* New York: D. Appleton and Co., 1881.

Shikes, Robert H. "Colorado's First Physicians: A Look at Medicine from Before the Gold Rush to the Gilded Age." *Colorado Heritage* 1983:18–24.

———. *Rocky Mountain Medicine: Doctors, Drugs, and Disease in Early Colorado.* Boulder: Johnson Books, 1986.

Sights and Scenes in Colorado for Tourists. 5th ed. Omaha: Union Pacific Railway Co., 1893.

Simpson, William H. "Thomas Moran—The Man." *Fine Arts Journal* 20(January 1909):19–26.

Sipes, William B. *The Pennsylvania Railroad: Its Origin, Construction, Conditions, and Connections, Embracing Historical Description and Statistical Notices of Cities, Towns, Villages, Stations, Industries and Objects of Interest on Its Various Lines in Pennsylvania and New Jersey.* Philadelphia: Passenger Department of the Pennsylvania Railroad, 1875.

Smalley, Eugene V. *History of the Northern Pacific Railroad.* New York: G. P. Putnam's Sons, 1883.

Smith, Henry Nash. "Clarence King, John Wesley Powell, and the Establishment of the United States Geological Survey." *Mississippi Valley Historical Review* 34(1947):37–58.

———. "Rain Follows the Plow: The Notion of Increased Rainfall for the Great Plains, 1844–1880." *Huntington Library Quarterly* 10(1947):169–93.

———. *Virgin Land: The American West as Symbol and Myth.* New York: Random House–Knopf, 1950. Reprint, Cambridge: Harvard University Press, 1970.

Solly, Samuel. *Colorado Springs for Invalids.* Colorado Springs: Gazette Publishing, 1880.

———. *The Health Resorts of Colorado Springs and Manitou Springs.* Colorado Springs: Gazette Publishing, 1883.

———. *Manitou, Colorado, U.S.A.: Its Mineral Waters and Climate.* London and St. Louis: J. McKittrick and Co., 1875.

Splendors of the American West: Thomas Moran's Art of the Grand Canyon and Yellowstone. Birmingham: Birmingham Museum of Art in Association with University of Washington Press, 1990.

Sprague, Marshall. *Newport in the Rockies: The Life and Good Times of Colorado Springs* 4th rev. ed. Athens, Ohio: Swallow Press and University of Ohio Press, 1987.

Standing Rainbows: Railroad Promotion of Art of the West and Its Native People. Wichita: Kansas State Historical Society, 1981.

Stegner, Wallace. *Beyond the Hundredth Meridian: John Wesley Powell and the Second Opening of the West.* Boston: Houghton Mifflin, 1953.

———. "Jack Sumner and John Wesley Powell." *Colorado Magazine* 26(January 1949):61–69.

———. "The Scientist as Artist: Clarence E. Dutton and the Tertiary History of the Grand Cañon District." *American West* 15(May–June 1978):17–18, 61–63.

Stein, Roger. *John Ruskin and Aesthetic Thought in America, 1840–1900.* Cambridge: Harvard University Press, 1967.

Stevens, Nina Spalding. "A Pilgrimage to the Artist's Paradise." *Fine Arts Journal* 34(February 1911):251–53.

"A Storm in Utah." *Aldine* 7(August 1876):175.

Strahorn, Robert E., ed. *Colorado Tourist* 2(September 1882).

Stucker, Gilbert F. "Hayden in the Badlands." *American West* 4(February 1967):40–45, 79–85.

Sturhahn, Joan. *Carvalho: Artist-Photographer-Adventurer-Patriot: A Portrait of a Forgotten American.* Merrick, N.Y.: Richwood, 1976.

Sweeney, J. Gray. "The Artist Explorers of the American West, 1860–1880." Ph.D. dissertation, Indiana University, 1975.

———. *Artists of Michigan from the Nineteenth Century.* Muskegon, Mich.: Muskegon Museum of Art, 1987.

———. "Endued with Rare Genius: Frederic Edwin Church's *To the Memory of Cole.*" *Smithsonian Studies in American Art* 2(Winter 1988):44–71.

Taft, Robert. *Artists and Illustrators of the Old West: 1850–1900.* New York: Charles Scribner's Sons, 1953. Reprint, Princeton: Princeton University Press, 1982.

———. *Photography and the American Scene: A Social History 1839–1889.* New York: 1938. Reprint, New York: Dover, 1964.

Teetor, Henry Dudley. "Manitou Springs, All Year Round." *Magazine of Western History* 11(November 1889):43–47.

———. "The Mountain of the Holy Cross: Study of a Historical Painting." *Magazine of Western History* 11(November 1889): 3–8.

Terrell, John Upton. *The Man Who Rediscovered America: A Biography of John Wesley Powell.* New York: Weybright and Talley, 1969.

"Thomas Moran." *Aldine* 9:265.

"Thomas Moran Art in Milch Galleries: An Amazing Record." *New York American* December 26, 1926.

Thomas Moran, N.A.: Centenary Exhibition. Los Angeles: Los Angeles Art Association, 1937.

Thomas Moran, N.A., Mary Nimmo Moran, S.P.E.: A Catalogue of Complete Etched Works. New York: Christian Klackner Gallery, 1889.

Thomas Moran: Works from the Thomas Gilcrease Institute of American History and Art. Phoenix: Phoenix Art Museum, 1986.

"Thomas Moran's Exhibition in His Native Town." *New York Herald* July 3, 1882:2.

"Thomas Moran's Grand Cañon of the Yellowstone." *Scribner's Monthly* 4(June 1872):251–52.

"Thomas Moran's Water Color Drawings." *Scribner's Monthly* 5(January 1873):394.

Three Grand Trips to the Yellowstone National Park with a Complete Round of All the Points of Interest in America's Wonderland. New York: J. M. Jenkins, 1888.

Toll, Roger W. "The Hayden Survey in Colorado in 1873 and 1874: Letters from James T. Gardiner." *Colorado Magazine* 6(July 1929):146–56. These letters are also printed in *Transactions of the Academy of Sciences of St. Louis* 1(1856–60):17, 107.

Topping, Eugene. *Chronicles of the Yellowstone.* St. Paul: 1886.

Trenton, Patricia, and Peter H. Hassrick. *The Rocky Mountains: A Vision for Artists in the Nineteenth Century.* Norman: University of Oklahoma Press, 1983.

Truettner, William. "Scenes of Majesty and Enduring Interest": Thomas Moran Goes West." *Art Bulletin* 58(June 1976):241–59.

———. "The Genius of Frederic Edwin Church's *Aurora Borealis.*" *Art Quarterly* 31(Autumn 1968):267–83.

———, ed. *The West as America: Reinterpreting Images of the Frontier, 1820–1920.* Washington, D.C.: Smithsonian Institution Press, 1991.

Tuckerman, Henry. *Book of the Artists: American Artist Life.* 1867. Reprint, New York: James F. Carr, 1966.

Union Pacific Sketchbook: A Brief Description of Prominent Places of Interest Along the Line of the Union Pacific. Omaha: Union Pacific Railroad Passenger Department, 1887.

"Utah Scenery." *Aldine* 7(January 1874):14–15.

Vaughn, Malcolm. "Moran Centennial Heads Art Shows Opened This Week." *New York American* January 16, 1937.

Vaughn, W. R. *Union Pacific Railroad Business Handbook and Emigrant's Guide.* Council Bluffs, Iowa: 1871.

Villard, Henry. *Memoirs of Henry Villard.* Two volumes. Boston: 1904.

———. *The Past and Present of the Pikes Peak Gold Region with Maps and Illustrations.* St. Louis: Sutherland and McEnvoy, 1860.

Wagner, Virginia L. "Geological Time in Nineteenth-Century Landscape Paintings." *Winterthur Portfolio* 24(Summer–Autumn 1989):153–63.

Walker, J. B. "The Great Railway Systems of the United States." *Cosmopolitan* 19(May 1895): 16–28.

Walther, Susan Danly. *The Railroad in the American Landscape.* Wellesley, Mass.: Wellesley College Museum, 1981.

Washburn, Henry Dana. "Yellowstone Expedition." *New York Times* October 14, 1870:4, col. 4.

Wasserman, Emily. "The Artists-Explorers." *Art in America* July–August 1972:48–57.

Water Colors by Thomas Moran N.A., 1837–1926. Los Angeles: Biltmore Salon, 1927.

Watercolor Sketches by Thomas Moran, N.A., Memorial Exhibition. New York: Milch Galleries, 1926.

Watkins, Tom H. *The Grand Colorado: The Story of a River and Its Canyons.* Palo Alto, Calif.: American West, 1969.

Watson, Elmo Scott. "John W. Powell's Colorado Expedition of 1867." *Colorado Magazine* 27(October 1850):303–11.

Weber, David J. *Richard H. Kern: Expeditionary Artist in the Far Southwest, 1848–1853.* Albuquerque: University of New Mexico Press, 1985.

Weiss, Ila. *Poetic Landscapes: The Art and Experience of Sanford Gifford.* Cranbury, N.J.: Associated University Presses, 1987.

Weitenkampf, Frank. "A Thomas Moran Centenary." *Bulletin of the New York Public Library* 41(1937):127.

Welling, William. *Photography in America: The Formative Years, 1839–1900.* New York: Thomas Y. Crowell Co., 1978.

Whitney, Josiah Dwight. "Geographical and Geological Surveys." *North American Review* 121(July 1875):37–85; (October 1875):270–314.

Wilkins, Thurman. "Moran." *American Scene* 1(1963):24–37, 57–59.

———. *Thomas Moran: Artist of the Mountains.* Norman: University of Oklahoma Press, 1966.

Williams, Henry T. *The Pacific Tourist: Williams' Illustrated Trans-Continental Guide of Travel, from the Atlantic to the Pacific Ocean.* New York: 1876. Reprinted until 1884.

———. *The Picturesque West.* New York: 1886.

Willis, Nathaniel Parker, et al. *Picturesque American Scenery.* Boston: Estes and Lauriat, 1885.

Wilson, James B. "The Significance of Thomas Moran as an American Landscape Painter." Ph.D. dissertation, Ohio State University, 1955.

Wilton, Andrew. *J.M.W. Turner: His Art and Life.* New York: Rizzoli, 1979.

Wolf, Daniel, ed. *The American Space: Meaning in Nineteenth-Century Landscape.* Middletown, Conn.: Wesleyan University Press, 1983.

The Wonderland of the World. St. Paul, Minn.: Northern Pacific Railroad Passenger Department, 1884.

Wood, Charles R. *The Northern Pacific: Mainstreet of the Northwest.* Seattle: Superior Publishing Co., 1968.

Wood, Stanley. *Over the Range to the Golden Gate: A Complete Tourist's Guide to Colorado, New Mexico, Utah, Nevada, California, Oregon, Puget Sound and the Great North-West.* Chicago: 1894.

Wylie, W. W. *Yellowstone National Park, or the Great American Wonderland.* Kansas City: 1882.

"The Yellowstone Park Bill." *New York Times* February 27, 1872.

"The Yellowstone Region." *Aldine* 6(March 1873):74–75.

INDEX

Page references to figures and plates appear in italics.